KU-875-805

The Interpretive Link
William Baziotes
Byron Browne
Arshile Gorky
Adolph Gottlieb
John D. Graham
Hans Hofmann
Gerome Kamrowski
Wifredo Lam
André Masson
Matta
Joan Miró
Robert Motherwell
Barnett Newman
Gordon Onslow Ford
Wolfgang Paalen
Jackson Pollock
Richard Pousette-Dart
Mark Rothko
David Smith
Theodoros Stamos
Yves Tanguy
Mark Tobey

KA 0023281 5

Newport Harbor Art Museum
Newport Beach, California

The Interpretive Link

Abstract Surrealism into Abstract Expressionism

W O R K S O N P A P E R 1938-1948

Organized by
Paul Schimmel

Essays by
Lawrence Alloway
Dore Ashton
Robert C. Hobbs
Philip Leider
Mollie McNickle
Martica Sawin
Paul Schimmel

WITHDRAWN FROM
THE LIBRARY
UNIVERSITY OF
WINCHESTER

741.973
SCH

4889

The Interpretive Link: Abstract Surrealism into Abstract Expressionism, Works on Paper, 1938–1948 has been made possible by a generous gift from The Irvine Company. Additional funding was provided by the National Endowment for the Arts, a Federal Agency. Support for The Interpretive Link Education Programs in California was made possible by a grant from the California Council for the Humanities, a state affiliate of the National Endowment for the Humanities.

Published for the exhibition **The Interpretive Link: Abstract Surrealism into Abstract Expressionism, Works on Paper, 1938–1948**

Newport Harbor Art Museum
Newport Beach, California
July 16–September 14, 1986

Whitney Museum of American Art
New York, New York
November 13, 1986–January 21, 1987

Walker Art Center
Minneapolis, Minnesota
February 21–April 19, 1987

Copyright © 1986, Newport Harbor Art Museum.
All rights reserved. No part of the contents of this book may be reproduced without the written permission of the publisher.
Mark Rothko images designated cat. 116 through 121 and 124 are © Estate of Mark Rothko, 1986.
Edited by Sue Henger, Newport Harbor Art Museum.
Designed in Glendale, California by Lilli Cristin.
Type set by R S Typographics, North Hollywood.
Printed and bound by Dai Nippon in Japan.

Library of Congress Cataloging in publication data
The interpretive link.
Bibliography: p.
 1. Drawing, American—Exhibitions. 2. Surrealism—United States—Exhibitions. 3. Abstract expressionism—United States—Exhibitions. 4. Drawing, Abstract—United States—Exhibitions. 5. Drawing—20th century—United States—Exhibitions. I. Schimmel, Paul Gordon. II. Alloway, Lawrence, 1926– . III. Newport Harbor Art Museum.
NC108.I57 1986 741.973'074'019496 86-5227
ISBN 0-917493-04-4

Cover illustration:
Arshile Gorky
Virginia Landscape, c. 1946 (detail)
pencil and crayon on paper
18½ x 23⅝ inches (47 x 60 cm)
Xavier Fourcade, Inc., New York

Contents

For nearly a quarter of a century, the Newport Harbor Art Museum has demonstrated its commitment to provide cultural experiences of international significance to the people of Southern California, a commitment The Irvine Company has shared throughout its history. In celebration of this mutual concern for the quality of Southern California's cultural life, The Irvine Company is sponsoring a series of major annual exhibitions to be presented by the Newport Harbor Art Museum through 1994.

The Irvine Company is pleased to be a part of the effort to present the exhibition and catalog, *The Interpretive Link: Abstract Surrealism into Abstract Expressionism, Works on Paper, 1938–48*. It is through exhibitions and publications such as these that our lives are enriched, while extending the benefits of this scholarship to the art historical community.

The Irvine Company is honored to share this exhibition with audiences in Southern California, New York and Minnesota, and looks forward to future presentations in this series.

Thomas H. Nielsen
President

THE IRVINE COMPANY

Foreword

Over the past 24 years the Newport Harbor Art Museum had undertaken increasingly ambitious and dramatic exhibition programs. Two years ago, "Action/Precision: The New Direction in New York, 1955–1960" not only surpassed all previous efforts but, in many respects, laid the groundwork for this exhibition. The research and scholarship necessary to make "The Interpretive Link: Abstract Surrealism into Abstract Expressionism, Works on Paper, 1938–1948" a worthy successor to "Action/Precision" has taken almost three years. Paul Schimmel, Chief Curator, has overseen the project with great energy and professionalism. The concerted effort that has gone into this exhibition will endure as exploration continues into this vital, transitional era in American art.

The drawings in this exhibition, encompassing the years prior to, including, and after World War II, are among the finest obtainable, and we are grateful to the public institutions, private collectors, and galleries who have lent them. We are grateful also to the Whitney Museum of American Art, New York, and the Walker Art Center, Minneapolis, for participating in the exhibition tour and for sharing our dedication to the investigation of this period in the history of art.

Finally, I wish to express our appreciation to The Irvine Company, Newport Beach, its Chairman, Donald L. Bren, and President, Thomas H. Nielsen, for their personal commitment to the support of significant historical exhibitions of art at the Newport Harbor Art Museum, and to the National Endowment for the Arts for its generous support of this project, which enabled us to expand and achieve the scope and quality of this exhibition and the accompanying catalog.

Kevin E. Consey
Director

Lenders to the Exhibition

Institutions

Albright-Knox Art Gallery, Buffalo, New York
Allen Memorial Art Museum, Oberlin College, Oberlin, Ohio
The Arkansas Art Center Foundation, Little Rock,
 Arkansas
Sarah Campbell Blaffer Foundation, Houston, Texas
Everson Museum of Art, Syracuse, New York
The Fort Worth Art Museum, Fort Worth, Texas
Solomon R. Guggenheim Museum, New York
Herbert F. Johnson Museum of Art, Cornell University,
 Ithaca, New York
The Museum of Modern Art, New York
Montana Historical Society, Helena, Montana
The North Carolina Museum of Art, Raleigh, North Carolina
Portland Museum of Art, Portland, Maine
Betty Parsons Foundation, New York
San Francisco Museum of Modern Art, San Francisco,
 California
Seattle Art Museum, Seattle, Washington
Wadsworth Atheneum, Hartford, Connecticut
Whitney Museum of American Art, New York
Jane Voorhees Zimmerli Art Museum, Rutgers–The State
 University, New Brunswick, New Jersey

Private Collections

The Ball Stalker Collection, Atlanta, Georgia
Mr. and Mrs. Walter Bareiss, New York
Ethel Baziotes, New York
Mr. and Mrs. Bruce Clark, New York
Douglas and Carol Cohen, Chicago, Illinois
Stefan T. Edlis, Chicago, Illinois
Dorothea Elkon, New York
Phil and Norma Fine, Boston, Massachusetts
Abby and B. H. Friedman, New York
Mary Jane Kamrowski, Ann Arbor, Michigan
Anne and Jean-Claude Lahumière, Paris, France
Richard E. and Jane M. Lang Collection, Medina,
 Washington
Duncan MacGuigan, New York
Mr. and Mrs. David Mirvish, Toronto, Ontario, Canada
Robert Motherwell, Greenwich, Connecticut
Mr. and Mrs. S. I. Newhouse, Jr., New York
Annalee Newman, New York
Gordon Onslow Ford, Inverness, California
Christopher Rothko and Kate Rothko Prizel, Washington,
 D.C.
Candida and Rebecca Smith, New York
Mr. and Mrs. Eugene Victor Thaw, New York
Varjabedian, H., California
Marcia S. Weisman, Beverly Hills, California
Cynthia and Micha Ziprkowski, New York

Galleries

Blum Helman Gallery, New York
Camillos Kouros Gallery, New York
Maxwell Davidson Gallery, New York
Marisa del Re Gallery, Inc., New York
Andre Emmerich Gallery, New York
Xavier Foucade, Inc., New York
Allan Frumkin Gallery, New York
Arnold Herstand & Co., New York
M. Knoedler & Co., Inc., New York
Luisa Laureati, Galleria dell'Oca, Rome
Margo Leavin Gallery, Los Angeles, California
Meredith Long & Co., Houston, Texas
Galerie Maeght Lelong, New York
Marlborough Gallery, New York
Pierre Matisse Gallery, New York
Herbert Palmer Gallery, Los Angeles, California
Allan Stone Gallery, New York
Turske & Turske, Zurich

Acknowledgments

The organization of an exhibition of this magnitude has involved the assistance and collaboration of many individuals. For all the help and support, I am indebted to the artists, art historians, estate and foundation directors, art dealers and museum professionals who have contributed so generously and enthusiastically toward a further understanding of the importance of this period. First and foremost the artists must be acknowledged for having created a body of work of such lasting value.

The sixty-two lenders to the exhibition are acknowledged for their generosity in allowing the Newport Harbor Art Museum to borrow these works and in permitting their subsequent travel. The very fragile nature of drawings has no doubt made the decision to lend all the more difficult; fortunately for the exhibition, these individuals recognized the need for a greater awareness of both the artists' work in general from this period and the drawings specifically. I would especially like to recognize the estates of William Baziotes, Arshile Gorky, Adolph Gottlieb, Hans Hofmann, Barnett Newman, Mark Rothko and David Smith, which have lent numerous works. Special thanks go to the Blum Helman Gallery, Peter C. Freeman and Mrs. Ethel Baziotes for the Baziotes estate; Xavier Fourcade for the Gorky estate; Sanford Hirsch and Mrs. Esther Gottlieb for the Adolph and Esther Gottlieb Foundation; Andre Emmerich Gallery and Nathan Kolodner for the Hofmann estate; Mrs. Annalee Newman for the Barnett Newman estate; Christopher Rothko and Kate Rothko Prizel for the Estate of Mark Rothko; and Peter Stevens and M. Knoedler & Co. for the David Smith Estate.

Museums and foundations have been very generous in lending key works to the exhibition. They include Douglas G. Schultz, Director, Albright-Knox Art Gallery; M. Kirby Talley, Jr., Director, Allen Memorial Art Museum; Townsend Wolfe, Director, and Michael Preble, Curator, The Arkansas Art Center; Terrell Hillebrand, Director, Sarah Campbell Blaffer Foundation; Ronald A. Kuchta, Director, Everson Museum of Art; E. A. Carmean, Director, and Diane Upright, Senior Curator, The Fort Worth Museum of Art; Thomas Messer, Director, and Diane Waldman, Deputy Director, Solomon R. Guggenheim Museum; Tom Leavitt, Director, and Cynthia Wayne, Assistant Curator, Herbert F. Johnson Museum of Art; Susan R. Near, Curator of Collections, Montana Historical Society; John Elderfield, Director of Drawings, and Beatrice Kernan, Assistant Curator of Drawings, The Museum of Modern Art; Edgar Peters Bowron, Director, and Mitchell Kahan, Curator of American and Contemporary Art, North Carolina Museum of Art; Marilyn Cohen, Curator, and Christopher Schwabacher, Executor, The Betty Parsons Foundation; John Holverson, Director, and Lisa Holst, Curator, Portland Museum of Art; Graham W. J. Beal, Chief Curator, and Carol Rosset of the Registrar Department, San Francisco Museum of Modern Art; John

Pierce, Modern Art Department, Seattle Art Museum; Tracy Atkinson, Director, and Gregory Hedberg, Chief Curator, Wadsworth Atheneum; Thomas N. Armstrong III, Director, Paul Cummings, Adjunct Curator of Drawings, and Patterson Sims, Associate Curator, Whitney Museum of American Art; and Phillip Dennis Cate, Director, and Jeffrey Wechsler, Assistant Director, Jane Voorhees Zimmerli Art Museum.

Galleries have been a significant resource for this exhibition. The individuals who have assisted with the loans include Maxwell Davidson III of the Maxwell Davidson Gallery; Marisa del Re, Glenn McMillan, and Claude Logan of the Marisa del Re Gallery; Allan Frumkin of the Allan Frumkin Gallery; Scott Cook of Arnold Herstand & Co.; Angelos Camillos of the Camillos Kouros Gallery; Meredith Long and Ben Crump of Meredith Long & Co.; Margo Leavin of the Margo Leavin Gallery; Daryl Harnisch of Galerie Maeght Lelong; Pierre Levai and Jack Mognaz of the Marlborough Gallery; Pierre Matisse and Pierre Boudreau of the Pierre Matisse Gallery Corp.; Herbert Palmer of the Herbert Palmer Gallery; Allan Stone, Joan Wolff, and Allison Stone of the Allan Stone Gallery; and E. V. Thaw and Patricia Tang of E. V. Thaw & Co., Inc.

We are especially grateful to lenders and artists who have allowed us to borrow works from their collections. Private lenders include The Ball Stalker Collection; Mr. and Mrs. Walter Bareiss; Mr. and Mrs. Bruce Clark; Douglas and Carol Cohen; Stefan T. Edlis; Dorothea Elkon; Phil and Norma Fine; Abby and B. H. Friedman; Richard E. and Jane M. Lang; Gerome Kamrowski and Mary Jane Kamrowski; Anne and Jean-Claude Lahumière; Luisa Laureati; Duncan MacGuigan; Mr. and Mrs. David Mirvish; Robert Motherwell; Mr. and Mrs. S. I. Newhouse, Jr.; Gordon Onslow Ford; Hrag Varjabedian; Marcia Weisman; and Cynthia and Micha Ziprkowski.

My deep appreciation goes to Thomas N. Armstrong III, Director; Lisa Phillips, Associate Curator and Head, Branch Museums; and Kathleen Monahan, Director, The Equitable Center, of the Whitney Museum of American Art; and Martin Friedman, Director, and Liz Armstrong, Assistant Curator, of the Walker Art Center, for having encouraged this exhibition and agreeing to participate in its circulation.

The quality of the catalog reflects the contributions of many art historians who submitted original material for this publication. The insights and expertise of essayists Dore Ashton, Robert Hobbs, Philip Leider, Mollie McNickle, and Martica Sawin added significantly to this publication. We are grateful to Lawrence Alloway, who granted us permission to reprint his earlier published article on the subject. Anne Ayres, Ruth Bowman, Ellen Breitman, Sue Henger, Dinah McClintock, Mollie McNickle, James Scarborough, Merle Schipper, and Betsy Severance have contributed esays focusing on the background of these artists and the individual merits of their drawings. Lilli Cristin is acknowl-

edged for her sensitive and fitting catalog design.

In addition to the insights provided by many of the artists, dealers and lenders, several art historians, either through conversations or previously published research, have provided this curator with knowledge and information that greatly enhances the exhibition. Appreciation goes to Lawrence Alloway, Dore Ashton, Martha Baer, Nicolas Calas, Barbara Cavaliere, Bonnie Clearwater, Stephen C. Foster, Ann Gibson, Eleanor Green, Serge Guilbaut, Sanford Hirsch, Robert Hobbs, Sam Hunter, Gail Levin, Stephen Polcari, Barbara Rose, Robert Rosenblum, William Rubin, Irving Sandler, Eugene Victor Thaw, Nancy R. Versaci and Judith E. Tolnick, Patrick Waldberg, Diane Waldman, and Jeffrey Wechsler.

Newport Harbor Art Museum's staff has shown passionate concern for the quality of this exhibition. The results are due in no small part to their commitment. I want to thank Kevin E. Consey, Director of the Newport Harbor Art Museum, who has enthusiastically supported this exhibition from its inception and has provided the necessary support to make it possible. I am in great debt to the Newport Harbor Art Museum's first Curatorial Fellow, Betsy Severance, who has worked on every phase of this exhibition and was instrumental in the areas of loan coordination and catalog compilation. Sue Henger, editor of this catalog, has labored lovingly to create a document that accurately reflects the exhibition and adds to our knowledge of the period. Natasha Sigmund, Registrar, with the assistance of Laurie German, Registration Intern, has successfully managed all aspects of shipping and special handling of these important works from such a large group of lenders. Lorraine Dukes, Assistant to the Chief Curator, has ably handled significant portions of the catalog and circulation correspondence as well as the basic organizational needs of an exhibition of this scale. In support of this exhibition, Ellen Breitman, Curator of Education, with the assistance of James Scarborough, former Assistant Curator of Education, and Dinah McClintock, Curatorial Intern, has organized a comprehensive program of lectures, films and poetry readings. Richard Tellinghuisen, Director of Operations, and Brian Gray, Chief Preparator, are acknowledged for the installation and the preparation of this exhibition. Jane Piasecki, Associate Director, Margie Shackelford, Director of Development, Kathleen Costello, Public Relations Officer, and Kim Litsey, Associate Director of Development, are acknowledged for their contributions in the areas of funding and public relations.

This exhibition has been made possible through the generous support of The Irvine Company. Their enlightened support of important exhibitions has helped the Museum to realize three of its most significant exhibitions. I would like to acknowledge the personal interest of Donald Bren, Chairman, and Thomas Nielsen, President. A grant from the National Endowment for the Arts has also contributed significantly to this exhibition. Support for Education Programs in California was made possible by a grant from the California Council for the Humanities, a state affiliate of the National Endowment for the Humanities. The Trustees of the Newport Harbor Art Museum have been committed from the very beginning to support this exhibition, by far the most complex and difficult exhibition and catalog the Newport Harbor Art Museum has ever originated.

Paul Schimmel
Chief Curator

Images of Metamorphosis

Paul Schimmel

"There's a style of painting gaining ground in this country which is neither Abstract nor Surrealist, though it has suggestions of both, while the way the paint is applied— usually in a pretty free-swinging, spattery fashion with only vague hints at subject matter—is suggestive of the methods of Expressionism. I feel that some new name will have to be coined for it, but at the moment I can't think of any."[1]
—Robert M. Coates
The New Yorker, 1944

During World War II, the center of the art world moved from Paris to New York. Concurrently in Europe and America, illusionist surrealism was supplanted by abstract surrealism. A new art evolved that would embrace abstraction, "reassert the picture plane," affirm that "subject is crucial," and find "simple expressions of complex thoughts." Art would be an "adventure into an unknown world" and would have a "spiritual kinship with primitive and archaic art."[2] As the art world was going through a period of change, the subjects of the artist—the images themselves—became visual metaphors for birth, growth, evolution and change. Depictions of landscapes, figures, "mindscapes," water, and biological and stellar formations became intermingled, creating complex images with multiple associations.

The Interpretive Link: Abstract Surrealism into Abstract Expressionism presents 137 drawings by 22 artists whose independent vocabularies, styles, attributes, and goals were distinct from orthodox surrealism and from abstract expressionism. This selection of drawings aims to define an abstract surrealist idiom leading to the breakthroughs in American painting that culminated in the heroic abstract expressionism of the 1950s. The exhibition examines the development of automatism into action and drip painting, the interplay between natural forms and abstraction, and the use of encoded signifiers as subject matter. Incorporating forms derived through the automatic drawing process with images abstracted from the natural world, science, religion, and myth, the abstract surrealist artists, during a period of unprecedented conflict, sought to infuse their work with human emotion. These artists rejected the surrealists' programmatic lack of esthetic or moral considerations, yet retained their goal of making visible the unseen. Serious in their commitment to pictorial means, the American artists distrusted the surrealists' playfulness and illusionistic representations. Replacing pure psychic automatism with a more controlled, plastic automatism, the abstract surrealists invented an art that addressed both painterly and iconographic concerns. As the drawings in this exhibition confirm, abstract expressionism descended from abstract surrealism and evolved into an art that no longer required recognizable imagery.

The tendency to equate the beginnings of abstract expressionism with the "big bang" or the "clap of thunder" theory portrays New York painting as originating spontaneously without a heritage. "When 'Abstract Expressionism' is employed by later critics, it is tacitly assumed that something new (and often uniquely American) is implied; in other words, the emphasis is usually centered on traits without clear precedents or contemporary European analogues."[3] This nationalistic interpretation has since been supplanted by more reasoned, formal and scientific analyses that reveal an evolutionary rather than cataclysmic development.[4]

The different direction each artist took subsequent to the 1938–48 period is critical to an understanding of his individual oeuvre, but our understanding of how the New York School developed is explained in part by the interaction of these artists at that time. The direct contact between the European surrealists and the American artists was the catalyst that American art needed to break from the prevailing regionalism and social realism, as well as from an American variant of geometric abstraction. It was the need for this break that Samuel Kootz had in mind when in 1941 he commented:

Under present circumstances the probability is that the future of painting lies in America. The pitiful fact is, however, that we offer little better than a geographical title to the position of world's headquarters for art.... Isn't there a *new* way to reveal your ideas, American painters? Isn't it time right now to check whether what you're saying is regurgitation, or tired acceptance, or the same smooth railroad track?[5]

With the outbreak of World War II in 1939, the European surrealist artists were already prepared for a relocation that would allow them to continue working. When Paris was overtaken, surrealist writer André Breton and artists Roberto Matta Echaurren, Yves Tanguy, Gordon Onslow Ford and others had relocated to a chateau in Chemillieu (Ain) that Gertrude Stein had rented. Later that year, Onslow Ford, Tanguy and Matta left for New York. In the ensuing exodus from France through the unoccupied zone, André Masson, Kurt Seligmann and Man Ray also made their way to New York, where their presence caused a resurgence of interest in revolutionary ideas previously known only through surrealist publications and exhibitions. America was suddenly host to the avant-garde.

The American artists and the European abstract surrealists in New York met and communicated through lectures, exhibitions, publications, and informal meetings. Peggy Guggenheim's gallery, Art of This Century, was an important arena, mounting one-person shows for the Europeans and for emerging American artists Pollock, Motherwell, Hofmann, Baziotes and others. Galleries directed by Julien Levy and Pierre Matisse also exhibited important European artists and became meeting places for Americans and Europeans. The Museum of Modern Art, which had championed European modernism from its inception, played a substantial role in this interaction through its exhibitions of Miró, Picasso, and others who remained in Europe but whose presence was felt throughout the '40s. The First Papers of Surrealism was a seminal coming together of the old and the new worlds. A group exhibition, it was organized by the surrealists in exile in New York, at the Whitelaw Reid Mansion on Madison Avenue in October 1942. Works by the more traditional surrealists (e.g., Ernst,

Masson, Miró, Picasso) were shown with the youngest generation of officially sanctioned surrealists (Matta and Gorky) and the younger American artists working in an abstract surrealist vein (Motherwell and Baziotes). Publications such as *Minotaure, VVV, The Tiger's Eye, The Nation, Partisan Review, Dyn,* and *Possibilities I* also contributed to a transatlantic exchange.

Sidney Janis, in his book *Abstract and Surrealist Art in America,* addressed the question of abstract versus surrealist art: "Though abstraction and surrealism are considered countermovements in twentieth-century painting, there is in certain painters a fusion of elements from each. American painters particularly have a strong inclination to develop interchanging ideas which may fit into either tradition, though there are purists in both categories who adhere to basic premises and moreover insist that it is impossible to do otherwise. Apparently the schism between the factions is not as unsurmountable as their members believe."[6] An exhibition, Abstract and Surrealist Art in the U.S., based on Janis' book, was organized by the San Francisco Museum of Art in 1944. The abstraction of this exhibition was not that of the American Abstract Artists group (AAA), which evolved from de Stijl and Mondrian, but a new and painterly abstraction influenced by the last phase of surrealism. In the exhibition catalog, American artists listed as surrealists included Baziotes, Gorky, Motherwell and Pollock. In subsequent versions of this exhibition, the roster was also to include Gottlieb and Rothko. There should be no doubt that the first generation of abstract expressionist painters developed initially in response to and ultimately against the last remnants of surrealism and the Europeans in America.[7]

The drawings can be categorized into broad groups useful in the context of the exhibition but not applicable to the works of these artists in the period preceding or subsequent to 1938–48. These overlapping categories represent brief working partnerships, friendships, and stylistic affinities. Several artists in the exhibition worked in concert. Onslow Ford, Motherwell and Matta, for instance, worked in Mexico and met with Paalen. Pollock, Baziotes and Kamrowski executed a collaborative painting. Rothko and Gottlieb, with the assistance of Newman, composed a letter to *New York Times* art critic Alden Jewell that outlined the esthetic concerns of their generation. These collaborations were themselves grounded in a fundamental surrealist attitude. For example, in the 1920s in Paris, Tanguy invented and Masson collaborated in the surrealist drawing game, "the exquisite corpse."

The breaking through the ice that occurred in the period 1947–48 created an essentially new art that does not visually reveal its European sources to the extent that the drawings do. And breakthroughs in the large "heroic" paintings precipitated the myth that America had spontaneously invented a new art with no connection to the history of twentieth century modernism. The Interpretive Link focuses on drawings that are neither representational nor abstract. The decision to include only drawings reflects the importance to these artists of drawing as a means of conveying a multitude of concerns through a diversity of images. Executed quickly and generally smaller, less expensive and less finished than paintings, drawings encouraged courageous acts of success and failure. In many cases, the drawings of this period are more advanced and experimental than the paintings, allowing the artists to develop a painterly and iconographic vocabulary. The shift in American painting from images and symbols in the early '40s to an abstract field orientation in the late '40s is documented in these works on paper.

The importance of drawing is affirmed by the large number of drawings extant. In this period, for example, Newman's first works were a group of more than twenty-five crayon drawings; Gorky executed hundreds of drawings both in preparation for and independent of paintings; Motherwell's first exhibition at Peggy Guggenheim's Art of This Century included forty works on paper and only eight paintings; and Rothko completed hundreds of drawings but only dozens of paintings. By comparing the mature paintings of these artists to their drawings, one realizes the significant stylistic changes generated through the drawing process: for example, Rothko's horizontal division of the picture plane (1943–44) and Newman's vertical divisions (1945), Gorky's incorporation of watercolor techniques into paintings (1942), Matta's linear, multipoint perspective (1941), and Motherwell's resolution of the tension between geometry and automatism (1943).

Traditionally, drawing is defined as a linear depiction primarily in graphite. But for these artists, no medium or material was inappropriate to apply to paper and any work on paper constituted a drawing. Their materials included watercolor, gouache, crayon, pastel, colored pencil and to a lesser extent graphite, collage, and charcoal. With such a wide variety of media available, the use of graphite to create a descriptive line was only a starting point for most of the artists. Furthermore. "liquid" media—watercolor, oil pastel, and gouache—were preferred over "dry" media. Liquid media were used to apply color at its full intensity and to activate large areas with a broad spectrum of colors without representational description or articulation of volume by chiaroscuro. Ink wash and watercolor fit the artists' need to explore nebulous subject matter and to create an atmospheric primordial brew. Techniques were invented that incorporated conventional materials in unconventional ways, such as the use of saturated watercolor brushes, the use of rags or paper to apply color, the direct application of pigment with the fingers, and the dripping or pouring of liquid pigment. Graphite and silverpoint were not used

to achieve a rigid or angular linear quality, as in classical draftsmanship, but for a spontaneous flowing or curvilinear effect. Color and line became interdependent and inseparable in the drawing process, a revolutionary step for these artists in the formation of their painterly attitude. In this period, drawing temporarily superseded and absorbed painting.

Moreover, the traditional understanding of composition as the placement of forms on a two-dimensional plane was not a primary concern of these artists. In fact, they reversed the composition process, first applying color and abstract forms and following with line for definition, rather than outlining forms and subsequently applying color. It is this important change in attitude that differentiates the Americans from their European colleagues in this exhibition. Reversing the traditional drawing process resulted in a flattening of the picture plane and brought into question the traditional figure/ground relationship. This important flattening process resulted in a specifically American synthesis of modernist pictorial concerns and surrealist-generated content.

The notion that there is no absolute way of perceiving pictorial space (which already had been clearly addressed by cubism) required the invention of a multifaceted, multi-perspectival space in which images of the unconscious, the sublime, the primordial, and the sexual could be suspended. Traditional Renaissance perspective was replaced by a hierarchical compression of pictorial space, where the size and placement of any particular image depended on its importance to what the artist was communicating rather than to any concrete visual evidence. Thus, the figure/ground relationship was constantly explored and a tension created between the linear elements that rest on the surface and the vague illusion of a third dimension. The abstract surrealist artists conjured a transparent space, interweaving line and color, foreground and background in a metaphorically rich primordial brew. In this regard, Douglas MacAgy pointed out in 1945,

> It is possible that pictorial metaphor could allude to a kind of dimensional idiom which would accord more with twentieth century thought than with the three dimensional instrument inherited from the Renaissance. Its expression marks an attitude rather than a style.[8]

Having abandoned traditional realist drawing, the artists were able to focus on developing a content that would be inseparable from the form. Working with images and symbols abstracted from unconscious, spiritual experience and from ancient and tribal myth helped solve the problem of how to make an abstract art that was neither merely decorative nor purely formal. This new abstraction found resources in the sublime beauty of the mind and in natural formations—not in a description but in a reinterpretation of nature as a symbol of man. As the signs, symbols, and decipherable imagery began to integrate with the formal properties of the drawing, the distinction between figure and ground started to dissolve, fluctuating not optically but poetically in an evocative mythic and symbolic netherworld.

Arshile Gorky and Matta are central to this exhibition for a number of reasons. First, the most significant achievements of their careers came during the 1940s. Secondly, ideas and images that other artists embraced briefly in their development were explored fully by these artists. Their mastery of abstract painterly techniques and richly evocative autobiographical iconography in a transparent two-dimensional space is critical to defining this period.

Gorky straddles two generations: although he was the last surrealist to be officially accepted by André Breton, art historians continue to describe him as the father, the step-uncle, or near relation to the abstract expressionists. But these categorizations obscure the true genius of his art, which is neither surrealist nor abstract expressionist but epitomizes this transitional period.

Gorky's commitment to European modernism resulted in lengthy periods of assimilating the discoveries of Cezanne, Braque, and Picasso into his own work. He blossomed, however, in the early 1940s, liberated by psychic automatism, abstract surrealism and a renewed interest in landscape. Prior to this breakthrough in 1942, Gorky had developed a set of autobiographical references (e.g., *Nighttime and Enigma*) that formed the iconographic foundation for his mature work. The *Garden of Sochi,* a seminal painting, is an idealized landscape based on childhood memories of Lake Van in Armenia. Following his paintings of remembered scenes, he began to work directly from nature, creating a series of works based on waterfalls he had seen in Connecticut in 1942. These landscapes (which would later include scenes from Virginia as well) are markedly more abstract than preceding paintings because of his purposive obfuscation of specific natural elements. In these works, images of land and water are blended with a myriad of microscopic biological details suggesting insects, plant life, and sea life. The water and landscape images of Virginia and Connecticut project autobiographical references into the natural world, a combination that became the hallmark of Gorky's work until his death. In the landscape works, Gorky developed his compositions organically rather than architecturally (as Matta did). Water imagery was critical to the change in Gorky's work, as it was for Rothko and many others in this exhibition. It stimulated experimentation with liquid and transparent media and the invention of techniques that allowed him to represent nonspecific natural phenomena in a fluid, painterly manner. The sense of earth, lush plant foliage and sky permeates

works such as *Virginia Landscape* (cat. 14); this abstract-natural melange is close, in its all-over nonspecific quality, to abstract expressionism.

The lyrical, diffused elements of Gorky's landscapes contrast with the more specific and identifiable elements of nonlandscape drawings such as *Study for "Summation"* (cat. 16). The landscapes are generally flatter, contain fewer iconographic details, and use a profusion of colors independent of linear description. In nonlandscape works, color primarily supports the linear elements that describe forms; images are more detailed and are situated in a more clearly defined space. With great consistency, Gorky repeats certain motifs—rooster, genital parts, leaves—throughout the series but confuses the meaning of these elements in the ensemble. In the three studies for *Agony,* for example, the colored disk-shaped form appears in exactly the same position in each drawing. Colors applied in pastel, crayon, and washes are used to give volume to descriptive linear elements of the nonlandscape drawings. In addition, color is applied independent of line, forming elliptical shapes that float in front of, behind, or among the linear elements.

Gorky synthesized representational modes with purely abstract painterly devices. Whether representing psychological landscapes, still lifes, or natural scenes, his drawings combine forms without regard to scale or specific indications of foreground, middle ground, and background. They are at once intimate and expansive in their incorporation of microscopic detail in a broad, landscape-inspired view.

During the period 1938 to 1948, Roberto Matta Echaurren, like Arshile Gorky, produced his most compelling and advanced drawings, in addition to profoundly influencing both his younger and older contemporaries. From the beginning of his career as an artist (after studying architecture, which no doubt affected his draftsmanship), Matta's work reveals his grasp of the possibilities raised by late surrealist art. His early contact with leading French surrealists Breton, Tanguy, and Masson catapulted his development, and by 1938 his work shows signs of independent thinking based on his theory of psychological morphology, which sought to engage the evolution of forms. For instance, as Matta saw it, "from a seed to a tree, the form is constantly changing under certain pressures, until it arrives at the final form, and then disintegrates....What interested me was to see if everybody could apply the system that to me was fascinating at the time, to use morphology about my psychic responses to life."[9]

Younger and less orthodox than his fellow surrealists, and able to communicate in English, Matta became involved in the American art scene more readily than the older, established European immigrant artists. In turn, the new surrealism he exhorted was a liberating force for Gorky and other American artists, providing them an alternative to illusionist surrealism. Robert Motherwell, William Baziotes, and Gerome Kamrowski, also were receptive to Matta's ability to codify, politicize and advocate new stylistic devices. Intersecting lines of force, concentric patterns, and the use of parallel lines to create floating fields or planes all have counterparts in works by these American artists.

More than the American artists of that generation, Matta expressed political concerns in his drawings. His shallow illusion of a third dimension becomes a scrim for acts of sexuality and violence and depictions of procreation, birth and death. Revealing the artist's anguish, tortured figures writhe in claustrophobic, hallucinogenic, stalactite-ridden environments; scenes of crucifixions (cat. 70), impaled women (cat. 68), and sexual activity are set in his richly evocative, nightmarish landscapes. Combining specific human figures with abstract elements, Matta creates drawings that are as lyrical as a Calder mobile and carry the political impact of Picasso's *Guernica.*

Matta scattered his multiperspectival, human-scale, psychonarrative battlefield across a picture plane that suggested to the Americans a shallow, all-over space in which to investigate iconography and the ever-flattening picture plane. Through drawings, Matta transformed interior states of mind into complex visual environments that contain both specific (figurative, architectural, perspectival) and nonspecific (organic, biomorphic) imagery. Increasingly, he articulated the illusion of space through converging vortexes of line and stagelike settings where figures float in front of and within a composition that is anchored neither by gravity nor a single, one-point perspective. This is Matta's most important contribution during the formative years of American art.

Another European, Yves Tanguy, affected the Americans' concept of form as Matta had altered their depiction of space. Yves Tanguy's illusionism separates him from the other abstract surrealists, but his biomorphic forms influenced Matta, Gorky, and, to a lesser extent, Motherwell and Baziotes. Although Tanguy was in America during the War, his noncommunicative nature and isolation in Connecticut separated him from the emerging New York School. Yet, like Joan Miró, his work was accessible to the American artists through exhibitions. Unlike French surrealist André Masson, whose work changed measurably after he left Europe, Tanguy seems to have become more committed to his own vernacular once in the United States. The biomorphic forms became more articulated and in greater contrast to the clearer, less-modulated backgrounds. Although derived through surrealist automatic techniques, Tanguy's organic forms suggest a quiet and composed plastic automatism, showing the Americans a way to incorporate the unconscious without succumbing to its random and uncontrollable nature.

Gordon Onslow Ford, an English artist who had worked alongside Matta in Paris, brought the most current ideas of abstract surrealism to America in a series of lectures sponsored by the New School for Social Research in 1939. Advocating an abstract and symbolic depiction distinct from the mainstream surrealism favored by The Museum of Modern Art exhibitions, Onslow Ford was instrumental in creating a vigorous final chapter of surrealism.

In drawings such as *Mountain Auras* of 1939 (cat. 96), Onslow Ford combines geometric abstraction with biomorphic forms—foreboding black shapes and Tanguy-like white shapes—in a field of conical hot spots and flat spirals. These images precede similar eruptive hot spots in Matta's work of 1943–44. Onslow Ford's innovation of pouring enamel in an automatic, driplike technique clearly predates the experiments of Hans Hofmann and others whose work forms a juncture between the automatic doodling of the abstract surrealists and the all-over gestural painting of abstract expressionists such as Pollock in the late '40s. However, unlike other artists in this exhibition, with the exception of Baziotes, Gottlieb, and Matta, Onslow Ford has continued to use abstract surrealist methods in representing his psychological and cosmic vision.

Robert Motherwell, an associate of Matta and Onslow Ford in the early '40s, was more receptive to surrealism than many of his American colleagues. Motherwell's youth, his grasp of French literature and psychoanalytic concepts, and his introduction to art through Meyer Schapiro, rather than through studio struggles with prevailing styles, made him an important link between Europe and America. The arrival of the intellectual surrealists, especially Matta and Kurt Seligmann, was important in his rapid development. For Motherwell, in his own words, "The surrealist presence brought hope, inspiration, action. They searched out the young among poets and painters."[10] From the outset, his work (like Matta's) was surprisingly sophisticated and, in some cases, revolutionary for a man in his mid-twenties.

Having spent 1938–39 in Europe, primarily in Paris studying French symbolist literature, Motherwell was ripe for the most advanced and, in retrospect, the last fully identifiable stage in surrealism. Aspects of plastic automatism, psychological investigations, and an abstract painterly approach to surrealism all contributed to the formation of his visual vocabulary in the '40s. In some respects, the works are closer to Europe in their Matissean decorativeness and literary spirit than to the work of other Americans. Motherwell's colleagues in New York, who were not schooled in French intellectualism, appeared somewhat anti-intellectual and anti-elitist, suggesting an American isolationist attitude. Motherwell, on the other hand, knew the Europeans better than he knew his fellow American artists, with the exception of Baziotes. As he stated, "The surrealists talked

about ideas, and since I happened to be interested in ideas ...I was more interested in the European talk than the American talk in the beginning."[11]

During his visit to Mexico with Matta in 1941, where he met Paalen, Motherwell began two seemingly separate bodies of work, the abstract geometric paintings, e.g., *Little Spanish Prison,* and the automatist drawings, e.g., *The Mexican Sketchbook* (cat. 76). Geometric and automatic aspects manifest themselves simultaneously in later works. For example, the vertical divisions and geometric harmony suggested by the prison bars appear in the collages of the mid-1940s and, more significantly, in the *Elegy to the Spanish Republic* series. The intuitive and spontaneous gestures evident in *The Mexican Sketchbook* are manifested in both the free association of collage and in the gestural "action paintings" of later years. Describing these initial gestures as doodles rather than pure automatic drawing, Motherwell was never, as can be said for every artist of the New York School, an automatist painter. This is an important distinction because, as Motherwell stated in 1944, "To give oneself over completely to the unconscious is to become a slave."[12]

In *The Mexican Sketchbook,* with its forced linear perspective and suspended biomorphic forms, Motherwell's work was closer to that of Matta and Baziotes than it was in subsequent periods. *The Mexican Sketchbook* drawings and *For Pajarito* (cat. 77) are similar to Baziotes' *Untitled* (cat. 2) and *Untitled* (cat. 4) and to Matta's works from the early '40s.

These automatist doodles rapidly evolved into more structured compositions, e.g., *Figure with Blots,* 1943 (cat. 78). Here, Motherwell combines geometry and spontaneous gesture by integrating the freely associative collage and spontaneous Rohrschach blot elements with an elegant geometric purity comparable to Mondrian's compositions. *Three Figures Shot* (cat. 79), one of forty works on paper included in Motherwell's first one-person exhibition (at Art of This Century Gallery in 1944), presents three figures arranged in a horizontal row. A similar use of three images can be seen in Baziotes' *Untitled* (cat. 5) and Rothko's *Entombment I* (cat. 126). Continuing the duality of his techniques with the same subject of three figures, Motherwell produced a refined, elegant, geometric counterpart to *Three Figures Shot* in *Three Important Personages* (cat. 80), in which volume is suggested through cross-hatching and parallel lines.

Motherwell's investigation of the formal concerns of surrealism made an end run around the illusionistic, political, and psychic issues. Combining the directness of abstract surrealism with the formal aspects of cubism and de Stijl and the pallette of Matisse, Motherwell developed a balanced and unique abstract vernacular.

Baziotes, Motherwell's closest associate from the New

York School, remained true, like Gottlieb, Matta, and Onslow Ford, to an art that combined abstraction with symbolically rich metaphorical forms. After a period of academic realist and social realist work, Baziotes began to experiment with surrealism prior to the arrival in New York of Matta, Seligmann and Onslow Ford, who were to encourage his move to abstract surrealism. These early drawings, inspired by Picasso's surrealism, contained specific figurative references that bear little resemblance to the graceful, gentle and poetic expressions that became the hallmarks of his mature paintings. By eliminating specific details in subsequent works and retaining the form or outline, Baziotes began to achieve a flatter, more textural imagery. Into a richly textured background, similar to Ernst's rubbings of natural forms, Baziotes traced subtle abstract organic shapes. Born from the primordial brew of his abstract grounds, the humanoid or cellular biomorphic images merge figure, plant, and aquatic references.

The positive influence of Matta and the group working sessions attended by Baziotes, Motherwell, Kamrowski, and Pollock can be seen in *Untitled* (cat. 4). Beginning with a wash, Baziotes creates a stagelike setting in which biomorphic and figurative elements are suspended in a netherworld of converging lines. Similar to Matta's early work and to Motherwell's *Mexican Sketchbook* (cat. 76), this work manipulates perspective, creating a picture plane that alludes to a space that is compressed. Combining automatism in his application of washes with the geometry of linear elements, Baziotes created an art stimulated by inner visualization yet resulting in a formal, plastic manipulation of space and image.

In drawings of the mid-1940s, Baziotes explored both rigorously composed geometric figuration, as seen in *Untitled* (cat. 5), and organically derived biomorphic images (cat. 2 or 3). In a later work, *Night Figure, No. 1* (cat. 8), the geometric spatial structure of the red and yellow square in the background is combined with a biomorphic/figurative element represented by the negative space of the paper. Geometric elements articulated by color are tempered through cross-hatching with ink, resulting in a more subtle delineation between biomorphic and geometric shapes. Further paring down referential allusions in the latter '40s, Baziotes arrived at a mode of expression that continued the tradition of abstract surrealism in the '50s with works in which single images became subdued in a quiet resonance between form and light.

Matta, Onslow Ford and Motherwell were attracted to Mexico not so much by the presence of the Mexican muralists and their obvious kinship with the American regionalist and social realist styles, but rather by Wolfgang Paalen. In 1940, with the help of André Breton, Paalen had organized the Exposición Internacionale del Surrealismo in Mexico City. His own exhibitions in New York that year and again in 1945 brought him into contact with abstract surrealists Newman, Rothko, and Gottlieb. In rejecting purely abstract painting in the mid-1930s, then accepting and ultimately rejecting doctrinaire illusionist surrealism, Paalen sought a new art that could include images of the unconscious, myth, and primitive sources within the framework of an abstract geometric surrealism. According to Paalen

> Man begins where art begins, with the faculty of holding life in suspense, now to reflect, now to project the world; for the painted image precedes writing as the imagination precedes thought, or rather, the imagination surrounds thought in every sense, thought being no more than the focal point of present consciousness. That is why, as inherent in the very sub-structure of all distinctively human activity, art can reunite us with our prehistoric past and thus only certain carved and painted images enable us to grasp the memories of unfathomable ages. So, too, in the direction of the future—as it is only through the imagination that thought can find its aim—it is art that often prefigures what might be....[13]

This attitude, in accord with emerging artists of the New York School, was intellectually supportive of the pursuit of a new art. Paalen's work, however, remained distinct from that of the New York artists, reflecting a more refined, European sophistication cognizant of Picasso, cubism and Tanguy.

Lam, originally from Cuba, emigrated to America, like Onslow Ford and Paalen, through France. Although Lam left Europe, his work continued to show the influence of Picasso and European modernism well into the '40s. Yet, unlike the Europeans, who used primitive art for its formal suggestions, Lam sought to express the meanings and beliefs embodied in primitive art, a desire he shared with the American artists. He created his own art with the same conviction of a God-like truth that inspired primitive man to create images of deities and abstract beings. The otherworldly beings that populate Lam's jungle are not formal devices but a manifestation of his Chinese-Cuban-African heritage. Counterparts to his jungle drawings from the mid-1940s can be seen in Gottlieb's *Untitled* (cat. 29).

John Graham, another artist who perceived the importance of primitive art, had an impact on the artists of the New York School that was far more extensive than his work from the late '30s would indicate. His ideas, as difficult as they are to pin down, opened new alternatives to these artists. Graham proclaimed in his *System and Dialectics of Art,* first published in 1937, that the purpose of art is to "reestablish a lost contact with the unconscious, the primordial past and to keep and develop contact in order to bring

to the conscious mind the throbbing events of the unconscious mind."[14]

Although Graham pointed out to the Americans that primitivism, religion, numerology, and astrology could be sources for modern art, his own figurative works were far more formally classical (with the exception of their iconographic references) than the thinking that went behind them. His commitment to figuration and portraiture was more consistent than his interest in images represented pictographically through abstracted signs and symbols. However, Graham's lesser-known works in this exhibition put him within the pictographic/ideographic arena with Gottlieb and Miró. While Gottlieb and Miró used symbols with abstracted figures and landscape, Graham works exclusively with symbols in these pieces. Appropriating existing symbols from religion, the occult, primitive art, and astrology, Graham creates decorative patterns that refer to stained-glass windows, Navajo rugs and medieval manuscripts. These richly patterned gouaches from 1942–43 incorporate abstracted symbols already functioning within our society.

Although Graham remained on the cutting edge of contemporary art conceptually in the '40s, it is interesting to note that his figurative work remained committed to the classical canons of Western European art, while his abstract works in this exhibition relate directly to Eastern mystical art. His combination of the primitive and contemporary, the classical and avant-garde, the pictorial and linguistic, and his ability to articulate this plurality in his written work and conversations make Graham important to the developments in American art during the '40s.

Encouraged by John Graham and the European surrealist artists and dissatisfied with social realism, Adolph Gottlieb broke from the positive influence of Milton Avery's realism and began to explore myth, primitivism, surrealism, and the unconscious in search of universal images of man. During the 1940s, Gottlieb led the other Americans into an exploration of mythic, religious and autobiographical signifiers and was the first New York artist to resolve the critical issue of how to depict these concerns on a flat surface without the illusion of depth. In contrast to his close associates Newman and Rothko, whose work in the later '40s turns away from specific imagery, Gottlieb pursued into the early 1950s his pictographic art that continued to address mythic, poetic, and historical themes. As a consequence, art historians did not include him conclusively with the rest of the New York School until his 1950s burst paintings, which accomplished a reconciliation between "gesture" and "field" painting.

Gottlieb's first pictographs did not occur in New York under the direct influence of the Europeans and the New York School, but in Arizona. A 1939 painting that combines aspects of still life and landscape, *Untitled (Box and Sea Objects),* clearly heralds a new priority in his work. Gottlieb paraphrases and excerpts from nature, recombining aspects of figure, still life, and landscape in a segmented structure that alludes to Mondrian's formal division of the picture plane. His images, inspired by Magritte and de Chirico, maintain an illusionistic representation of the natural world; however, Gottlieb ultimately extrapolates them into signs and pictographs that represent the contours of objects rather than their illustrative, volumetric shapes. By 1941, in paintings such as *Eyes of Oedipus,* Gottlieb combines images of classical mythology with personal signs on a two-dimensional surface that is both referential and nonspecific. Mythology and primitive art suggested a means to distill complex human experiences into simple gestures. In the pictographs, the issue of creating a flat pictorial space was resolved by using abstract images and symbols; Gottlieb devised the gridlike armature to unite his seemingly random, unrelated images.

For Gottlieb, the flattening and abstraction of image was not simply a formal pictorial question. The signs and symbols decontextualized from the original myth or source take on additional meaning when recontextualized in the drawing, creating a new subject that addresses the process and content of drawing simultaneously. Unlike Egyptian and Mayan glyphs, whose concrete meanings have been established, Gottlieb's glyphs remain mysterious. Although they appear to function as discrete words, they suggest multiple meanings and interpretations. Gottlieb deeply felt that

> The role of the artist, of course, has always been that of image-maker.... Today when our aspirations have been reduced to a desperate attempt to escape from evil, and times are out of joint, our obsessive, subterreanean and pictographic images are the expression of the neurosis which is our reality. To my mind certain so-called abstraction is not abstraction at all. On the contrary, it is the realism of our time.[15]

Gottlieb continued to combine both mythic and personal themes in his pictographic works from 1941 to 1946. His ability to develop and break from the art of Milton Avery, Picasso and Miró into his flat, nonillusionist language secured him a prominent place as one of the founders of the New York School and as the originator of a unique pictorial language of referential images and signifiers.

The work of Joan Miró, the only European artist in this exhibition who remained in Europe during the 1940s, had a significant impact on artists such as Gottlieb, Motherwell, Graham, Rothko, and Pollock, among others, who saw his exhibitions at the Museum of Modern Art (1940–41) and Pierre Matisse Gallery (1945, 1947 and 1948). Providing an

alternative to Picasso and to the illusionist surrealists, Miró's historical, personal, contemporary, and religious images, extracted from reality and the imagination, suggested ways for American artists to create abstract surrealist art that conveyed subject matter. Miró, a surrealist, remained committed to a painterly approach that eliminated narrative, illusionistic, and literary references. Combining a complex personal language in compositions freed from specific allusions to horizon or depth, Miró demonstrated that abstract painterly art could be rich in associative images.

Miró's art was formal yet spontaneous. A disarming array of real and imaginary forms, undoubtedly inspired by Klee and achieved through the surrealist exploration of the unconscious by automatic techniques, were suspended in a uniform wash of color, creating a cohesive, all-over composition. By metamorphosing images into schematic references, he developed a larger referential vocabulary than the other artists in this exhibition. The linear web tying the floating images together in the picture plane was a device adopted later by Gorky and Rothko. Miró's drawings combine personal images of his Catalan childhood with primitive, archaic and mythic sources into abstract painterly compositions. Miró's identification with the art of the prehistory, an age that (at least in the minds of Miró and the Americans) combined childish wonderment with a sense of the human imperative, provided a powerful alternative for the American artists.

Like Miró, Gottlieb, and Graham, Richard Pousette-Dart sought to combine his own language of images and symbols drawn from religious and contemporary sources into a freely composed pattern. His coloristic works combine abstract cellular shapes with recognizable images of eye, half-moon, seedpod, and starfish. These disparate organic forms are woven together with fluid line in compositions that are at once rigorously exacting and seemingly spontaneous.

Portraying germination and the cosmos simultaneously on a flat surface, his drawing *Untitled* (cat. 114) presents an organic, microscopic image of the universe, like a cell in its formative stage. Pousette-Dart begins with a watercolor wash to which he adds linear elements. Similar to Gottlieb's framing of images in geometric linear divisions, Pousette-Dart isolates his organic forms with curvilinear lines that conform to and integrate with the images. Although they resemble automatic drawings, Pousette-Dart's lines are also used to define, outlining a chance drip in the watercolor ground and shaping a neoclassical eye.

Barnett Newman was critical to the development of American art in the 1940s through his painting as well as his involvement in organizing exhibitions, writing, and discussing current artistic issues with fellow artists. Even though he was temporarily inactive as an artist until 1945,

his interest in primitivism, myth, religion, and the sciences of ornithology and botany suggested alternatives to regionalism, social realism and surrealism. Serge Guilbaut has observed, "What the artists who formed a group around Barnett Newman rejected was salon surrealism, the black humor and lack of seriousness they found in the work of certain surrealists."[16]

Newman's studies at the Brooklyn Botanical Garden between 1939 and 1941 and classes in botany and ornithology at Cornell University in 1941 contributed to his acumen for abstracting complex, scientifically informed images from the natural world. In the first drawings, Newman represents his biomorphic (insect) imagery without reference to spatial or planar orientation, as though looking through a microscope at a specimen that extends beyond the field of view. Newman, who had not gone through a period of social realism, automatism, or a gradual flattening of the picture plane, began from the point at which artists such as Gottlieb and Rothko had struggled to arrive.

Newman's titles suggest myth, while his organic images suggest life cycles of the natural world. His writing and his scholarly pursuits into primitive art, religion, and science enlarge our understanding of the multifaceted references and content of his work. His description of a Northwest Coast Kwakiutl Indian work could pertain to his own attitudes: "The abstract shape he used, his entire plastic language, was directed by a ritualistic will toward metaphysical understanding."[17] *Song of Orpheus* (cat. 89) and *Slaying of Osiris* (cat. 87) refer to the decimation of culture and the chaos that ensues. The subject of the drawing *Gea* (cat. 92), as the title and image suggest, derives from mythology. Gea was the first being to spring from the chaos that followed the formidable creation of earth. In *Gea* Newman evokes early primordial existence and the beginnings of order out of chaos by portraying a cell- or egg-shaped form bursting from a sac of yellow nutrients floating in a luminous red ground.

That Newman turned to drawing after a long period of writing, studying, talking and searching for a way through the crisis of modern art is significant in this exhibition. Newman confirmed the importance of drawing in his oeuvre in 1962:

I am always referred to in relation to my color. Yet I know that if I have made a contribution, it is primarily in my drawing. The impressionists changed the way of seeing the world through their kind of drawing; the cubists saw the world anew in their drawing, and I hope that I have contributed a new way of seeing through drawing. Instead of using outlines, instead of making shapes or setting off spaces, my drawing declares the space. Instead of working with the remnants of space, I work with the whole space.[18]

Drawing encouraged him to move within a year through specimen-like and biomorphic stages to a concentration on a vertical division of the picture plane. In 1945 Newman began to lay down a series of vertical bands of color as backgrounds to nonspecific, yet seemingly automatic, tendril-like shapes. These vertical "zips" became the signature of his mature work. This was the final phase before Newman's move into a more complete abstraction. Like Rothko, Newman ultimately discarded the biological details of the foreground in favor of the abstraction of the background.

Early in the 1940s Mark Rothko realized a need to draw on resources of myth, primitivism, and surrealism in creating a new pictorial language. From 1940–41 to 1946–47, Rothko worked in an abstract surrealist mode, executing hundreds of drawings. Moreover, he helped to establish the esthetic concerns of this era through meetings, exhibitions, and written statements. Newman, Gottlieb and Rothko all used myth to convey universal truths without relying on the illusionistic, illustrative and narrative techniques of surrealist art or a pure abstraction, seemingly cold and over-analytical. Rothko explained in 1959,

> I quarrel with surrealist and abstract art only as one quarrels with his father and mother; recognizing the inevitability and function of my roots, but insistent upon my dissension: I, being both they, and an integral completely independent of them.[19]

The early careers of Rothko and Gottlieb are parallel; both had worked in a social realist style and with Milton Avery. As a result of the close friendship between them, as evidenced by their letter to the New York Times that established many of the esthetic concerns for a new art, Rothko and Gottlieb have been compared with each other more than to Newman, who had also assisted them with the letter. Rothko's Untitled (cat. 116), an abstracted still life with a seashell and sea life forms, clearly has affinities with Gottlieb's painting Untitled (Box and Sea Objects), 1940. However, by 1946–47 Rothko's work shared more with Newman's work than with Gottlieb's. Rothko's Tentacles of Memory, 1945, has a counterpart in Newman's Untitled (cat. 93) and Untitled (cat. 94) of 1945. Both artists employ a single, biomorphic cell-shaped image floating in a field of water, divided horizontally in the work of Rothko and vertically in Newman's work.

Rothko's drawings represent creation itself. In a primordial brew, primitive organic forms come to be. Nonspecific, yet clearly cellular, shapes populate the misty sea of watercolor that Rothko has applied as a wash. Creation is evidenced as the single-cell images spread, divide, and attenuate in the stratified sea of color wash. Rothko incorporated automatic techniques in highly structured and formal watercolors. Prior to applying the watercolor wash (the most automatic aspect of the drawings), Rothko drew in

horizontal lines. The consistency with which he composes his drawings, i.e., the horizontal division of the background and vertical orientation of the images in the foreground, confirms that this spontaneous-looking art is not purely automatic. Alternating spontaneous and deliberate techniques was in general accord with methods used by many of the artists in this generation. For Rothko, this duality is amplified by the abstract-versus-subjective nature of his work.

Initially Rothko represented myth through archaic and classical imagery, leading to an intensive period in which he incorporated biomorphic images representing the most elementary life forms. By 1945 Rothko, like Newman, peeled away specific figurative details of the foreground revealing the clarity and mythic luminosity of the background.

In April 1946, Rothko exhibited the watercolors in a "culmination of a period of concerted painting in this medium."[20] He pared down the complexity of his subject without bypassing aspects of figuration, microscopic imagery, and evolution. Rothko's period of struggle between abstraction and "material reality" is not merely the last phase before his 1947–48 breakthrough but, to a certain extent, represents the success that he had in fulfilling his own ambitions:

> I adhere to the material reality of the world and the substance of things. I merely enlarge the extent of this reality, extending to it coequal attributes with experiences in our more familiar environment.[21]

Theodoros Stamos, like Rothko, suspended his images in a watery, atmospheric ground. Coming to abstract surrealism later than most of the artists in this exhibition, Stamos concentrated on painting during the 1940s. Like Matta and Motherwell, he achieved a remarkably poignant, advanced and poetic imagery early in his career. His subjects included natural life forms and organic shapes drawn from mythology and the ocean near which he lived during his adolescence (cat. 131)—images derived through intuitive and chance techniques and elaborated with line. His work from the late 1940s signifies Stamos as the last of the first generation of American artists to embrace and incorporate an abstract surrealist vernacular with personal references. Like Baziotes and Onslow Ford, Stamos continued to investigate abstract painting with references to recognizable natural organic forms well beyond the more mature artists of the New York School.

Hans Hofmann, like Onslow Ford, employed an automatic drip technique superimposed on biomorphic images well in advance of Pollock's breakthrough into the all-over field paintings of 1949–51. Hofmann's tentative breakthrough, as seen in paintings such as Spring 1940, was inspired by nature, revealing through its iconography the theme of genesis and rebirth, rather than the more rigor-

ously formal concerns of his and Pollock's subsequent work. One of America's most influential teachers, Hofmann was known internationally for his "push-pull" theory regarding the planar surface, which became a formative issue of abstract expressionism. Having experimented throughout his career with a diversity of styles, in the 1950s Hofmann created classic works that combine gesture and geometry. While the drawings from the '40s do not emphatically reveal his push-pull theories, the biomorphic images establish planes that whirl, roll, and collide. The fame of Hofmann's later compositions, in which hard geometric shapes float in front of fields of color activated by heavy impasto, obscures the importance of his organic works of the mid-1940s. Drawings from this period depict sea life, cellular shapes, egg forms, personages, cilia, and tentacle-like arms that suggest an exploration of automatist techniques.

In 1944, the same year Peggy Guggenheim's Art of This Century gallery gave him a one-person exhibition, Hofmann pointed to the possible connection between surrealism and his art: "To me, creation is a metamorphosis, the highest art is the irrational…incited by reality, imagination burns into a passion for the potential inner life of a chosen medium."[22] Hofmann's surrealism is neither automatic nor unconscious. His carefully studied compositions have an even distribution of organic and natural elements that activate the entire picture plane. In Hofmann's biomorphic surrealism, washes of color intensified with linear elements elaborate his formal painterly concerns and reveal his love of nature. Cellular, biomorphic subjects prominent in his work of this period were never to appear with such concentrated force again.

André Masson had worked extensively with automatism and images of the unconscious before arriving in the United States in 1941. Masson was to have a positive effect on the emerging New York School artists, especially Jackson Pollock. America, in turn, encouraged one of the finest periods in Masson's oeuvre. During the 1940s Masson created a large body of pastels which range stylistically from cubist and surrealist to automatic—some elegantly decorative and others intentionally awkward. Masson combined his interest in religious cults, astrology, alchemy, and biology into a melange of references. His recognition of the power of myth to reveal essential human emotions brought him to primitive art and ancient religion.

After the fall of France, Masson fled with his family to unoccupied France. Because of the shortage of supplies, he began to work on paper, creating the drawings that were published in The Anatomy of My Universe (1940). These drawings influenced the mid-1940s work of Rothko (Slow Swirl at the Edge of the Sea) as well as many other artists in this exhibition. Vois l'antre des metamorphoses (cat. 51) was made at the time of his drawings for Anatomy of My Universe, in France.

The heroic grandeur of the American landscape and the autumn colors inspired Masson's Telluric Series (1942–45), in which line, color, and form are integrated in increasingly rich, nondecorative abstract works. Nature for Masson, as it had been for Gorky and others, was the source and nourishment for his development in America. Discussing Masson's work of the 1940s William Rubin pointed out, "Masson achieves as never before the successful synthesis of his innate gifts as a draftsman with his great skill as a painter. Form is often determined from the inside, by color, in a way unprecedented for Masson."[23] The same may be said for his drawings of this period.

By the end of 1943, Masson's highly stylized, swirling compositions, such as Sexus (cat. 53), indicate a concern with automatic techniques without being totally automatic, spontaneous or haphazard. In Amants entrelacés, 1943, Masson carefully drew the calligraphic shapes in pencil (in contrast to automatism), before tracing over them with red paint. Line reappears more forcefully in the Miróesque work, Regardant l'aquarium (cat. 58). Beginning with a watery blue background, Masson creates the floating environment of an aquarium, including fish, insects, and egg-shaped forms, with human heads behind the picture plane peering into the aquarium. In this pictographic drawing depth is indicated through placement of the image rather than through three-dimensional perspective. Vieux souliers sous la pluie (cat. 59), executed during Masson's last year in America, refers specifically to the War in its last year. Masson's line transforms the old shoe into a symbol of growth and genesis, referring to the end of the War and his return to France.

Jackson Pollock's drawings from 1939–48, even more than Masson's, reveal a multiplicity of concerns, styles and images. Pollock drew constantly, and the importance he attached to these works is evidenced by the large quantity of drawings that remain. Several subgroupings of drawings from the period 1938–48 can be identified, including the Jungian-inspired pictographic, the biomorphic, the Picassoesque, and the abstract-surrealist works.

For Pollock (like Gorky, but to a greater degree), drawing became painting, and paintings ultimately were superseded by line taken to an extraordinary degree, as he confirms in a later interview: "…I approach painting in the same sense as one approaches drawing…."[24]

Drawings completed during the period 1939–42, when Pollock was in psychoanalysis, contain animal and human figures, Egyptian imagery, and religious and mythical symbols in concert with highly expressive tortured forms directly inspired by Picasso's Guernica. Aside from the psychological content of these drawings, the subjects and the techniques coincide with those used by other American artists who were in awe of Picasso's surrealist paintings. However, Pollock's drawings are more notebook-like with

their obsessive filling up of the page. The move to surrealism, with its symbolic content, was for Pollock a way out of the quagmire of the American regionalist and social realist painting of his teacher, Thomas Hart Benton.

An extraordinary drawing from 1943 (cat. 104) is typical of Pollock's prolific imagery; human forms, faces, full figures, emblems sprouting body parts, hieroglyphs, petroglyphs, a compass and weathervane, trees, snakes, and birds all float in an agitated sea of splattered ink wash. Pollock splashes and drips the ink directly on the paper and then draws in lines that respond to and elaborate on the accidental images discerned in the splattered ink. Pollock incorporates automatism, the biomorphism of Miró, and specific references to Egyptian and American Indian imagery in a drawing that is automatic and pictographic.

In the same year, Pollock combines pictorial and graphic images in a single drawing. Two untitled works (cat. 106 and 105) contain human figuration (inspired by Picasso's surrealism) in the central portion of the picture and glyphic drawings in the upper right border, a combination recalling medieval manuscripts as well as Gottlieb's pictographs.

In *Untitled* (cat. 109), a work populated with totemic figures, the similarity between the paintings and drawings becomes clearer. Sharing aspects of his better-known paintings from this period (*Shewolf* from The Museum of Modern Art and *Guardians of the Secret* from the San Francisco Museum of Modern Art), its archaic upright figure in the center is intermeshed in the gestural white, yellow, and red linear elements. Unlike Rothko and Newman, who ultimately peeled away the linear representational elements of the foreground and retained only the abstract coloristic background, Pollock keeps the linear elements and eliminates the figuration and background. In *Untitled,* 1946 (cat. 110), and *Untitled,* 1947 (cat. 111), two of the most accomplished drawings prior to his "drip" period, Pollock creates densely packed images of glyphs, halfmoons, stars, skeletons and amoeboid forms in a flat, uninterrupted field with no allusion to depth.

Pollock was initially closer than the other abstract expressionists to the spirit of surrealism, yet broke from it more dramatically and profoundly with his all-over drip paintings. As Pollock himself explained,

> The fact that good European moderns are now here is very important. They bring with them an understanding of the problems of modern painting. I am particularly impressed with their concept of the sources of art being the unconscious (surrealism and automatic writing). This idea interests me more than the specific painters do, for the two artists I admire most, Picasso and Miró, are still abroad.[25]

Although there are similarities between surrealist automatism and Pollock's drip paintings, there is a distinct break between his automatist wash technique of 1943, with its symbolic and pictographic images, and the more formally composed drip paintings of 1948.

The Interpretive Link begins with works from 1938, when American artists were beginning to reveal an independent American vision that could embrace international tendencies. The exhibition concludes with works from 1948, when the breakthroughs by Newman, Rothko, Motherwell and Pollock, among others, became distinctive. As James Thrall Soby saw the situation,

> Surrealism seems to be dying out as a formal movement in this country, though its rejuvenation of art's imaginative faculties remains a major and pervasive contribution, and has affected many younger American artists.[26]

After 1948, American painting was increasingly larger, abstract in imagery and nonrelational ("all over") in compositional format. As Matta recalled, "I left in 1948, when everything was getting too 'painting' for me."[27] American abstract expressionism did, however, continue to incorporate the mythical, spiritual and psychological concerns that persisted from the first half of the '40s.

To interpret these drawings in either formal painterly terms or from an iconographic standpoint would overlook the fact that they reflect a conscious decision on the part of the artists to be neither purely formal (abstract) nor iconographically illustrative (representational). The artists invited a multiplicity of associations. The objective was to create works with poetic, metaphorical meaning that would respond to the unconscious and nature, and would reveal the process of making art.

This exhibition gives further evidence to the links between Europe and America and between surrealism and abstract expressionism; a metamorphosis occurred in the art of the '40s that not only opened the doors to abstract expressionism, but also created an independent body of work combining aspects of surrealism—automatism, primitivism, religion, and spirituality—and resulting in an abstract-surrealist/proto-abstract-expressionist art. Through surrealism the avant-garde artists found a means to express an interest in myth. Through their own intentions, however, myth was no longer expressed in representational, illusionist modes. The biomorphic, abstract surrealist art that emerged in New York was a result of contact between the European and American artists whose conversations, deliberations, and group working sessions intermingled ideas of science, automatism, and the unconscious. The focus of this exhibition is on a brief period of great change, when the relationship between abstract and representational modes, the unconscious and the consciously controlled, the visible and the spiritual, and the all-important tension between three-dimensional illusionism and the two-dimensional picture plane were in a state of metamorphosis. ∎

I would like to acknowledge Sue Henger for her invaluable assistance and contributions in editing this essay.

NOTES

[1]Robert M. Coates, "Assorted Moderns," *The New Yorker* XX, no. 45, December 23, 1944, p. 51.

[2]Letter sent by Gottlieb and Rothko to *The New York Times,* June 7, 1943. Reprinted in Serge Guilbaut, *How New York Stole the Idea of Modern Art: Abstract Expressionism, Freedom, and the Cold War* (Chicago: The University of Chicago Press, 1983), pp. 75–76.

[3]Stephen C. Foster, *Critics of Abstract Expressionism* (Ann Arbor, Michigan: UMI Research Press, 1980), p. 8.

[4]Exhibitions that have focused on the linkage of European and American art rather than their independence include Dada, Surrealism, and Their Heritage (1968), organized by William Rubin for The Museum of Modern Art, New York; Abstract Expressionism: The Formative Years (1978), organized by Robert Hobbs and Gail Levin for the Whitney Museum of American Art; The Spirit of Surrealism (1979), organized by Edward Henning for the Cleveland Museum of Art; and Flying Tigers (1985), at the Bell Gallery, Brown University.

In addition to the group exhibitions of paintings, recent one-person exhibitions have focused on drawings by prominent American abstract expressionist masters: Pollock drawings at the Museum of Modern Art (1969), Newman's at the Baltimore Museum of Art (1979), and Rothko's for the American Federation of Arts (1984).

[5]Samuel Kootz, Letter to *The New York Times,* printed in "The Problem of Seeing," by E. A. Jewell, *The New York Times,* August 10, 1941, sec. 9, p. 7.

[6]Sidney Janis, *Abstract and Surrealist Art in America* (New York: Reynal and Hitchcock, 1944) p. 89.

[7]Clyfford Still, Kay Sage, and Willem de Kooning were not included in The Interpretive Link because drawings that contributed to the main thrust of this exhibition were not available. Picasso was not included because his work from the period 1938–48 did not have the effect or influence on these artists that his work from the '20s and '30s had. Secondly, Picasso's images were so powerful that many of these artists had to work through and out of his images before developing their own independent style and language. Max Ernst was also to have a discernable effect on these artists; however, like Picasso, his works from the earlier surrealist period (frottage and its inherent use of accident and chance) were the most influential.

[8]"A Symposium: The State of American Art," *Magazine of Art,* vol. 42, no. 3 (March 1949), p. 94.

[9]Matta, in Max Kozloff, "An Interview with Matta," *Artforum,* vol. 4 (September 1965), pp. 23, 25.

[10]Max Kozloff, "An Interview with Motherwell," *Artforum,* vol. 4 (September 1965), p. 33.

[11]Ibid., p. 34.

[12]Robert Motherwell, "The Modern Painter's World," *Dyn,* no. 6 (November 1944) p. 13.

[13]"Introduction," *Dyn,* no. 4–5 (Spring 1944), n.p.

[14]John D. Graham's *System and Dialectics of Art,* With a critical introduction by Marcia Epstein Allentuck (Baltimore: Johns Hopkins Press, 1971).

[15]Adolph Gottlieb, "The Ides of Art," *The Tiger's Eye,* no. 2 (December 1947), p. 43.

[16]Guilbaut, p. 111.

[17]Barnett Newman in the catalogue for the exhibition, "Northwest Coast Indian Painting" (New York: Betty Parsons Gallery, 1946).

[18]Barnett Newman in Dorothy Gees Seckler, "Frontiers of Space," *Art in America,* vol. 50, No. 2 (Summer 1962), p. 87.

[19]"Personal Statement" in the exhibition catalogue for the David Porter Gallery, Washington, D.C., *A Painting Prophecy— 1950* (February 1945), n.p.

[20]Letter to Laurine Collins, May 21, 1947; on file at the Brooklyn Museum.

[21]"Personal Statement," David Porter Gallery.

[22]Statement on announcement for Hofmann's exhibition at Art of This Century, New York (March 1944).

[23]William Rubin and Carolyn Lanchner, *André Masson* (New York: The Museum of Modern Art, 1976), p. 161.

[24]Pollock in a taped interview with William Wright, cited in Eugene Victor Thaw and Francis V. O'Connor, eds., *Jackson Pollock: A Catalogue Raisonné of Paintings, Drawings, and Other Works,* 4 volumes (New Haven and London: Yale University Press, 1978).

[25]Jackson Pollock, "Jackson Pollock," *Arts and Architecture,* LXI, No. 2 (February 1944), p. 14.

[26]James Thrall Soby, "Some Younger American Painters," in *Contemporary Painters* (New York: Museum of Modern Art, 1948), p. 79.

[27]Max Kozloff, "An Interview with Matta," p. 26.

Crisis and Perpetual Resolution

Dore Ashton

An invigorating sense of crisis accompanied the artists of the 1930s right up to the outbreak of the Second World War. In the mid-1930s, for instance, Arshile Gorky had called a dozen of his friends to his studio and made a little speech that began: Let's face it, we're bankrupt.

When the war they had so long expected finally erupted, many painters slipped into a mood of despondency that all but halted their work. The makeshift community that had been so effective in furthering the goals of the modernists among the artists (formed on the paycheck line of the WPA in which so many avid discussions took place and then spilled over into the local cafeterias) was totally disrupted. The war was a serious business and took up the energies of many artists who were enlisted in propaganda offices or war plants as draftsmen or eventually even in the armed forces. The crisis feeling that had only shadowed their existence until late 1938 was really and truly upon them. Adolph Gottlieb, recalling the period many years later, wrote: "During the 1940s, a few painters were painting with a feeling of absolute desperation. The situation was so bad that I know I felt free to try anything no matter how absurd it seemed."[1] Barnett Newman said, "In 1940, some of us woke up to find ourselves without hope."[2] Others remember the last days of the 1930s and the early months of the Second World War as a watershed; as both an end and a beginning. Something hard to define, but definitely sensed by all the artists who were later to be called abstract expressionists, had happened. All the heterogeneous elements that had flooded into the vacuum during the Depression now hung in the balance.

One of those elements was composed of several strands of the European surrealist movement, ranging from the literary revolution inspired by André Breton (didn't Gorky purloin Eluard's poems?) to the various interests put forward with an air of great discovery, and artful ingenuousness, by the surrealist specialists. They included forays into anthropology, primitive art, the art of children, madmen, and criminals, political mythology and, above all, the structure of the psyche as described by Freud. These horizons, initially new to many Americans, had been well scanned for a number of years and, in some cases, assimilated theoretically into their esthetic. But it was not until the new vacuum, produced by the trauma of the war, stared them in the face that most of the abstract expressionists had recourse to surrealist techniques. They suddenly felt, as Gottlieb expressed it, free to try anything no matter how absurd. What they tried first was to release their frozen souls through drawing. In the visual arts, the very germ of surrealism lay in the act of drawing. The hand with the pen was the most immediate means of taking down what Breton had called thought's dictation. For many artists at that depressing juncture it seemed a possible salvation.

The acquisition of the technique called automatic drawing performed a useful function for them, although many were to denounce it later. For the majority, it seems, automatic drawing was merely a way of loosening up. Rothko called his scribbled annotations of 1938–39 "warmup exercises," while Motherwell to this day refers to "artful scribbling" as the initial phase, only, in his painting process. Although almost all of the abstract expressionists at one time or another had experimented with surrealist techniques for limbering up the imagination, few were disposed to accept Breton's ideal of "pure psychic automatism." Perhaps the word "pure" put them off. There was always something rebellious in Americans, who looked with suspicion upon the purity of certain European movements. Heterogeneity was more to their taste. Yet, not a single artist in the group could claim immunity from the powerful rhetoric of the surrealists, kept alive among them not only by the arrival of the surrealists themselves but by the flurry of wartime publications, such as *View* and *VVV*, dedicated to prolonging the life of surrealism.

There was definitely something equivocal in the American response to surrealism, as reflected in the attitude of the seasoned painter, Arshile Gorky, who had been an early aficionado. (He was one of the first and most assiduous visitors to Julien Levy's gallery, which opened in 1932 and in the course of the next few years exhibited the works of Max Ernst, Salvador Dali, Man Ray, Marcel Duchamp, Alberto Giacometti, Yves Tanguy and Rene Magritte.) Gorky had fully accepted the surrealists' belief in the redeeming powers of dreams and was no stranger to Freudian truisms that he could hear every night in the cafes he frequented in the late '20s in Greenwich Village. In the late 1930s he wrote to his sister:[3]

> Dreams form the bristles of the artist's brush. And, as the eye functions as the brain's sentry, I communicate my innermost perceptions through art, my worldview. In trying to probe beyond the ordinary and the known, I create an interior infinity. Liver. Bones. Living dreams!

But as Gorky's work quickly evolved in the 1940s, he began to reconsider his earlier premises. In a letter to his sister shortly before his death, he wrote:[4]

> Surrealism is an academic art under disguise and anti-aesthetic and suspicious of excellence and largely restrictive because of its narrow rigidity. To its adherents the tradition of art and its quality mean little. They are drunk with psychiatric spontaneity and inexplicable dreams...Really they are not as earnest about painting as I should like artists to be....

Gorky was the first of many abstract expressionists who, having found an initial release through the tenets of sur-

realism, later retracted this allegiance and, in so doing, greatly modified surrealism itself (for no matter how much the abstract expressionists did protest, they had drawn heavily upon their surrealist sources). The modification, which eventuated in an identifiable point of view called abstract expressionism, was wrought by artists who, like Gorky, could not, finally, accept the element of play in surrealist life. Earnestness was essential to the abstract expressionist project, and although it certainly was subtly present in the European surrealists, it could not be discerned by their more sober American acolytes. Out of this mis-understanding, as so often happens, came something new.

The transformation of orthodox surrealism into ab-stract expressionist art during the war years is not readily explained, and even now, as painstaking researchers turn up more and more documents, the outlines remain blurred. As Benedetto Croce said, art history like human history doesn't remember everything at the same time, but calls up what has been forgotten when needed. The sudden active interest in surrealist techniques in the late 1930s can be interpreted as a sign of urgent need. It can also be seen as a response to the new situation of crisis felt by the com-munity that had initiated experimental painting through constant discussion and mutual interest. The standard explanations of the sudden surge of interest not only in sur-realist themes—which had long been there—but also in techniques, are sound enough but perhaps too restricting. There was more at stake. It is certainly true that Gorky was profoundly stimulated by the young Matta who arrived in New York in the fall of 1939, and true that Matta impressed many of the painters with his doctrine of "quadridimen-sional space" and his emphasis on "morphology." It is also true that Baziotes, Pollock and Motherwell, among others, were induced to try automatic drawing largely through Matta's electric presence. Then, with the arrival of Ernst, Tanguy and André Masson, the circle widens, and it is true that Ernst fascinated many a young painter (Baziotes was spellbound by Ernst's descriptions of his encounters with American Indians). It is also true that Masson, who had translated the automatic linear impulse into a fluent, almost cursive drawing style that was introduced to Americans through his books as well as in exhibitions, made an im-pression with his metamorphic imagery, fusing organic allusions from all of nature. Finally, it is true that Miró had an abiding presence in the imaginations of his young American admirers and would, in his 1941 exhibition at the Museum of Modern Art, bowl them over with his audacity of line, free use of color, and erotic allusions. These forceful presences and events have all been rightfully noted as in-fluences in the formation of the abstract expressionists. But to answer why, finally, the orthodox surrealist stance was abandoned by the Americans, it is necessary to take into account the local traditions and special circumstances—

sometimes accidental—in their lives, as well as countless other artistic experiences that mitigated their approach to the visual image.

There is the large and difficult question of American traditions and customs and how they, perhaps against the will of the adventurous artists, made inroads on their attitudes. The Puritanical tradition, with its wariness of merely sensuous pleasures and its—to use Gorky's word—earnestness, was certainly a factor. The surrealists had preached surrealism as a way of life more than an esthetic, and the element of wit or irony, the sometimes arch play-fulness, in their works repelled many Americans. A painter such as Clyfford Still, with his notable lack of humor, would easily misunderstand certain exuberantly playful modes of existence among the surrealists. On the other hand, Gorky, with his Slavic background (at least that is the background with which he most intimately identified) could more easily assimilate the abstraction of Kandinsky, with its moral un-derpinnings, than the psychiatric and seemingly random in-formal approach of the surrealists. In Kandinsky (who was amply exposed in America long before he was well known in Paris through the peculiar circumstance of there being a Solomon Guggenheim in New York and a Baroness Rebay in love with a Kandinsky epigone) New York artists had a preview of Matta's quadridimensional universe. Kandinsky had long advocated a pictorial space that eliminated single vanishing points and that intimated the existence of a "spiritual" space encompassing all spaces. When his "Con-cerning The Spiritual in Art" was published in English after the war, a preface by Stanley William Hayter specifically dis-cussed the nature of Kandinsky's pictorial space with its multiple vistas and its cosmological ambitions. The radical transformation of the idea of space, as well as the romantic will to articulate infinities, was implicit in Kandinsky's work known to the artists through the Museum of Non-Objective Art, later called the Guggenheim Museum. Perhaps even more, the notion of art as an ethic rather than an esthetic was borne in upon the Americans as much through Kandinsky's approach as through the lucubrations of the surrealists.

Yet, even Kandinsky was overshadowed by the most powerful figure of all, Picasso. The Americans were haunted by him and hard-put to keep up with his seemingly inexhaustible feints. They constantly questioned either his formal innovations or his seeming eclecticism. No twen-tieth century figure or movement had elicited so much dis-cussion and consternation as Picasso. To weigh the role of Picasso in the development of abstract expressionist paint-ing requires an assessment of the situation peculiar to America—the situation reflecting the great upheaval of val-ues called the Depression. The crude juxtaposition of social realism and a European modernism based largely on the articulation of cubism brought many American artists into

dismaying conflicts. None of the artists who would later be abstract expressionists could quite ignore the pressing social issues in the crisis of the Depression, not even de Kooning, who had a more sophisticated European formation. Yet, none could accept the nationalistic bombast of the social realists either. Those who had schooled themselves in the structural principles of cubism (as nearly all had) were not easily deflected from the modernist vision. And among them were figures and mentors, such as John Graham, who could sponsor an open attitude, even toward the other avant-garde phenomenon, surrealism. So devoted a cubist as Stuart Davis, an elder statesman of some power in the artists' WPA community, could defend the work of Salvador Dalí with fervor while remaining firmly ensconced in the cubist tradition. Yet the dilemma for American artists was not resolved, as even a cursory survey of the drawings of Pollock, for instance, reveals. Picasso, of all Europeans, was the most volatile and the most flexible, and the figure with whom many Americans, given heterogeneous backgrounds, could best identify. When, in the late 1930s, the situation became exacerbated (the political arena being inundated with betrayals such as the Hitler-Stalin pact), and when American artists of a progressive frame of mind were at a spiritual nadir, an event of incalculable importance occurred: the exhibition in 1939 of Picasso's *Guernica*. Artists in New York flocked to the Valentine Gallery to see it, having known the fabled masterpiece in reproduction only. For more than a few, the existence of *Guernica* pointed to a way out of the dilemma. They saw the father of modern art bringing together several seemingly irreconcilable modes of expression, a feat they themselves had sought to bring off without notable success. Here was a work at once theatrical, mythical, emotional, political and still true to cubist compositional principles. It was a shocking abstraction, reduced to black, white and gray, and yet a readable allegory of tragedy with specific political allusions. This fusion of ethical and esthetic principles helped to free New York School painters from two assumptions: that to be "modern" meant to be abstract and that to use "subjects" was counter to the modern impulse. The characteristic abstract expressionist position emerged from this liberation and the concurrent surrealist flareup. A young painter such as Robert Motherwell, whose interest in cubism was as profound as his temperamental affinity for surrealism, could see the implications of the circuitous path that sporadically had brought Picasso close to the surrealists. In 1944 Motherwell wrote an essay, "The Modern Painter's World," in which he argued, among other things, that Picasso had helped to restore social values. That same year Pollock stated that the artists he most admired were Picasso and Miró.

Given the seductive power of surrealism and the commitment of so many American painters to a kind of truth that would not find full expression in mere plastic beauty,

the existence of Picasso armed them against total capitulation to the most cherished surrealist principles. It is well known that the group called abstract expressionists was far from unanimous in any particular position except a general agreement that even abstract art could have, indeed *must* have, an authentic subject. But as Gorky objected, the psyche was not enough. Moreover, the uneasiness and the unsureness in the American camp was endemic and to some degree based on bitter experience. Most painters by 1939 harbored a deep suspicion of fixed ideology. They had watched and, in some cases, shared the unhappy course of political ideologies grafted onto art during the Depression and were chastened. The surrealists had a strong tendency to ideological pronunciamentos (even if their ideologies changed from year to year) that made the Americans uncomfortable.

Another ground for resistance to surrealist orthodoxy was quite simply the American artists' need to differentiate themselves, which, given the long American subservience to Europe when cultural matters were under consideration, took on considerable energy once the Europeans themselves appeared and proved to be human. An artist with an equable temperament such as Baziotes could welcome them and talk about how wonderful it was to see them outside their studios, "what their manners and attitudes were towards specific situations, how they lived, how they believed in and practiced their uniqueness, how they never spoke of ideas but only of the things they loved."[5] But Pollock and several others were extremely ambivalent and, at times, violently attacked the Europeans with a kind of bravura that sprang from a strong desire to become psychologically independent as artists. These artists were in the habit, among themselves, to refer derisively to Breton in their midst as "Mr. God."

It can be said that all the artists of the abstract expressionist conformation were intent on distinguishing themselves from their European mentors. Yet, the diversity among themselves was considerable. Seen as a whole, they cannot be easily characterized. But there were little kinship groups within that can be more specifically discussed. Rothko, Gottlieb and Newman, for instance, shared Gorky's distaste for the surrealists' seeming lack of earnestness, while Motherwell and Baziotes understood it on a different level. Pollock shared an aggressive, challenging attitude, while the young Stamos was content to absorb nearly everything the surrealists proffered.

For many of the artists, the whole problem of the immediate prewar years had been, as Gottlieb said, "how to get rid of these traps—Picasso and Surrealism—and how to stay clear of American Provincialism, Regionalism and Social Realism."[6] One way out, as both he and Rothko argued, was through the evocation of myth. It was from the most poetic of surrealists, Miró, that the impetus came pri-

marily. Miró's exhibition at the Museum of Modern Art in 1941 proved to be the strongest stimulus, although one of his most important paintings, *The Hunter,* had been hanging permanently at the Museum since 1936. Miró's translation of time into intercollated regions and simultaneities, his hints of mythic elements, and his biomorphic imagery suited the needs of these artists intent on going back to origins in a quite literal way. Their impulse to explore the "unknown world" was spurred by the abstract wing of the surrealist movement, and yet even in their famous statement in 1943, Rothko and Gottlieb departed from their surrealist colleagues in declaring that they would reassert the picture plane and use large, flat forms—esthetic choices that related more to Matisse than to any of the surrealists.

No doubt the ability of the abstract expressionists to spring free of their obvious sources was enhanced by the special nature of their exposure to the history of modern art. It must be borne in mind that Alfred H. Barr, Jr., had systematically presented the entire gamut of modern movements in a series of carefully constructed exhibitions. Artists in New York were able to see the considerable fanlike spread perhaps with even more clarity than their confrères in Europe. In Paris there was always a tendency to concentrate on one or two movements at a time, avoiding discussion and exposure of works that could not be conveniently grouped in schools. In New York, the general fund of news from Europe was richer, and while the 1936 exhibition at the Museum of Modern Art focusing on dada and surrealism had considerable effect, it was by far not the only one to impress the artists of the 1930s. While it is undeniably evident in the drawings of the late 1930s and early 1940s that surrealism was a compelling spur, it is also true that when these artists began to expand in their paintings, other memories and other movements were invoked. The originality of the movement lay in the peculiar fusion that several abstract expressionists succeeded in effecting. As Lawrence Alloway remarked, "The transformation of Surrealist automatic techniques in America took various forms, but is fundamentally a change from graphic to full-scale painterly procedures."[7] Once the full-scale painterly procedures predominated, a flood of individuations occurred indicating the depth of the painterly culture at work.

It can be said, finally, that the wholesome effect of surrealism was to free both the hand and the imagination to the extent that artists felt free to enlarge and finally modify surrealist propositions. Most American artists could say with Masson: "Fundamentally I am more a sympathiser with surrealism than a surrealist or a non-surrealist."[8] ∎

Notes

[1] Pollock Symposium, *Art News,* April 1967

[2] Ibid.

[3] Gorky letters to Vartoosh, in Karlen Mooradian, *Arshile Gorky Adoian* (Chicago: Gilgamesh Press, 1978).

[4] Ibid.

[5] "Symposium: The Creative Process." *Art Digest,* New York, vol. 28, no. 8, January 15, 1954.

[6] Verbal communication to the author.

[7] Lawrency Alloway, Introduction to *William Baziotes: A Memorial Exhibition* (New York: Solomon R. Guggenheim Museum, New York, 1965).

[8] "Europeans in America," *Bulletin, Museum of Modern Art, New York,* vol. 13, no. 4–5, 1946.

The Biomorphic Forties

Lawrence Alloway

Bio: "a combining form denoting relation to, or connection with, life, vital phenomena, or living organisms."

Morphology: "the features, collectively, comprised in the form and structure of an organism or any of its parts."

The movements of 20th-century art, to the extent that they began with artists' acts of self-identification, in opposition either to another group of artists or against a public made grandiose and threatening as the Philistines, tend to stay monolithic. Efforts are made to unify these discrete movements, like different shaped beads on a string of "the classical spirit" or "the expressionist temperament," but obviously this delivers very little, except an illusion of mastery to the users of cliché. More is needed than a revival of the exhausted classical/romantic antithesis, which leaves the movements to be united sequentially undisturbed. Modern art tends to be written about by the artists and their friends, in the first case, and by generalizers and popularizers after that, with the result that the mosaic of movements has remained largely unaffected to the detriment of unorganized artists and traditions. For example, there is a line of biomorphic art (which combines various forms in evocative organic wholes), that, to the extent that it is discussed in the usual framework, could only be viewed as a part of Surrealism. What failed to fit would come under such headings as Precursors of, or The Inheritance of, Surrealism, or, maybe, just plain independents (as if the artists were eccentrics, or nuts, off the main-line).

Biomorphism, so far as Surrealism goes, is a painterly equivalent of the transcriptual puzzles and combinations of objects of Magritte and Dali. However, the main painters of biomorphism have been merely affiliated to Surrealism, or Shanghai-ed into it, as is the case with Arp and Miró; Masson alone, for much of his career, was an official Surrealist. Biomorphism, with its invention of analogies of human forms in nature and other organisms, has wide connections, for example, with Art Nouveau (in which the human body shares a promiscuous linear flow with all created objects) and with Redon, whose ambiguous imagery is born of reverie.

In New York in the mid-40s biomorphism was of the greatest importance and one of its sources was certainly Surrealism. However, we must also account for the position of an artist like Baziotes whose "Moon World," 1951, is very close to the bland sack of Brancusi's marble seal, "Le Miracle," 1936. Another example of the pervasiveness of biomorphism apart from the influence of Surrealism, is the late work of Kandinsky. After 1934 there is a persistent use of waving tendrils and squirming free forms, but dried out when compared with the juiciness of Miró, or the ripeness of Arp. These irregular radiating or flattened forms, however arched, are fully characteristic of biomorphism's inventory of organic form. In the visual arts it is a cultural reflex to regard nature as landscape. However, in biomorphic art, nature can also be a single organic form, or a group of such forms (like Baziotes' "Moon World"). Or they can be presented in swarms, tangling with one another. Barnett Newman, writing about Stamos, indicates the im-

portance of nature to him, as to other biomorphic artists: "His ideograph captures the moment of totemic affinity with the rock and the mushroom, the crayfish and the seaweed. He redefines the pastoral experience as one of participation with the inner life of the natural phenomenon.[1]

In addition to the flat, more-or-less placid, and (as it were) one-cell biomorphs, another aspect of organic imagery is important. This is linear-based (as opposed to painterly and planar) biomorphism, with the canvas or paper swarming like the jungle which exists below the ordinary scale of human vision. (Hence the importance of microscopy, either as a direct visual influence, or, more usually, as conceptual backing to justify an artist's working assumption of "endless worlds," extensions of consciousness beyond the proportionate contour of classical and Renaissance art.)

Proliferating biomorphism is the analogue of manic activity in the artist, whose muscular activity issues in the marks which we interpret as a self-discovering subject. The graphic preliminaries of the artist suggest forms out of which conflations of human, floral, animal, and insect-like forms can be developed. Crowded and manic biomorphism is directly linked to automatism, which was cultivated by the Surrealists as a means of direct access to the Unconscious mind. The ideal of direct action was most clearly recognized in drawing, except for phases of Masson's and Ernst's painting. In New York in the '40s automatism was pressed as a cause by Matta, who influenced Motherwell and Baziotes. Pollock too, expressed interest in its procedures. Referring to "European moderns" Pollock said: "I am particularly impressed with their concept of the source of art being the unconscious."[2] There is an unbroken link between automatic processes in art (working at speed, encouraging accidents) and belief, often of a rather nonchalant and expedient sort, in the unconscious.

The unconscious, in its turn, is linked to mythology, which, after a lively influence on 20th-century culture, reached a climax in the '40s, and nowhere more than in New York. The appeal of myth must have had something to do with the fact that it offered a control mechanism by which all data, all experiences, could be handled. It was not myth as a body of precise allusions as, say, in 17th-century poetry, but myth as a kind of "manna." Myths, absorbed more or less automatically in our education, updated by Freud and Jung, revealed ubiquitous patterns that tied in the personal psyche with the greatest events, new or old. Revealing of this aspect is "A Special Issue on Myth," published by the magazine "Chimera" in 1946.[3] Here is a partial name-list from its 88 pages: Alcestis, John Buchan, Columbus, Dante, Earwicker, Faustus, Gluck, Hitler, and so on to Veblen and John Wesley; subjects discussed include witches and warlocks, Hegel's spirit, the Siegfried cycle, and Walpole's "Castle of Otranto." This should be enough to show that in the '40s, mythology was seriously regarded

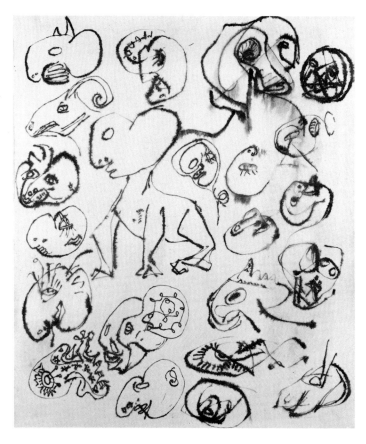

Jackson Pollock. *Animal Figures,* c. 1939–42. C. R. #601. Ink on paper, 13 x 10⅜ inches. Collection of The Fort Worth Art Museum, Fort Worth, Texas; Purchase made possible by a grant from the Anne Burnett and Charles Tandy Foundation. Photo: David Wharton

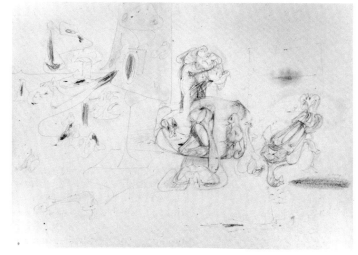

Arshile Gorky. *Drawing,* 1946–47. Pencil and crayon on paper, 18½ x 25¼ inches. Xavier Fourcade, Inc., New York. Photo: Bruce C. Jones

as a key to the psycho-social order we share with world culture. (Adolph Gottlieb remembers that he had a copy which he kept for about ten years.) Mythology, used like this, turned the whole world into an intimate and organic spectacle. Thus, an artist with an interest in mythology could discover its enduring and fantastic patterns in his art and, at the same time, project his personal patterns out into the world. The pleasure taken in pre-history, as subject and title, in Rothko and Stamos, for example, is indicative of this quest for unplumbed humanity, with the remote in time as a metaphor of psychological depth.

At a moment when abstract artists were turning from existing geometric styles, mythology gave to evocative and suggestive, but not precisely decodable, signs, the appropriate atmosphere and ideal context. Of the biomorphists, Baziotes, Gottlieb, Pollock, and Rothko used myth-conferring titles, and so did Gorky in the sense of binding his paintings to personal desire and memory. There is a psycho-sexual content in biomorphic art, which abounds in visceral lyricism full of body allusions. Gorky, in this respect comparable to Baziotes and Rothko, creates a kind of polymorphous fabulism. Particular cases of resemblance are not interesting: the point is the identity of everything with its simultaneous phases of seeding, sprouting, growing, loving, fighting, decaying, rebirth. The impression is of a natural and personal abundance, in opposition to geometric art (urban or platonic) or figurative art (bound to particular cases). The desire for a nuanced and subjective imagery was manifested in paintings that did not subordinate the artist's use of paint to a tidy and cleaned up end-state. On the contrary, rich meanings were located within the creative act itself, so that the processing record itself is sensitized. Biomorphic art depends in part (1) on the depiction of beings and places, but also (2) on the enactment of the work itself. The artist's gestures are image-making and keep their identity as physical improvisation beyond the point of completion. Gorky's and Pollock's linearism, Rothko's liquidity, Baziotes' scumbled haze of color, were all technical devices fused with permissive meanings.

Thus biomorphic art emerged in New York as the result of a cluster of ideas about nature, automatism, mythology, and the unconscious. These elements fed one another to make a loop out of which this evocative art developed. It made possible, too, the continuation of aspects of biomorphism familiar to European art (especially Miró and Klee) although native artists like Arthur G. Dove, with his uterine landscapes, may have helped predispose American artists to the ambiguous mode. If it was the conjunction of these varied elements that was fruitful in New York for biomorphism, considerable latitude in its forms is to be expected. This, in fact, is the case, and assuming that a tradition is validated more by how far it can be stretched than by how narrowly it can be administered, it is a sign of biomorphic

art's historical appropriateness that so much could be made of it. One aspect of its diversity is seen in Still's biomorphism which is at the border of his abstract art, and hence ambiguously interpretable as abstract. His paintings of circa 1938 to circa 1946 are rocky and troll-like; a stickily dragged paint creates a Northern melodrama of thrones and presences, like Mount Rushmore as the statue of the Commander.

A checklist of American biomorphists in the '40s would be unmanageable if it were comprehensive, but it is possible to indicate the central groupings. Pollock, in drawings of the late '30s made what are virtually straight biomorphic exercises. These chain-reactions of repetitive and transforming imagery, are presumably the type of drawing that he discussed with his Jungian analyst in 1939. Pollock's paintings were not stylistically kin with these fluent drawings, however: his biomorphic paintings of 1943–46 set the human or totemic passages in a late Cubist framework.[4] "Composition" is a turbulent extension of Picasso's so-called "Surrealist" "Three Dancers," 1925, in the direction of more direct passion and fuller human traces. It was not until 1951 that he revived the iconography of these periods, ambiguously human, fully biomorphic, in the black paintings, without any Cubist bracing. Gorky's early metamorphic scenes also derive from Cubism; in the '30s he made what Alfred Barr called Curvilinear Cubism, as undulant as cartoons of well-stacked girls or rippling biceps. In a way, Gorky's development parallels André Masson's, who, from being a Cubist, and friend of Gris, expanded Cubist subject-matter, and then relinquished its forms entirely for organic and improvisatory

work. However, Gorky's sexy Cubism was only a preliminary for the full biomorphism of the three "Garden in Sochi" paintings (1940–41), with their conspicuous adaptation of Miró, leading into linear twists and folds, washed with transparent color and flecks of clear hue (like a parted orifice) of "The Pirate 1," 1942. Gorky influenced de Kooning, but biomorphism in de Kooning (circa 1945–48, 1949–50), no matter how many breasts and slits jerk and ripple, in forms like ghosts made out of sheets in old-fashioned cartoons, is implicitly urban. His mannequins piled in a warehouse are a rationalized version of the pastoral bacchanals of Gorky.

Four artists were particularly occupied with the evocation of the primal, using pre-history and marine biology. Rothko, between circa 1945 and 1947, paints an imagined ocean floor in which linear organisms wriggle as his wrist moves, creating animate forms transparent to their misty backgrounds. A 1945 painting was entitled "Birth of Cephalopods," which are a class of Mollusca "characterized by a distinct head with 'arms' of tentacles attached to it; comprising Cuttlefishes, the Nautilus, etc., and numerous fossil species." (OED). Alien but beguiling, disembodied but sexual forms drift, hover, and coalesce. Stamos stated the theme clearly in 1946 (after hesitant moves in the preceding year). "Omen" and "Nautical Warrior," both of 1946, present marine forms animated in ways to imply combat, encounter, self-awareness and contact. Biological low life is the analogue of human feeling and order. Gottlieb's pictographs, begun in 1941, have a biomorphic potential as when the artist speaks of using "hand, nose, arms" as details in painting "often separating them from their associations as anatomy."[5] Beyond this, however, is the frequent appearance in paintings of 1946–47 of fleshy marine forms, as in "Return of the Mariner," 1946. Baziotes evolved in 1947 (after a period in 1942 when he was occupied by the promises of automatism) a biomorphic style that was the base of all his subsequent work. He used, in that year, rudimentary human contours which assimilated references to a dwarf, Cyclops, an armless and legless veteran of World War I, a heavy female contour. These elements were not opposed, but subsumed to unified images. Other interests of Baziotes' were "lizards and prehistoric animals,"[6] not to mention the zoo and the aquarium.

To conclude: a description of biomorphic art cannot be restricted to a Surrealist ambience, although this was certainly a stimulus. It is important to stress that several of the American artists contacted earlier, original traditions which Surrealism had adapted and rigidified. Thus, Baziotes went around "behind" Surrealism to a form of reverie more like Redon's than, say, Dali's: in Baziotes flora and fauna lyrically oscillate but within a formal canon of unperturbed refinement. When he wrote "it is the mysterious I love in painting. It is the stillness and the silence,"[7] he raised unmistakably the symbolist canon of inert and strange beauties.

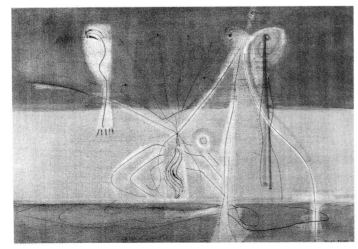

Mark Rothko. *Tentacles of Memory,* c. 1945–46. Watercolor and ink on paper, 21¾ x 30 inches. San Francisco Museum of Modern Art, San Francisco, California; Albert M. Bender Collection, Albert M. Bender Bequest Fund purchase 46.2794

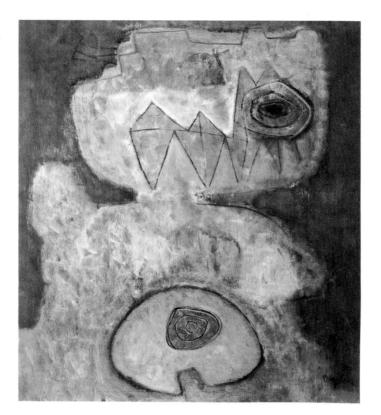

William Baziotes. *Dwarf*, 1947.
Oil on canvas, 42 x 36⅛ inches.
Collection The Museum of
Modern Art, New York.
A. Conger Goodyear Fund

Gorky, too, can be connected behind André Breton, who helped with his titles, to a broader style, the tradition of the Grotesque. Vitruvius, who objected to this capricious ornamental style, described it well by writing against it: "How can a tender shoot carry a human figure, and how can bastard forms composed of flowers and human bodies grow out of roots and tendrils?"[8] Several aspects of biomorphic imagery can be considered as an incorporation into easel painting of the monstrous fusions and calligraphic energy of the Grotesque. Other connections could be made back to traditional iconographies of herbal, bacchanal and paradise, which combine pastoral scene with erotic act. However, enough has been said to show that biomorphism is a continuation of extensive traditions of fantasy, as well as the product of a particular historical situation in New York in the '40s. ∎

This essay, reprinted without illustrations from Artforum, *Vol. 4, September 1965, incorporates brief passages from two other pieces by the author: the introduction to "William Baziotes, A Memorial Exhibition," The Solomon R. Guggenheim Museum, New York, 1965, and "Gorky,"* Artforum, *Vol. 1, March, 1963.*

Notes

[1]"Theodoros Stamos." Exhibition Catalog. Betty Parsons Gallery, New York, March 1947.

[2]Quoted from "Arts and Architecture," February, 1944 in: "New York School, The First Generation," Los Angeles County Museum, 1965.

[3]"Chimera," New York vol. 4, no. 3, Spring 1946.

[4]According to Lee Krasner Pollock, "Untitled Painting" (in her collection) dates from circa 1937, but it is hard to envisage this work preceding the heavily Picassoid "Masque Image," 1938, and structurally it is closer to such works as "Night Dancer" (Green), 1944.

[5]Quoted from "Limited Edition," 1945 in: "New York School. The First Generation," Los Angeles County Museum, 1965.

"The Tiger's Eye," 2, 1947 (a magazine that Barnett Newman was an associate editor of) included an anthology of poetic writing and painting on the theme of "The Sea" (pp. 65-100). It included a Milton Avery beach scene, two fully biomorphic Stamos paintings of circa 1946, and Baziotes' patterned cubist "Florida Seascape" 1945. Elsewhere in the magazine Stamos wrote (in "The Ides of Art"): 'I am concerned with the Ancestral Image which is a journey through the shells and webbed entanglements of the phenomenon." (my emphasis).

[6]For these quotations, and others, see: "William Baziotes, A Memorial Exhibition," The Solomon R. Guggenheim Museum, New York, 1965.

[7]Baziotes, ibid.

[8]Quoted by Wolfgang Kayser: "The Grotesque in Art and Literature." Indiana University Press, 1963.

The Cycloptic Eye, Pataphysics and the Possible: Transformations of Surrealism

Martica Sawin

Art is not produced by one artist, but by several," wrote Max Ernst in 1946. "It is to a great degree a product of their exchange of ideas with one another." He was attributing the lessening of the surrealists' productivity during their wartime years in the United States to their greater distance from each other and the lack of a cafe as a casual meeting place.[1] He could as well have been speaking of what *did* happen in New York during those years and of an exchange of ideas that *did* take place, which resulted in an unprecedented cultural transfusion.

Too often this exchange is portrayed as a collective surrealist arm extending the automatist brush to a unanimously outstretched American hand. The truth is that some of the artists mentioned in this exchange never knew each other and on the part of others there was a certain amount of antipathy. Further, the surrealist ranks were split and the ideas of some of the younger members were looked on with skepticism by veterans of the movement's early days. The surrealist painter most admired by the Americans, Joan Miró, did not come to New York until 1946, and André Masson, who, like Breton, spoke no English, rarely left his retreat in rural Connecticut. To be sure, André Breton had hoped for a spread of surrealism when he sought to emigrate to America after his demobilization in the summer of 1940. He wrote to Kurt Seligmann in New York urging him to try to procure official invitations for himself and Pierre Mabille because he was "convinced that the future of Surrealism is where you are." Finally en route nine months later, he wrote again, saying that he had renounced all backward glances in favor of the tasks they must "undertake at any cost. Historically the word is with us."[2]

Breton could hardly have envisioned, however, the form his *revolution surréaliste* would take in New York, nor how the historic "word" would be interpreted. Suffering from the dual chagrins of having to work for the Voice of America and not speaking English, he had to rely on others to be the voice of surrealism, and these voices were, at the very least, pluralistic. Naturally the interpretations of surrealism most easily transmitted were those of the younger artists who were bilingual: Gordon Onslow Ford, Matta, and Robert Motherwell. The two youngest of Breton's prewar recruits, Onslow Ford and Matta, had worked closely together in 1938 and 1939, developing what Matta described as "psychological morphology," which was more concerned with the occult than with Freudian-oriented surrealism. From Mexico, a third former surrealist, Wolfgang Paalen, established ties with the same younger American artists who were drawn into the surrealist orbit in New York. In resigning from the surrealist movement in 1942, Paalen called for a new cosmic sense in art, based on the directives of modern physics. The title of the English language periodical he published in Mexico, *Dyn,* was derived from the Greek word for "possible," which would become the title of

the first collective statement of the abstract expressionists, the single-issue journal, *Possibilities,* of 1947. The subject of this essay is the influence of these three émigré artists in three specific forms: the series of lectures given by Gordon Onslow Ford at the New School of Social Research in 1941, the sessions at Matta's studio in 1942, and Paalen's periodical, *Dyn,* which appeared in six numbers from 1942 to 1944.

Onslow Ford's lectures, which were listed in the New School bulletin under the title "Surrealist Painting: an adventure into Human Consciousness," were held on four alternate Wednesday evenings, starting on January 22, 1941. They had been arranged in order to justify the terms under which Onslow Ford, an officer in the British naval reserve, had been invited to the United States in a time of war; that is, as a cultural emissary. To supplement the lectures, he organized, with the help of Howard Putzel, exhibitions of surrealist paintings, some of which he had brought from Europe; others were borrowed from the Museum of Modern Art and private collectors. Estimates of the number of people in attendance vary greatly, as does the list of attendees; however, it is certian that William Baziotes, Motherwell, Jimmy Ernst, David Hare, Matta, Yves Tanguy and Frederick Kiesler were in the audience and some accounts add Mark Rothko, Jackson Pollock and Arshile Gorky.[3]

The first three talks were devoted to an interpretive analysis of the works of de Chirico, Miró, Max Ernst, Magritte and Tanguy and carried out his stated aim of "following their work as a psychological barometer registering the desires and impulses of the community." In the last lecture he turned to those who had joined surrealism during the 1930s—Stanley Hayter, Victor Brauner, Kurt Seligmann, Paalen, Matta and himself—and he differentiated between the aims of the older and younger generations. "The young generation today are expressing the desires of the collective unconscious in new ways of looking at the world. We all now have the discoveries of Freud in our blood; the young generation knows him by instinct, as we also have the psychological adventures of the first part of surrealism in our blood."

Having nudged Freud over to make room for Jung, Onslow Ford went on to describe the tasks of the new generation: "The barriers that for our intelligence separate the different parts of space as they separate the different parts of time have shown their artificial character...the barriers dividing time into past, present and future must be broken down to give man a greater consciousness." Here he introduces the ideas about time, space and simultaneity to which he and Matta had been drawn. They thought of the visible world as a section through a largely invisible reality and sought to reveal the morphologies that were absorbed into the flux of their transparent universe.

Urging his listeners to "switch on the cycloptic eye in

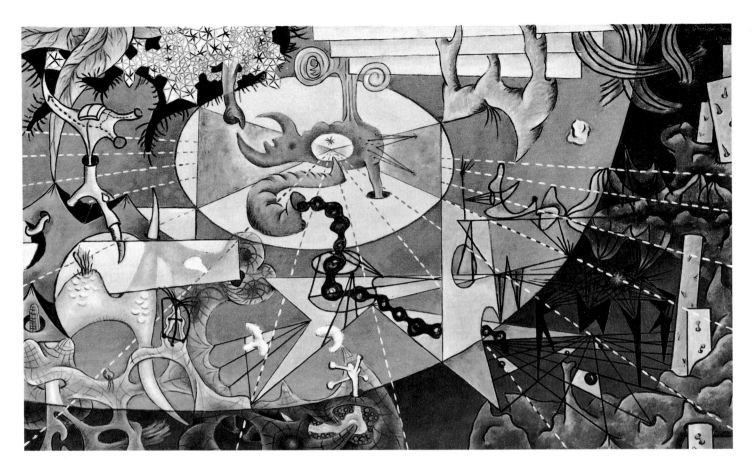

Gordon Onslow Ford.
Propaganda for Love, 1940. Oil
on canvas, 41 x 67 inches.
Collection of the artist

the middle of the forehead to look inside yourselves at the internal landscape," he again referred to the problem of time. "The ordinary eye is a slave to the present moment, but in our imagination we are free to move along the time length...To see Hayter's *Three Dancing Women* you have to switch your eye to a speed that is different from the normal, where the present moment can be expanded at will to embrace an action." He described the lure of the *merveilleux* (as opposed to the devalued English "marvelous") and he pointed to the need to "tear down, one by one, the veils that hide the reality of our own incomprehensible universe."

At the end of his fourth lecture, Onslow Ford mentioned five artists who had joined them in the United States: Kay Sage, Boris Margo, Helen Phillips, Bill Baziotes, and Jimmy Ernst. "Together," he said, "we hope to make a vital contribution to the transformation of the world."[4] No longer, apparently, in his view, was surrealism's contribution envisioned, as it had been by Breton, as being a necessary prelude to a social revolution; now it was seen as leading, in metaphysical terms, to a cosmic consciousness. Evidently no one has recorded the audience reaction to Onslow Ford's

words, although he himself saw it as an incitement to revolution. Tanguy expressed some doubt about the manner in which surrealism was being interpreted, but Breton, having heard about the lectures on his arrival in New York in April, wrote Paalen that he was in complete agreement.[5] The immediate result appears to have been that Onslow Ford came to be regarded as a kind of surrealist guru and he was pursued by questions, even eventually by Alfred Barr, who wrote asking for his interpretation of Max Ernst's *Two Children Threatened by a Nightingale*.[6] Wary of such a role and anguished over the war, he left New York in the spring of 1941 and went to live in a remote Indian village in Mexico where he exchanged visits from time to time with former surrealist Wolfgang Paalen.

In 1942 there was considerable disagreement between the more literally pictorial and the more abstract surrealists, the latter contending that the periodical *View* was biased in favor of the former. Hence a new periodical was envisioned which would represent the more autonomous and abstract point of view, to be called the *Triple V* or *VVV*. However, the quarrel was patched up and Matta reported to Onslow Ford that summer that "*VVV* has turned into a democratic organ ...everybody must have his percentage of the space and the original idea of a laboratory for the word and form in all its suicidal possibilities is gone. So much so that I'm thinking of starting a different publication." Matta had been hoping to involve some of the younger American artists in the pursuit of psychological morphology and wrote in the same letter: "Baziotes, Nelson and Motherwell, especially Bob, are full sphere interested in our pataphysics. Bob will spend the summer around here so we may unfog."[7] Hence it was with the idea of attracting support for a new direction that

differed from surrealist orthodoxy that Matta held gatherings in his Ninth Street studio on Saturday afternoons in the winter of 1942–43.

In the fall of 1942 several Americans were perceived as being close enough to surrealism to be included in the First Papers of Surrealism exhibition. These artists included Baziotes and Motherwell, and the latter also extended an invitation to Pollock, who declined. At the same time, Peggy Guggenheim opened her Art of This Century gallery and in the following year she invited the above artists to participate in a collage exhibition. Matta brought her to Pollock's studio with the result that she commissioned a mural for her apartment and gave him a contract and his first exhibition.

Pollock, Baziotes and Gerome Kamrowski had been in the same mural painting unit of the Federal Art Project which was coming to an end by 1941. Kamrowski remembers that Baziotes was working with display lacquers and that both he and Pollock were dissatisfied with oil paint and wanted to be able to build up a heavy surface, yet not have the colors blend.[8] It is possible that Baziotes' interest in experimenting with fast-drying paints may have come from seeing the "coulages" that Gordon Onslow Ford had painted in France in 1939, as Baziotes helped Onslow Ford improvise a studio in a cold-water flat on 8th Street in 1940. These had come about when Onslow Ford found it difficult to work one day and picked up a can of Ripolin enamel and began pouring it on his canvas. He found that the colors dried fast without blurring and that the paint skin could be peeled off in places to yield unusual effects. Whatever the source of the technique, for Baziotes it was identified with surrealist automatism. According to Peter Busa, Baziotes "insisted on the automatic use of the surrealist image. 'This is what I am talking about,' he would say, and lead you into it."[9]

Later, the same artists, along with Motherwell, met at Matta's studio. These meetings, according to Kamrowski, "were more structured. We would bring our work and discuss it, analyze the images. Matta was trying to project certain ideas, particularly about time. He had a lot of enthusiasm and we enjoyed the meetings. The most important thing for us was the device of free association the surrealists provided. They helped to unhinge us from our provincialism."[10]

Peter Busa recounted that "Matta would look at our work and make comments as to what dimension we were reflecting. He also had organic attitudes and was interested in whether you were reflecting a rhythm that would be associated with water or with fire or with rock forms. The things that Pollock did were really outstanding because he had a very natural exuberance about this point of view. He worked in wash and ink—most of us did...that was the beginning of three years of good solid work. Then Peggy gave us our first one-man shows. One didn't have an image to begin with, but rather a hand and a motor ability. If one

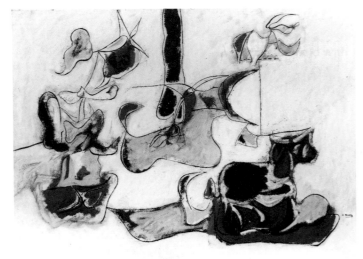

Arshile Gorky. *Garden in Sochi*, 1943. Oil on canvas, 31 x 39 inches. Collection, The Museum of Modern Art, New York. Acquired through the Lillie P. Bliss Bequest. Photo: Geoffrey Clements

trusted the ability just to move one's hand, one could tap many of the sources of images and come up with not only a discernible surrealist image, but at the same time a certain amount of freedom."[11]

One can sense from these words the kind of catalytic force Matta exerted and the way in which he helped his American colleagues break through certain barriers. However, one can also discern where the differences lay, in Kamrowski's mention of Matta's ideas about time and Busa's recollection that he "would comment on what dimension we were reflecting." They were preoccupied with their new-found gestural freedom, while, according to Matta: "what interested me was to see if they could apply the system that was to me fascinating at the time, to use morphology about my psychic responses to life."[12] Among the writers Matta and Onslow Ford had read and discussed in the early days of their friendship was Ouspensky, who held that the artist must be a clairvoyant and make others who "are confined to the prison house of sight see what they do not see by themselves."[13] Matta was also fascinated with the idea of morphology, which he later explained as "following a form through a certain evolution. For instance from a seed to a tree, the form is constantly changing under certain pressures until it arrives at its final form and then disintegrates...this notion of morphology relates to how one's feelings were formed and transformed through life."[14]

There was a fundamental difference not only in their ways of seeing but in their ways of working. Matta, trained in architectural drawing, was conditioned to use his brush-drawn lines to establish perspectives. He was attempting to add a time dimension to his multidimensional space, and little diagrams on his letters to Gordon Onslow Ford testify to his preoccupation with the means of charting his unseen world. Concentric dotted circles represented space, destiny was shown by receding transparent squares within squares, time by a grid, and movement by a warped grid. He even urges Onslow Ford to "write, sending charts of what you are doing (painting)."[15] Not drawings, one notes, but *charts,* guides, that is, to navigation in space. "I was trying to get into a space where all the ordinates and coordinates are moving in themselves because the references, shall we say, to the wall of space are constantly changing. One can't reproduce any more what happens in a Euclidian cube."[16]

The sessions ceased. Peter Busa, although initially very responsive, decided that the gesture tended to become repetitive and mechanical. Kamrowski appears to have been affected by Matta's ideas about morphology, for his works of that period deal largely with changes and transformations of organic form in a fluid medium. Motherwell sums up: "I moved away from Surrealism almost as quickly as I had moved into it. It was one of the most illuminating experiences of my life."[17] Baziotes was probably closest to Matta's style in paintings of 1942 such as *The Butterflies of Leonardo*

da Vinci, especially in the contradictory aspects of the space and the complications of the brush drawings. His subsequent quiescent and translucent works are deeply personal, but the direction he had chosen was surely reinforced by the period of closeness to Matta. Although he is not mentioned as having been present at the studio sessions, Rothko was reportedly much affected by Matta's work at that time and told William Rubin that he wanted to capture an experience similar to Matta's in *Slow Swirl at the Edge of the Sea.*[18] This 1944 painting by Rothko has details in it that bear a marked similarity to Matta works of 1942–43, notably *The Bachelors Twenty Years After,* with its fluent brush-drawing, transparent structures and swirling circular lines.

Both in terms of the concept of morphology and the development of a painting style, it was without a doubt Arshile Gorky who was most profoundly affected by his exchanges with Matta, which continued over a longer stretch of time than those of the artists mentioned above. Matta speaks of him as one of the participants in the 1942–43 studio sessions, and we know from various accounts that they exchanged drawings and each worked in response to the other's work.[19] Meyer Schapiro, who knew both artists, emphasized that Matta helped Gorky to extricate himself from the heavy buildup of paint of his Picassoesque still lifes and the earlier versions of *Garden in Sochi* by literally showing him how to flow on thinned paint and to draw with his brush.[20] One has only to look at Gorky's canvases of 1942, such as the two versions of *The Pirate* or the last *Garden in Sochi,* to be aware of a newfound spontaneity and transparency that made the final flowering of his art possible.

If neither orthodox surrealism nor the metaphysical ideas of its younger adherents provided a program or a rationale for the New York artists as they groped for new means and images toward the mid-1940s, how were they to define themselves? "Unhinged," as Kamrowski described it, could they stand without a supporting structure? Existentialism would soon come to their rescue, but in the interim a suggestion came from another source. In Mexico Wolfgang Paalen wrote a "Farewell to Surrealism," which he published in the first number of a new periodical he had started in April 1942. Rejecting "sham mythologies, plastic analysis of subject matter (cubism) and interpretations of given things," Paalen asked, "What then could be the new themes of art? The new directions of physics as much as those of art led me to a potential concept of reality, opposed to any concept of deterministic finality. This concept, which I shall call *dynatic* (from the Greek word dynaton: the possible) or the Philosophy of the Possible, excludes any kind of mysticism and metaphysics, because it includes the equal necessity of art and science...The new theme will be a plastic cosmogony, which means no longer a symbolization or interpretation but, *through the specific means of art, a direct visualization of forces which move our body*

and mind"[21] (italics mine).

Paalen had moved in the mid-1930s from "abstraction creation" to surrealism, where he found "experience entirely lived, a heroic attempt at an integral synthesis which no longer admitted an arbitrary separation between plastic expression and poetry, between poetry and life."[22] He visited New York in 1939 en route to British Columbia and in 1940 had an exhibition at the Julien Levy Gallery of the *fumage* paintings of his surrealist years. Settling in Mexico at the outbreak of the war, he organized a large surrealist exhibition with Cesar Moro. Motherwell met him in Mexico in the summer of 1941 and subsequently translated some of his articles from French to English for *Dyn;* the final issue in 1944 included a lecture Motherwell had given at Mt. Holyoke. Reproduced in the second and third numbers of *Dyn* are paintings that can only be described as proto-abstract expressionist, works by Jean Caroux, Edward Renouf, John Dawson, by Paalen himself and by his wife, Alice Rahon. The last issue, no. 6, 1944, included works by Baziotes, Motherwell, Matta, Calder, and Onslow Ford and Jackson Pollock's *Moon Woman Cuts the Circle.* That the publication was intended largely for New York consumption is evident in the ads for the Gotham Book Mart, Partisan Review, and other New York cultural institutions. Pollock had *Dyn* among his books and there was a Pollock drawing of 1943 among Paalen's papers; a collection of Paalen's essays from *Dyn* was published by Wittenborn as *Form and Sense* in 1946, presumably on Motherwell's recommendation. He exhibited at Art of This Century in 1945 and at Nierendorf in 1946, and Francis Lee gave a party for him at his New York loft at which he met Baziotes and others of the New York artists.

For the announcement of his Nierendorf exhibition, Paalen wrote a plea for *"positive statements,"* which he explained as "organizations of colors and lines which are neither abstractions from nor distortions of given things, but a kind of cosmic integration in which our human consciousness finds its true place as the beam of balance." There are three particular concerns to which Paalen and his contributors give voice in *Dyn.* The first is a firm opposition to dialectical materialism; the second is both an anthropological and esthetic interest in the Indian art of the western hemisphere, and the third is the rapprochement of art and science, which most directly affected his own work. Paalen's library included a number of books on physics and he wrote an article on art and science for *Dyn* no. 3, while his own work changed drastically during 1941 from the phantasmagoric figures of his surrealist period to pulsating abstractions which dispersed interchanges of energy through color and line over the entire canvas surface.

Although Motherwell has said that Paalen had no influence on him, it seems likely that the works and ideas published in *Dyn* helped to establish the sense that the gestation of a new art was underway and that a westward transfer of artistic momentum was in process. Paalen's words, "a direct visualization of the forces that move our body and mind," seem already to describe the Pollock of the later 1940s. Further, his "philosophy of the possible" offered exactly the kind of open-ended theory of art that the younger New York artists were waiting for. And his own paintings were the first canvases to become truly fields across which marks of the brush simulating sheer energy were dispersed. Unfortunately a series of personal setbacks overtook Paalen; he lost the thread of his own artistic direction, and the memory of his small but potent contribution had faded even before his clouded suicide in 1959.

These three examples of encounters between artists who had been associated with Breton in the prewar Paris-based surrealist movement and the future abstract expressionists demonstrate three steps in a process of artistic change that was only a small part of a larger cultural transformation that was taking place. The hortatory words of Gordon Onslow Ford offered an invitation and a challenge and, in a sense, prepared a receptive ground. The intensity of Matta, experienced in personal encounters and particularly in demonstrations of actual studio practice, provided the opportunity to turn idea into form. The synthesizing intelligence of Paalen, transmitted via the authoritative medium of print, offered a way of capitalizing on potential rather than on existing modes.

Meyer Schapiro, who played a significant role in these events, observed years ago that it was not automatism that the Americans learned from the surrealist émigrés, but how to be heroic. All the details of specific encounters between artists and artworks are subsumed in the one overriding fact that what transpired was a form of empowerment that arose out of the group process as well as out of the momentous sense of both continuity and change that was embodied in this small circle of individuals. ∎

Notes

[1] *Museum of Modern Art Bulletin,* vol. 13, no. 4–5, September 1946, p. 25.

[2] Letters to Kurt Seligmann, August 10, 1940, and May 29, 1941. Seligmann Papers.

[3] Among those consulted were Robert Lebel, Susanna Hare Coggeshall and Onslow Ford himself. From a conversation with Peter Busa shortly before his death last fall, I think he attended the lectures also.

[4] These quotations are all from the handwritten preparatory notes for the lectures in Onslow Ford's papers.

[5] The Breton comment was mentioned by Gordon Onslow Ford in a conversation with the author, January 1984. The Tanguy letter was written to Kurt Seligmann in July 1941. Seligmann Papers.

[6] Letter to Gordon Onslow Ford, April 1942. Onslow Ford Papers.

[7] Wellfleet, Mass., May 25, 1942. Onslow Ford Papers. For elucidation of the meaning and origin of "pataphysics," see Roger Shattuck, "What is Pataphysics?" in *The Innocent Eye, On Modern Literature and the Arts* (New York: Farrar, Straus, Giroux, 1984), p. 105. He sums up this invention of Alfred Jarry's Père Ubu saying, "Pataphysics is an inner attitude, a discipline, a science and an art. It allows each person to live his life as an exception, proving no law but his own, remaining loyal to the precarious condition of his species,"

[8] Interview with Dennis Barrie, January 22, 1976. Archives of American Art.

[9] Interview with Dorothy Gees Seckler, May 9, 1965. Archives of American Art.

[10] Telephone conversation with the author, January 20, 1986.

[11] Conversation with the author, Fall 1985.

[12] Max Kozloff, "An Interview with Matta," *Artforum,* vol. 4, no. 1, September 1965, p. 23.

[13] *Tertium Organum* New York: Random House, 1982, p. 133.

[14] Kozloff, "Interview with Matta."

[15] Onslow Ford Papers

[16] Ibid.

[17] Telephone interview with the author, February 17, 1980.

[18] "Matta aux États-Unis; Une note personelle," in *Matta* (Paris: Centre Georges Pompidou, 1985), p. 24.

[19] For further discussion see Julien Levy, *Arshile Gorky* (New York: Abrams, 1966), p. 24.

[20] Conversation with the author, February 1980.

[21] Statement for catalog of his 1945 exhibition at Art of This Century, New York; repeats portions of earlier statements in *Dyn.*

[22] "Farewell au Surréalisme," *Dyn,* no. 1, April 1942.

Surrealist and Not Surrealist
In the Art of Jackson Pollock and
His Contemporaries

Philip Leider

In a late 1930s article entitled "Myth and History," Harold Rosenberg briefly compares Jean Cocteau with Thomas Mann:

> Respectable people reject Cocteau as an irresponsible impresario of cultural *trompe l'oeil,* and his art as a mixture of opium levitation and surrealist hoaxing. Yet in the same quarters a heavy solemnity greets Mann's...more careful blending of the same gases.[1]

The present interest of this remarkably wrong-headed comparison resides in its confirmation of the general antipathy to surrealism which seems to have been a fixture of American intellectual life during that period. This hostility appears to have been based at least in part upon the way in which surrealism treated certain ideas—the myth, the unconscious, the dream—that were then at the center of American intellectual life. The surrealist approach to these ideas was regarded as flawed by a characteristically European (if not specifically French) lack of seriousness, marred by too much levity, cleverness, wit, estheticism and affectation. Reviewing the poetry of Paul Eluard, for example, Louise Bogan is at pains to distinguish the "true journey" into the subconscious from the kinds of things surrealists do:

> The truth is, that in surrealism, the dream is treated in the most primitive way: it is recounted or imitated; Surrealist poets have gone into the subconscious as one would take a short trip into the country, and have brought back some objects of grisly or erotic-sadistic connotation, or a handful of unrelated images, in order to prove their journey. It has not occurred to them that the journey has been taken many times, that human imagination has, before this, hung a golden bough before the entrance to hell, and has described the profound changes the true journey brings about. It is a journey not to be undertaken lightly, or described without tension of any kind. And the *aller et retour,* if merely approximated, produces approximate expression: the sulphurous, the sadistic, the luxurious macabre, the Grand Guignol; or the childish, fatuous game.[2]

The reference to the "golden bough" reminds us that the route of the "true journey" for many Americans was considerably different from that of the surrealists. Its beginning was not in Baudelaire, Jarry, Lautreamont, Freud or even Frazer directly, but most frequently in T. S. Eliot's *The Waste Land,* or, more specifically, in the notes to that poem. It was from these that many Americans were directed to Frazer and to Jesse Weston's *From Ritual to Romance,* and from thence, usually in no systematic order, to Jung, Jane Harrison, Joseph Campbell and myriad other elaborators of the inner meaning of the Myth.[3] The revelation of this intellectual journey was the universality of the

Myth, and above all of the vegetation rites that linked and revealed the inner meaning of myths as diverse as the Persephone story to that of the search for the Holy Grail, and works of art as various as the tribal sculpture of Africa to the idols of biblical Sumeria. A new world of meaning opened up to American artists and intellectuals, one of fresh, new subject matter which was at the same time ancient and timeless, one whose most brilliant promise was embodied in a work almost as central to the times as *The Waste Land,* James Joyce's *Ulysses.* Molly Bloom's soliloquy is perhaps a more prominent feature of the intellectual landscape that produced the American art of the late 1930s and early 1940s than, say, Freud's *The Interpretation of Dreams* or the First Papers of Surrealism. It is also perhaps the supreme example of the *"aller et retour"* done well, the exact opposite of the "childish, fatuous game" Louise Bogan so detested. It is therefore doubly interesting that a critic who found "a flood of Dadaism" in *Ulysses* was the one who brought forth Eliot's sharp defense of Joyce's method:

> In using the myth, in manipulating a continuous parallel between contemporaneity and antiquity, Mr. Joyce is pursuing a method which others must pursue after him...It is simply a way of controlling, of ordering, of giving a shape and a significance to the immense panorama of futility and anarchy which is contemporary history....Psychology... ethnology, and the *Golden Bough* have concurred to make possible what was impossible even a few years ago. Instead of narrative method, we may now use the mythical method. It is, I seriously believe, a step toward making the modern world possible for art.[4]

The presiding influence of Molly Bloom provided not only the mythic dimension that links, say, Temple Drake to de Kooning's *Women,* but a general fascination with what Jung called "the archetypal foundations of feminine psychology" (evidenced perhaps most perfectly in the Museum of Modern Art's acquisition in 1938 of Picasso's *Girl Before a Mirror*). The phrase is from Jung's introduction to M. Esther Harding's *Woman's Mysteries,* subtitled "A Psychological Interpretation of the Feminine Principle as Portrayed in Myth, Story and Dreams,"[5] a book which must have fallen into Jackson Pollock's hands sometime between its publication in 1935 and 1939, when Pollock drew heavily upon it for a series of drawings of that year.[6] Its subject is the moon and its bond with women, and from it may have come some of the thoughts that led Pollock to such titles as *Moon Woman, Mad Moon Woman, Moon Woman Cuts the Circle,* etc. In addition, a number of the iconographical motifs visible in the 1939 series of drawings, many of which he discussed with his Jungian analyst, Dr. Joseph L. Henderson, are directly drawn from the illustrations in *Woman's Mysteries.*

Pollock's untitled drawing from 1939 (illus. 1) has across the top the repeated motif of a moon swastika of the sort reproduced by Harding (illus. 2 and 5). As interpreted by Harding, "these symbols represent the movement of the moon, both in its cyclic changes and also in its nightly journey over the heavens. They represent the journeyings of the moon goddess night by night and also through the twenty-eight days of her cycle." In the lower left of illustration 1 is a figure derived from one reproduced by Harding as one of the "Phases of the Moon," as depicted by a patient of the author (illus. 3). In the mid-lower left of illustration 4 Pollock has drawn on several of the moon stones and altars shown in *Woman's Mysteries* (illus. 5, especially her fig. 38, and illus. 6, especially her fig. 5). These stones are identified by Harding as among the "early representations of the moon diety," (illus. 6) and as symbols of the phases of the moon (illus. 5) and they are exploited repeatedly by Pollock in his drawings of this period, mostly (but not always) in the group of drawings analyzed by Dr. Henderson.[7]

It is unseemly to seek to reconstruct the personal, or even therapeutic, uses to which Pollock and/or his analyst might have put such drawings. Whatever the urgency with which such uses enhances them, they are more decently available to us on the extrapersonal level attesting to the ardency with which painting takes up the central intellectual adventure of the times, seeking to replace the "narrative method" by the "mythical method," by "manipulating a continuous parallel between contemporaneity and antiquity." Characterized by a sense of restless searching, as if they wished to appropriate for themselves some of the depictive authority of the ancient images they draw upon, they undertake to "dream the myth onward," in Jung's words, an ambition that would in the next year or two be articulated repeatedly in the writings and remarks of the abstract expressionists, Rothko and Gottlieb in particular.

Unlike the literary intelligentsia, however, Pollock was drawn to a contradictory current as well. Fascinated by a new, profound, image-filled subject matter on the one hand, he was equally committed on the other to the bias against ordinary depiction in the art of Kandinsky, Picasso and Miro. The attempt to reconcile these contrary desires (subject without depiction) comprises the history of American painting from 1940 to 1947, and not the attempt to reconcile surrealism with abstraction.

That surrealism, however, played a catalytic role in the resolution of this contradiction seems undeniable, but it is difficult to reconstruct the process. Arriving during the early years of the war less like bewildered emigres than like visiting royalty, the surrealists appear to have swept the New York art world off its feet. The year 1942 alone, for example, began with exhibitions of Dali and Miro at the Museum of Modern Art, followed by "Artists in Exile" at the Pierre Matisse Gallery in March, the first issue of *VVV*

in June, First Papers of Surrealism in October, and culminated with the opening of Art of This Century in the same month. The attitude of mistrust and hostility with which the Americans viewed surrealism in the 1930s began to change, if not for most of them to open acceptance, at least to a strategic accommodation. Pollock, for example, had declined an invitation to exhibit in "First Papers" on the ground that he was a "'loner' who did not like 'group activity'"[8] but showed earlier in the year in the McMillen Gallery's "American and French Painting," a show long on the School of Paris and short on the surrealists. By 1943, however, the quickest way to earn the attention of the art world was to be seen by it as a surrealist. "This jury," writes Pollock's biographer, B. H. Friedman, of the Art of This Century show that accepted Pollock's *Stenographic Figure* in that year, "was looking for 'Surrealism' and 'automatic writing.'..."[9]

Now, "automatic writing," even after a period of growing familiarity with surrealist theoretics, would have remained the most intractable aspect of surrealist methodology for the Americans. American artists in general were simply too uptight by nature to lose themselves in automatist trances, or to place much faith in the results of them even if they could. Nevertheless, at the heart of automatism there lay an extremely attractive proposition: it was that the artist was not responsible for the legibility of depictions. The artist could, perhaps even should, produce images he did not understand, perhaps not even *see*, without obligation to explain or account for them. The reason, of course, was the surrealist faith in the universal validity of subconscious forms, but regardless of the attitude of any given artist about the subconscious as a repository of meaningful forms—Pollock's was respectful, Gorky's contemptuous—the idea that the artist was not responsible for the immediate meaning of his work proved to be not only a liberating one, but one which would, in fact, make each member of the School of New York owe something of his future greatness to surrealism. Even the critic Clement Greenberg, who had consistently argued with more clarity than anyone else for how little surrealism really had to offer in overcoming the genuine difficulties of the times, had to acknowledge the value to artists of "the reliance upon the unconscious and the accidental" in serving "to lift inhibitions."[10] Thus an imagery came into being which was, in a sense, not depiction at all, and with it the Americans were able to reconcile their need to engage the "modernism" of the mythical method with their equally powerful need to investigate the nondepictive legacy bequeathed them by the artists they most admired. It was a transitional solution, of course, but it managed to stave off—and then some—the paralysis threatened by confronting too soon the exclusionary logic of abstract art.

Illus. 2. Moon swastika motifs from Esther Harding's *Woman's Mysteries*. Courtesy C. G. Jung Foundation, New York

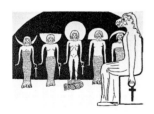

Ilus. 3. Depiction of figures representing phases of the moon. From Esther Harding's *Woman's Mysteries*. Courtesy C. G. Jung Foundation, New York

Illus. 1. Jackson Pollock.
Untitled, c. 1939–40. C.R. 525.
Pencil and red pencil on paper,
14 x 11 inches. Courtesy Nielsen
Gallery, Boston. Photo: Greg
Heins

Illus. 4. Jackson Pollock.
Untitled, c. 1939–40. C.R. 521?
Pencil on paper, 14 x 11 inches.
Promised gift to the Museum of
Art, Rhode Island School of
Design, in memory of Ida Malloy

Illus. 5. Symbols of the phases
of the moon. From Esther
Harding's *Woman's Mysteries.*
Courtesy C. G. Jung Foundation,
New York

Illus. 6. Early representations of
the moon deity. From Esther
Harding's *Woman's Mysteries.*
Courtesy C.G. Jung Foundation,
New York

Fig. 33 *Fig. 34* *Fig. 35*

Fig. 36 *Fig. 37*

Fig. 38 *Fig. 39*

Fig. 33. Coin of Mesopotamia entitled "Hecate Triformis." Fig. 34. Coin of Megara. Three crescents represent the three aspects of the moon. (Figs. 33 and 34 from *The Migration of Symbols,* Goblet d'Alviella, 1894. By permission of Constable & Co., London. Fig. 35. Phœnician Stela, the Moon Deity represented in triune form. (From *Themis,* Jane Harrison, 1912. By permission of The Cambridge University Press and The Macmillan Company.) Fig. 36. Phœnician Moon Emblem. (From *A New System or Analysis of Ancient Mythology,* Jacob Bryant, 1774.) Fig. 37. A symbol found on the walls of the catacombs, entitled "The Kingdom of Heaven." Fig. 38. The Moon Deity in triune form. Three little altars are shown side by side. On the first, a cross-marked stone crowned with a crescent represents the waxing moon; in the centre, a similar cross-marked stone is surmounted by horns to represent the full moon; on the third, the dark or waning moon is represented by one of the "Hounds of Hecate." (From *Sur le Culte de Mithra,* Felix Lajard, 1847.) Fig. 39. "Hecate Triformis." (From *Religions de l'antiquité,* Georg Frederic Creuzer, 1825.)

217

EARLY REPRESENTATIONS OF THE MOON DEITY

Fig. 5. Deus Lunus. (From *A New System or Analysis of Ancient Mythology,* Jacob Bryant, 1774.)

Fig. 6. The Sacred Moon Tree of Babylon. The lower branches bear torches, symbolizing the light of the moon.

Fig. 7. The Sacred Moon Tree of Chaldea with fruits.

Fig. 8. The Sacred Moon Tree with trellis and torches.

Fig. 9. Three forms of the Sacred Moon Tree of Assyria, showing the gradual conventionalization till it is a mere stump or pillar. (All from *Sur le Culte de Mithra,* Felix Lajard, 1847.)

Fig. 5

Fig. 6 *Fig. 7*

Fig. 8 *Fig. 9*

While this "nondepictive imagery" did not make surrealists of the abstract expressionists, it brought their work close enough to it that a jury looking for "surrealism" and "automatic writing" could find both in *Stenographic Figure*. Under similar vaguely surrealist auspices, first one-man shows at Art of This Century were given to Pollock in 1943, Baziotes and Motherwell in 1944, Rothko in 1945 and Still in 1946. Gorky was more expressly welcomed into the surrealist movement with an exhibition at the Julien Levy Gallery in 1945 along with a catalog introduction by Breton himself.

The strategic accommodation by way of which the Americans secured their recognition by the art world in return for muting their instinctive misgivings about surrealism began to come apart during the second half of the 1940s. "...In New York it is now admitted that Surrealism is dead," wrote Barnett Newman around 1945. But the brief legitimization which surrealism enjoyed during 1940–1945 spawned considerable critical mischief, some of which dogs our understanding of the period to this day: it formulated, incorrectly, the major issues of the times in terms of a supposed search for a reconciliation (or a "wedding") of surrealism and abstraction; it confused the Americans' involvement with Eliot, Joyce, Frazer and Jung with surrealism's involvement with Lautréamont, Jarry, Freud and "the future resolution of the states of dream and reality...."; it placed Rothko, Still, Gottlieb and Pollock in a supposed "middle ground" between surrealism and abstraction, and took at face value surrealism's claim to Gorky as one of its own. Gorky did pick the brains of surrealism during the 1940s, but little in his work needs to be accounted for in a surrealist context, and doing so is invariably both misleading and diminishing of his accomplishment. Especially damaging is to project onto Gorky a surrealist *attitude,* as the surrealist dealer Julien Levy does in explaining that what Gorky "had thought had been his work had been just practice, and what had been his play was closer to his art."[11] Such is precisely what Gorky found most offensive in surrealism. In expressing his reaction against it in 1947 as an Armenian to Armenians, Gorky may have had the last word in explaining the alienation of the Americans as well:

...Surrealism is academic art under disguise and anti-esthetic and suspicious of excellence and largely in opposition to modern art. Its claim of liberation is really restrictive because of its narrow rigidity. To its adherents the tradition of art and its quality mean little. They are drunk with psychiatric spontaneity and inexplicable dreams. These Surrealists. These people are haltingly entertaining. We do not think alike since their views on life differ so vastly from mine and we are naturally of opposite backgrounds. Their ideas are quite strange and somewhat flippant, almost playful. Really they are not as earnest about painting as I should like artists to be. Art must always remain earnest. Perhaps it is because I am an Armenian and they are not. Art must be serious, no sarcasm, comedy. One does not laugh at a loved one.

Beloveds, art is never play. They feel it is play and they are players, not artists, as I view art. Nonsense.[12] ∎

Notes

[1]Harold Rosenberg, "Myth and History," *Partisan Review,* vol. VI, no. 2, Winter 1939, p. 27.

[2]Louise Bogan, "The Poetry of Paul Eluard," *Partisan Review,* vol. VI, no. 5, Fall 1939, p. 80. Coincidentally, this issue of *Partisan Review* is listed as having been in the Pollocks' library, in Francis V. O'Connor and Eugene V. Thaw, *Jackson Pollock: A Catalogue Raisonné of Paintings, Drawings and Other Works Vol. IV* (New Haven and London: Yale University Press, 1978), p. 198.

[3]A typical list of such books appears in the Pollocks' library, cited above.

[4]T. S. Eliot, "Ulysses, Order and Myth," 1923. Reprinted in *Selected Prose of T. S. Eliot,* New York: Harcourt, Brace & Jovanovich, New York, 1975, p. 178–9.

[5]New York: Harper Colophon Books, Harper & Row, 1976.

[6]Most, but not all, of these drawings were published in C. L. Wysuph, *Jackson Pollock: Psychoanalytic Drawings* (New York: Horizon Press, 1970). The numbered references here, however, are to the reproductions in O'Connor and Thaw, op. cit., vol. 3.

[7]For moon stones and/or moon trees, see ibid., nos. 518v, 521v, 533v, 571, 581v, 585r, 722. For moon swastikas see nos. 519r, 583v, 588. Nos. 516r/v, 519v, 534v, 615 and 616 also make more or less explicit use of various illustrations in *Woman's Mysteries.* Interested readers will doubtless find others which are less plainly dependent.

[8]B. H. Friedman, *Jackson Pollock* (New York: McGraw-Hill, 1972), p. 55.

[9]Ibid., p. 58.

[10]Clement Greenberg, "Surrealist Painting," *The Nation,* August 12, 1944; quoted in Irving Sandler, *The Triumph of American Painting* (New York: Praeger, 1970), p. 85.

[11]Julien Levy, Foreword to William C. Seitz, *Arshile Gorky: Paintings, Drawings, Studies* (New York: Museum of Modern Art, distributed by Doubleday, 1962), p. 8.

[12]Karlen Mooradian, "The Armenian Correspondence of Arshile Gorky: 1937–1948," in *Arshile Gorky Adoian* (Chicago: Gilgamesh Press, 1978), p. 303.

The Victorian Unconscious: Tonalist Sources for Abstract Expressionism

Robert Hobbs

Isabella Stuart Gardner's home in Boston, Fenway Court, contains a room which sums up the American tonalist painting tradition. Decorated in silvers and golds to harmonize with late afternoon light, it is filled with paintings by James Abbott McNeill Whistler. The gently reflective light of the room reinforces the overall tonal quality of Whistler's paintings. The room was mainly used by Mrs. Gardner in the afternoons while she waited for her daily carriage ride. Its purpose as a late afternoon habitation and its collection of predominantly twilight paintings intended for sensitive appreciation of subtle nuances calls to mind conservative, gently nostalgic reveries central to tonalism.

American tonalism, which is sometimes known as American decorative impressionism or American Barbizon painting and was practiced by such artists as Thomas Dewing, George Inness, John Twachtman, Dwight Tryon and Whistler, received its first clear definition in 1972 when art historian Wanda M. Corn organized *The Color Mood: American Tonalism 1880–1910* at the M. H. de Young Memorial Museum and the California Palace of the Legion of Honor, San Francisco. Tonalism, as Ms. Corn clearly shows, is an art of reverie and sentiment. Conceived in sub-dued colors, the paintings are summas of subtle gradation. The artists, differing from the earlier generations of American painters, particularly the Hudson River landscapists and luminists, emphasize atmosphere over sharp value contrasts. Frequently, in the same work they will employ hues of roughly the same value. Tonalist art, which is late Victorian painting and a special brand of American impressionism, embodies sweeping, embracing environments: atmospheres conceived as ambient fluids. Everything in this art appears in gentle flux. As in Mrs. Gardner's sitting room, the atmosphere recalls the veiled, overcast environment people once savored as they sat in gazebos listening to crickets and fantasized about Oriental pavilions and Japanese gardens. Charles Laing Freer, who avidly collected Whistler's work, encouraged his guests to study tonalist art quietly and patiently. He would bring out only one object at a time for his guests to contemplate; sometimes he would keep an object on view for as long as half an hour so that its inherent qualities could be properly understood.

Tonalist art, then, favors the esthete over the naturalist. As an extremely delicate, late-nineteenth-century hothouse hybrid, it would appear to have nothing in common with the abstract expressionist painting of the 1940s and 1950s made by action painters called existential irascibles. These artists protested the Metropolitan Museum of Art policies in spring 1950 and posed for a group portrait in which they looked like no-nonsense characters from a Dashiell Hammett story. Going against all standard interpretations of abstract expressionism, I wish to suggest that American art of the 1940s and 1950s does not entirely break with its Victorian past but has certain continuities with tonalist tradition which Whistler, among others, epitomized.

I do not mean to imply that these later artists were consciously aware of tonalism. Rather, I suggest that tonalism in the 1940s formed part of a broad, conservative, and largely unacknowledged approach toward art in the United States. Although tonalist qualities were consciously eschewed by Ash Can painters who rebelled against a refined art in favor of prosaic subjects and energetic brushwork and was avoided by Midwestern regionalists and magic realists of the 1930s, it was perpetuated in the work of such painters as Milton Avery, Edwin Dickinson, and Arthur Dove. Avery, it is worth noting, joined the flat fauvist shapes and sturated hues of Henri Matisse's art with the low value contrasts and softly defined edges of tonalism. His art was important for William Baziotes, Adolph Gottlieb, Mark Rothko, and Theodoros Stamos, and his grounding in tonalism is crucial to a proper understanding of the brand of abstract expressionism which they fostered.

What has been emphasized in the literature has been the influx of European ideas, the coming to the United States of the surrealists, and the exhibitions at the Museum of Modern Art in the 1930s and 1940s. Tonalism, however, served as a reservoir for the abstract expressionists; the tradition existed as a set of unquestioned assumptions about the nature of art and metaphorically it functioned as an analog for the unconscious, a means of signifying in formal terms the abstract expressionists' interest in creating —to use the words of Robert Motherwell—a truer surrealism based on the plastic means of psychic automatism.[1] Just as these artists used improvisation as a method for courting the subconscious mind, so they used a tonalist style as a way to suggest this dimly understood locale which seemed to avoid the clear light of conscious reason.[2] Although Hans Hofmann, Motherwell and, to some extent, de Kooning and Gorky opted for brightly lit canvases, most of the other abstract expressionists consistently used a dimmer light. Artists such as Baziotes, Rothko, Stamos, and Gottlieb rejected brilliant lighting both in their work and in their installations, finding a penumbral light closer to their understanding of the real source of art: the unconscious, subconscious, or preconscious mind.

I suggest that tonalist landscapes were the artistic equivalent of the inscapes that the abstract expressionists were intent on creating. These inscapes represented a new, abstract surrealism based on the principles of free association, improvisation, and nonobjective art. And these inscapes served as testaments to the fact that truth could only be personally intuited. It is, then, possible to indicate six commonalities between tonalism and abstract expressionism.

1) The abstract expressionists, despite their posturing, share with the tonalists a commitment to "estheticizing" Fine Art. The abstract expressionists are romantics who believe truth to be personal, intuitive, and spontaneously conceived. In spite of the fact that many of them worked on

the Federal Arts Project and enjoyed a working-class camaraderie, they were reacting against their immediate artistic forebears, the social realists, who believed art should be made available to the masses. The abstract expressionists, except for Robert Motherwell, who created the *Spanish Elegies,* aimed to keep their art separate from politics. In their letter of 1943 to the *New York Times,* Gottlieb, Rothko, and Barnett Newman agreed that the purpose of their art was the "poetic expression of myth." What is indeed this "poetic expression" if not an art of refinement and distillation, freed from the vulgarity of proletarian realism?

2) Both groups are convinced that true meaning is attainable only through indirection. Mists, fogs, and twilight engulf tonalist work, and the classical past is savored. The classical past is also invoked by such artists as Gottlieb, Rothko, and Newman. Hands and faces in early Gottlieb pictographs, whose titles refer to Greek myths, point to possible meanings without specifying them.

Both Gottlieb's and Rothko's art has distinct affinities with tonalism. In the early 1940s these artists root their art in the subject matter of the tribal unconscious. Gottlieb may use grids in his pictographs but he refuses to settle for static frames. The grids, reflective of rationality, frequently are overlain on an ambient background and participate in a staccato rhythm which differs markedly from the machine-like dash and uncompromising clarity of Piet Mondrian.

The art of both tonalism and abstract expressionism requires ambiguity in order to function, because ambiguity is rooted in sentiment and evocation. Not concerned with political activism, this art offers viewers scenes of reverie and contemplation. In the mid-twentieth century, psychology replaced sentiment. Instead of using nature as an external mirror of internal yearning, abstract expressionists invoked the unconscious as it is presented in Freud's and Jung's writings. But more real, and certainly more vital than the yearning of these paintings—and here it is yearning for the ineffable, yearning for becoming one with nature, whether nature be a garden or the unconscious within—is the insistent physicality of the paintings themselves. The culture's materialistic bias is clearly evident in these artists' reliance on painterly values, on paint itself, and more importantly on the belief in paint as a medium capable of expressing such feelings as yearning. Paint as a material object of great value is central to the spontaneously conceived work of both George Inness and Jackson Pollock. The spiritual goals of Reflection and self-knowledge are manifested through distinct material means. The abstract expressionists constantly affirm the importance of their medium as they research its inherent properties: Gottlieb creates nuanced, spontaneous strokes; Rothko, shimmering pools; Pollock, dense coruscations; and Motherwell, eloquent fumblings. In contrast to the formal qualities of these works, the spiritual is not so much manifested as suggested:

Gottlieb's *Eyes of Oedipus* provides clues to spiritual/ psychological blindness; Rothko's works veil; Pollock's overlapping, energized skeins of color overwhelm; and Motherwell's *Elegies* nostalgically reflect.

3) Both tonalists and abstract expressionists refuse to create narrative works of art, even though they use stories as enticement or clues to feeling. The avoidance of narration is allied to their interest in indirection and suggestion. Probably a common source for this art of indirection is symbolist poetry and the writings of Edgar Allen Poe. Symbolism, predominantly a late-nineteenth-century French movement exemplified by the writings of Stephane Mallarmé, is a marvel of indirection. The symbolists' use of language frequently was esoteric and refined, removed from current usage so as to be pure and unfamiliar. Artists following the symbolists or related to them, latched onto the idea of indirection. They created an art of suggestiveness that relied on formal qualities of paint and canvas or watercolor and paper in order to communicate ideas. And subject matter, no longer a primary means of communication, became auxiliary: it provided clues to perceptual esthetic experiences.

Symbolist ideas, which permeate American tonalism, were also examined by abstract expressionists Motherwell, Baziotes, de Kooning, and Lee Krasner. *Possibilities 1,* largely an abstract expressionist periodical of 1947–48, reprinted a significant selection of Edgar Allen Poe's *Marginalia* that contains, in embryo, many symbolist ideas that came to be important to the tonalists and abstract expressionists, particularly the emphasis on manifesting ideas in a distinct medium, the interest in indirection, and the curiosity about barely perceived intuitions which might become an interesting subject for art.[3] Thus, in Gottlieb's, Pollock's, and Rothko's art in particular, the subject exists as a possibility; it is descriptive but not narrative, presented but not assigned. The work of art exists as a possibility of being, a metaphor of Freud's magic writing tablet or of Jung's archetypes—those potentialities that humankind supposedly has for genetically encoding certain meaningful forms which occur in myths, rituals, and dreams.

The crux of the argument about the nature of art, for both the tonalists and the abstract expressionists, is that art must have a subject but that the subject must be evocative and ambiguous. The prevalency of this attitude in the 1940s is grounded in well-known surrealist doctrine but it also stems from tonalism, the symbolists, and Poe. Both the interest in ambiguity and the distrust of the rational mind were important for abstract expressionists who reveled in intuition, who used imposing subjects to direct viewers to the significance of their art, and who opted for enigmatic suggestive forms.

4) In formal terms, tonalists and abstract expressionists emphasize in their art dominant tones. Value contrasts are

minimized and an overall greyness prevails in works that depend on subtle gradation of hue. In both types of art, painters emphasize a prevailing atmosphere as a primary form-bearer of their ideas. Through literal use of dimmed lighting and holistic modulated fields which envelop viewers but provide them little to focus on, Rothko encourages peripheral vision. Similarly, Pollock overloads viewers with a plethora of detail, causing them to scan, not focus, and consequently to feel that they are surrounded by the work of art.

In both tonalism and abstract expressionism, the works themselves are resolutely physical; it is the act of peripheral seeing that makes them immaterial and spiritual. Frequently in the criticism of both tonalism and abstract expressionism, the act of the artist is extolled and the role of the viewer minimized. In this art the viewer's participation is of paramount importance because it makes the subject manifest. The yearning often indicated by the subject becomes, in the act of seeing, the viewer's struggle to make sense of a desire for evocative forms.

5) Both tonalists and abstract expressionists assume that artists are more than form givers: they are form distillers who categorize and refine initial impressions, being careful to pare away unessentials so that only feeling/sentiment is manifested and exposed in the work of art. This aristocratic approach to the world through abstraction and refinement, so important to the tonalists and the expressionists who find art a means of research and also a refuge, is frequently indicative of a larger cultural schism between individuals and society. Certainly at the turn of this century, artists clung to little-understood spiritual values in the face of overwhelming commercialism and industrialism. And in the 1940s and 1950s, faced with the onslaught of World War II and the alienating Cold War, abstract expressionists turned inward and often opted for a gently reflective art.

6) Finally, both groups believe art's primary intent is to deal with feeling—nineteenth-century sentiments enveloped in grey atmosphere become in the twentieth century a form of abstraction which testifies to the artists' inward journeys to unconscious realms. In both, the art represents painters' retrieval of their own feelings; and in both, viewers are enticed into a relationship with an artist through the work of art. The art, a surrogate for the artist's feelings, is definitely romantic because one communes with the artist's own perception of reality and not, as in classical art, with a group or class attitude.

While tonalism is only one current among several of importance to abstract expressionism, it is certainly an important indigenous one. Because it was not discerned by the abstract expressionists as an influence, its impact was more pervasive; it had more to do with underlying assumptions about what constitutes art and what determines the artist's rightful privileged status than it did with specific motifs. As artificial and precious as tonalism was, it was important because it underscored art's precarious position in the United States, a position in which art is upheld as an arena of significance and the work of art as a physical object of value. The yearning for the ineffable, contrasting with the physicality of substances manifesting it, was again undertaken as a theme and an inherent contradiction in the 1940s and 1950s when artists, faced with the horrible facts of World War II and mass genocide, attempted to invoke individually intuited spiritual values in paint. Victorian tonalism, an unacknowledged American art form in the 1940s, served as the stylistic unconscious for the abstract expressionists who used it to reinvigorate French surrealism and transform it into a distinctly American expression. ∎

Notes

[1] In the winter of 1942 Motherwell entered into a plot with Matta whereby they and Baziotes would form a group based on the methods of psychic automatism, which worked outside the official surrealist movement. They intended to make a manifesto which would "...show the Surrealists up, so to speak, as middle-aged grey-haired men who weren't zeroed in to contemporary reality." And yet they attempted to go back to an original tenet of surrealism, psychic automatism, and to use it as a creative principle for a newer style. In other words, they wanted to return to a truer version of surrealism. In an effort to form a new group, Motherwell and Baziotes visited Jackson Pollock, Peter Busa, Gerome Kamrowski, and Willem de Kooning and explained to them the theory of automatism, while Matta converted Arshile Gorky. Only de Kooning was uninterested in this theory at the time. In addition, Motherwell, at Lee Krasner's request, went with Pollock to talk with Hans Hoffman but realized the absurdity of a twenty-six-year-old man's explaining painting to someone like Hofmann, then in his sixties, and talked in a roundabout manner. Even though the Pollocks, Bazioteses, and Motherwells met informally several times and wrote automatist poems, the group never became a tight circle like the French surrealists. The American were too much loners for such a group to ever become a reality. Motherwell believes that the beginnings of abstract expressionism can be traced to the principle of psychic automatism and to the proselytizing of Baziotes, Matta, and himself:

Nevertheless, my conviction is that, more than any other single thing, the introduction and acceptance of the theory of automatism brought about a different look into our painting. We worked more directly and violently, and ultimately on a much larger scale physically than the Surrealists ever had. It was the germ, historically, of what later came to be called abstract expressionism.

(Quotations from Sidney Simon, "Concerning the Beginnings of the New York School: 1939–1943: An Interview with Robert Motherwell by Sidney Simon in New York in January 1967." *Art International,* vol. 11, no. 6, Summer 1967, pp. 20–23.)

[2] See my essay "Early Abstract Expressionism: A Concern with the Unknown Within" in *Abstract Expressionism: The Formative Years* (New York: Whitney Museum of American Art, 1978; later republished by Cornell University Press) for a discussion of the interconnections between abstract expressionism, surrealism, the unconscious, peripheral vision, and twilight.

[3] The following excerpt from Poe's *Marginalia* (L x 1, Expression) appeared in *Possibilities 1,* Winter 1947/48, p. 40:

How very commonly we hear it remarked that such and such thoughts are beyond the compass of words! I do not believe that any thought, properly so called, is out of the reach of language.... There is, however, a class of fancies, of exquisite delicacy, which are *not* thoughts, and to which, *as yet,* I have found it absolutely impossible to adapt language. I use the word *fancies* at random, and merely because I must use *some* word; but the idea commonly attached to the term is not even remotely applicable to the shadows of shadows in question. They seem to me rather *psychical* than intellectual. They arise in the soul (alas, how rarely!) only at its epoch of most intense tranquillity—when the bodily and mental health are in perfection—and at those mere points of time where the confines of the waking world blend with those of the world of dreams. I am aware of these "fancies" only when I am upon the very brink of sleep, with the consciousnesses that I am so.... It is as if the five senses were supplanted by five myriad others alien to mortality.... Now, so entire is my faith in the power of *words,* that at times I have believed it impossible to embody even the evanescence of fancies such as I have attempted to describe.

The American Response to Surrealism:
Barnett Newman

Mollie McNickle

Of all the abstract expressionists, the relationship of Barnett Newman to surrealism is the most problematic. The visual evidence is decidedly meager: only works of 1944 onward survive to illuminate Newman's formal explorations of surrealism, since he destroyed whatever he produced prior to that date. But for his own writings, the documentary traces of a connection would also be slight. Newman was not affiliated with the groups and gatherings of artists which were preoccupied with trying out the themes and techniques of surrealism. He did not participate in the joint activities that have been so profitably recalled for the histories of his friends and colleagues. Newman certainly did not ignore surrealism, nor was he secretive about his solitary thoughts on the subject. His essays and catalog forewords of the 1940s, along with his unpublished statements and manifestoes, reveal a studious consideration of both the potential benefits and shortcomings of the European movement. Those writings make it possible to piece together the fragmentary testimony of Newman's friendships, sympathies, and interests during the crucial decade from 1938 to 1948 into a reasonable account of his interaction with surrealism, one that is confirmed by the ultimate fate of surrealist-derived elements in his painting.

Any discussion of Barnett Newman and surrealism immediately encounters a number of fundamental problems and objections. Although the abstract expressionists generally disliked the surrealists' embrace of the Freudian creed, Newman was probably less enchanted than any of his confreres by the psychoanalytic probings of Freud or of Jung. Newman was constitutionally ill-disposed toward their line of inquiry. A stable, untroubled childhood and adolescence resulted in an individual secure in himself, not particularly attracted to therapeutic means of resolving deep internal conflicts. Advanced education in philosophy at City College of New York convinced him of man's inherent capacity to reason, despite the grim lessons of modern history. Newman's academic training encouraged his own predilection for rational habits of thinking and instilled in him a lifelong commitment to an art of intellectual content. The legacy of his college years made Newman intolerant of surrealism's willful irrationality, disorder, and negativism. Even his political philosophy intervened in his review of surrealism. As an anarchist, he was repelled both by the collective organization of the surrealists under André Breton and by their Marxist leanings. Finally, Newman shared the distaste felt by many of his generation for much surrealist work. He scorned their dogmatism, their erotic, sometimes perversely private and anecdotal subject matter, the "deception" of their "realistic fantasy," and their obsession with technique.[1]

One difficulty Newman did not have with surrealism was in gaining exposure to it. A dedicated gallery-goer like Newman could form a fair estimate of surrealist painting and sculpture based upon the exhibitions mounted in New York in the 1930s, which culminated in the Museum of Modern Art's Fantastic Art, Dada, and Surrealism held in 1936.[2] But the chief conduit of surrealist ideas at that time for Newman, as for Mark Rothko, Adolph Gottlieb, Jackson Pollock, David Smith, and Arshile Gorky, was the Russian émigré, John Graham.[3] To the young Americans who frequented his apartment, Graham transmitted firsthand knowledge of surrealist art, artists, and writers, which he had gained while living in Paris and on numerous return trips as a dealer in tribal arts. To his New York friends he also displayed his copies of the profusely illustrated publication of the avant-garde, Cahiers d'Art, as well as his collection of African sculpture.[4] Graham even assisted Newman's friend Gottlieb in building his own collection of primitive art, beginning in 1935.[5] Through Graham personally, and through his writings such as System and Dialectics of Art (1937), Newman and his contemporaries absorbed an eccentric but predigested version of critical surrealist theories regarding primitive art, the unconscious, and their promise for modern man.[6]

Newman's disdain for aspects of surrealism did not preclude his appreciating some of its accomplishments and concurring with some of its enthusiasms. Newman gratefully acknowledged that the surrealists had revolutionized art by replacing the conventional genres with a new category of subject. For the clearly organized, predictable figure, landscape, and still life compositions of the Western tradition, the surrealists substituted challenging psychological conundrums evocative of an unfathomable past and an unseen present. In so doing they proved, in Newman's words, "that it was possible to paint a subjective thought, a feeling, a subjective idea."[7] Their achievements made it easier for an unfledged American painter to dismiss harshly and finally the superficial sentimentality of regionalism and its detested pictures of the "old oaken bucket."[8]

Of surrealism's enthusiasms, Newman was especially impressed by its informed regard for primitive art. Availing themselves of recent scholarship in anthropology and psychology, the surrealists enriched the modern artist's mental stock of primitive art in scope and depth. They extended their attention to the previously neglected cultures of Oceania and America, where they found imageries of enormous variety and affective power. They recognized that power as emanating from a world in which the Western schism of man from nature, spirit from matter, did not exist—a state of pervasive harmony they devoutly wished to recreate in the twentieth century.[9]

In his essays of the 1940s, particularly "The Plasmic Image" (c. 1943–45), "The New Sense of Fate" (1945), and "Art of the South Seas" (1946), Newman attempted to spell out what he judged to be the flaws in the surrealists' attitude toward primitive art and to define his own position

by contrast.[10] He understood that the primitivizing of the surrealists was anticlassical yet nostalgic. "Primitive peoples, whether pre-classical or non-classical, have what our ancestors refined away, but if we use their forms, we may recover in and through our art the qualities for which we long;" so might the thinking of the surrealists be paraphrased. Newman perceived, however, that the surrealists hoped in vain to transcend their cultural inheritance and circumstances by inserting exotic primitive motifs into an art founded on European esthetics, even in protest. Only an artist who was free to "start from scratch, as if painting never existed before," could view the primitive esthetic as an alternative to Western traditions of realism or abstraction.[11]

For Newman, the power of primitive art to rejuvenate the modern stemmed not from its divers and magical forms but from its metaphysical nature. Dreams and design mattered not at all to him; Newman the artist wanted to face the world as the primitive did, without mediation, and to register that experience in his painting. His model was the primitive artist to whom "shape was a living thing, a vehicle for an abstract thought-complex, a carrier of the awesome feelings he felt before the terror of the unknowable."[12] Newman aspired to the primitive state where art was an expression of being rather than belief.[13]

Newman's study of primitive art yielded a concrete, practical reward. It offered him a way out of the stranglehold that formalism had on abstract art. According to Newman,

> The whole attitude of abstract painting...has been such that it has reduced painting to an ornamental art whereby the picture surface is broken up in geometrical fashion into a new kind of design-image. It is a decorative art built on a slogan of purism where the attempt is made for an unworldly statement....[14]

For an artist who sensed that only some form of abstraction would permit him the subjective content that he craved, the seemingly pandemic plight of abstract art in the 1930s and early 1940s was crippling. Newman was understandably quick to note that primitive cultures strictly separated the geometric abstraction of the decorative arts from the symbolic distortions of ritualistic art. The example of primitive art reassured him that abstraction was not monolithic, that it was intrinsically neither empty nor objective.[15]

While Newman's familiarity with primitive art may have dated as far back as the late 1920s,[16] the strong primitive theme in his writings of the 1940s probably partook of a widespread reassessment of the surrealist program in reaction to the Europeans' temporary residence in America during World War II. The surrealists began to arrive on the New York scene in the fall of 1939. By March 1942 the dealer Pierre Matisse was able to muster an exhibition of Artists in Exile that included Breton, Ernst, Masson, Matta, Seligmann, Tanguy, and Tchelitchew. Although the Europeans remained largely aloof from the Americans, their presence in New York quickened the tempo of exhibitions, publications, and discussions of surrealism there.[17] Differences in language, age, and class did not diminish the impact of regular showings in the city's commercial galleries or of extravaganzas like Dali's installations at the World's Fair in 1939 or the massive group exhibition called The First Papers of Surrealism in 1942.

If surrealism did not precisely sweep New York, it became an issue impossible for an artist there to overlook. In the spring of 1941, Surrealism invaded the New York institution where Thomas Hart Benton and Jose Clemente Orozco had painted murals exactly ten years earlier, the New School for Social Research. Four successive exhibitions of surrealism accompanied a series of lectures given by the Englishman Gordon Onslow Ford. Hailed in Art News as "the most important [event] New York has seen since the Modern Museum's 1936 effort,"[18] the combined presentation drew William Baziotes, Tony Smith, David Hare, Arshile Gorky, Jimmy Ernst, and possibly Jackson Pollock to the lectures,[19] and Barnett Newman to at least one of the exhibitions.[20] With the publication of several little magazines, surrealist ideas expressed in English also started to appear in print and in accessible quantities, a surprisingly rare occurrence in America.[21] Most valued by Newman was Dyn, in which primitive art repeatedly received a most intelligent treatment from the editor, Wolfgang Paalen.[22] But undoubtedly the most influential forum for surrealist interests in the years 1942 to 1947 was Peggy Guggenheim's museum-gallery, Art of This Century. Besides housing an exceptional collection of recent art, Art of This Century served as one of the few crossroads for the European emigrés and sympathetic American artists. At Peggy Guggenheim's one could see the latest surrealist work; one could also witness the advent of the new American art, in the one-man shows given Pollock, Hans Hofmann, Baziotes, Robert Motherwell, Hare, Rothko, Clyfford Still, and Richard Pousette-Dart.[23]

Like John Graham in the 1930s, however, one individual supplied American artists with the most direct information about surrealism in the 1940s, as well as the impetus to examine its premises and practices. The young Chilean painter Roberto Matta Echaurren urged his American contemporaries to collaborate with him to revitalize surrealism by restoring the tactic of psychic automatism. Breton himself had originally promoted automatism, or the use of free association as a means of tapping the treasure trove of the unconscious, in his First Manifesto in 1924, but it was virtually abandoned in a matter of years. The surrealist novice Matta enlisted Baziotes and Motherwell, who in turn called upon Gerome Kamrowski, Peter Busa, and Pollock to join in the campaign to decalcify both surrealism and the genera-

tive process on which it was founded. The six artists met sporadically in Matta's studio during the winter of 1942–43, but the group effort fizzled as the Americans characteristically pursued their own paths.[24] Though his assault on surrealism collapsed, Matta succeeded in marshalling the movement and its investigation of psychic automatism into the forefront of American ideas of art-making.

Although most of the Americans who pondered the possibilities of surrealism in the early 1940s concentrated on the boons that its automatic techniques conferred, some artists were more concerned with the implications of surrealist content. Beyond casual contacts at Art of This Century, Newman had no connection with the circle around Matta, but he was involved behind the scenes in the surrealist-related project of his good friends Gottlieb and Rothko.[25] While they hardly eschewed automatism, Gottlieb and Rothko were convinced, as was Newman, that subject matter should be the focus of their strivings to create a new art. As Gottlieb explained in retrospect, "the hope was that given a subject matter that was different, perhaps some new approach to painting…might also develop."[26] After endless discussions devoted to determining what to paint, to which Newman contributed regularly, Gottlieb and Rothko settled on mythological themes.[27] Mythology had assumed a more prominent role in surrealist art in the 1930s[28] and hence in the work the Americans were seeing in New York. Whatever the influence of surrealist painting on Gottlieb and Rothko might have been, readings in some of the surrealists' own sources, especially Nietzsche and Jung, and probably conversations with Graham, were immediately responsible for their interest in myth.[29] Thus around 1941, bolstered by their faith in the universality of the collective unconscious and the timelessness of myth, both artists turned from the urban expressionist canvases of their early careers to semiautomatic paintings such as Gottlieb's *Eyes of Oedipus* and Rothko's *Antigone.*[30] Their intentions in appropriating ancient myths emerge clearly from a joint statement of 1943:

> If our titles recall the known myths of antiquity, we have used them again because they are the eternal symbols upon which we must fall back to express basic psychological ideas. They are the symbols of man's primitive fears and motivations, no matter in which land or what time, changing only in detail but never in substance, be they Greek, Aztec, Icelandic, or Egyptian. And modern psychology finds them persisting still in our dreams, our vernacular, and our art, for all the changes in the outward conditions of life.
>
> Our presentation of these myths, however, must be in our own terms, which are at once more primitive and more modern than the myths themselves—more primitive because we seek the

primeval and atavistic roots of the idea rather than their graceful classical version; more modern than the myths themselves because we must redescribe their implications through our own experience. Those who think that the world of today is more gentle and graceful than the primeval and predatory passions from which these myths spring, are either not aware of reality or do not wish to see it in art. The myth holds us, therefore, not thru its romantic flavor, not thru the remembrance of the beauty of some bygone age, not thru the possibilities of fantasy, but because it expresses to us something real and existing in ourselves, as it was to those who first stumbled upon the symbols to give them life.[31]

Newman helped Gottlieb and Rothko to prepare for the radio broadcast in which they expressed the above ideas, just as he had lent them a hand in replying to the art editor of the *New York Times* several months previously.[32] He agreed with his friends' assertion that subject matter was crucial. He admired their insistence on delving beyond outward appearances in search of timeless human truths and their dedication to enriching contemporary experience with "all the individual and collective wisdom of past generations."[33] He shared their fascination with primitive and archaic cultures and their belief that primitive art could speak vibrantly to twentieth-century man. Yet in the numerous writings of the same period in which he touched on primitive art, Newman scarcely mentioned myth.

It is not as insignificant as it might at first seem that Newman, with little company among the artists of his time or later among their critics and historians, distinguished primitive art from mythology.[34] From his contemplation of primitive art Newman extracted an esthetic he judged a more suitable model than the classical European for a twentieth-century, American artist. He never felt the need, however, to jettison the formal devices of Western modernism in favor of primitive forms; instead, he consciously took his plastic inheritance for granted as his starting point.[35] Myth was simply another component of the Western tradition to which he was naturally heir. Mythology to Newman meant Greek and Roman, or Judeo-Christian, not a body of constants in the collective unconscious or cultural relics indicative of an enviable social order. Newman adhered to the humanist conception of myth instead of adopting the attitudes of modern psychology and anthropology.[36] That tradition did not impede his progress in finding a new subject and a new style, but was a part of the being, the cultivated American self, out of which Newman planned to make his art.

When Newman finally began to paint and preserve his paintings in 1944–45, he gave mythological tags to many of the works that he titled. When he painted *The Song of*

Orpheus and *The Slaying of Osiris,* he was not exploring the phenomenon of the hero myth. He did not start out with those tales in mind, then proceed by adapting identifiable motifs from the verbal tradition and rendering them in modernist form, as Gottlieb and Rothko had done in *Eyes of Oedipus* and *Antigone,* respectively. Compared with his friends, Newman was less literal, less ambiguous, and more traditional in his use of myth. In these early works Newman resorted to automatic techniques to generate forms reflective of the state of mind and spirit out of which he was creating. Then he assigned titles appropriate to that state and hence to its visual expression, "so that the audience could be helped."[37] The familiar themes clarify for the viewer the content of the abstract compositions, in these instances, Newman's feelings about returning to artistic life after so many years of "limbo."[38]

Newman's interpretation of myth was not surrealist or even surrealizing; certainly his method of choosing titles was neither. Newman did not search out collective archetypes because he did not take the prevalent position that the unconscious was the wellspring of the creative imagination. He did not arrive at his titles randomly or arbitrarily because he had no interest in overturning reason in order to free the unconscious. Newman accorded chance, accident, and other surrealist devices for circumventing conscious control little scope in determining the content of his works. Why, then, would he have turned to surrealist automatism for the form of his drawings of 1944–45?

Newman experimented with automatism because, by 1943, he had found the subject matter for which he had hoped but no means to express it. In Part I of "The Plasmic Image" Newman wrote

> The subject matter of creation is chaos....All artists whether primitive or sophisticated have been involved in the handling of chaos....The present painter can be said to work with chaos not only in the sense that he is handling the chaos of the blank picture plane but also in that he is handling the chaos of form. In trying to go beyond the visible and the known world he is working with forms that are unknown even to him. He is therefore engaged in a true act of discovery in the creation of new forms and symbols that will have the living quality of creation....in his desire, in his will to set down the ordered truth, that is the expression of his attitude towards the mystery of life and death, it can be said that the artist like a true creator is delving into chaos. It is precisely this that makes him an artist for the Creator in creating the world began with the same material, for the artist tries to wrest truth from the void.[39]

Automatism offered Newman a rope out of the void, a way to start after years of desperate bafflement. For him and for most of the future abstract expressionists, automatism met the initial need for what Motherwell termed a "creative principle."[40] But automatism was peculiarly appropriate to the subject matter Newman had identified as his own. Through automatic drawing he was able to produce biomorphic elements throbbing with the pulse of life and the promise of unceasing regeneration. In so doing Newman succeeded in reenacting the original Creation of form from nonform, of living, growing beings out of nothing. Yet his early biomorphic drawings, such as *Gea,* fell short of his ambition, since the finished works only depicted the consequences of creation, rather anonymously. They did not contain in themselves evidence of the artist's positive will to order. By 1946 Newman reduced the role of automatism in his work, using it to elaborate upon his new, but traditional, genetic symbols. Eventually these traces of the Creator's act—orbs, stalks, and beams of light—gave way to the artist-creator's act alone, when Newman discovered in *Onement* (1948) that his own assertion of order and meaning could stand by itself as form and content.

The aspect of surrealism that most influenced American artists in the 1940s, then, probably contributed least to the development of Barnett Newman. Automatism helped him conquer the blank canvas when he first returned to painting, but he valued surrealist processes of image-making less than the metaphoric potential of the resultant biomorphs. Surrealist automatism did teach Newman the crucial lesson that the subject of a work of art was to be discovered, not assumed in advance. But Newman differed from the surrealists in his notion of the terrain to be explored. For the psychic unknown of the surrealists he substituted the unknowable: not that within reach, however strained, of man's knowing but that which eternally defies man's comprehension. The metaphysical mysteries that Newman wanted to confront in his painting required the engagement of his entire self, including his rational faculty. Reason and order did not threaten Newman; after all, they did not represent the burden of *his* artistic past. A study of Barnett Newman and surrealism brings to light the central paradox in Newman's work: at the same time that, as a modern, American artist, he declared his independence of a tired, European tradition, as an educated man of the West Newman cherished the vestiges of humanist values and traditions to which he was heir and enshrined them in his art. ∎

Notes

[1] Newman's rather uneventful biography is well known thanks to the work of Thomas B. Hess, in *Barnett Newman* (New York: Walker & Co., 1969), and *Barnett Newman* (New York: Museum of Modern Art, 1971). Newman expressed his judgments of surrealism most completely in "Art of the South Seas," trans. and rpt. in *Studio International,* vol. 179 1970, pp. 70–71, and most succinctly in a Letter to the Editor, *Art News,* vol. 67 Summer 1968, p. 8. Beyond these printed sources, however, I have relied heavily on the testimony of Annalee Newman, who has graciously and generously answered my questions about her husband and his work for more than a decade. To her go my warmest thanks.

[2] Newman's energy in attending museums, galleries, and artists' gatherings was legend in New York. See Hess, 1971, p. 33; also various artists' accounts in Jeanne Siegel, "Around Barnett Newman," *Art News,* vol. 70, Oct. 1971, pp. 42–46, 59–66. Newman himself described his youthful diligence in seeing all that New York had to offer in "In Front of the Real Thing," *Art News,* vol. 68, Jan. 1970, p. 60: "By the time I was 25, I had also searched out twentieth-century art by myself in the galleries, in the Quinn Collection exhibitions and auctions, etc. so that, with the exception of *Guernica,* I can say that I was familiar with perhaps every painting in the Museum of Modern Art before it got there."

[3] On John Graham see Marcia Epstein Allentuck, Introduction to *John Graham's "System and Dialectics of Art"* (Baltimore and London: Johns Hopkins University Press, 1971). Although Newman is never mentioned among the artists who congregated around Graham in the early years, according to Mrs. Newman, the two artists met at the Art Students League in the 1920s. Mrs. Newman also recalls numerous later visits to Graham's apartment.

[4] Dorothy Dehner, Foreword to *John Graham's "System,"* ed. Allentuck, p. xiv.

[5] Mary Davis MacNaughton, "Adolph Gottlieb: His Life and Art," in Sanford Hirsch and Mary Davis MacNaughton, organizers, *Adolph Gottlieb: A Retrospective* (New York: The Arts Publisher in association with the Gottlieb Foundation, 1981), p. 20.

[6] Graham gave Newman an inscribed copy of his *System and Dialectics,* which remains in Newman's library to this day. Since, according to Mrs. Newman, her husband viewed Graham's book dubiously, Graham's conversation probably impressed Newman more than his writings did.

[7] Letter to the Editor, cited n. 1 above.

[8] One of Newman's favorite derisive references to American Scene painting, "the old oaken bucket" appears in Newman's unpublished monologue of 1942, "What about Isolationist Art?" (Hess, 1971, pp. 34–37), and in Newman's foreword to *American Modern Artists* (New York: Riverside Museum, Jan.–Feb. 1943).

[9] On the surrealists' interest in primitive art, see Elizabeth Cowling, "The Eskimos, the American Indians and the Surrealists," *Art History,* I, 1978, 484–499; also Evan Maurer, "Dada and Surrealism," in *"Primitivism" in 20th Century Art,* vol. 2, ed. William Rubin, (New York: Museum of Modern Art, 1984), pp. 535–593.

[10] Newman's unpublished essays, including "The Plasmic Image" and "The New Sense of Fate," are excerpted in Hess, 1971, pp. 34–43. "Art of the South Seas" first appeared in Spanish, was only published in English in 1970 (cited n. 1 above).

[11] Newman, quoted in "Jackson Pollock: An Artists' Symposium, Part I," *Art News,* vol. 66, Apr. 1967, p. 29.

[12] Newman, foreword to *The Ideographic Picture* (New York: Betty Parsons Gallery, Jan.–Feb. 1947).

[13] "Art of the South Seas," p. 71.

[14] "The Plasmic Image," in Hess, 1971, p. 37.

[15] Foreword to *The Ideographic Picture.* The value judgments expressed here are Newman's, e.g.: "Abstract art in America has to a large extent been the preoccupation of the dull, who by ignoring subject matter, remove themselves from life to engage in a pastime of decorative art..." ("The Plasmic Image," Hess, 1971, p. 39).

[16] Allentuck, p. 12, claims that John Sloan fired Graham, who studied with him at the Art Students League in the 1920s, with his own enthusiasm for primitive art. Since Newman also studied with Sloan at the Art Students League, and was friendly with Graham, it seems likely that he was also awakened to the merits of primitive art at that time. The Museum of Modern Art stimulated interest in primitive and archaic art in the following decades by a succession of exhibitions: Africa Negro Art (1935), Prehistoric Rock Pictures in Europe and Africa (1937), Twenty Centuries of Mexican Art (1940), Indian Art of the United States (1941), Ancestral Sources of Modern Painting (1941), and Art of the South Seas (1946). Above all, for Newman, as for Baziotes, Gottlieb, Rothko, and Stamos, knowledge of primitive and archaic art in New York was fostered by the ethnographic collections of the American Museum of Natural History.

[17] Mrs. Newman, in conversation, Jan. 1986, recalls virtually no direct contacts between the American artists and the European émigrés. Furthermore, she does not remember that her husband was particularly excited by the presence of the surrealists in New York, even though he was interested in his city becoming an international art center.

[18] J[eannette] L[owe], "Surrealist Series, New School Style," *Art News,* vol. 40, Feb. 15, 1941, p. 34.

[19] Melvin P. Lader, "Howard Putzel: Proponent of Surrealism and Early Abstract Expressionism in America," *Arts,* vol. 56, March 1982, p. 90, includes Baziotes, Tony Smith, and Kamrowski on the rolls of the lectures, and notes (p. 96, n. 60) that Onslow Ford was told that Pollock also attended his lectures. Nancy Miller, in *Matta, The First Decade* (Waltham, Mass.: Rose Art Museum, Brandeis University,

1982), pp. 24–24, adds Hare and Gorky to the list but removes Kamrowski, by his own testimony, who did nevertheless share Baziotes' lecture notes.

[20]Mrs. Newman has no recollection of the New School series, but a creased checklist of what appears to be the final exhibition at the New School is preserved in the Newman files.

[21]Dore Ashton, *The Life and Times of the New York School* (Bath, England: Adams & Dart, 1972), pp. 85–86, emphasizes how uncommon English-language accounts of surrealism were prior to the arrival of the artists themselves.

[22]Newman had met Paalen while he was in New York, and *Dyn* remains today in Newman's library.

[23]On the exhibitions of Americans at Art of This Century, see Lader, pp. 90–92. For memoirs of the gallery, see Peggy Guggenheim, *Out of This Century, Confessions of an Art Addict* (New York: Dial Press, 1946), of which Newman had an inscribed copy, given him in thanks for his help; also Jimmy Ernst, *A Not-So-Still Life* (New York: St. Martins/Marek, 1984).

[24]Sidney Simon, "Concerning the Beginnings of the New York School: 1939–1943," *Art International,* vol. 11, Summer 1967, pp. 17–23 (Interviews with Peter Busa and Matta, and with Robert Motherwell).

[25]Mrs. Newman, Jan. 1986.

[26]Gottlieb, 1963, quoted in Maurice Berger, "Pictograph into Burst: Adolph Gottlieb and the Structure of Myth," *Arts,* vol. 55, March 1981, pp. 134–139.

[27]Hirsch and MacNaughton, p. 35. Newman's participation in the discussions is recalled by Rothko's first wife, Edith S. Carson, in Diane Waldman, *Mark Rothko, A Retrospective* (New York: Solomon R. Guggenheim Museum, 1978), p. 34.

[28]Whitney Chadwick, *Myth in Surrealist Painting, 1929–1939* (Ann Arbor: UMI Research Press, 1980), ch. 1.

[29]Gottlieb, 1967, in Hirsch and Mac-Naughton, p. 31: "I was reading Jung at the time . . . it was Jung who came up with the idea of the collective unconscious." On Rothko's reading see Stephen Polcari, "The Intellectual Roots of Abstract Expressionism: Mark Rothko," *Arts,* vol. 54 Sept. 1979, pp. 124–134.

[30]Waldman, p. 26, acknowledges a problem with Rothko's retrospective dating of early works, although she allows his dates to stand. Rothko's first wife remembers that "His work changed dramatically in the early 40's;" Waldman, p. 34. Mac-Naughton, in Hirsch and MacNaughton, p. 51, n. 39, remarks that *Antigone* did not appear publicly until Jan. 1942 and prefers to use Gottlieb's contemporary dating for works of this period. Obviously I agree that a date in the early 1940s makes more sense for the beginning of the mythic venture.

[31]Rothko, from the joint broadcast of Gottlieb and Rothko, "The Portrait and the Modern Artist," on Radio WNYC, Oct. 13, 1943, rpt. in Alloway and MacNaughton, pp. 170–171.

[32]Mrs. Newman recalls that her husband not only helped his friends with the letter to the *Times,* as is well known, but also with the radio broadcast and with matters concerning the Federation of Modern Painters and Sculptors, of which Gottlieb was a vice president in 1942 and President in 1944–45.

[33]The quotation is from Graham's article, "Primitive Art and Picasso," *Magazine of Art,* vol. 30, Apr. 1937, p. 237. It seems likely that this article, in its brevity and relative clarity, was more influential than the knotty *System and Dialectics.*

[34]Generally no distinction is made between primitive art and mythology in the writings of any period; all is subsumed under the broad category of primitivism. Newman's conclusions regarding the primitive aesthetic would probably have applied to both, but he did not devote the attention to myth that, for example, Gottlieb and Rothko did.

[35]"The Plasmic Image," Part V, in Hess, 1971, p. 39: "New painting has arrived at a point where the technical problems of the language have been pretty well solved. The new painter is taking his language for granted. He accepts and has absorbed the plastic devices of art and has developed what perhaps is the most acute level of sensitivity to the grammar of art ever held by any painter in history."

[36]See Chadwick, p. 7ff., on changes in the understanding of myth in the twentieth century.

[37]Newman, 1950, in "Artists' Sessions at Studio 35," *Modern Artists in America,* ed. Robert Motherwell and Ad Reinhardt (New York: Wittenborn, Schultz, 1952). Newman also said, "I tried to make the title a metaphor that describes my feelings when I did the painting;" quoted in Hess, 1969, p. 54.

[38]Hess, 1971, p. 27.

[39]Hess, 1971, pp. 37–38.

[40]Quoted by Simon, "Concerning the Beginnings of the New York School," p. 23.

Plates/Entries

Reproductions of drawings in the exhibition are presented alphabetically by artist. For more detailed notes, refer to the Catalog of the Exhibition, page 193. Authors of the artist entry essays are designated by their initials:

AA	Anne Ayres
RB	Ruth Bowman
EB	Ellen Breitman
SH	Sue Henger
DM	Dinah McClintock
MM	Mollie McNickle
JS	James Scarborough
MS	Merle Schipper
BS	Betsy Severance

William Baziotes
1912–1963

William Baziotes, one of the first New York artists to explore surrealism, experimented with fantastic Picassoid images before participating in Matta's automatic drawing sessions. Baziotes' mature vocabulary of biomorphic forms, achieved through automatic and intuitive means, places him with abstract surrealists who, like Miró, sought "a combination of formal freedom and human content."[1] Born of Greek immigrant parents who settled in Reading, Pennsylvania, Baziotes moved to New York in 1933 and enrolled at the National Academy of Design, where he studied primarily with realist Leon Kroll until 1936. Working on WPA Federal Art Projects from 1936 to 1939, Baziotes pursued in his own work images "coming in from the unconscious making irrational elements work together."[2] The Picasso exhibition at the Museum of Modern Art in 1939 impressed him strongly, as he later recounted: "I saw that the figure was not his real subject. The plasticity wasn't either.... No. Picasso had uncovered a feverishness within himself and is painting it—a feverishness of death and beauty."[3]

If Picasso's work confirmed for Baziotes the validity of turning to the unconscious for subject matter, it was Matta who urged him to invent new images through the technique of psychic automatism. Baziotes' drawings in this exhibition demonstrate his ardent search for singular organic form evoking multiple associations. In a series of brightly colored gouaches of 1939–40, a bizarre human/animal demon fills the flat picture plane, recalling Picasso's distorted figures. The beginnings of Baziotes' amorphous imagery surface in *Untitled* (cat. 2 and 3), where linear outline defines mysterious form, transparent wash creates liquid field, and radiating or intertwining lines hint at organic structure or cosmic interrelatedness. Pale, transparent color, foretelling his pallette of the 1950s, appears in *Untitled* (cat. 4), a composition whose spatial arrangement resembles Matta's inscape and psychological morphology works of 1939–41 and Motherwell's early sketches. The grid structure of *Untitled* (cat. 5) suggests an experimentation with synthetic cubism and is the basic formal element of Baziotes' 1944 painting, *The Parachutists.* Miró's influence is seen in *Summer Landscape* (cat. 7), where fanciful beings circumscribed with sawtooth lines stare through radiating concentric circles from a watery pastel world. The looming eye/breast/sun image is repeated in *Untitled* (cat. 6), here overlooking an opaque nightmarish landscape inhabited by a hybrid plant/snake form. In *Night Figure No. 1* (cat. 8), Baziotes combines watercolor brushstrokes and feathered ink line to delineate a phantom biomorph whose counterpart image reflected in the background has more substance than the void-form itself.

Typical of Baziotes' paintings after the late 1940s is a diffused translucent color space inhabited by one or two flat animal/amoeboid shapes and a linear insect-being.

Although his retention of biomorphic forms into the 1950s distinguishes him from contemporaries such as Rothko, Pollock, and Newman, who by then had abandoned all reference to objects in their paintings, he shared with them an interest in mythic content and a commitment to the controlled automatism that allowed intuitive interaction in the painting process. Elements of shape, line and field became increasingly simplified in Baziotes' mature work, reaching a sensuous, poetic balance in paintings completed after 1955. "It is the mysterious that I love in painting. It is the stillness and the silence. I want my pictures to take effect very slowly, to obsess and to haunt."[5]

Baziotes participated in a group exhibition at the New School of Social Research in conjunction with Gordon Onslow Ford's lectures on surrealism (1941), the First Papers of Surrealism exhibition organized by Breton and Duchamp (1942), and the collage exhibition at Art of This Century (1943). Solo exhibitions followed at Art of This Century (1944) and at Kootz Gallery (1946 and succeeding years). In 1948 Baziotes joined Motherwell, Rothko, Newman, and David Hare in founding The Subjects of the Artist school.—SH ■

Notes

[1] Lawrence Alloway, Introduction to *William Baziotes: A Memorial Exhibition* (New York: Solomon R. Guggenheim Museum, 1965), p. 13.

[2] Baziotes, quoted in Barbara Cavaliere, "William Baziotes: The Subtlety of Life for the Artist," *William Baziotes: A Retrospective Exhibition* (Newport Beach, California: Newport Harbor Art Museum, 1978), p. 42. (Organized by Michael Preble.)

[3] Baziotes, quoted in ibid., p. 36.

[4] Baziotes, quoted in ibid., p. 44.

[5] Baziotes, quoted in "Statements by the Artist," *William Baziotes: A Memorial Exhibition,* p. 42.

2
William Baziotes
Untitled, c. 1941–42
watercolor and ink on
paper mounted on board
11⅞ x 7⅜ (30.5 x 19.1)
Collection Ethel Baziotes,
Courtesy Blum Helman
Gallery, New York

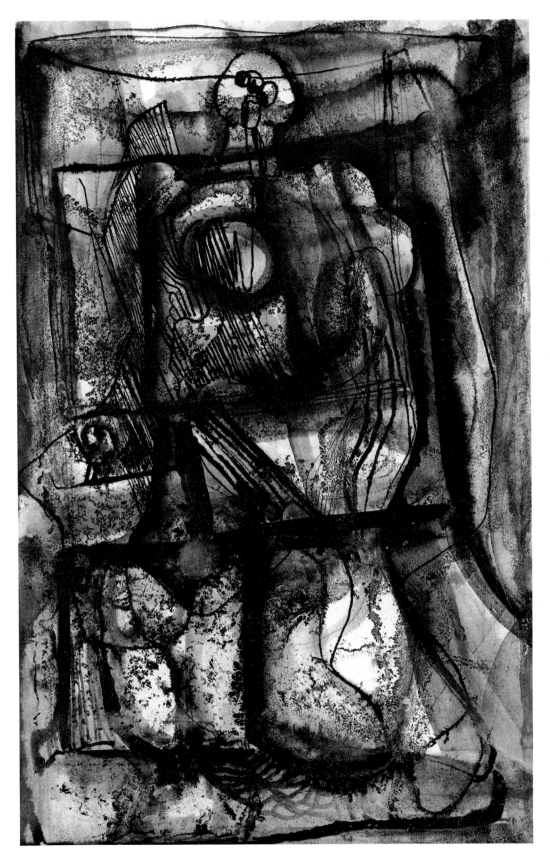

3
William Baziotes
Untitled, c. 1942–43
watercolor with frottage
and ink on paper
9 x 11⅞ (30.5 x 22.9)
Collection Ethel Baziotes,
Courtesy Blum Helman
Gallery, New York

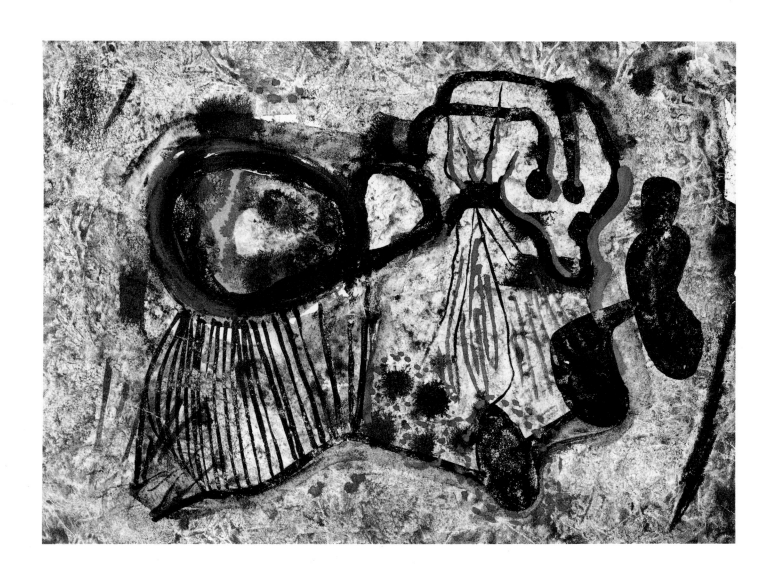

4
William Baziotes
Untitled, n.d.
watercolor on paper
7¾ x 9¾ (19.7 x 24.8)
Herbert F. Johnson
Museum of Art, Cornell
University, Ithaca, New
York; Gift of Dr. & Mrs.
Emanuel Klein

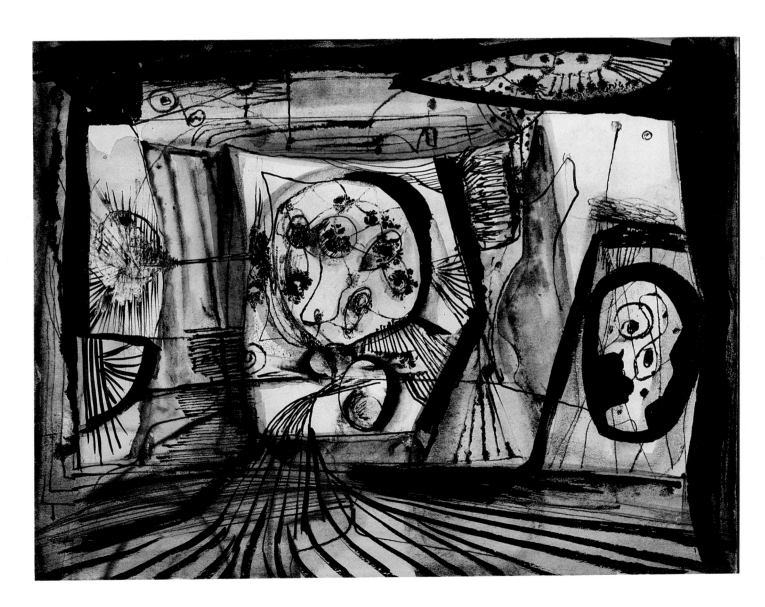

5
William Baziotes
Untitled, c. 1943–44
charcoal on paper
12¼ x 15¼ (31.1 x 38.7)
Collection Ethel Baziotes,
Courtesy Blum Helman
Gallery, New York

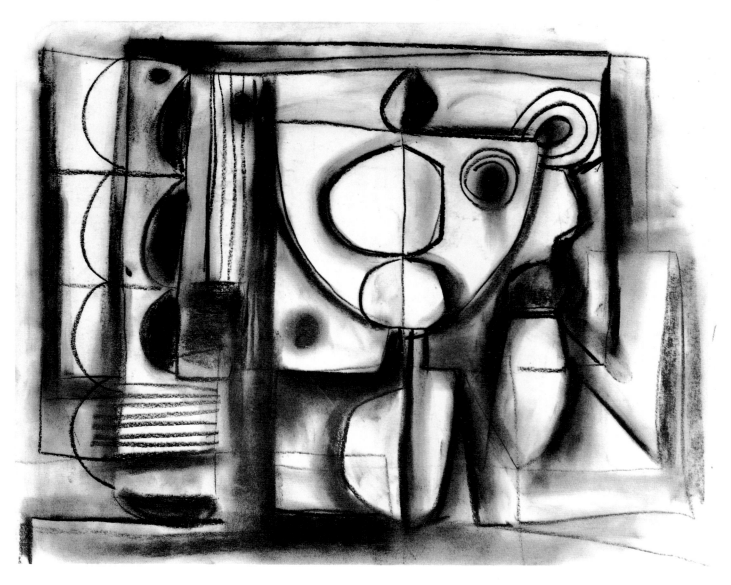

7
William Baziotes
Summer Landscape, 1947
watercolor, ink and pencil
on paper
14 x 16 (35.6 x 40.6)
Collection Mr. and Mrs.
Bruce Clark, New York

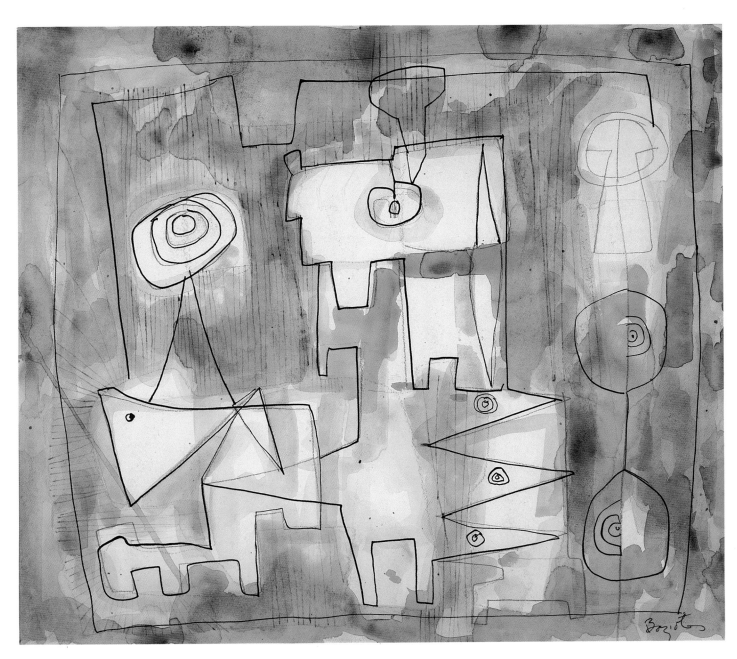

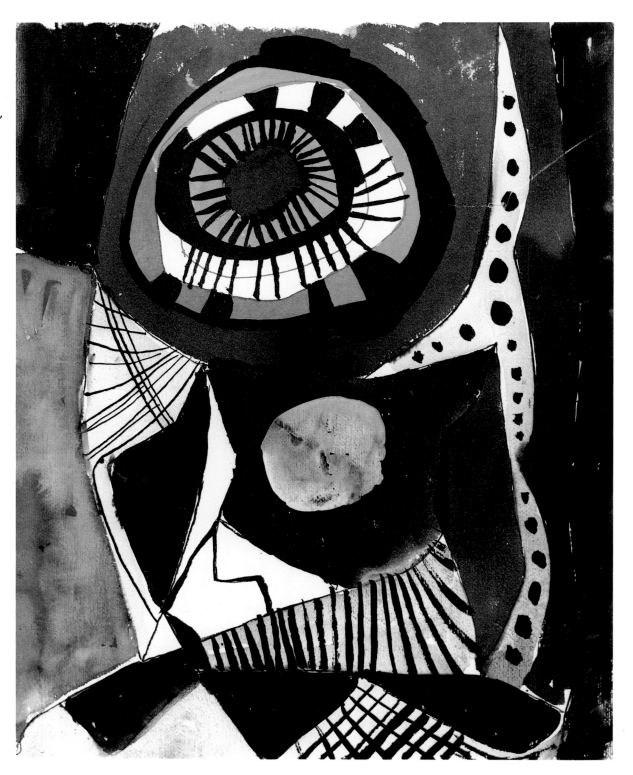

6
William Baziotes
Untitled, c. 1946–47
watercolor, gouache
and ink on paper
13⅞ x 10⅞ (35.6 x 26.4)
Collection Ethel Baziotes,
Courtesy Blum Helman
Gallery, New York

8
William Baziotes
Night Figure, No. 1, n.d.
watercolor, gouache, ink
and pencil on paper
18 x 15⅛ (45.7 x 38.4)
Solomon R. Guggenheim
Museum, New York

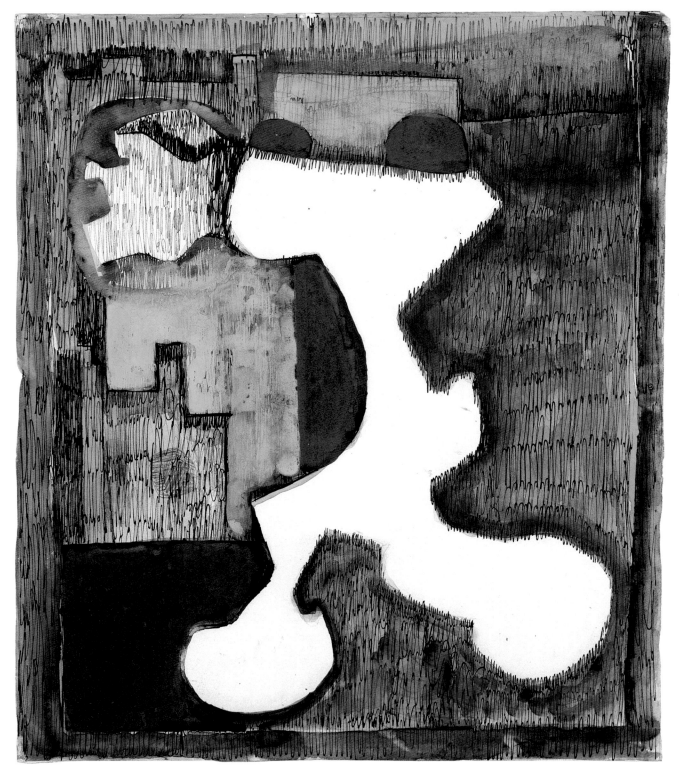

Byron Browne
1907–1961

Echoing the texture and line of Gorky from the 1930s and displaying strong influences of Jean Arp and Joan Miró, Byron Browne's draftsmanship has earned him a place among these explorers of abstraction. Because he was allied closely with the New York artists of the 1940s, Browne's personal contribution to a biomorphic abstract expressionist esthetic has resulted in increased public recognition of his works in recent years. Born George Byron Browne in Yonkers, New York, he studied at the National Academy of Design from 1924 to 1928. At age twenty-one, he won the Third Hallgarten Prize at the National Academy Exhibition, becoming the youngest artist to win the award in the Academy's history. This award had a dual role in beginning his career as a modernist: not only did he achieve early recognition, but when he tore up his award-winning classical still life canvas, he symbolically denounced his realist past and turned his art toward modernism.[1]

During the 1930s and 1940s, Browne was one of the leading figures in the American avant-garde movement. But as he explored the route to abstraction, his inspiration and constant fascination were with the external and internal workings of nature. Even in the most seemingly nonobjective of Browne's drawings and paintings, nature is the subject: "There is only the depiction of nature...."[2] Browne was not interested in the idea of a purely gestural, rapid and automatic creation of a work. His approach was an "art of deliberation and meditation...rather than an art of swift expression."[3]

Byron Browne's works between 1938 and 1948 consisted of semiabstract still lifes, highly stylized depictions of female figures interwoven with classical motifs, and abstractions based on nature but filtered through a lens of synthetic cubism. In these abstractions, unique biomorphic shapes that became Browne's personal signature animate his works. The crescent moon shape appears, a ringed eye often replaces the human eye, and bold, energetic floating shapes provide the weight and balance of the composition. Browne's works often are highlighted by rich textures created by cross-hatching, washes, and his extraordinary linear quality, as seen in *Flying Shapes* (cat. 10). Within these works, he creates spatial references through his use of scale, proportion, and a collage-like handling of both positive shapes and interior calligraphy without designating a comparative horizon. One observes a continuous reference to the primitive, a reaching back to the original symbols of life, and a description of the human form in the most basic terms. His diverse style and wide range of technical skills gave Browne the tools to "...recreate the force of nature, without copying nature."[4]

Browne showed regularly in New York during the 1940s, with one-person exhibitions at the Artists' Gallery and the Kootz Gallery; he taught at the Art Students League and New York University from 1948 until his death.—BS ∎

Notes

[1] April J. Paul, *Byron Browne—A Retrospective.* (Naples, Florida: The Harmon Gallery), p. 8.

[2] From Browne's notebook, June 26, 1951, cited by Greta Berman, "Byron Browne: Builder of American Art," *Arts,* vol. 53, December 1978, p. 101.

[3] From Browne's notebook, April 15, 1952, cited in Berman, p. 98.

[4] Berman, p. 102.

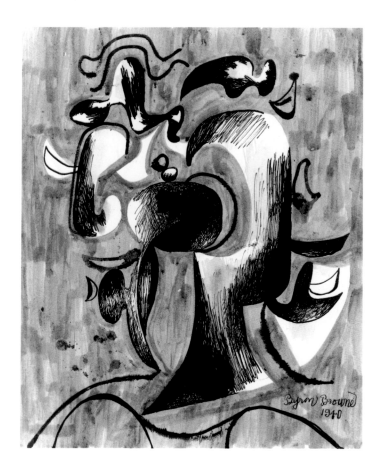

9 (opposite)
Byron Browne
Head in Violet and Brown,
1940
india ink and wash on
paper
14 x 11 (35.6 x 27.9)
Meredith Long & Co.,
Houston, Texas

10
Byron Browne
Flying Shapes, 1943
india ink and crayon
on paper
12½ x 20¼ (31.8 x 51.4)
Meredith Long & Co.,
Houston, Texas

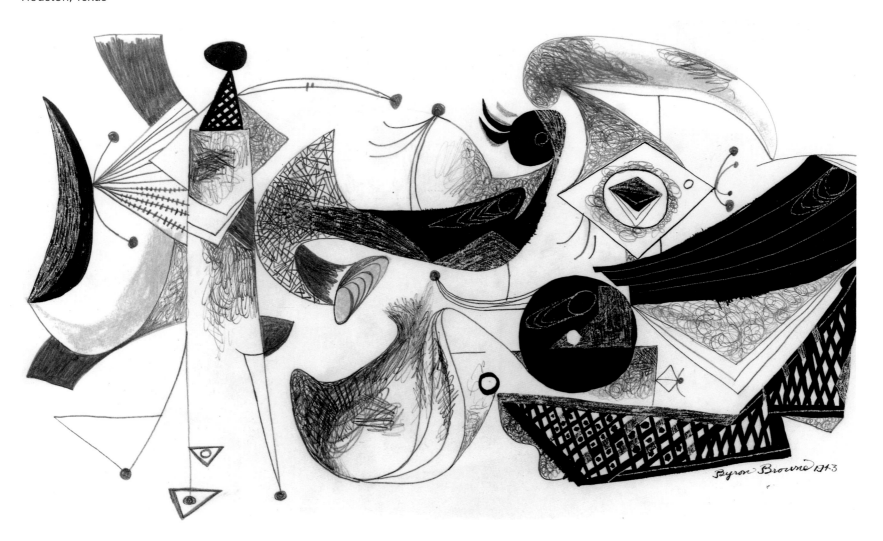

Arshile Gorky
1904–1948

Born on April 15, 1904, in east Armenia, the artist was named Vosdanik Adoian. From earliest childhood, he showed an interest in drawing and was exposed to ancient Armenian religious painting. In 1908 his father emigrated to Providence, Rhode Island, to escape the Turkish army draft. In the summer of 1915, the remaining family was forced by the Turks into the long "death march" to Caucasian Armenia. In 1919 the artist and his younger sister Vartoosh were left alone by the starvation death of their young mother. The two were helped to emigrate to America the following year. After living with relatives in Providence, Watertown and Boston (where he taught at the Boston New School of Design), the artist moved to New York in 1925, taking a studio near Washington Square. He adopted the name "Arshile," a Caucasian form of the Armenian royal name Arshak, and "Gorky," Russian for "bitterness." He began a five year affiliation with the Grand Central School of Art, moving to a studio at 36 Union Square in 1930, the year he first showed work at the Museum of Modern Art. He joined the Abstraction-Creation group in 1932 and, his first one-person show was held in 1934 at the Mellon Galleries in Philadelphia. Through the WPA Federal Art Project he was awarded the Newark Airport mural commission in 1935. He painted murals for Ben Marden's Riviera nightclub and the New York World's Fair Aviation Building in 1938–39 and had his first solo museum exhibition in San Francisco in 1941. By the end of World War II, he had begun showing his easel paintings and drawings annually at the Julien Levy Gallery. His suicide in Sherman, Connecticut, July 21, 1948, left a widow, Agnes, and two daughters, Maro and Natasha.

"Arshile Gorky—for me the first painter to whom the secret has been completely revealed!...it is my concern to emphasize that Gorky is, of all the surrealist artists, the only one who maintains direct contact with nature...." So stated André Breton in an essay for the first Gorky show at the Julien Levy Gallery in 1945. For more than any other American "abstract" artist of his era, Gorky's art is descriptively autobiographical. Breton called his drawn and painted pictorial forms "hybrids," segments from his life.

In the period 1938 to 1948 Gorky's art shows Picasso, Miró and even Leger as stylistic sources for his imagery. His contemporary models may also be found in the work of Tanguy and Matta; but Gorky's drawings provide dynamic reading possibilities that allow the viewer to take phases of his life and find specific shapes, textures and colors which refer to observations, recollections and even transmogrified sensations. Thus, details in Agony, Virginia Landscape, and particularly in The Liver is the Cock's Comb can refer to parts of his memory and experience.

Images that manifest themselves in Gorky's drawings can be found in his descriptions of religious rites in his childhood, as recalled in his interpretation of the Newark Airport murals: "In the ceiling was a round aperture to permit the emission of smoke. Over it was placed a wooden cross from which was suspended by a string an onion into which seven feathers had been plunged....Through these elevated objects...was revealed to me...the marvel of making from the common the uncommon!...Through the denial of reality, by the removal of the object from its habitual surrounding, a new reality was pronounced...."

This "new reality" enabled Gorky to transform into drawing his spiritual and esthetic concerns. The suspended, floating "feather" images seem to have found their way into many of Gorky's late works. They occur in the Study for "Last Painting" (cat. 25), Study for "The Plough and the Song" (cat. 13) and, in several parts of the composition of the image-wrought Study for "The Liver is the Cock's Comb" (cat. 11). Looking at the scumbled surfaces in the Study for "Summation" (cat. 16) and the crayoned glazes of strong color in the Study for "The Liver is the Cock's Comb," we see simulated pictorially the vibrant sensations of recollection.

The mystery of why Gorky has used childlike scribbles on some of his drawings can be uncovered by recognizing that there is an energy and a mood created by that counterpoint of scribble against delicate linear shapes, setting forth an immediacy and a revelation of the process of thought and feeling that are emblematic of Arshile Gorky's major contribution to the history of art.

Gorky was able to make a linear form pulsate with vitality in the Study for "The Plough and the Song," its surreal lines compressing time and implying fecundity. His titles and the act of drawing began simultaneously, unlike the random "unconscious" development of the works of some of his contemporaries. Each Gorky drawing may be a study for a painting, for his late paintings are drawings on canvas with strong color as reinforcement, but the drawings stand alone as esthetic documents of his original place in his time. Moreover, Gorky continued drawing a theme after his painting was complete.

Gorky developed the skill of indicating a quality of sensation, transmitting fragmentary meaning by a line or a form, a "-ness" in shape and texture among other forms with other meanings, so that "flower-ness," "landscape-ness" or "plough-ness" is even more meaningful than exact representation would be, a shift in the shape of content.—RB ■

11
Arshile Gorky
*Study for "The Liver is
the Cock's Comb,"* 1943
ink, pencil and crayon
on paper
19 x 25½ (48.3 x 64.1)
Collection Marcia S.
Weisman, Beverly Hills,
California

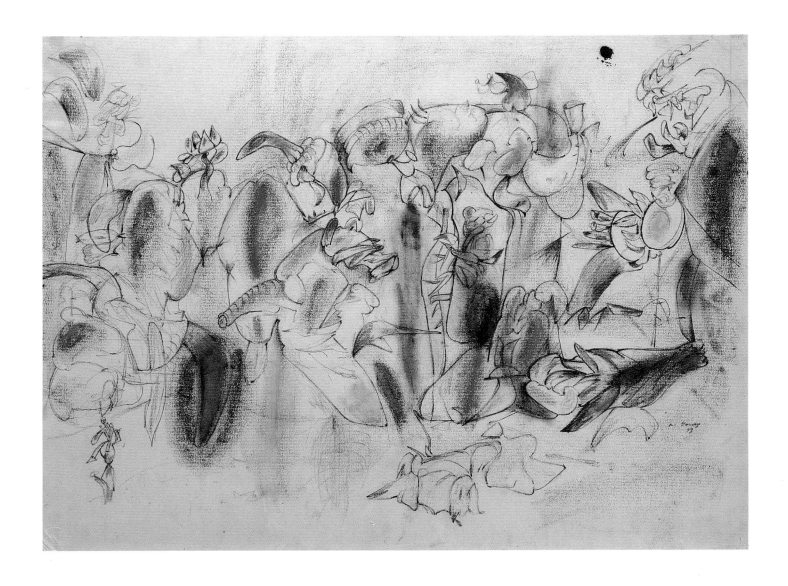

12
Arshile Gorky
Anatomical Blackboard,
1943
pencil and crayon on
paper
20¼ x 27⅜ (51.4 x 69.5)
Mr. and Mrs. Walter
Bareiss, New York

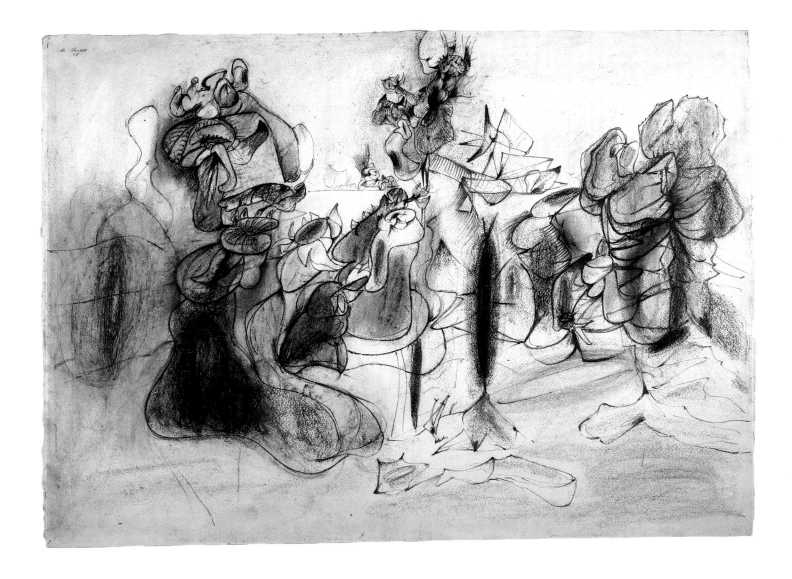

13
Arshile Gorky
Study for "The Plough and the Song," 1944
pencil and crayon on paper
18½ x 24¾ (47 x 62.9)
Allen Memorial Art Museum, Oberlin College, Oberlin, Ohio; Friends of Art, Fund, 56.1

15
Arshile Gorky
Untitled, 1946
pencil, pen, ink and crayon on paper
19⅛ x 24¾ (48.6 x 62.9)
Courtesy Marisa del Re Gallery, Inc., New York

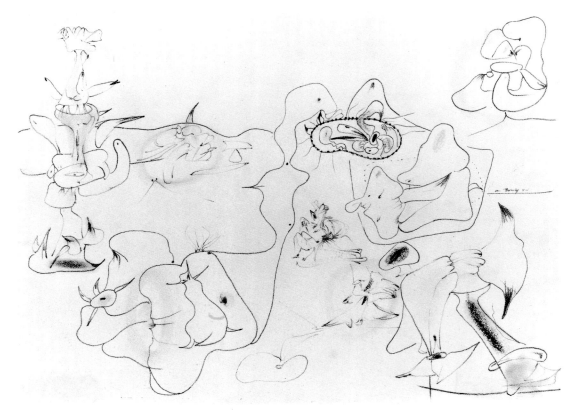

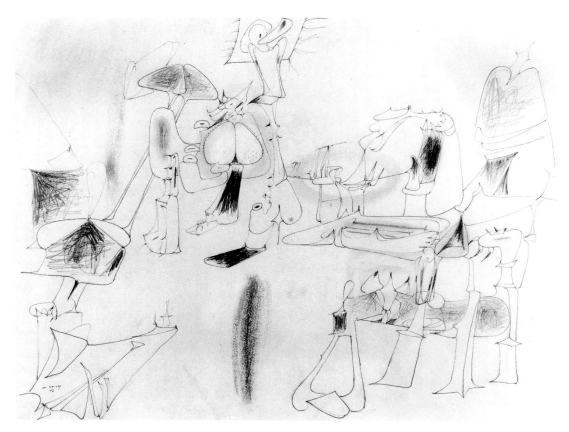

14
Arshile Gorky
Virginia Landscape, 1944
pencil and sargent crayon
on paper
19 x 25 (48.3 x 63.5)
Stefan T. Edlis, Chicago,
Illinois

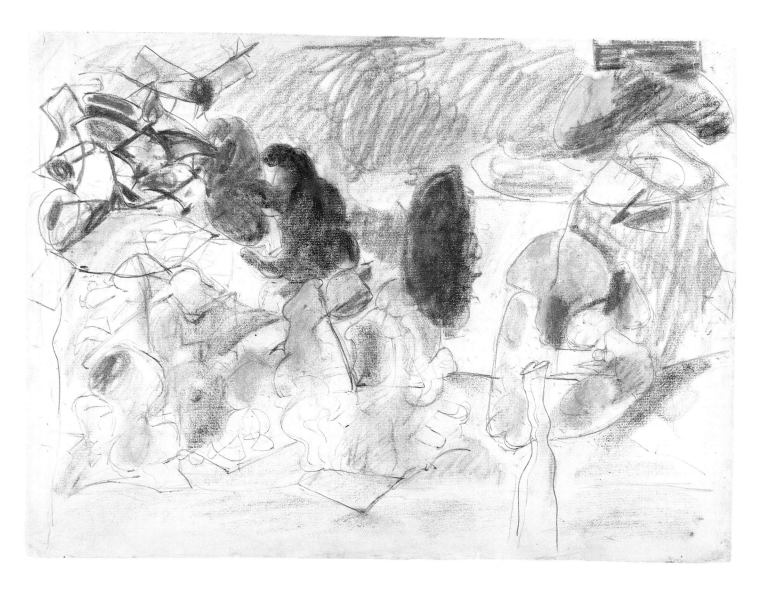

16
Arshile Gorky
Study for "Summation,"
1946
pencil and crayon on
paper
18½ x 24½ (47 x 62.2)
Collection Whitney
Museum of American Art,
New York; Gift of Mr. and
Mrs. Wolfgang S.
Schwabacher, 50.18

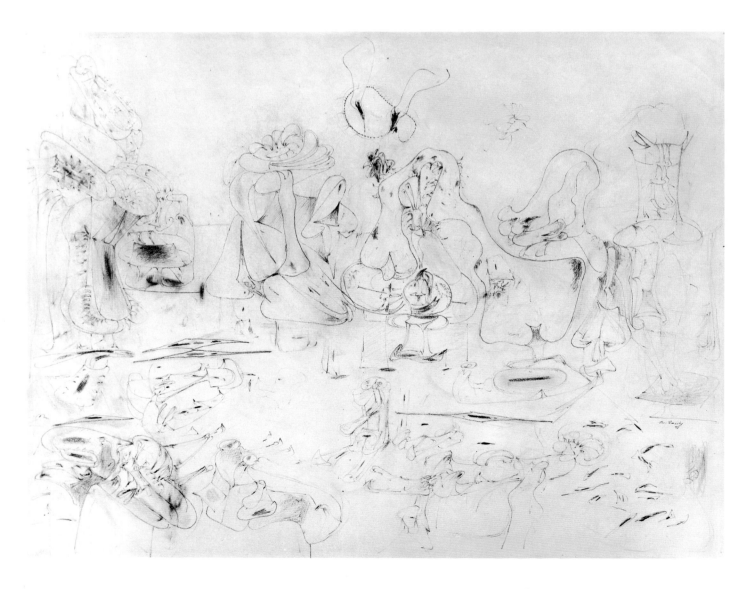

17
Arshile Gorky
Virginia Landscape,
c. 1946
pencil and crayon on
paper
18½ x 23⅝ (47 x 60)
Xavier Fourcade, Inc.,
New York

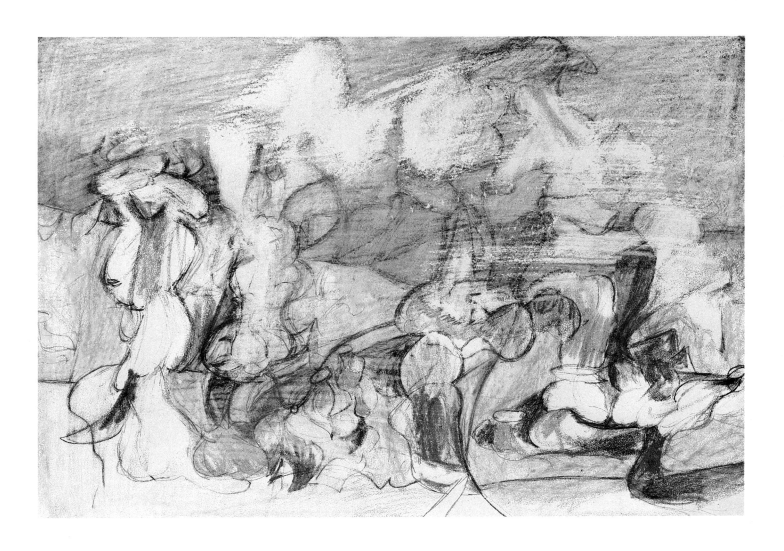

18
Arshile Gorky
Untitled, c. 1946
ink, watercolor, pencil
and wax crayon on paper
18¾ x 24⅛ (47.6 x 61.3)
Collection Solomon R.
Guggenheim Museum,
New York, Gift, Rook
McCulloch, 1976

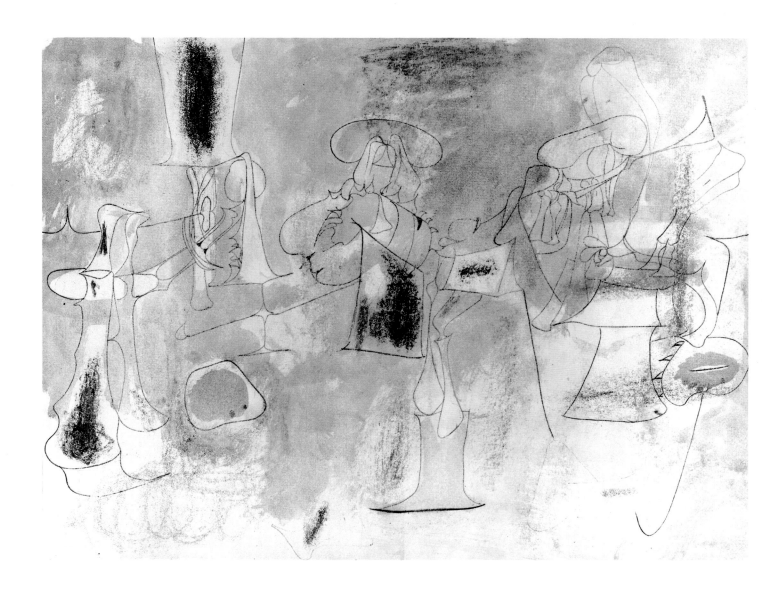

20
Arshile Gorky
Untitled, 1946
pencil and crayon on
paper
19⅛ x 24 (48.6 x 61)
Varjabedian, H., California

19
Arshile Gorky
Untitled, c. 1946
pencil and crayon on
paper
19¼ x 25 (50.2 x 63.5)
Xavier Fourcade, Inc.,
New York

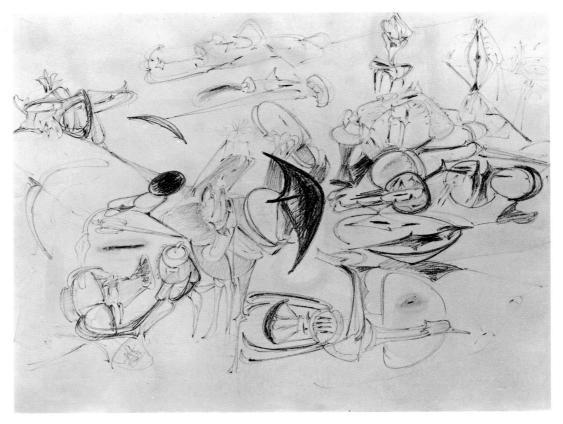

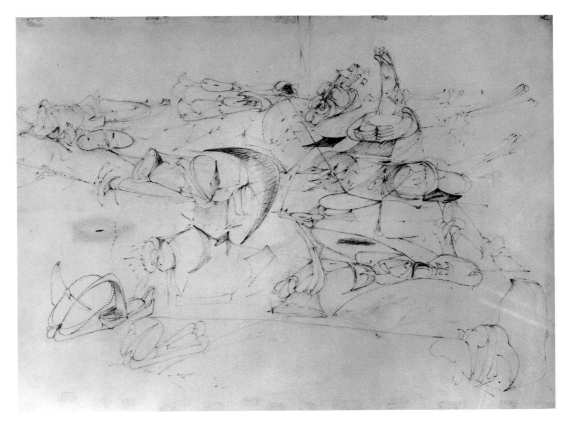

21
Arshile Gorky
Study for "Agony," 1946
pencil, wax crayon, and
watercolor on paper
18½ x 23¾ (47 x 60.3)
Collection Solomon R.
Guggenheim Museum,
New York, Gift, Rook
McCulloch, 1978

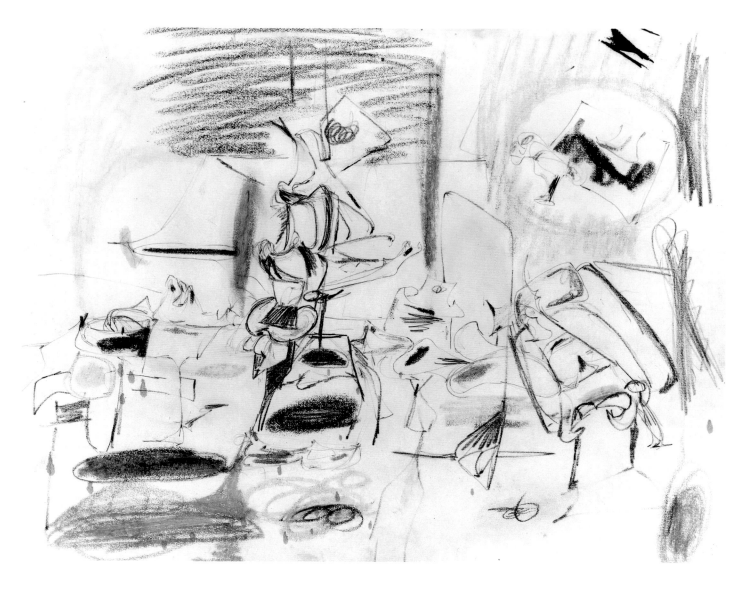

22
Arshile Gorky
Study for "Agony I,"
1946–47
pencil, crayon and wash
on paper
21¾ x 29½ (55.2 x 74.9)
Sarah Campbell Blaffer
Foundation, Houston,
Texas

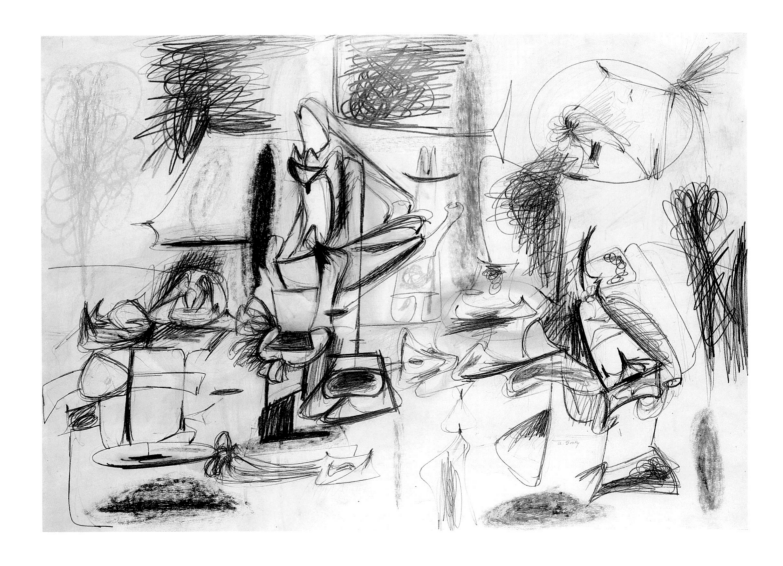

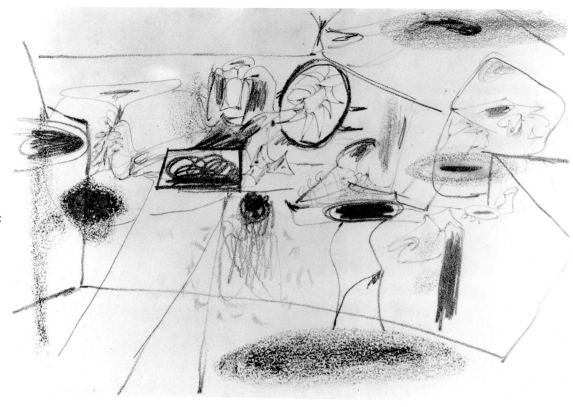

25
Arshile Gorky
Study for "Last Painting,"
1948
pencil and sargent crayon
on paper
11 x 14½ (28 x 37)
Herbert F. Johnson
Museum of Art, Cornell
University, Ithaca, New York;
Herbert F. Johnson
Acquisition Fund

23
Arshile Gorky
Drawing, 1946–47
pencil and crayon on
paper
18½ x 25¼ (47 x 64)
Xavier Fourcade, Inc.,
New York

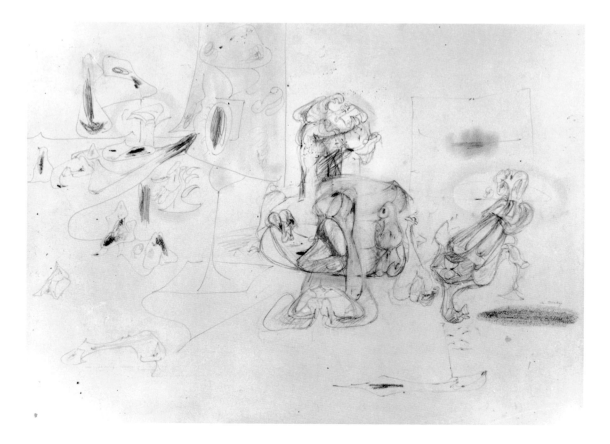

24
Arshile Gorky
Study for "Agony," 1947
wax crayon and pencil
on paper
19 x 24 (48.3 x 70)
Collection Mr. and Mrs.
S. I. Newhouse, Jr.,
New York

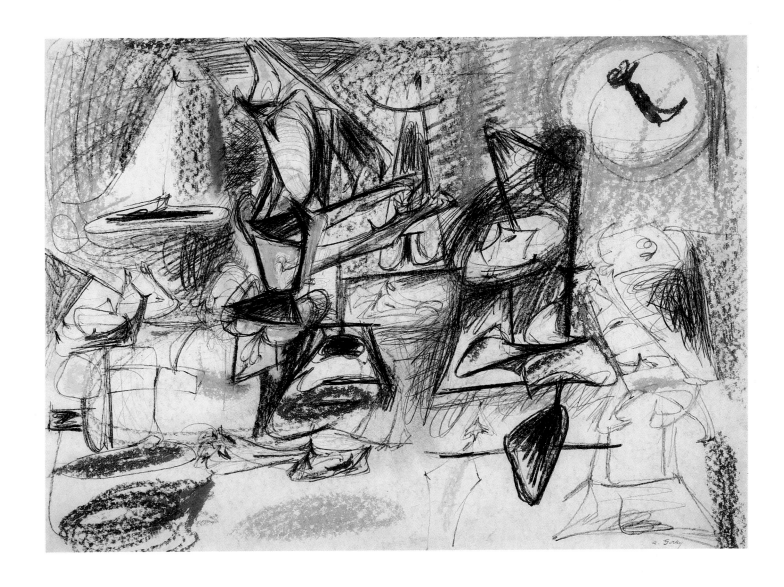

Adolph Gottlieb
1903–1974

Born in New York, Adolph Gottlieb was the son of immigrants who came to the United States from an area which is now Czechoslovakia. During high school Gottlieb's interest in art led him to Saturday classes at the Art Students League and later to Parsons School of Design and Cooper Union. Among the early influences were his teachers Robert Henri, whose idea of painting directly on canvas Gottlieb employed throughout his career[1] and John Sloan, whose encouragement to "study the masters" and to pursue his own direction inspired Gottlieb to leave for Europe in 1921 at the age of 18. On his return, Gottlieb met two artists with whom he would form lifelong friendships, Barnett Newman and Mark Rothko. In 1932 he and Esther Dick were married and moved to Brooklyn, where Gottlieb came under the influence of Milton Avery. Both Gottlieb and Rothko admired Avery's muted expressionism and flat manner of painting. Gottlieb's own "magic realist" works of this time, with their depiction of shells and other natural objects seen in compartmented boxes along the shore, were inspired by Avery's seascapes. In 1936 Gottlieb, like many of his contemporaries, worked as an easel painter for the WPA Federal Art Project.

With the Pictographs of 1941, Gottlieb first reached maturity as an artist. These works were significant not only within Gottlieb's own development, but also for the other artists of the New York School who sought to break away from the banalities of American scene painting and the excessive formalism of pure abstraction. For with the Pictographs, Gottlieb became one of the first to introduce myth into American painting, thereby providing subject matter "which is tragic and timeless...the simple expression of a complex thought."[2] These early Pictographs already exhibit the duality of subject and form which would characterize Gottlieb's entire oeuvre. Images such as *Voyager's Return* (cat. 28) and *Composition* (cat. 27) combine mythic, archaic images with a flat, arbitrary, though rationally conceived grid, putting Gottlieb "in the vanguard of artists who fashioned a personal style from the major strains of the modern tradition, Cubism and Surrealism."[3]

The Pictographs derived from a multiplicity of sources and influences. The obvious connection for the grid work is to cubist structure, Mondrian, and the work of Joaquin Torres-Garcia. But Gottlieb himself points to the compartmentalized, 15th century Italian panel paintings he so greatly admired during his visit to Europe twenty years earlier. The imagery recalls the work of Miró, Paul Klee, and Picasso, while the colors in works such as *Untitled* (cat. 30) and *Untitled* (cat. 32) suggest the influence of native American art, which he both admired and collected. Derived from the unconscious through surrealist automatist techniques, the signs and symbols in the Pictographs—the eyes and anatomical parts in *Incubus* (cat. 31) or *Pictograph* (cat. 33), the cross in cat. 30 or the plant-like forms in *Untitled* (cat.

29)—are not meant to be interpreted specifically but, instead, to evoke universal themes. Based on his interests in surrealist literature, the writings of Freud and Jung, and primitivism (all of which were reinforced by his close association with John Graham), the Pictographs are symbolic expressions of Gottlieb's attitudes towards man's primeval nature and the relatedness of all things.

Gottlieb remained an abstract surrealist and continued to produce the Pictographs until 1951. As a "barometric spokesman for the development of New York painting in general,"[4] Gottlieb was an activist throughout his career, organizing exhibition groups, participating in artists' forums, drafting letters of protest, and bringing his fellow artists to the attention of the critics. His famous letter to *New York Times* critic Edward Alden Jewell, cosigned with Mark Rothko (and written with the aid of Barnett Newman), was not only the first statement of the importance of subject matter in American abstract art, but also set a precedent of artists "forcefully presenting their views."[5]

Gottlieb's work was seen in numerous group exhibitions in the period 1938–48 and in one-person shows at Artist's Gallery, A.C.A. Gallery, and Howard Putzel's 67 Gallery. In 1947 Gottlieb joined the Kootz Gallery, where he had numerous one-person shows through 1954.—EB ■

Notes

[1] Mary Davis MacNaughton, "Adolph Gottlieb: His Life and His Art," in Sanford Hirsch and Mary Davis MacNaughton, organizers, *Adolph Gottlieb: A Retrospective* (New York: The Arts Publisher, in association with the Adolph Gottlieb Foundation, 1981), p.11.

[2] Adolph Gottlieb and Mark Rothko (with the assistance of Barnett Newman), Letter to Edward Alden Jewell, Art Editor, *The New York Times*, June 7, 1984, printed in Jewell, "The Realm of Art: A Platform and Other Matters; 'Globalsim' Pops into View," *The New York Times*, June 13, 1943, p. 9. This letter is reprinted in its entirety in Hirsch and MacNaughton, *Adolph Gottlieb*, p. 169.

[3] Mary Davis MacNaughton, *Adolph Gottlieb: Pictographs, 1941–1953* (New York: André Emmerich Gallery in association with the Gottlieb Foundation, 1979), n.p.

[4] Judith E. Tolnick, "The Painting—A Background," *Flying Tigers: Painting and Sculpture in New York, 1939–1946* (Providence, Rhode Island: Bell Gallery, Brown University, et al., 1985; exhibition catalog), p. 15.

[5] Hirsch and MacNaughton, *Adolph Gottlieb*, p. 48. In her essay, pp. 18–19, 47–49, MacNaughton fully outlines Gottlieb's role as an artist and activist.

26
Adolph Gottlieb
The Centers of Lateral Resistance, 1945
gouache on paper
32 x 24 (81.3 x 61)
Collection Solomon R. Guggenheim Museum, New York

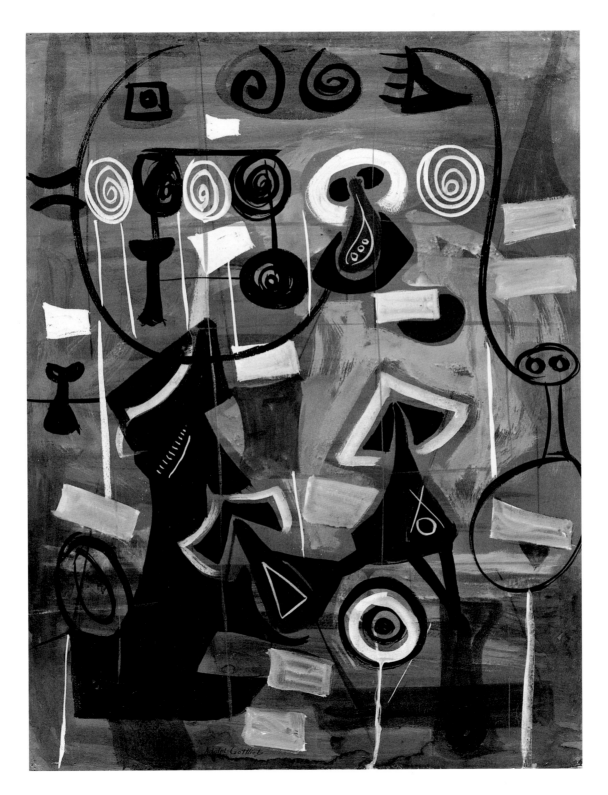

27
Adolph Gottlieb
Composition, n.d.
gouache and watercolor
on paper
25¾ x 19⅝ (65.4 x 49.9)
Marlborough Gallery,
New York

28
Adolph Gottlieb
Voyager's Return, 1946
gouache and watercolor
on paper
25½ x 19⅝ (64.8 x 49.9)
Collection Whitney
Museum of American Art,
New York; Gift of Mr. and
Mrs. Samuel M. Kootz,
51.38

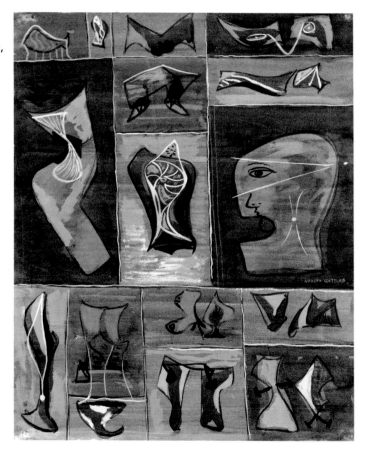

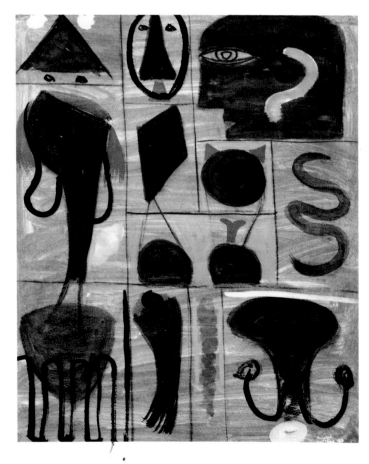

29
Adolph Gottlieb
Untitled, c. 1946
gouache and crayon on
paper
19⅜ x 24⅞ (49.2 x 63.2)
Collection Phil and
Norma Fine, Boston,
Massachusetts

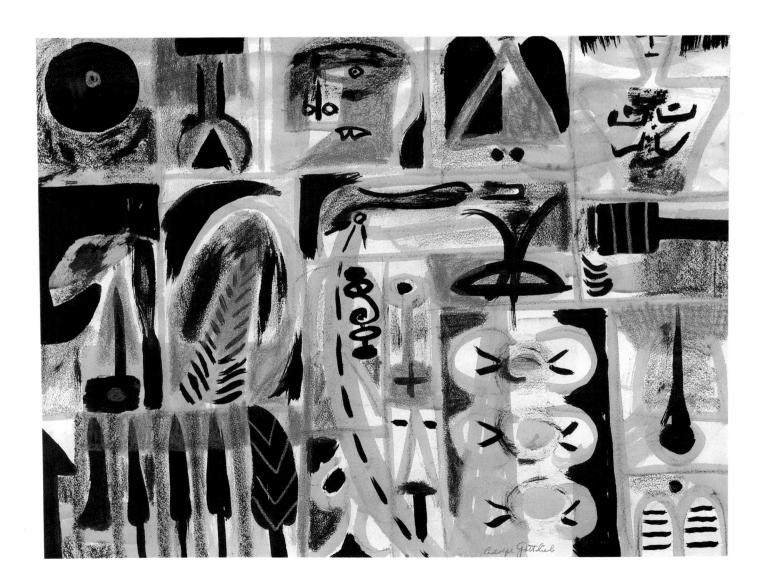

31
Adolph Gottlieb
Incubus, 1947
gouache on paper
23 x 17 (58.4 x 43.2)
The North Carolina
Museum of Art, Raleigh,
North Carolina

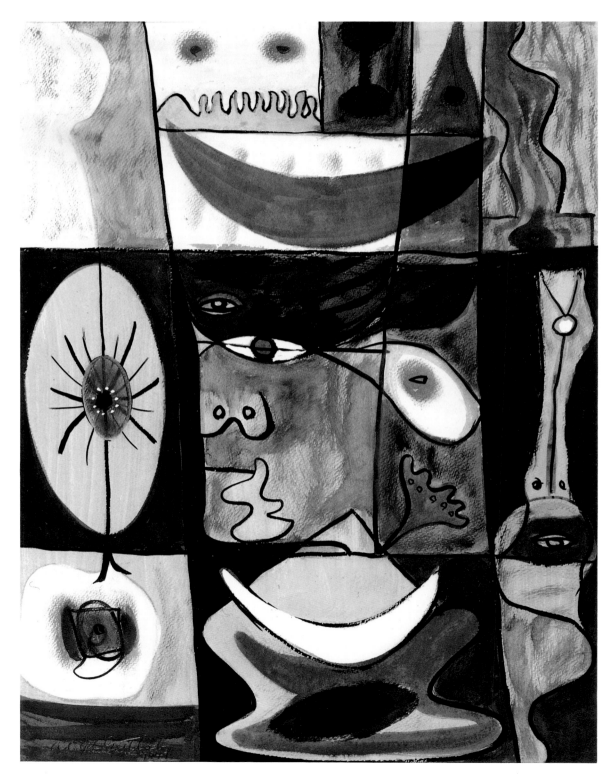

30
Adolph Gottlieb
Untitled, 1946
gouache on paper
20 x 26 (50.8 x 66)
Everson Museum of Art,
Syracuse, New York; Gift
of André Emmerich, 1969

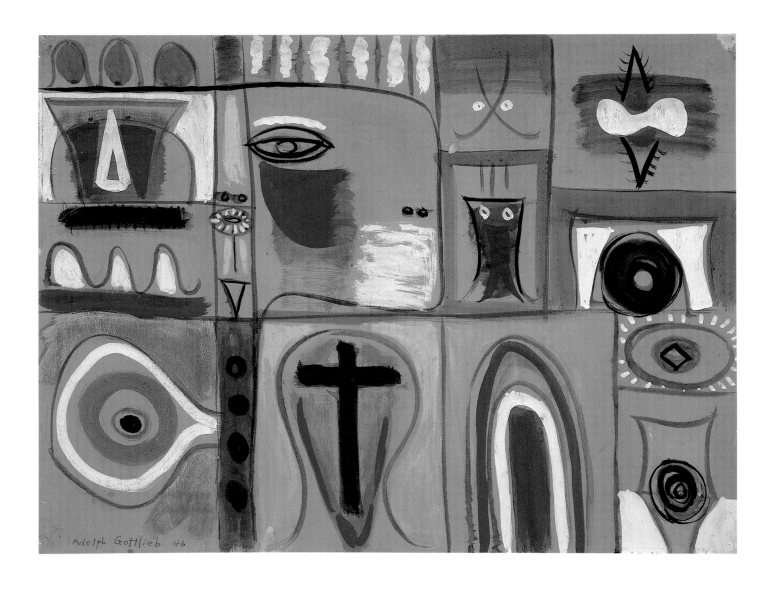

33
Adolph Gottlieb
Pictograph, 1948
gouache on paper
18 x 24 (45.7 x 61)
The Arkansas Arts Center
Foundation, Little Rock,
Arkansas

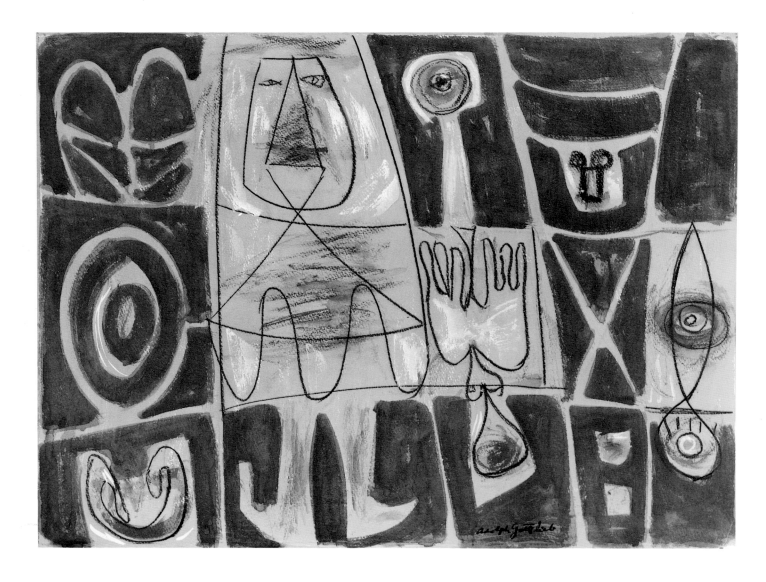

32
Adolph Gottlieb
Untitled, c. 1947–48
gouache and sgraffito on paper
24 x 18 (61 x 45.7)
Private Collection

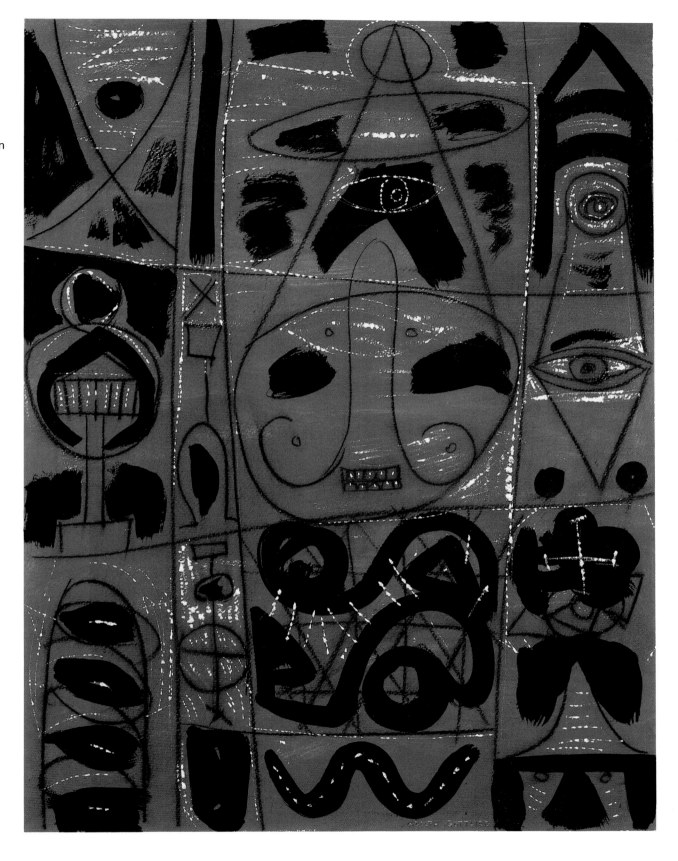

John D. Graham
1881–1961

John D. Graham, one of the most enigmatic figures in American art, was renowned during his lifetime as a connoisseur, polemicist and collector with an extraordinary eye for quality. Graham's knowledge of European modernist trends and primitive art greatly influenced a generation of young American artists, including Stuart Davis, Arshile Gorky, Willem de Kooning, David Smith, Adolph Gottlieb, Barnett Newman, and Jackson Pollock. Graham was born in Kiev in 1881 into an aristocratic Polish family.[1] Known as "Ivan Dombrovski" as a youth, Graham served as an aid to the staff of Czar Nicholas II. That experience led to his first exposure to the art of Pablo Picasso, which was to have a profound impact on Graham's paintings of the 1920s and 1930s. After serving as an officer in the Russian army during World War I, Graham emigrated in the 1920s to the United States and settled in New York.

As a dealer and collector of tribal arts, Graham traveled frequently to Paris, returning to share information on current European art theories with his fellow artists in New York. His collection offered many of these artists their first concentrated look at primitive objects, and Graham would eagerly share his ideas on art with the visitors to his apartment. A prolific writer, Graham published his philosophies of art in 1937 as *System and Dialectics of Art.* He revered the paintings of Picasso, although he was to renounce Picasso before the end of his life.

Much of the art produced by Graham during the 1940s typically contradicts many of the artistic philosophies he espoused. The drawings for which he is best known today are self-portraits and portaits of women in a style characterized by crisp outlines, continually refined, abstracted, and reworked in search of an "unobtainable Platonic perfection of form."[2] In the period 1938 to 1945 he strongly advocated spontaneity, originality, and primitive qualities as desirable in art. As Eleanor Green suggests, he "used everything that caught his eye as a source."[3] The role of the unconscious mind on the creative process intrigued him: "The purpose of art in *particular* is to reestablish a lost contact with the unconscious."[4]

Graham pursued an interest in numerology, astrology, and occult symbols, which is reflected in the stars, moons, and other cosmological symbols he employed as ideograms in gouaches such as *Untitled* (cat. 35). In this work, the artist includes small swirls, crescent moons and stars similar to Miró's astral creations, rendered in a compositional scheme resembling Gottlieb's pictographs and recalling primitive textiles.

Although Graham's works are less known than the work of many of his contemporary followers, he was held in high esteem by the generation of young New York painters who became leaders in the abstract expressionist movement. His impact on Jackson Pollock, for example, was widely acknowledged and prompted Robert Motherwell to identify Graham as "Pollock's 'Guru.'"[5] Graham's contributions through his involvement as a collector, his connoisseur's eye, and his writings as theoretician and critic are just now beginning to be assessed in their own right as well as for their value to the New York art scene of the 1940s. —DM ∎

Notes

[1] Eleanor Green, in the introductory essay to *John Graham 1881–1961: Drawings* (New York: André Emmerich Gallery, 1985), explains that Graham's baptismal certificate claims that he was born 27 December 1886, according to the Julian calendar.

[2] Ibid.

[3] Ibid.

[4] Joseph T. Butler, "The Work of John D. Graham," *Connoisseur,* vol. 169, December 1968, p. 270.

[5] Fairfield Porter, "John Graham: Painter as Aristocrat," *Art News,* vol. 59, October 1960, p. 40.

[6] Donald E. Gordon, "Pollock's 'Bird' or How Jung Did Not Offer Much Help in Myth Making," *Art In America,* vol. 68, October 1980, p. 47 and note 39.

35
John D. Graham
Untitled, 1943
gouache on paper
24 x 19 (61 x 48.3)
Courtesy Allan Stone
Gallery, New York

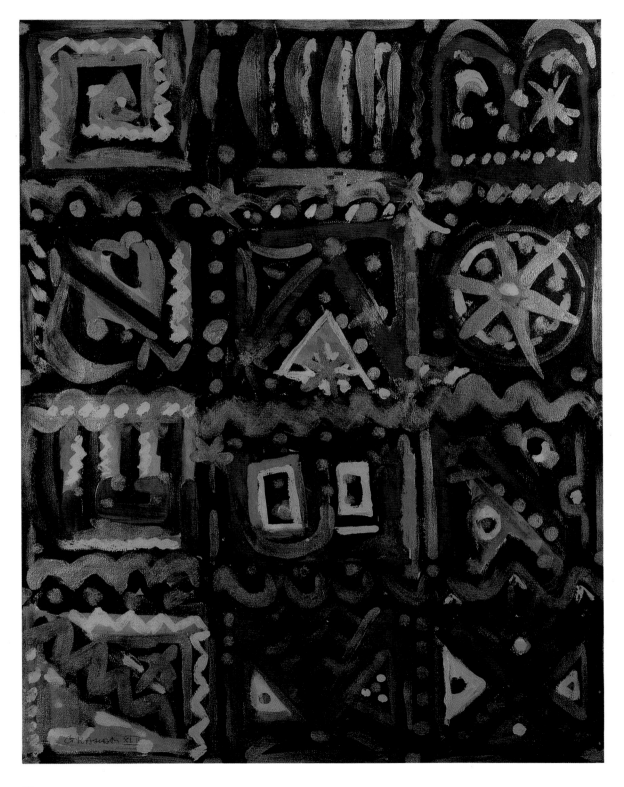

Hans Hofmann
1880–1966

One of the most vital artists and influential teachers of his time, Hans Hofmann is distinguished for bringing about a synthesis, in a nonobjective mode, of the spatial tenets of cubism and the coloristic gestural paint handling of expressionism. Approaching modernism as a deeply felt commitment transcending the historical moment, Hofmann transmitted to American students concepts of dynamic and plastic composition at a time when the New York art world was ripe for exploring the modernist esthetic.

Hans Hofmann was born in Bavaria in 1880. Although he began his art studies in Munich where a late neoimpressionism was in favor, he was in Paris by 1904, immersed in the radical reformulations of fauvism and cubism. Impressed by both Kandinsky and Delaunay (whose coloristic cubism ventured into nonobjectivity in the service of a mystical sensibility), Hofmann was nourished in his belief that "the whole world, as we experience it visually, comes to us through the mystic realm of color."[1] In 1915 when he opened the Hans Hofmann School of Fine Arts in Munich, Hofmann stressed not the imitation of the appearances of nature but "the artistic experience evoked by objective reality and the artist's command of the spiritual means of the fine arts...."[2] After teaching at the University of California, Berkeley (Summers, 1930 and 1931) and at the Chouinard School of Art in Los Angeles (1931), Hofmann settled in New York when he was forced to close his Munich school in face of the disastrous political situation; by the mid-1930s he had opened his school in New York, with summer sessions in Provincetown, Massachusetts. Hofmann became a United States citizen in 1941.

The recognizable imagery in Hofmann's landscapes and still lifes of the 1930s gave way in the 1940s to abstraction based on the rhythms of nature. This was also the period in which he most consistently explored the spontaneity of surrealist automatic drawing. In the seminal paintings *Red Tickle* (1939), *Spring* (1940), and *Fantasia* (1943), Hofmann developed a free calligraphy and a spatter and drip technique that prefigured Jackson Pollock's more persistently focused inventions. Although predating Pollock, these investigations were not pursued over a long period of time.

In a surrealist mood Hofmann could say that "the highest in art is the irrational."[3] But he also felt that "every real artistic expression that can lay claim to quality is the product of conscious feeling and perception."[4] It is just this sort of tension that is evoked in Hofmann's works on paper in this exhibition: the dynamic interplay between recognizable image and abstract shape, between spontaneity and control, and between foreboding irrationality and joyous affirmation. For instance, *Monster of the Ocean* (cat. 36) is related to the aggressively fantastic creatures seen in such well-known paintings as *Idolatress, No. 1* of 1944 and *Black Demon,* which join dark mythic connotations with the feroc-

ity of contemporary historical events. The imagery of discordance becomes both more abstract and emotionally felt in the ominous *Untitled* (cat. 41). Although the underlying structure is cubist, the planar organization almost caves in to spatters, drips and a spontaneous calligraphy of black ink that is dominated in turn by heavy black brushstrokes clinging to the picture plane and throwing into stark relief the deep space created by the white paper. Abstraction begins to dominate in *Phantasie in Red* (cat. 40), with its lively drips and scrubbed paint applications; nevertheless, this work is rooted in nature's imagery, and, despite the "push and pull" of the color areas, its surface continues to be read as a window into receding space. This watercolor is remarkable for the tiny pictographic creature situated in a space that cannily compromises between the illusionistic space of veristic surrealism and the abstract expressionists' commitment to the integrity of the picture plane. However, in *Midnight Glow* (cat. 38) and *Untitled* (cat. 42) Hofmann effects an angulation of the picture plane that suggests an upward look into the night sky or an aerial survey from great heights; scientific investigations into the infinities of macro- and microspace correlate with this shift in viewpoint. *Untitled* (cat. 37) shows Hofmann taking a different tack. The squiggles and forms vibrate with implied motion in a softly brushed field cut loose from the appearance of reality. This gouache is related to the psychological inscapes as well as to Hofmann's passion for embodying the underlying forces of nature. In *Untitled* (cat. 43) Hofmann brings together the psychological investigations of European surrealism with the form-creating inventiveness and pictorial emphasis of the New York abstract expressionists. As Hofmann put it that same year, "The creative process lies not in imitating, but in paralleling nature—translating the impulse received from nature into the medium of expression, thus vitalizing this medium. The picture should be alive, the statue should be alive and every work of art should be alive."[5]

Hofmann's first exhibition in the United States was a show of landscape drawings at the California Palace of the Legion of Honor, San Francisco. During the 1940s, he had one-person exhibitions at Peggy Guggenheim's Art of This Century Gallery (1944), Howard Putzel's 67 Gallery (1945), Betty Parsons Gallery (1947), and the Samuel Kootz Gallery (1947). —AA ∎

Notes

[1] Hans Hofmann, quoted in William C. Seitz, *Hans Hofmann* (New York: Museum of Modern Art, 1963), p. 15.

[2] Ibid., p. 11.

[3] Hans Hofmann, quoted in Frederick S. Wight, *Hans Hofmann* (Los Angeles: University of California Press, 1957).

[4] Hans Hofmann, quoted in Seitz, *Hofmann,* p. 15.

[5] Hans Hofmann, *Search for the Real and Other Essays* (Andover Mass.: Addison Gallery of American Art, Phillips Academy, c. 1948).

41
Hans Hofmann
Untitled, 1945
gouache and ink on paper
17½ x 22½ (44.5 x 57.2)
Courtesy André
Emmerich Gallery,
New York

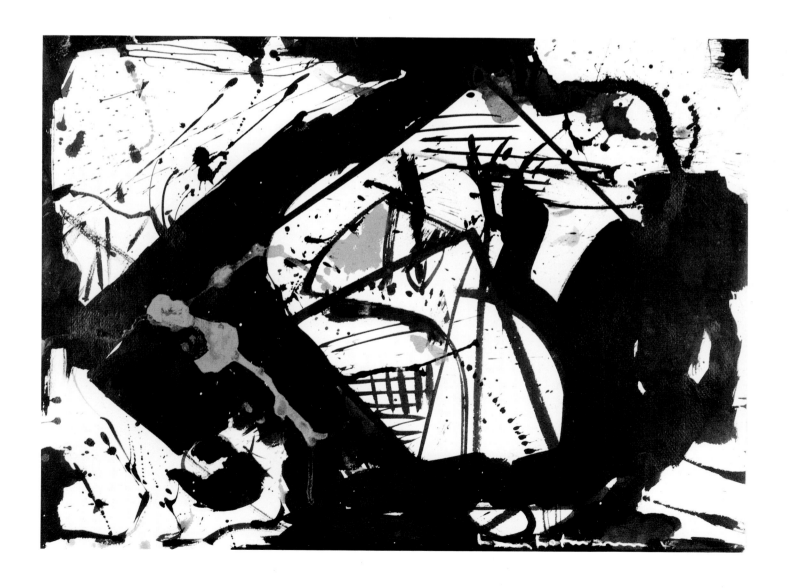

36
Hans Hofmann
Monster of the Ocean,
1944
gouache on paper
16¾ x 13¾ (43 x 35)
Courtesy André
Emmerich Gallery,
New York

37
Hans Hofmann
Untitled, 1945
gouache on paper
23½ x 17¾ (59.7 x 45.1)
Courtesy André
Emmerich Gallery,
New York

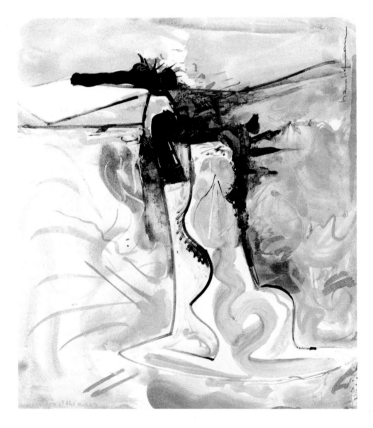
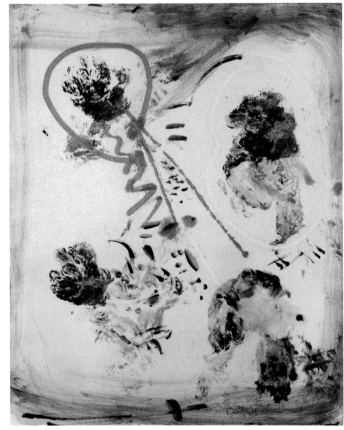

38
Hans Hofmann
Midnight Glow, 1945
gouache on paper
28¾ x 22¾ (73 x 57.8)
Courtesy André
Emmerich Gallery,
New York

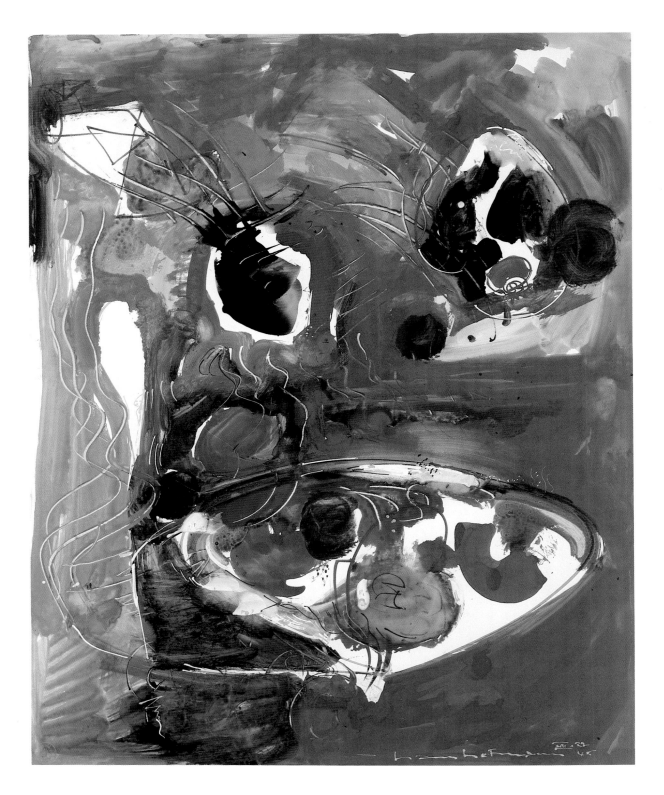

39
Hans Hofmann
Flower Garden, 1945
gouache on paper
23 x 28⅞ (58.4 x 73.3)
Courtesy André
Emmerich Gallery,
New York

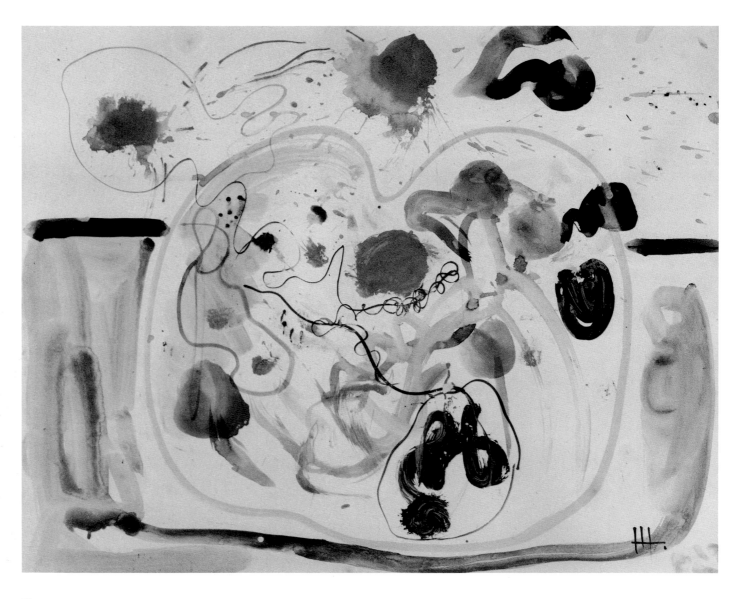

40
Hans Hofmann
Phantasie in Red, 1945
watercolor on paper
29 x 23 (73.7 x 58.4)
The Ball Stalker Collection,
Atlanta, Georgia

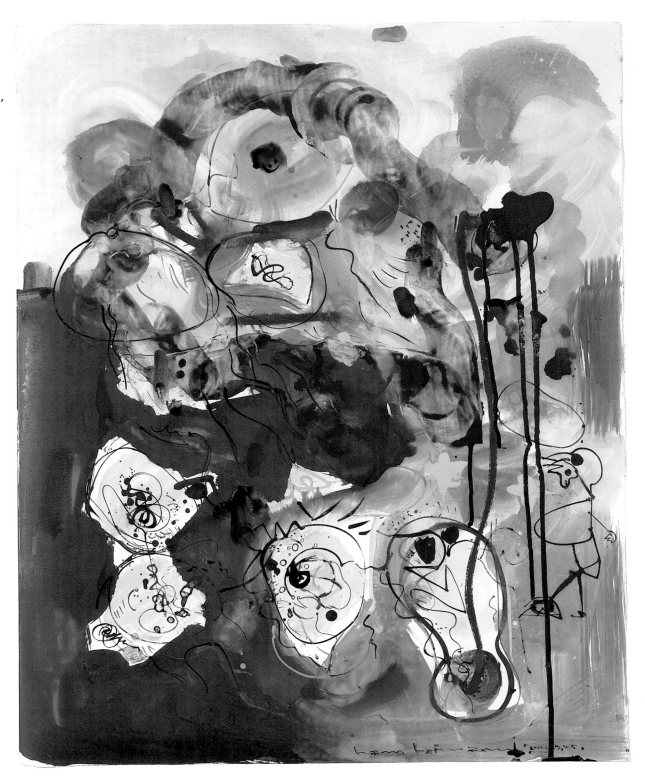

43
Hans Hofmann
Untitled, 1948
india ink on paper;
drawings on both sides
of paper
22¾ x 30 (57.8 x 76.2)
Courtesy André
Emmerich Gallery,
New York

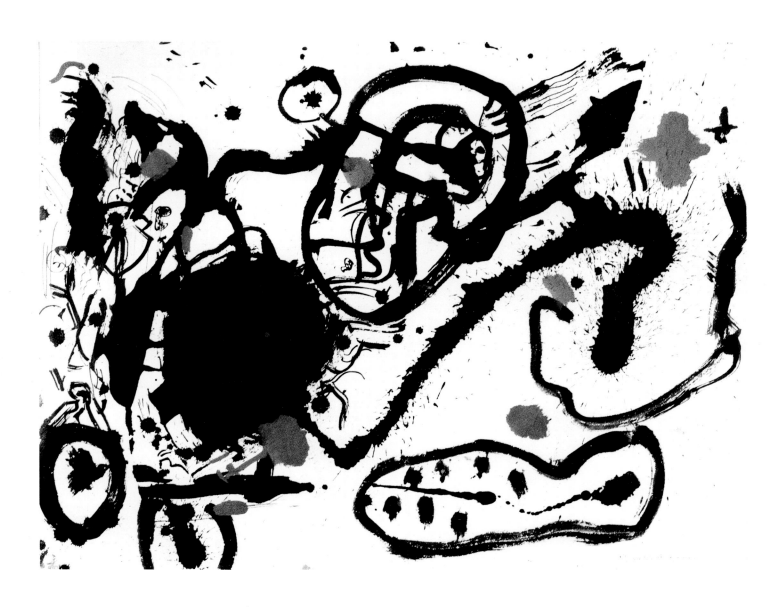

42
Hans Hofmann
Untitled, c. 1946
gouache on paper
28¾ x 23⅛ (73 x 58.7)
Cynthia and Micha
Ziprkowski, New York

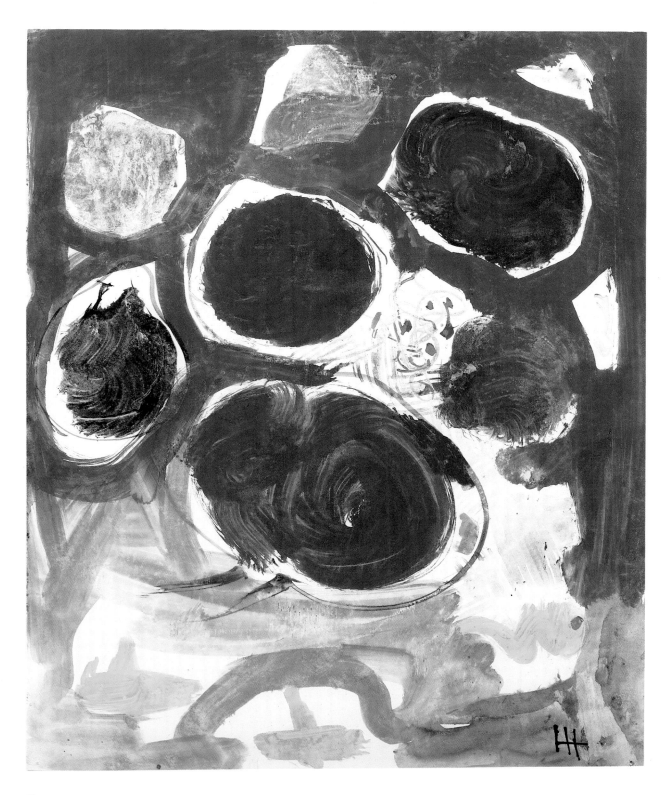

Gerome Kamrowski
b. 1914

Born in Warren, Minnesota, Gerome Kamrowski studied painting at the St. Paul School of Art, the Art Students League in New York, and the New Bauhaus in Chicago before returning to New York via a Guggenheim Fellowship in 1938 to enroll at the Hans Hofmann School in Provincetown. Already familiar with European surrealist work through exhibitions and publications circulating in the 1930s, Kamrowski was to see these techniques demonstrated when he met Baziotes in the fall of '38. The possibilities offered by creating paintings by means other than brushwork stimulated these artists to experiment with combinations of nontraditional materials (enamel and latex) and techniques such as fumage, collage, and coulage, which they had seen in the works of practitioners of surrealism. Kamrowski soon abandoned the "expressionist cubism" of his Hofmann days and began to infuse his work with forms derived from nature. *Rouge* (cat. 44) of 1940 is an organic abstraction combining conscious composition with spontaneous drips, spatters, and flowing paint. In this work a dimensional transparency is achieved, with darker areas appearing as caves or recessions and lighter, linear traces seemingly closer to the picture plane.

Kamrowski remembers the arrival of the European surrealists in New York as a vital period and was drawn to their sense of optimism, adventure, and freedom: they "had a certain aspect of humanism that was part of their culture, and that brought out a more comprehensive scheme than just the narrow, professional attitude towards form which Hofmann would try to present."[1] The sessions at Matta's studio, attended by Kamrowski, Baziotes, Motherwell, Gorky, Pollock, and Peter Busa, gave these artists first-hand exposure to late-surrealist ideas, among which was psychic automatism. This belief that untapped content existed in human gesture "unhinged [us from] preconceived ideas... from all sorts of residual things. You got a direct expression without mirroring Europe, or mirroring the Midwest, or the fashionable painting uptown; the automatic techniques were a springboard for the imagination."[2] Following the surrealist lead, Kamrowski and his fellow artists experimented with the abstract representation of space and time, psychological space, unseen organic structure, myth, and prehistory, conveying variations of automatist-inspired surrealism.

Kamrowski's two-sided work *Emotional Seasons* (cat. 47) presents two versions of a series the artist repeated in 1943. *Emotional Seasons* (recto) shows the influence of Matta, whose psychological inscape paintings of 1939–42 include similar cave and rock formations; Kamrowski adds organic calligraphic images of sperm, wavy tendrils, and spiky antennae. Illustrating the surrealist conviction of "simultaneity in nature," Kamrowski's linear pattern at the top center at once brings to mind wave action, electromagnetic fields, and wood grain. (Kamrowski's *Alienated Emissaries*, a 1939 painting influenced by Ernst's frottage technique, bears a similar natural pattern in the plywood ground.) Dots of paint appear, not freely spattered as in *Rouge*, but more deliberately applied. The verso of this work abandons landscape format for a flatter, all-over orientation with pockets of illusionistic space enclosing leaves applied as collage elements. *Small Scene on a Pagan Bluff* (cat. 46) combines landscape references, rendered in a blotchy manner similar to Matta's technique of applying paint with rags, with abstract linear drawing. The network formations of lines and dots recall Miró's zig-zag tracings as well as scientists' models of molecular structure.

Gerome Kamrowski was included in the collage exhibition at Art of This Century in 1943 and participated in group exhibitions throughout the '40s, with his first one-person show at Mortimer Brandt Gallery, New York, in 1946. Leaving New York in 1946 to teach at the University of Michigan, Kamrowski continued working in an abstract-surrealist vein for many years. To this day, Kamrowski's art is energized by randomly applied pattern as he explores the inherent "metaphysical aspect...of varied materials."[3]—SH ■

Notes

[1] Evan M. Maurer and Jennifer L. Bayles, *Gerome Kamrowski: A Retrospective Exhibition* (Ann Arbor: The University of Michigan Museum of Art, 1983), p. 1.

[2] Ibid., p. 3.

[3] Ibid., p. 7.

44
Gerome Kamrowski
Rouge, 1940
oil and enamel on paper
20 x 32 (50.8 x 81.3)
Collection Mary Jane
Kamrowski, Ann Arbor,
Michigan

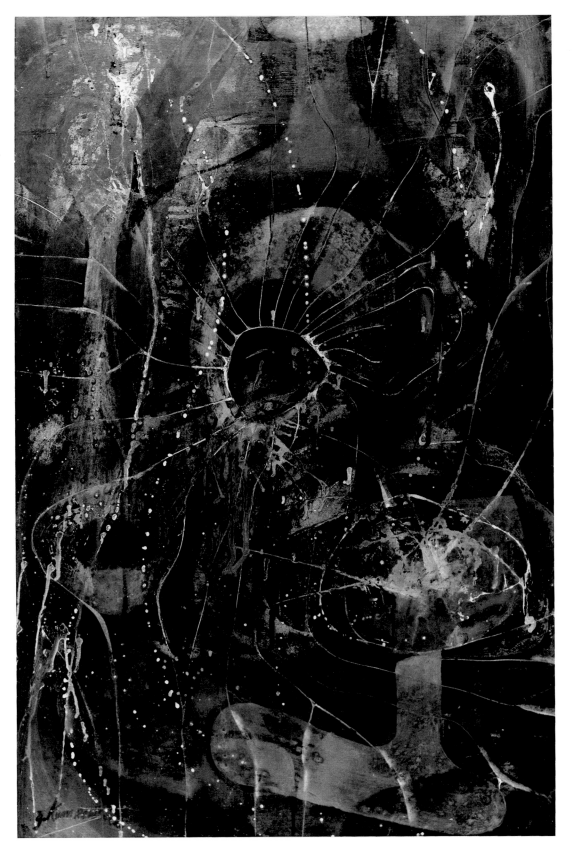

46
Gerome Kamrowski
*Small Scene on a Pagan
Bluff,* 1943
gouache on paper
22 x 30 (55.9 x 76.2)
Jane Voorhees Zimmerli
Art Museum, Rutgers—
The State University,
New Brusnwick, New
Jersey; Gift of the artist

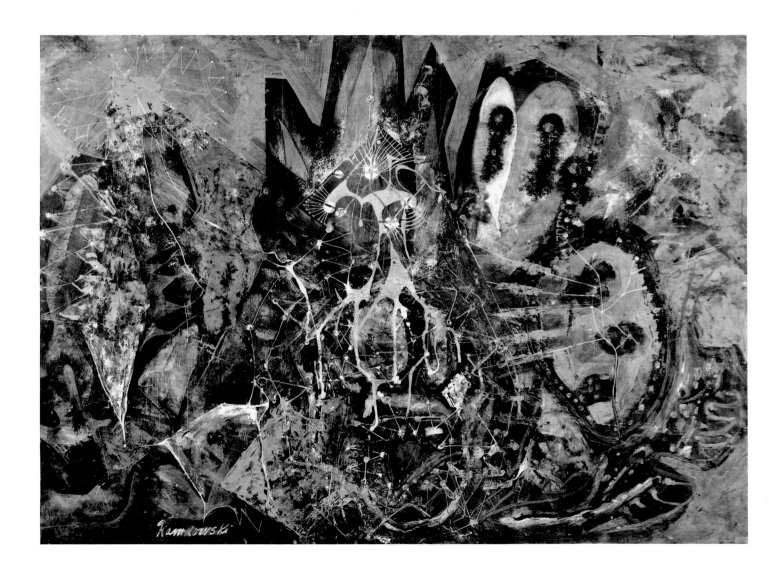

47
Gerome Kamrowski
Emotional Seasons, 1943
(recto)
gouache and collage on
paper on wood
21½ x 21⅛ (54.6 x 53.7)
Collection Whitney
Museum of American
Art, New York; Purchase,
with funds from Charles
Simon, 78.69

47
Gerome Kamrowski
Emotional Seasons, 1943
(verso)
gouache and collage on
paper on wood
21½ x 21⅛ (54.6 x 53.7)
Collection Whitney
Museum of American
Art, New York; Purchase,
with funds from Charles
Simon, 78.69

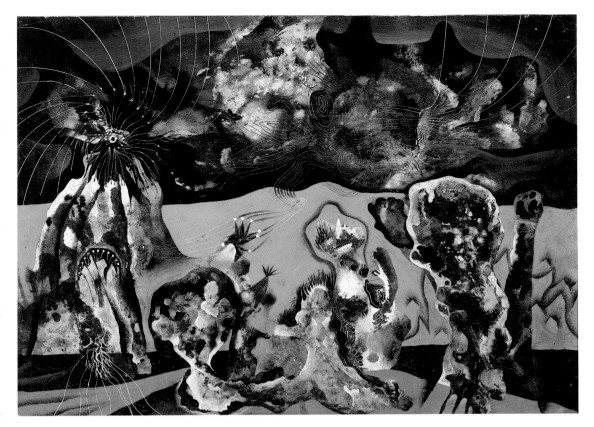

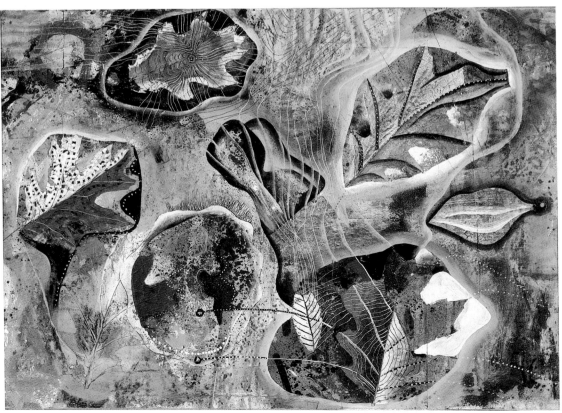

Wifredo Lam
1902–1982

Wifredo Lam was born in Sagua la Grande, a region in northern Cuba characterized by an intermingling of cultures and peoples. In Lam's own words, his homeland was "a privileged geographical cross-roads, both a meeting point and a point of departure."[1] The son of a Chinese merchant from Canton and a Cuban mulatto woman, Lam inherited a blend of African, European, Indian, and Chinese cultural traditions. During his childhood, Lam was greatly influenced by his godmother, a professional sorceress of African descent who told him stories of strange spirits that haunted the Antilles and who provided his first exposure to African masks and figurines used in cult rituals.

In 1923 Lam left his home in the Antilles to attend painting classes in Madrid. Upon his first visits to the Prado, he began to study the formal elements and irrational qualities in the works of European artists such as El Greco. Lam discovered the art of Pablo Picasso in 1936. The fall of the Spanish Republic in 1937 forced Lam to flee to Paris; there he was taken in by Picasso, who became his mentor and close friend. Picasso introduced Lam to André Breton, André Masson, Yves Tanguy, and Max Ernst, and in 1941 Lam and several of his surrealist colleagues left Paris to escape the Nazi invasion. His travels during the 1940s included several excursions to New York, which brought him into contact with American artists who were exploring surrealist techniques. Returning to Havana in 1942, Lam rediscovered his African and Cuban heritage.

In *Maternidad-Yoruba* (cat. 48) Lam pays homage to nature's irrepressible fecundity, blending cubist and surrealist styles in a composition that fuses human form with vegetation. The strange creature in *Les yeux de la grille* (cat. 50) recalls the spirits of which his godmother had spoken, and its primitive, distorted features resemble ancient Iberian and African tribal masks. The imaginary, fanciful quality of Lam's figures is similar to the dreamlike imagery in the works of his surrealist colleagues in Paris, but what differentiated Lam from the Europeans and placed him closer ideologically to the painters of the New York School was his attitude about primitivism; for him, primitivism was not something to be adopted as a formal device but was an approach that would reveal essential human truths and infuse art with mythic content. Although his tightly controlled composition can be traced to the lessons he learned from El Greco, the greatest influence on his art during this period was the expressive cubist work of Picasso, whose *Guernica* of 1937 had a great impact on Lam's imagery and style. Lam synthesized the muted palette and cubist spatial organization that he learned from Picasso with European artistic principles and fantastic imagery from his own personal experience to create a deeply personal art which transcends cultural boundaries.

Lam's work was seen in New York as early as 1939, when he was included in an exhibition at the Museum of Modern Art and in a two-person exhibition with Picasso at Perls Gallery. He was included in the First Papers of Surrealism show at Reid Mansion in 1942 and was given one-person exhibitions at Pierre Matisse Gallery from 1942 to 1948. A retrospective was held at the Palais des Beaux-Arts in Brussels (1967), and a posthumous retrospective at the Museum of Modern Art of the City of Paris (1983). Lam died in Paris in September 1982.—DM ∎

Notes

[1] Quoted by Francisco Fernandez-Santos in Lam's obituary, "Wifredo Lam: 1902–1982," *Unesco Courier,* November 1983, p. 27.

48 (opposite)
Wifredo Lam
Maternidad—Yoruba, 1942
charcoal, crayon, and
gouache on paper
48 x 37½ (122.5 x 95.5)
Private Collection

50
Wifredo Lam
Les yeux de la grille, 1942
gouache on paper
41½ x 33 (105.4 x 86.4)
Pierre Matisse Gallery,
New York

André Masson
b. 1896

A leader of the painterly automatism branch of surrealism, André Masson essayed more than any other surrealist to link the culture of modern man with the culture of prehistoric man. Stylistically, he best accomplished this with his line, particularly his painted line, which, it has been contended, was never matched in the history of art.[1] Not only does Masson's line guide him through his metaphorical labyrinth, it also propels him ever onward in his restless wandering;[2] this accounts for the apparent lack of stylistic unity in his work. His 1923–24 pen and ink drawings are considered among the most remarkable achievements of surrealism. These are works described by a pen which moves rapidly with no predetermined idea of subject, forming images which are sometimes built upon, sometimes left unfinished, but all evincing a psychic unity.

From 1938 to 1948, Masson struck a balance between line drawing and color.[3] After moving to Connecticut in 1941, his drawing freed itself from mere description and fused itself with colored forms, devouring any sense of space, as witnessed in his 1942 pastel *Le Rapt* (cat. 52). Subsequent works (e.g., *Combat légendaire* and *Le nu bleu*) saw drawing virtually disappear into luminous though nebulous space. His influence on Jackson Pollock is obvious and hardly surprising since both were "tough, vigorous, earthy, and more given to creation than theory."[4] Masson had splashed glue on his canvas (and covered it with sand) long before Pollock's drip paintings. At heart, this affinity was essentially "a question of line, a kind of line that breaks away from...contours or modelling the surface."[5] Iconographically, their works posit a similar mythic (both painted similar versions of "Pasiphae" in 1943) and psychic content. Samuel Beckett's 1949 observation is an apt encapsulation of Masson's work in this period: "here is an artist literally skewered on the ferocious dilemma of expression...[yet] he continues to wriggle."[6]

André Masson was born in 1896, at Balogny, Oise, France. In 1912 he studied at the École Supérieure des Beaux-Arts, Paris. He came to America in 1941 and lived in Connecticut from 1941 to 1945. Masson had a one-person exhibition at the Baltimore Museum of Art (1941) and was included in many group exhibitions, including the International Exhibition of Surrealism organized by Breton and Paalen in Mexico City (1940), several shows at Art of This Century, and the European Artists in America exhibition at the Whitney Museum of American Art (1945).—JS ∎

Notes

[1] Muriel Emanuel, ed., *Contemporary Artists* (New York: St. Martin's Press, 1983), p. 599.

[2] Michel Leiris, "The Unbridled Line," *Drawings* (London: Thames and Hudson, 1972), n.p.

[3] Otto Hahn, *Masson* (New York: Abrams, 1965), p. 27.

[4] Edward B. Henning, *The Spirit of Surrealism* (Cleveland: Cleveland Museum of Art in cooperation with Indiana University Press), p. 47.

[5] William Rubin, "Andre Masson and Twentieth-Century Painting," in William Rubin and Carolyn Lanchner, *André Masson* (New York: Museum of Modern Art, 1976), p. 68.

[6] Rubin, ibid., p. 68.

51
André Masson
*Vois l'antre des
metamorphoses,* 1938
ink on paper
19½ x 25¼ (49.5 x 64.1)
Herbert F. Johnson
Museum of Art, Cornell
University, Ithaca, New
York; Membership
Purchase Fund

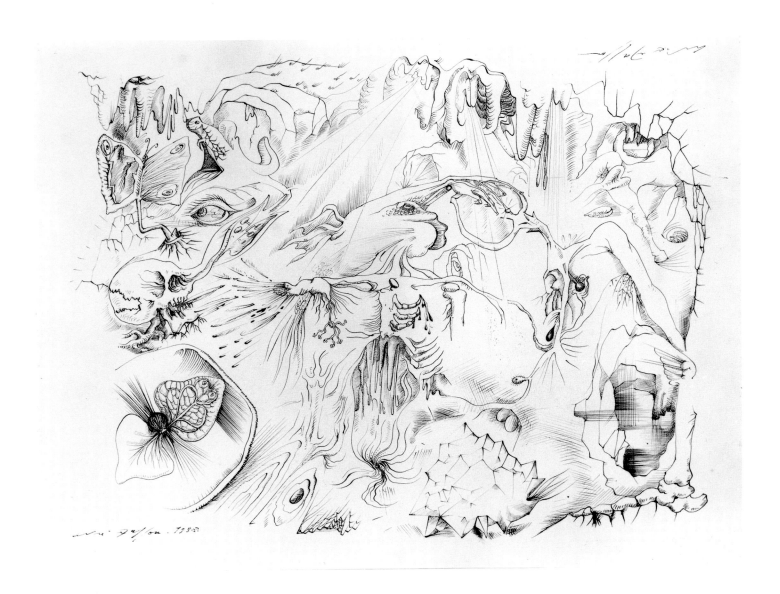

52
André Masson
Le rapt, 1942
pastel on cardboard
19 x 25½ (48 x 65)
Courtesy Marisa del Re
Gallery, Inc., New York

53
André Masson
Sexus, 1942
charcoal, tempera, and
Chinese ink on paper
17⁹/₁₀ x 24 (46 x 61)
Courtesy Marisa del Re
Gallery, Inc., New York

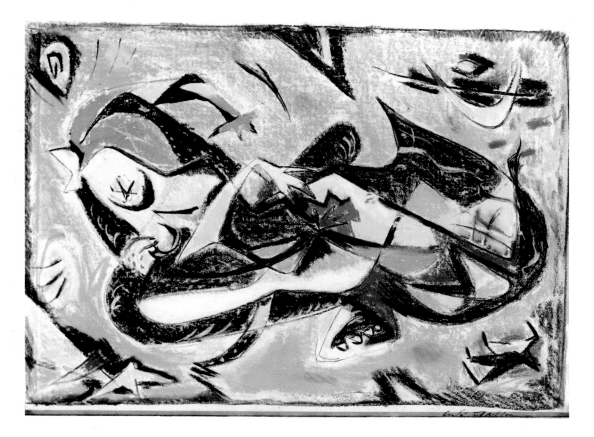

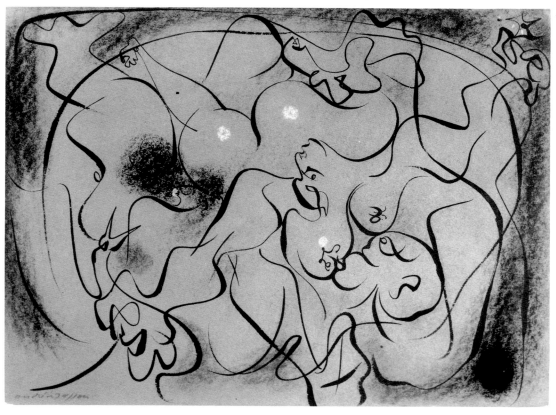

54
André Masson
Amants entrelacés, 1943
gouache on paper
10½ x 8 (27 x 20)
Courtesy Marisa del Re
Gallery, Inc., New York

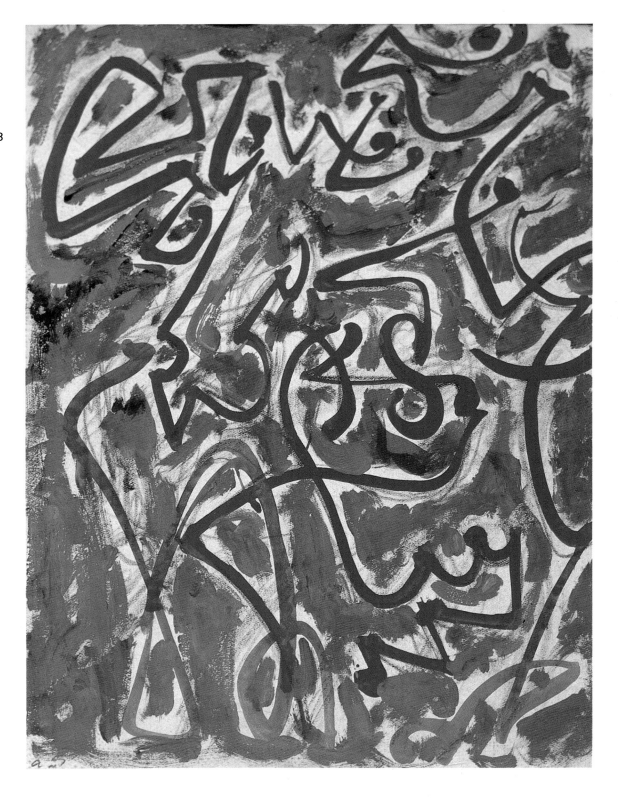

58
André Masson
Regardant l'aquarium,
1944
watercolor, ink, and
pastel on paper
19¾ x 23½ (50 x 59.3)
Collection Anne and
Jean-Claude Lahumière,
Paris

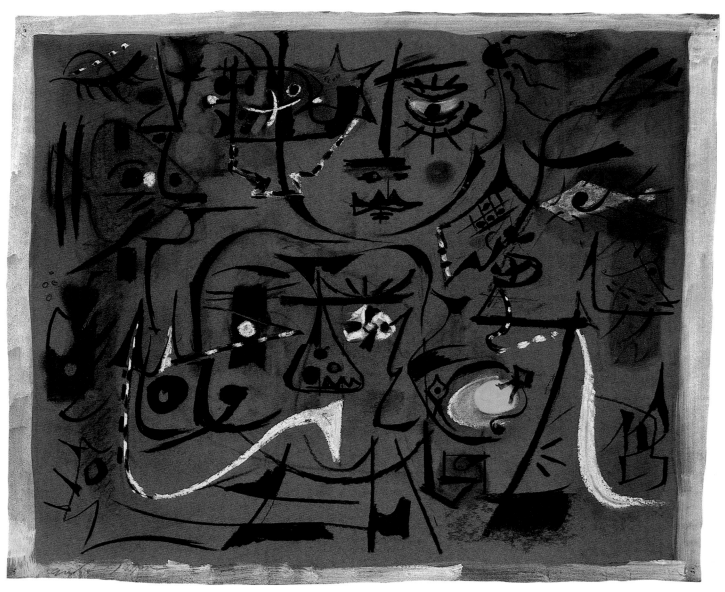

55
André Masson
Combat légendaire, 1943
pastel on paper
30 x 22 (76 x 56)
Courtesy Marisa del Re
Gallery, Inc., New York

57
André Masson
Le nu bleu, 1944
pastel on paper
15¾ x 19 (40 x 48)
Courtesy Marisa del
Re Gallery, Inc., New York

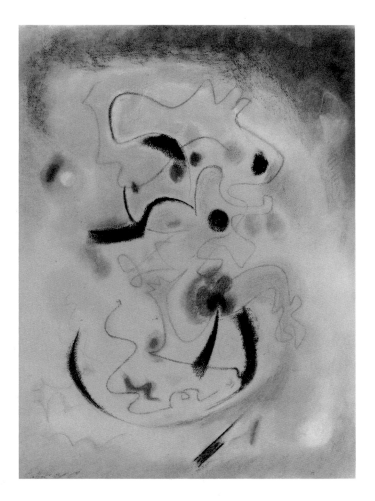

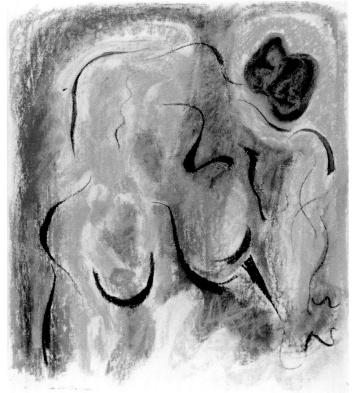

59
André Masson
Vieux souliers sous la pluie, 1945
tempera and Chinese ink on paper
21¾ x 18½ (55 x 47)
Courtesy Marisa del Re Gallery, Inc., New York

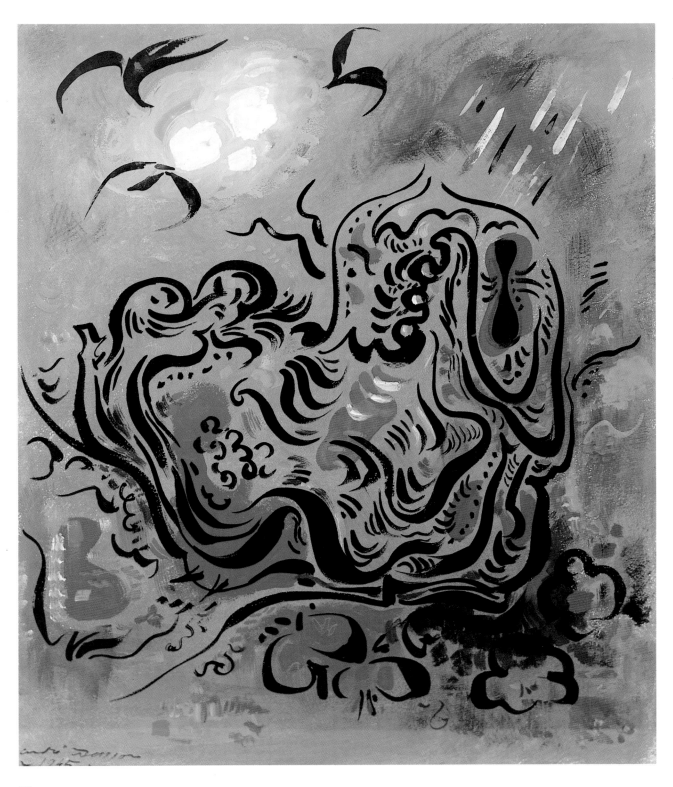

Matta (Roberto Matta Echaurren)
b. 1911

Third in the line of abstract surrealists after Miró and Masson, Roberto Matta Echaurren was dubbed the "absolute automatist" by André Breton. His automatism was reflected in the biomorphic and geological shapes suspended in the deep, glowing phosphorescence of the 1938–40 psychological morphologies, simultaneously representing inner, psychological space and cosmic space. Automatism continued in *Here Sir Fire, Eat!* (1942), among the "chaoscosmic" series which followed, inspired by observations of volcanic soil in Mexico. There, erotic organisms of aqueous blue-green are held in a liquescent blaze of sulphurous yellow. These paintings were of singular importance for the emergent abstract expressionists then exploring mythic ideas stimulated by Matta's imagery. For Arshile Gorky, especially, exposure to Matta's execution with thin washes, oily rags, and hues squeezed directly from the tube, prompted the leap reflected in *The Pirate* (1942). In Matta's *To Escape the Absolute* (1944), modeling gave way to the compartmented, multiperspective structure and linear network which recall both the stringed-labyrinth gallery of The First Papers of Surrealism exhibition (1942) and the cavernous ambiance of Peggy Guggenheim's gallery, Art of this Century, designed by Frederick Kiesler later in the same year; but the crowning work of the first half of Matta's New York years was *Vertigo of Eros,* 1944 (its title, a Duchampian pun on eros and rose). Gorky's transparent planes enter Matta's vocabulary, with modeling only in the tiny cosmic rocks glittering in space along with neon-like streaks and eddying circles of light that illuminate a deep, dark, elliptical field. *Vertigo of Eros* reflects Matta's affinity with the abstract expressionists; the liquid fires of the prior work all but disappear, but skeletal fragments forecast the emergence of the figuration announced by *The Poet* (1944), a witty portrait of André Breton. Here Matta reaffirmed his ties to surrealism. A succession of huge, horizontally-disposed mythic narratives populated with totemic figures having sources in primitive art and science fiction followed. *Science, conscience et patience du vitreur* (1944) is a cataclysmic interpretation of Breton's concept of a transparent, higher being, its vitrine surface reflecting the impact of Duchamp's *Large Glass,* but with Matta passage is from life to death, an obsession which pervades the second half of the New York period.

Matta's drawings illuminate the evolution of content and development of style in the paintings of the New York period and the role chance and accident played in the building of his esthetic vocabulary. Indeed, the *Preliminary Study for "Prescience"* (cat. 62) and *Psychological Architecture* (cat. 63) reveal how images induced by automatism determine the final achievement. Drawn with wax crayons and pencil, the psychological morphology drawings delineated flowers, stars, genitalia and the amorphous geological furniture that made up fantastic landscapes. In the densely filled *Untitled* (cat. 60), voluptuously modeled, erotic images recede in one-point perspective; but *Endless Nude* (cat. 61) is created with delicately inflected line in an open space of earth and sky separated by a horizon line. Matta's theme changes with the harder line of *Untitled* (cat. 64) endowing personages with the monstrous attributes to appear in later paintings, only a modicum of landscape imagery remaining. In *Untitled* (cat. 65) figures, now filled in with color and tenuously linked by thin line, swirl helplessly in vast cosmic space, but within the more structured space of *Woman Impaled and Five Other Scenes* (cat. 68) isolated figures are tortured. In *On ne possède sur les immeubles* (cat. 67) personages, including animals, interact in an expansive but compartmented space, while in the labyrinthine line of *Les lits des vulqivaques* (cat. 66), they whirl at the mercy of an unknown force. Indeed, this series of drawings, executed 1938–48, reveals the compelling, predictive, inner vision guiding his responsive hand at the core of the pictorial achievement that meticulous brushwork and technical virtuosity brought about on canvas even years later.

Born in Santiago, Chile on November 11, 1911, Roberto Antonio Sebastian Matta Echaurren graduated in architecture from Santiago's Catholic University in 1932, arriving in Paris in 1934 to work in Le Corbusier's atelier. Turning to automatist drawings of fantastic images, he joined the surrealist milieu in 1938 and began painting, encouraged by Gordon Onslow Ford. After emigrating to New York in October 1939, his drawings were shown at the Julien Levy Gallery in 1940. His first solo exhibition was at the Pierre Matisse Gallery in 1942, the year he participated in Artists in Exile there, and the landmark First Papers of Surrealism, organized by Duchamp and Breton. Numerous major group exhibitions include the International Surrealist Exhibition in Mexico City (1939); Galerie des Beaux-Arts, Paris; Abstract and Surrealist Art in the United States (1944), circulated by the Cincinnati Art Museum; and the Whitney Museum of American Art's European Artists in America exhibition (1945). Matta left New York in 1948 and settled in Rome. Since the end of the 1950s, he has continued to paint in London, Paris and Italy.—MS ∎

60
Matta
Untitled, c. 1938
crayon and pencil on
paper
12¼ x 19 (31.1 x 48.3)
Maxwell Davidson
Gallery, Courtesy Arnold
Herstand & Company,
New York

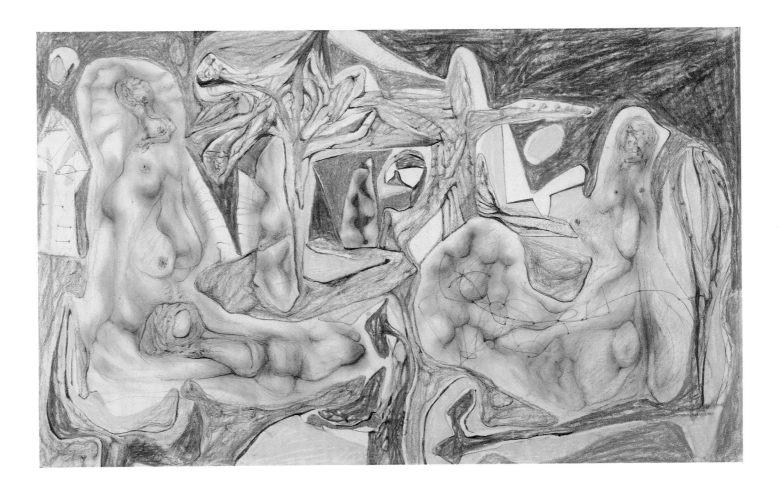

61
Matta
Endless Nude, 1938
crayon and pencil on
paper
12¾ x 19½ (32.4 x 49.5)
The Museum of Modern
Art, New York, Katherine
S. Dreier Bequest

64
Matta
Untitled, 1941
crayon and graphite on
paper
11 x 15 (27.9 x 53.3)
Courtesy Allan Stone
Gallery, New York

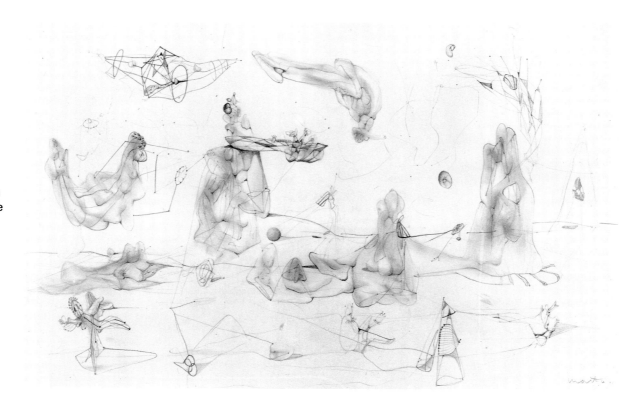

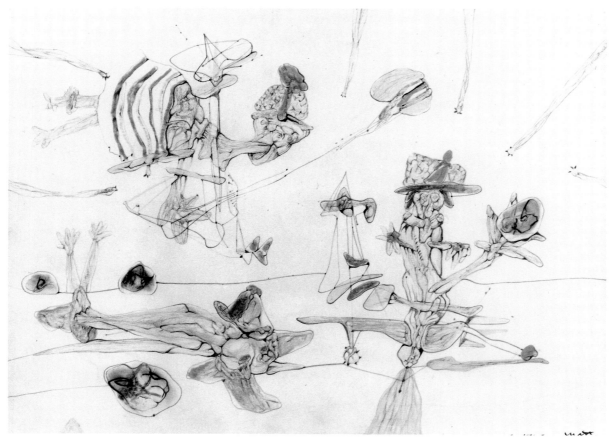

62
Matta
Preliminary Study for
"Prescience," 1939
pencil and colored pencil
on paper
11 x 14⅝ (28 x 37.3)
Collection Luisa Laureati,
Galleria dell'Oca, Rome

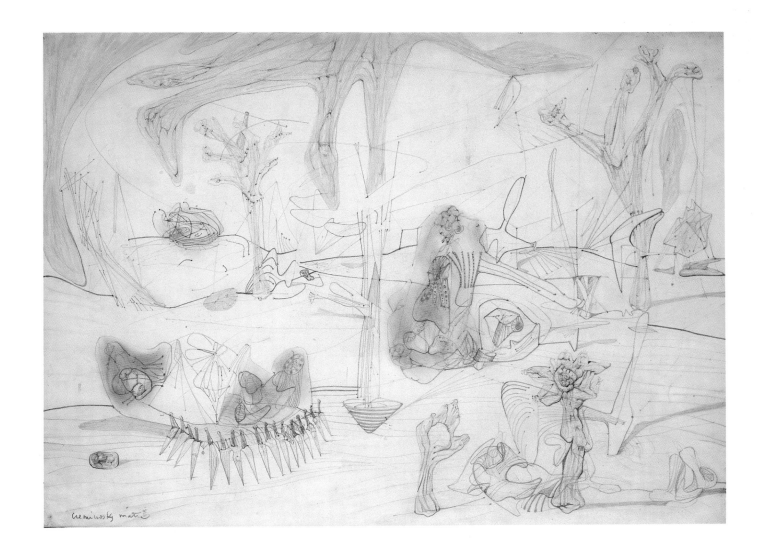

65
Matta
Untitled, 1942
crayon and pencil on
paper
23 x 29 (58.4 x 73.7)
Private Collection,
New York

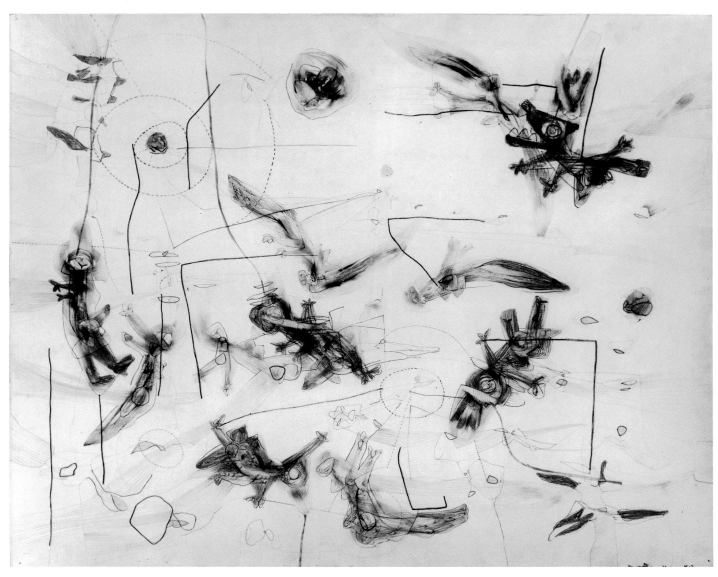

63
Matta
Psychological Architecture,
1940–41
crayon, pencil and colored
pencil on paper
16¾ x 21 (43 x 53.3)
Collection Mr. and Mrs.
Bruce Clark, New York

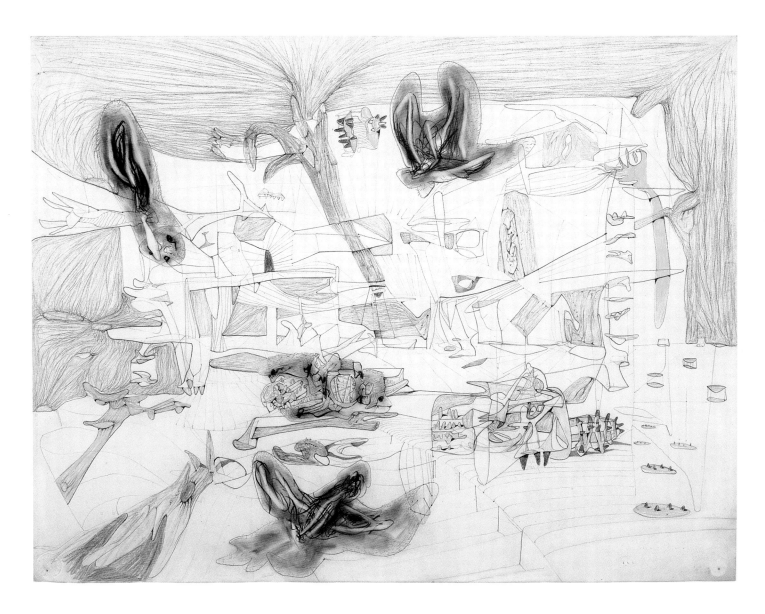

66
Matta
Les lits des vulqivaques,
1943
pencil and crayon on
paper
22½ x 28½ (57.2 x 72.4)
Allan Frumkin Gallery,
New York

67
Matta
*On ne possède sur les
immeubles,* 1943
pencil and crayon on
paper
22½ x 28½ (57.2 x 72.4)
Private Collection,
New York

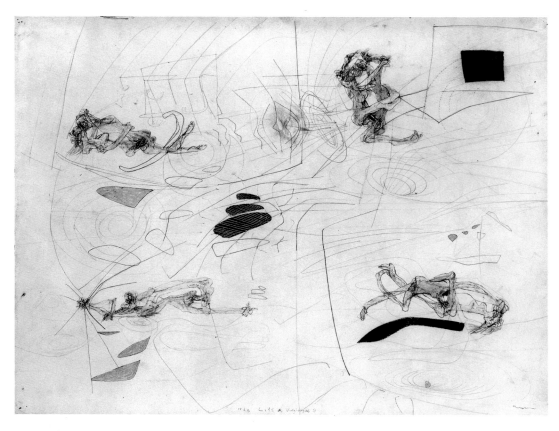

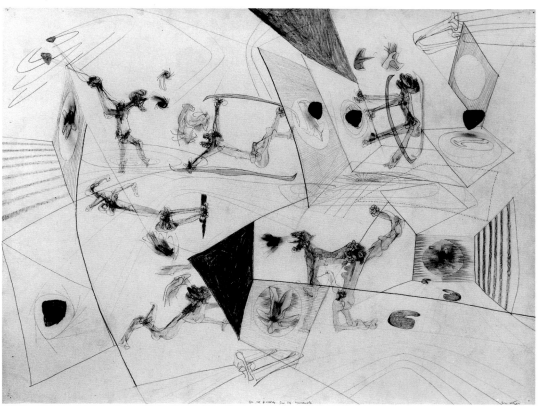

68
Matta
*Woman Impaled and
Five Other Scenes,* 1943
pencil and crayon on
paper
23 x 29 (58.4 x 73.7)
Private Collection,
New York

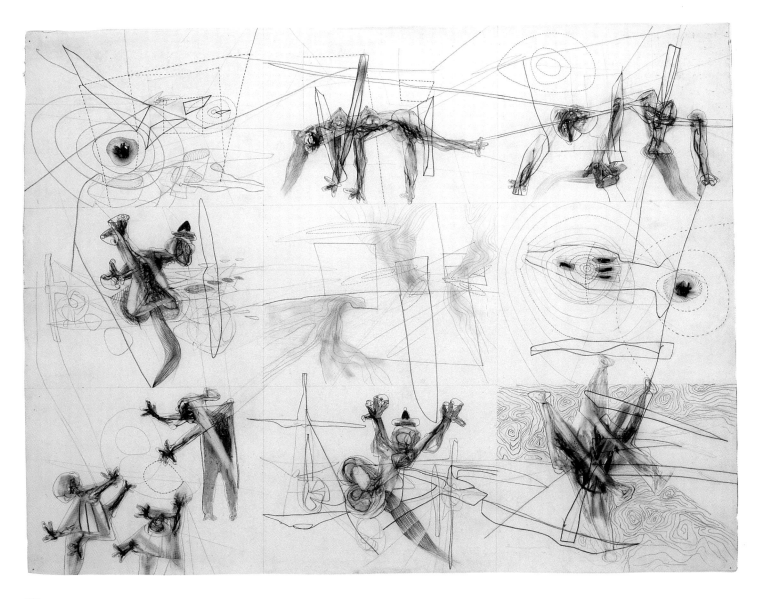

71
Matta
Untitled, c. 1948
pastel on paper mounted
on canvas
39 x 59 (100 x 150)
Private Collection

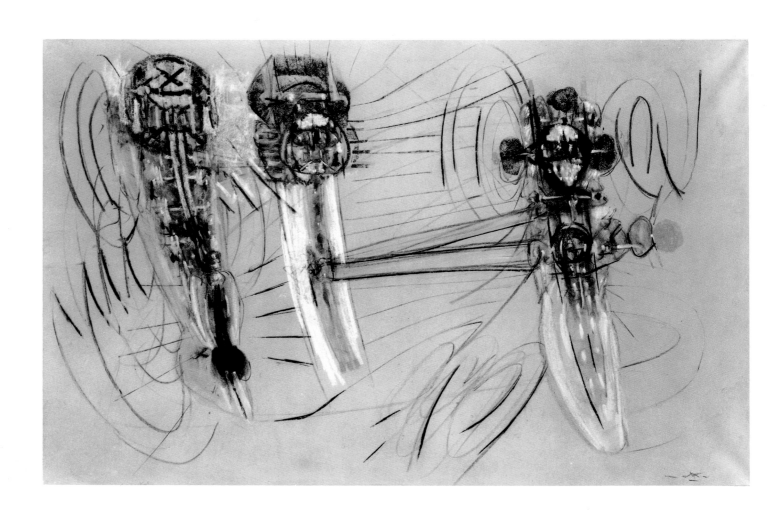

70
Matta
Crucifixion, c. 1946
pencil and crayon on
paper
17 x 21¾ (43.2 x 55.2)
Private Collection

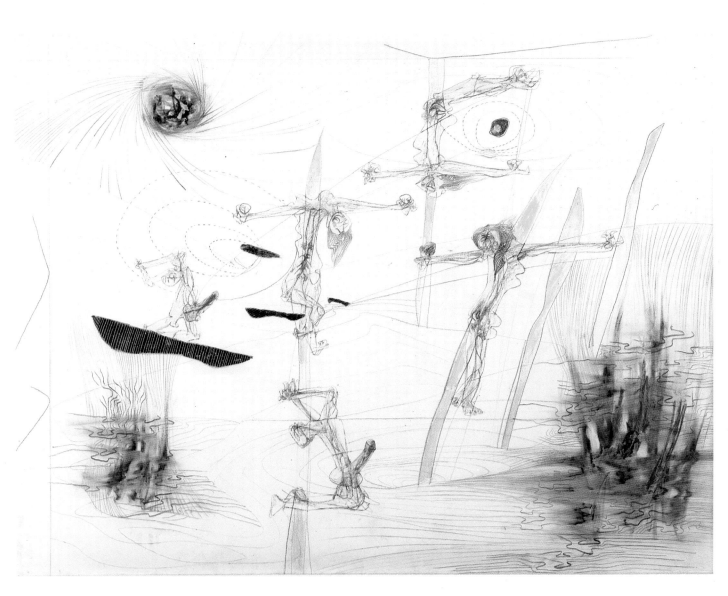

Joan Miró
1893–1983

Joan Miró has been called the leader of the abstract branch of surrealism as opposed to that branch represented by artists such as Salvador Dalí and Rene Magritte, who were interested in more naturalistic representation. Although Miró was not among the European surrealists who came to New York at the onset of World War II, a retrospective of his work was seen in 1941 at the Museum of Modern Art. As Barbara Rose has pointed out, many New York artists saw in Miró's paintings a way out of tight geometric composition and a way to incorporate organic imagery with abstraction.[1]

Miró's oeuvre concerned itself with "establishing a valid aesthetic reality, understood and enjoyed as such."[2] This he achieved not just technically, with his sense of color, rhythm, fantasy and decorative harmony, but also iconographically as he incorporated his dream research into his predilection for Catalan folk art, children's art, and the paintings of Bosch. Inasmuch as he plumbs his unconscious for sources and works from chance splashes on the canvas, his work is filtered through a calculating sensibility: "For me a form is never something abstract; it is always a sign of something. It is always a man, a bird, or something else. For me painting is never form for form's sake."[3] Miró's work makes no distinction between painting and poetry; for him, creation is the "re-creation"[4] of a unity man once possessed. Profoundly human, his work runs the gamut of man's most elementary emotions—love, despair, confidence; his is a very personal sign language of biomorphic forms.

Events in Europe greatly affected Miró from 1938 to 1948. In 1940–41 his structurally intricate *Constellations* series, which includes *Acrobatic Dancers* (cat. 72), shows him trying to disengage himself from the "stink and decay of a world built by Hitler and his friends,"[5] to balance spontaneity and control, joy and anger. The forms pulsate like musical notes in counterpoint against a carefully prepared, fathomless background; with this series, Miró sought to liberate pictorial space from the cubist grid. Once done with this series, Miró felt the need to be less exacting, to work with less control. Out of his concern came *Personnages, oiseaux, étoiles* (cat. 74), in which the colors are more somber than the preceding series, the space less crowded. The scene is imbued with doubt and uncertainty, with ferocious, menacing shapes resembling graffiti scrawled across a dark alley wall. Miró's significance to Adolph Gottlieb's pictographs rests chiefly in his use of a personal vocabulary of form as expressed through myths, primitive art and totemic allusions. To Arshile Gorky, Miró imparted a vocabulary of biomorphic shapes and an opening up of pictorial space. With the sensibility of a magician, Miró has, as André Breton pointed out, allowed us "to penetrate into the cosmic order with all that is involved in going beyond our condition."[6]

Joan Miró was born on April 29, 1893, in Barcelona, Spain. He studied at both the School of Fine Arts and the Academy Gali in Barcelona. He first visited America in 1947 to paint a mural for Cincinnati's Terrace Plaza Hotel, returning to Paris in 1948. Important exhibitions during the period 1938 to 1948 include his major retrospective at The Museum of Modern Art, New York (1941), annual solo shows at Pierre Matisse Gallery, and group shows at the New School for Social Research (1941), First Papers of Surrealism and Art of this Century (1942), and Howard Putzel's Gallery 67 (1945).—JS ■

Notes

[1] Barbara Rose, *Miró in America* (Houston: The Museum of Fine Arts, Houston, 1982), p. 117.

[2] Roland Penrose, *Miró* (London: Thames and Hudson, 1985), p. 64.

[3] Miró, quoted in James Johnson Sweeney, "Joan Miró: Comment and Interview," *Partisan Review,* 1948, reprinted in Rose, *Miró in America,* p. 117.

[4] Margit Rowell, *Miró* (New York: Abrams, 1970), p. 7.

[5] Miró, quoted in Penrose, p. 102.

[6] Penrose, p. 105.

72
Joan Miró
Acrobatic Dancers, 1940
gouache and oil wash
on paper
18½ x 15 (47 x 38.1)
Wadsworth Atheneum,
Hartford, Connecticut;
The Philip L. Goodwin
Collection

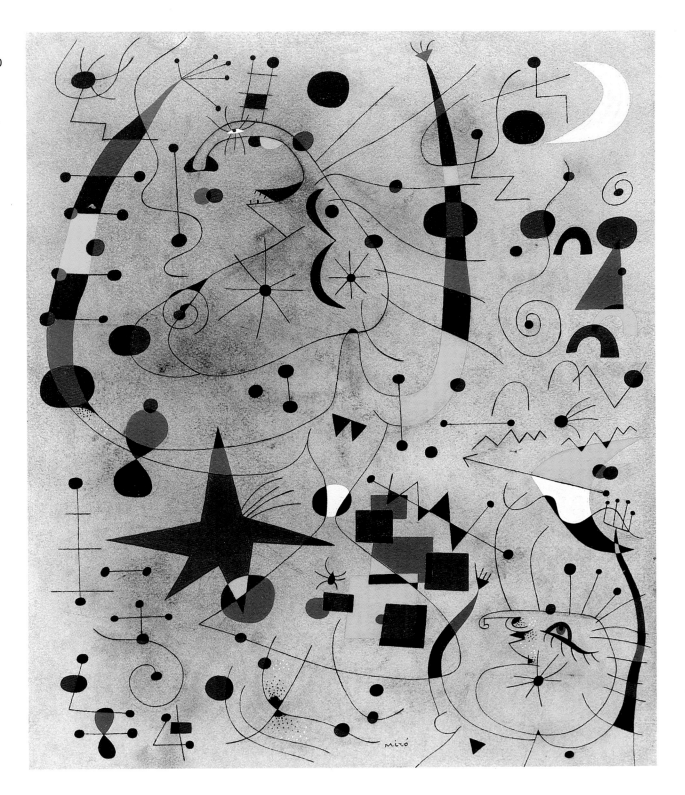

74
Joan Miró
Personnages, oiseau,
étoile, 1942
gouache on paper
43 x 30½ (109.2 x 77.5)
Pierre Matisse Gallery,
New York

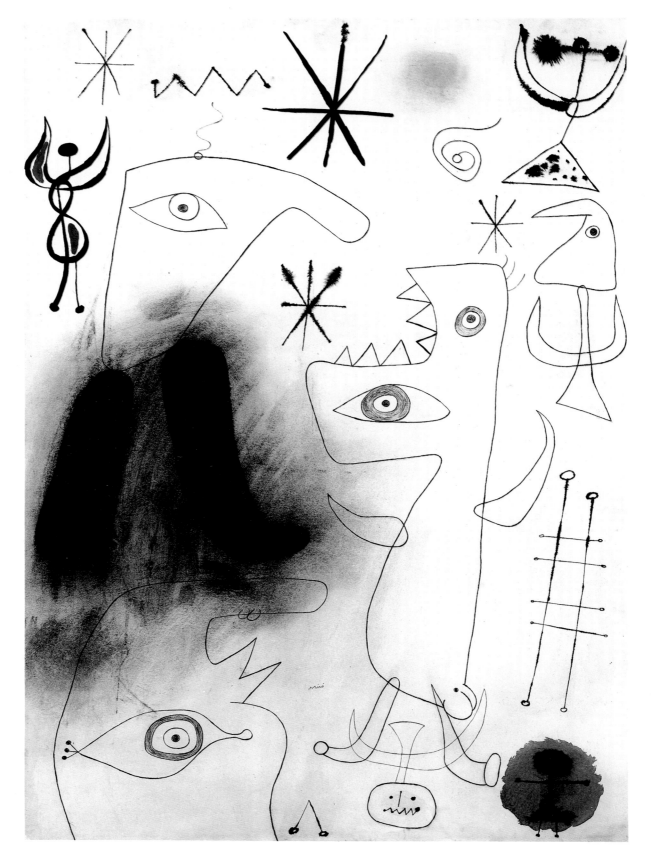

73
Joan Miró
Untitled, 1941
watercolor and ink
on paper
19½ x 25½ (49.5 x 64.8)
Courtesy Marisa del Re
Gallery, Inc., New York

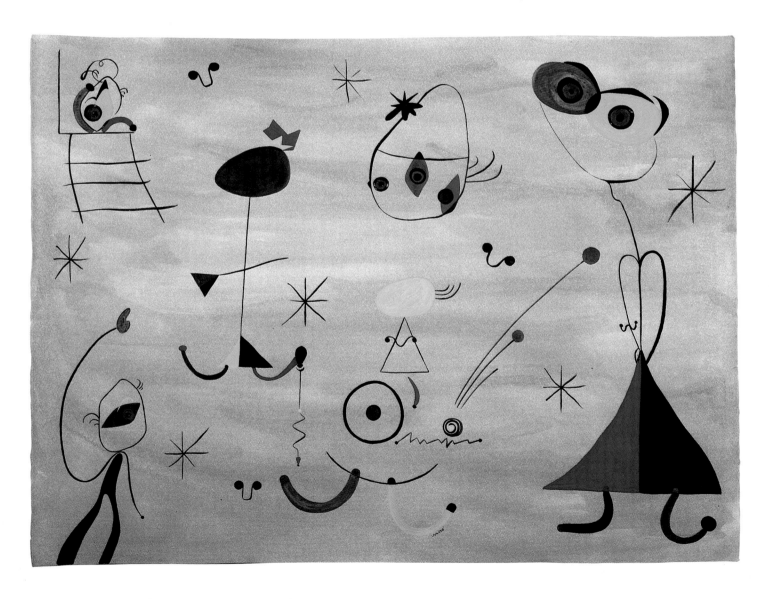

Robert Motherwell
b. 1915

As a pivotal contributor to abstract expressionism, Robert Motherwell was concerned with synthesizing surrealist automatism with the spatially flattened, painterly esthetics of Picasso and Matisse into American abstract paintings of deeply felt experience. Motherwell was born in Aberdeen, Washington. He lived his childhood in California, where he gained his first exposure to painting during brief enrollments at the Otis Art Institute, Los Angeles (1920s), and the California School of Fine Arts, San Francisco (1932). His formal training, however, was in philosophy at Stanford University (A.B. 1937) where he developed an interest in psychoanalytic theory. His graduate studies were at Harvard University (1937–38) where he pursued esthetics. In 1940, he entered Columbia University and studied with art historian Meyer Schapiro, who encouraged his interest in French symbolist and surrealist literature.

Motherwell's association with Schapiro led to introductions to the exiled European artists. His esthetic sophistication made him sensitive to the concerns of dadaist Marcel Duchamp, and his literary bent was congenial to the surrealists. Although he considered nonobjective reductionism too limited for expressing deep feeling, Motherwell greatly admired Piet Mondrian; and, unlike the other New Yorkers, Motherwell's painting was abstract from the very first. Of all the surrealists in New York, Motherwell was most drawn to Matta; together they visited Mexico in 1941, where Motherwell met Wolfgang Paalen. The *Mexican Sketchbook* (cat. 76), a record of that trip, shows experiments with surrealist inspired "doodling," as he called it; in these drawings Motherwell toys with traditional space creation as his dark, fluid ink shapes and linear calligraphy metamorphose into uneasily grasped illusions of organic creatures.[1] *For Pajarito* (cat. 77) begins to flatten space and employ a brushy, atmospheric background, but the "doodling" is almost programmatic in its effect. Back in New York, Motherwell joined (along with Baziotes, Kamrowski, and Pollock) a short-lived group (1941–42) formed by Matta to explore automatism as a means of tapping psychic depths.[2] Motherwell was soon disenchanted with automatic techniques that denied the well-made picture and conscious design decisions. The 1943 *Figure with Blots* (cat. 78), for instance, calls attention to the automatic and collage elements that Motherwell sets into a planar composition of Matissean elegance. His sensitivity to a cultivated and painterly Western tradition made him less susceptible than his American contemporaries to the lure of primitivism and mythology. He also distrusted illusionistic surrealism and stressed instead the important link between automatism and the creation of "an abstract picture as rich as nature."[3] Thus, of the European surrealists, it was Joan Miró whose paintings Motherwell respected most.

For Motherwell, the emphasis was on plasticity. As he put it in 1944, "Plastic automatism...as employed by modern masters, like Masson, Miró and Picasso, is actually very little a question of the unconscious. It is much more a plastic weapon with which to invent new forms. As such it is one of the twentieth century's greatest formal inventions."[4] Two ink drawings of 1944, *Three Figures Shot* (cat. 79) and *Three Important Personages* (cat. 80), reveal the polarities of Motherwell's spontaneity and deliberateness; works of similar subject matter, they cross the chromatic scale from white to black and the textural scale from line variation to opaque washes. The 1945 *Collage No. 2* (cat. 81) assimilates a learned heritage of European cubism and surrealism into a bold, gestural abstract expressionist handling; it seeks to condense the complexity of human feeling into a perceptual object of great beauty.[5] For Motherwell, then, the artist's job is "to find a complex of qualities whose feeling is just right—veering toward the unknown and chaos, yet ordered and related in order to be apprehended."[6] In 1949, as Motherwell succeeded in forging his unique link between abstract surrealism and abstract expressionism, he found his monumental subject matter in the great *Elegies to the Spanish Republic* series.

In 1943 Motherwell joined Baziotes and Pollock in exhibiting collages at Art of This Century Gallery, where in 1944 he had his first one-person exhibition. He was included in Howard Putzel's landmark Forty American Moderns (1944) at the 67 Gallery and exhibited regularly during the 1940s and 1950s (Samuel Kootz and Sidney Janis). Beginning in 1945 he became the chronicler/editor of *The Documents of Modern Art,* including the influential *The Dada Painters and Poets: An Anthology* (1951). He was editor of the one-issue *Possibilities* (1947–48, with John Cage and Harold Rosenberg); and he frequently contributed essays to the catalogs of his contemporaries. In 1948 Motherwell cofounded, with Baziotes, David Hare, Newman and Rothko, the Subjects of the Artist school.—BS and AA ∎

Notes

[1] H. H. Arnason, *Robert Motherwell* (New York: Abrams, 1982, 2nd edition), p. 18.

[2] See Irving Sandler, The Triumph of American Painting, *A History of Abstract Expressionism* (New York: Harper & Row, Icon Editions, 1978), p. 38.

[3] Robert Motherwell, quoted in Max Kozloff, "An Interview with Robert Motherwell," *Artforum,* vol. 4, September 1965, p. 34.

[4] Robert Motherwell, "The Modern Painter's World," *Dyn,* no. 6, November 1944, p. 13, cited in Sandler, *American Painting,* p. 41.

[5] See Sandler, *American Painting,* p. 203; *Flying Tigers: Painting and Sculpture in New York 1939–1946* (Providence, Rhode Island: Bell Gallery, Brown University, 1985), p. 76.

[6] Robert Motherwell, "Beyond the Aesthetic," *Design,* vol. 47, April 1946, p. 15.

76
Robert Motherwell
The Mexican Sketchbook,
1941
ink on paper, eleven pages
9 x 11½ (29.2 x 28.7)
Collection of the artist

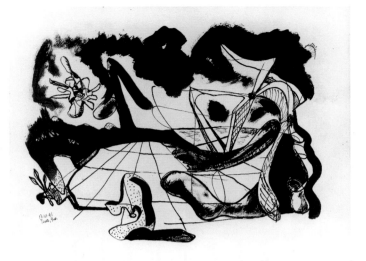

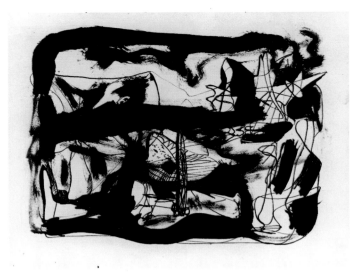

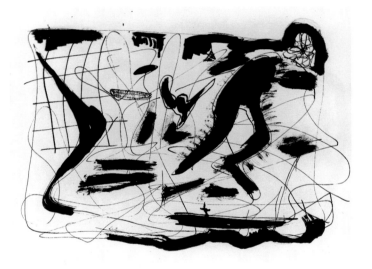

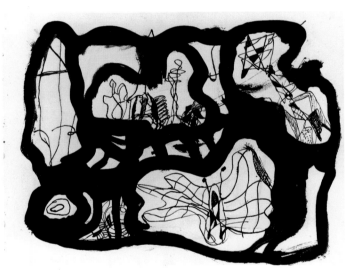

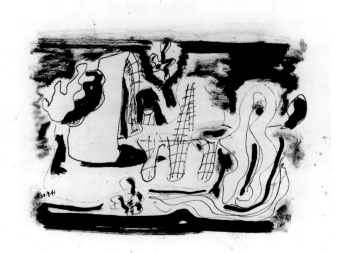

77
Robert Motherwell
For Pajarito, 1941
oil wash and ink on
paperboard
8 x 10 (20 x 25)
Portland Museum of Art,
Portland, Maine;
Purchase with matching
grants from the National
Endowment for the Arts
and Casco Bank and
Trust Co., 1981

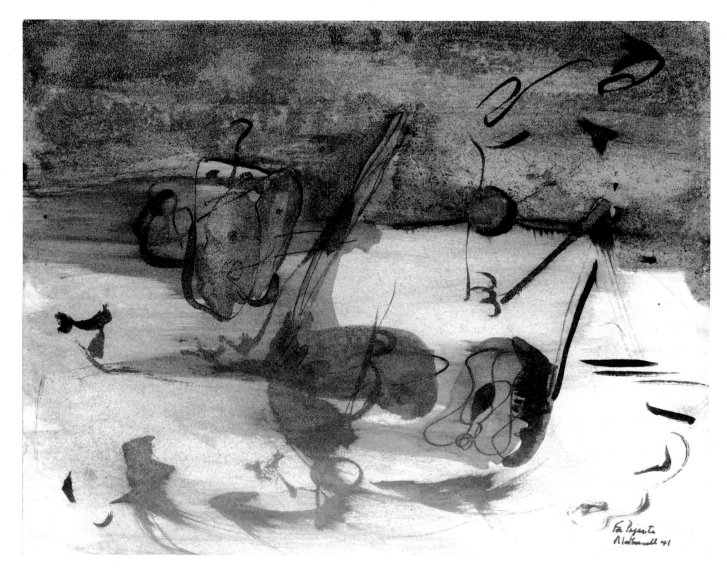

78
Robert Motherwell
Figure With Blots, 1943
oil and collage on paper
45½ x 38 (115.6 x 96.5)
Mr. and Mrs. David
Mirvish, Toronto, Ontario,
Canada

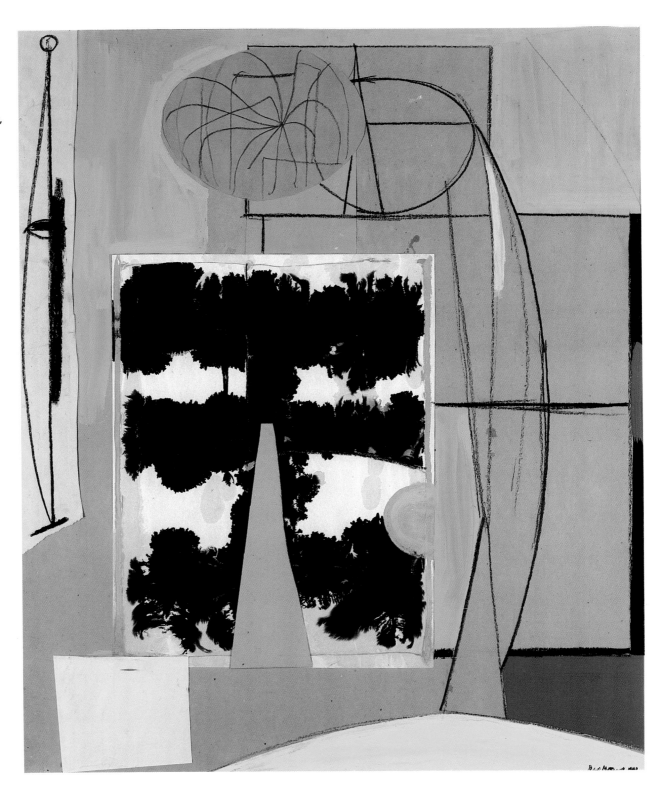

131

79
Robert Motherwell
Three Figures Shot, 1944
colored ink on paper
11⅜ x 14½ (28.9 x 36.8)
Collection Whitney
Museum of American
Art, New York; Purchase,
with funds from the
Burroughs Wellcome
Purchase Fund and the
National Endowment for
the Arts, 81.31

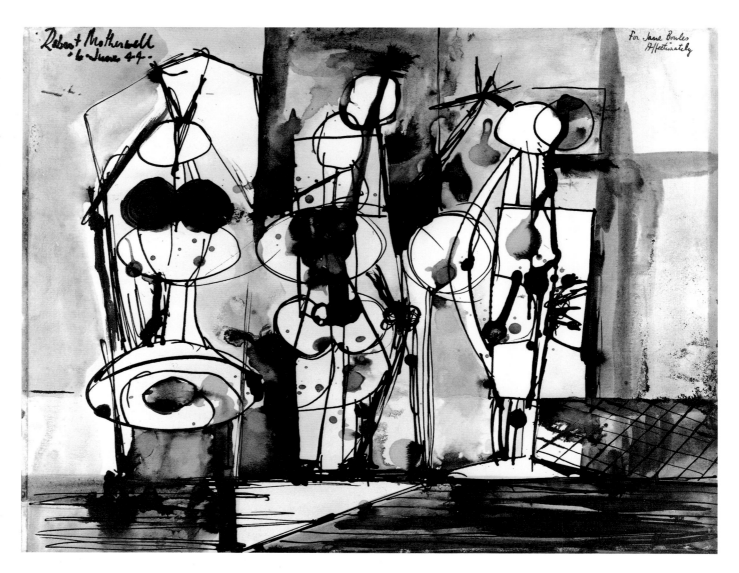

80
Robert Motherwell
*Three Important
Personages,* 1944
ink on paper
11 x 14 (27.9 x 35.6)
Richard E. and Jane M.
Lang Collection, Medina,
Washington

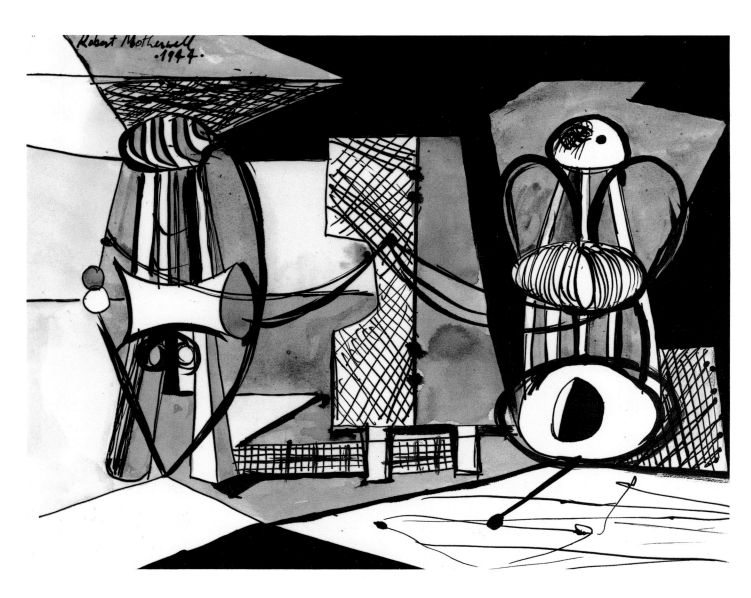

82
Robert Motherwell
Untitled, 1945
watercolor and ink on
paper
10½ x 8¾ (26.7 x 22.2)
The North Carolina
Museum of Art, Raleigh,
North Carolina

83
Robert Motherwell
*Untitled (Figure with
Green Wash),* 1947
india ink and wash on
paper
8 x 4 (20.3 x 10.2)
Collection of the artist

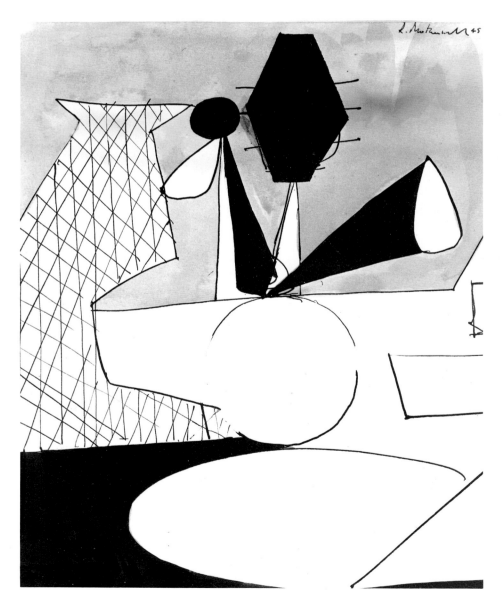

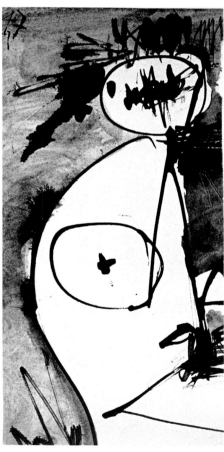

81
Robert Motherwell
Collage #2, 1945
oil and collage on board
21⅞ x 14⅞ (55.6 x 37.8)
Collection of the artist

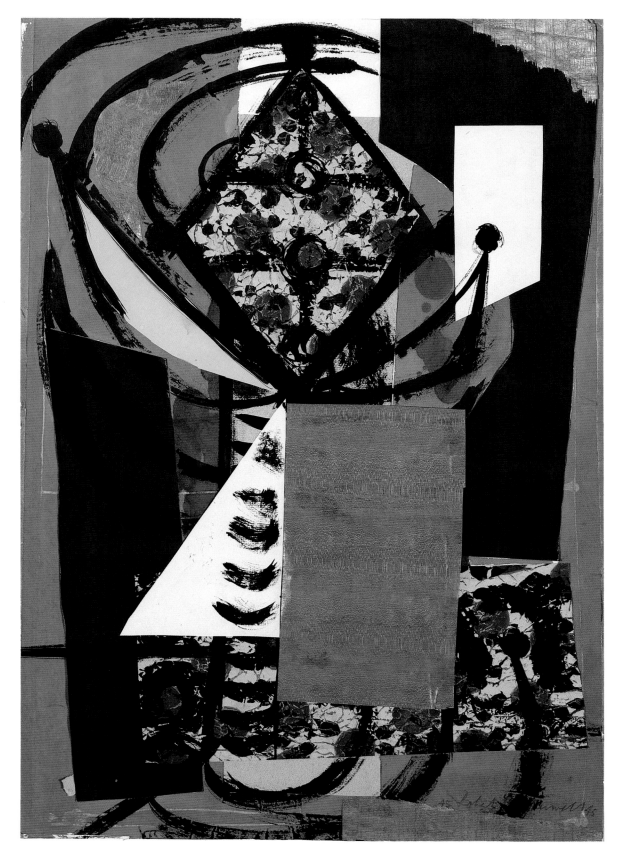

135

Barnett Newman
1905–1970

Barnett Newman was born in New York and lived there his entire life, receiving his first formal art training at the Art Students League in 1922. He continued to study there on a part-time basis while he attended the City College of New York, from which he graduated in 1927. To finance his anticipated career as an artist, he was persuaded to go into the family business for a short time, but the Depression tied him to it until 1937. Unlike most of his colleagues, Newman did not participate in the government relief projects; instead, he eked out a living as a substitute art teacher in the public schools from 1931 to 1939. During the same years, he ran for mayor of New York on a cultural write-in ticket and met and married his wife Annalee. Around 1939 Newman stopped painting for several years, desperately uncertain of the future of art in general and of his own work in particular. After a period of experimentation in the mid-1940s, he discovered his characteristic style in 1948 with *Onement I.*

During the period covered by the current exhibition, Newman was active only from 1944 onward. Until 1946 he worked exclusively on paper, experimenting with motifs and techniques drawn mainly from surrealism. Most of his early works on paper were spontaneous productions, automatic doodlings that Newman pinned to the walls of his studio in varying orientations to contemplate over time. They were not preliminary drawings, but independent investigations of ideas that Newman hoped would be fruitful for his new art. As such they reveal a number of Newman's concerns prior to the breakthrough of *Onement I.* The winged seeds, pendulous sacs, and dangling tendrils in *Untitled* (cat. 84 and 88), for example, link Newman to the biomorphism that proliferated in American art in the 1940s. At the same time they reflect his long-standing fascination with the study of the life sciences, especially botany, geology, and ornithology. Out of a plethora of biomorphic forms Newman evolved images suggestive of the natural cycle of generation and regeneration such as *Gea* (cat. 92), where the swollen shapes of a mother biomorph ringed by seedlings and sproutings offer a constant promise of productivity. Yet other works in the exhibition indicate that biomorphism was not long the focus of Newman's attention. Already in *The Song of Orpheus* (cat. 89) he was attempting to impart the life force of his biomorphs to the areas surrounding them by treating those areas as patches of brilliant color on a visual par with the organic forms. Through watercolors such as *Untitled* (cat. 93 and 94), Newman eventually came to realize that abstract form—that is, defined zones of color—begotten of non-form—that is, the blank page—could have the vital fullness of lush biomorphism without its specificity. Demonstrative of a shaping power outside the processes of nature, his later use of bands and bars of color allowed Newman to replace the anonymous efflorescences of biomorphism by the more autographic act of creation.

Newman's contribution to the world of art is not limited to his pictorial and sculptural oeuvre, especially for the period 1938 to 1948. Working from the conviction that New York must develop into an international art center, Newman sought to increase awareness and foment discussion of advanced art and ideas. He wrote catalog forewords for several of his colleagues as well as for the dealers Betty Parsons and Peggy Guggenheim. He organized important exhibitions of primitive art, most notably of pre-Columbian stone sculpture in 1944 and of Northwest Coast Indian painting in 1946. In 1947 and 1948 he wrote for the avant-garde periodical, *Tiger's Eye,* raising issues such as the origins of the creative impulse and the sublime in art. And in 1949 Newman joined the faculty of the new art school that he himself had named The Subjects of the Artist, in the belief that matters of content and not technique should be the primary concern of both artists and teachers of art.—MM ■

88
Barnett Newman
Untitled, 1945
oil, oil crayon and pastel
on paper
19⅜ x 25½ (49.5 x 64.5)
Collection Annalee
Newman, New York

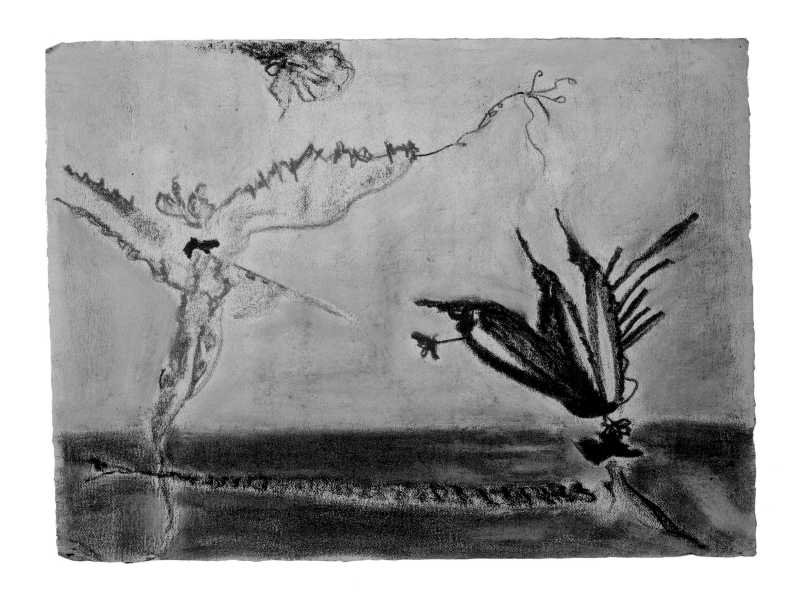

84
Barnett Newman
Untitled, 1944
tempera and wax crayon
on paper
15 x 20 (38.1 x 50.8)
Collection Annalee
Newman, New York

85
Barnett Newman
Untitled, 1944
wax crayon and oil crayon
on paper
15 x 20 (38.1 x 50.8)
Collection Annalee
Newman, New York

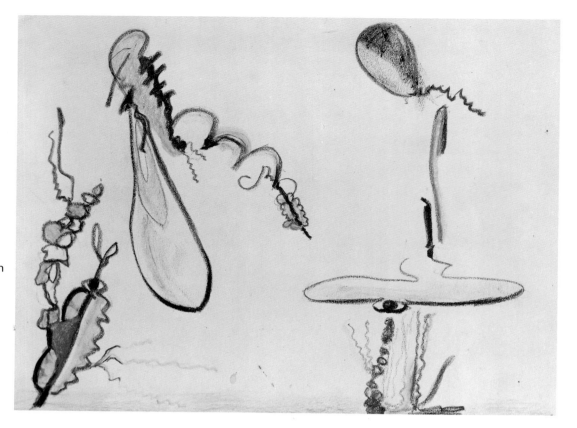

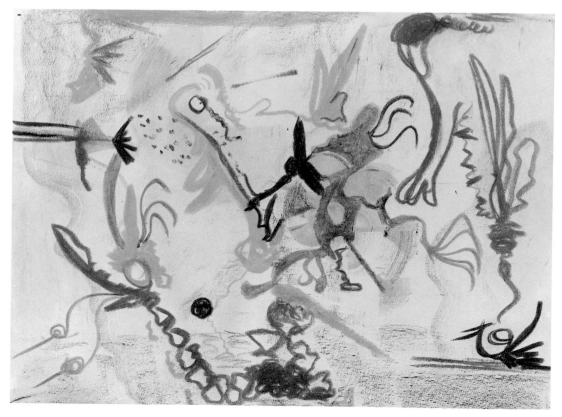

86
Barnett Newman
Untitled, 1944
wax crayon and oil
crayon on paper
20 x 15 (50.8 x 38.1)
Collection Annalee
Newman, New York

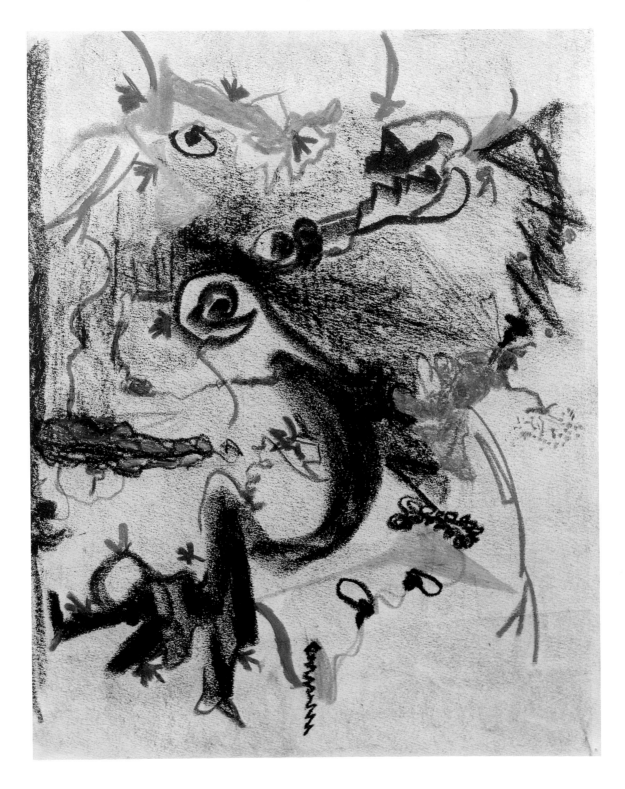

87
Barnett Newman
The Slaying of Osiris,
1944
oil and oil crayon on
paper
19⅞ x 14¾ (50.5 x 37.5)
Collection Annalee
Newman, New York

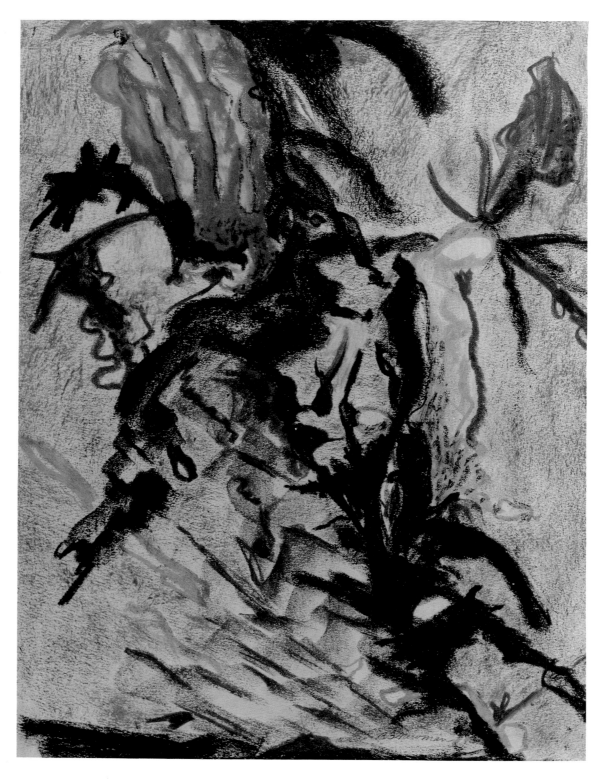

89
Barnett Newman
The Song of Orpheus,
1944–45
oil, oil crayon and wax
crayon on paper
19 x 14 (48.3 x 35.6)
Collection Annalee
Newman, New York

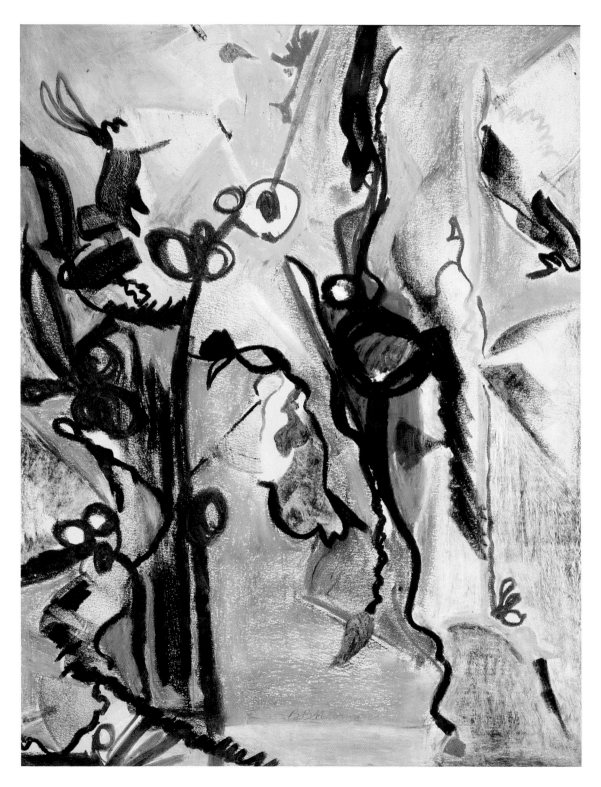

90
Barnett Newman
Untitled Drawing, 1945
ink on paper
19⅞ x 14¾ (50.5 x 37.5)
Collection Annalee
Newman, New York

91
Barnett Newman
Untitled, 1945
ink on paper
14⅞ x 16⅜ (37.8 x 41.8)
Collection Annalee
Newman, New York

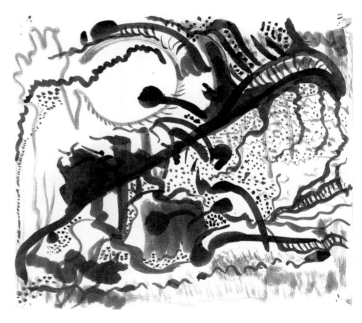

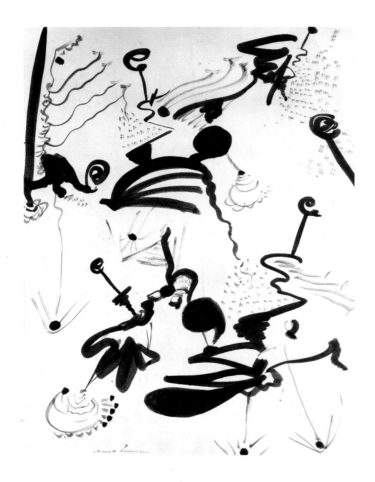

92
Barnett Newman
Gea, 1945
oil and oil crayon on
cardboard
27¾ x 21⅞ (70.5 x 55.6)
Collection Annalee
Newman, New York

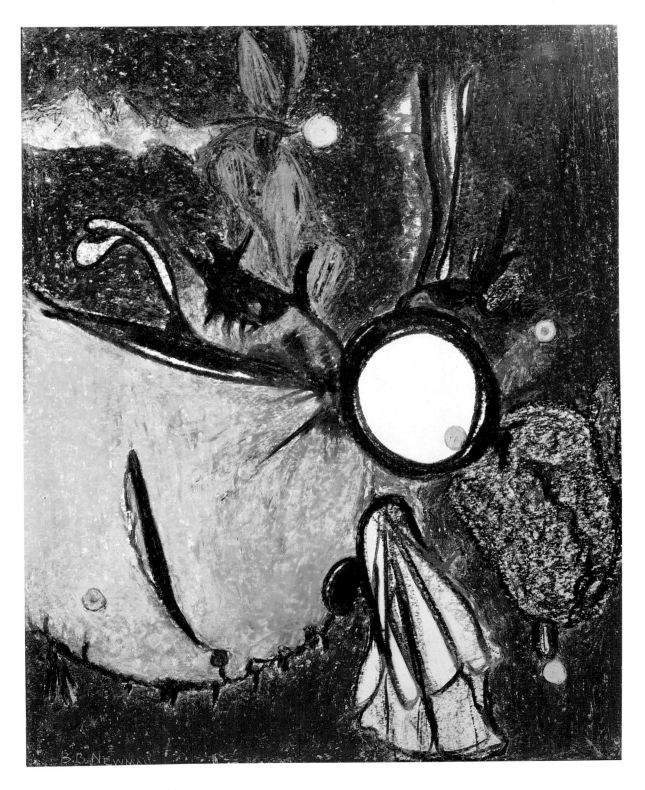

93
Barnett Newman
Untitled, 1945
watercolor and tempera
on paper
11½ x 16¼ (29.2 x 41.3)
Collection Annalee
Newman, New York

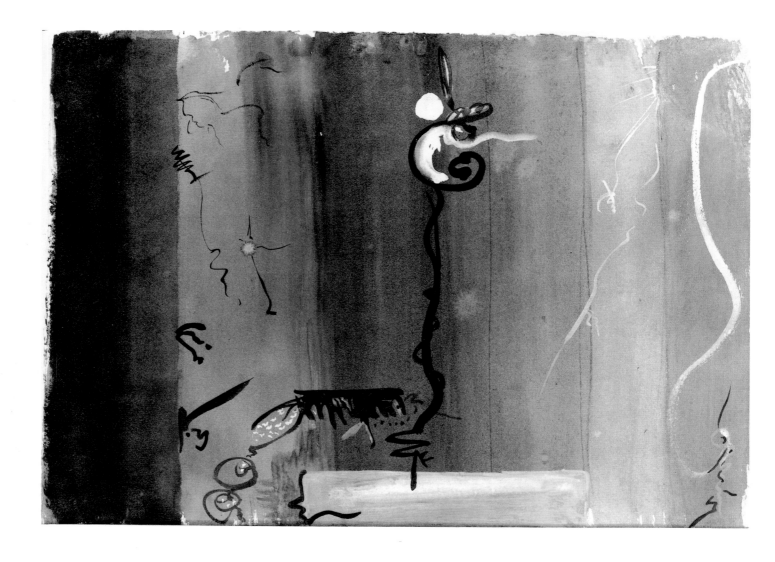

94
Barnett Newman
Untitled, 1945
watercolor on paper
11½ x 16¼ (29.2 x 41.3)
Courtesy Margo Leavin
Gallery, Los Angeles,
California

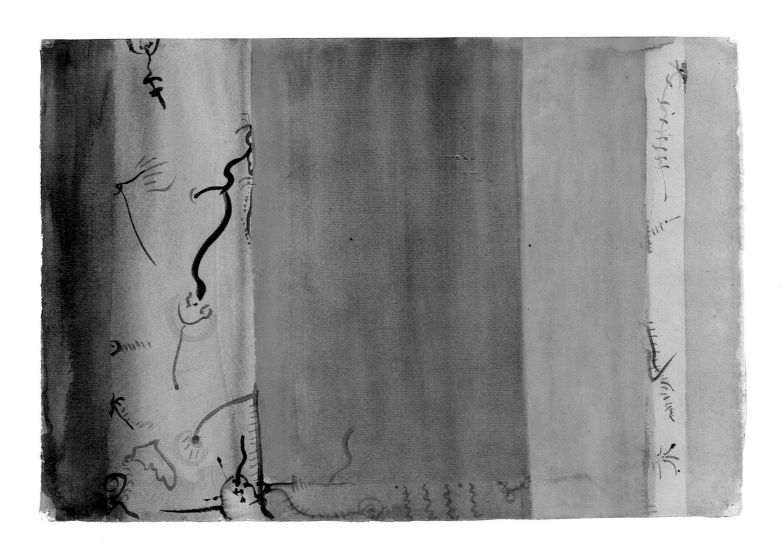

Gordon Onslow Ford
b. 1912

The British-American painter Gordon Onslow Ford was born in Westover, England, in 1912. His first love was the sea, and he served the Royal Navy for ten years before turning to art. Later he claimed that stuydying the movement of water and its teeming life was "perhaps my biggest single influence."[1] Onslow Ford was in Paris by 1936 where he frequented the studios of Fernand Leger and André Lhote. A self-taught artist, he had four weeks of academic training before his decisive meeting with Matta. It was during travels in Egypt (1937) and in Britanny with Matta (1938) that Onslow Ford felt the limitations of naturalism: "From that time on I have never worked from nature, but have let nature work through me in the guise of automatic drawings."[2] His 1938 *Mountain White* (cat. 95) makes schematic reference to naturalistic landscape but introduces biomorphic personages and a spontaneously generated entanglement of lines and shapes that project a vision of both micro- and macroscopic dimensions.

In 1938 Onslow Ford was enlisted by Breton into the ranks of surrealism; joining just after Wolfgang Paalen, Esteban Francés, Kurt Seligmann, and Matta, Onslow Ford was the last recruit before the group's exodus from Europe. In a 1939 statement in *Minotaure* (No. 13), the artist wrote of the need to find "auras independent of the illusions which assail us"—to go beyond rational thinking and the evidence of the senses which give only "the misshapen shadow of realty."[3] Both Matta and Onslow Ford were reading Ouspensky's *Tertium Organum;* its emphasis on space/time and on many dimensions of consciousness was crucial. In *Mountain Auras* (cat. 96) Onslow Ford flattens traditional perspective space into an all-encompassing plane of blue; loosely brushed concentric circles of white give birth to shooting flames and contrast with dark, exploding star shapes whose implied movement through space is given by the curvilinear twists of white. The artist's visionary genius played down orthodox surrealism's embrace of dream symbolism as "too literary" and "a deterrent to inner states of vision."[4] *Amorous Landscape* (cat. 97) looks forward to the more completely abstract paintings of the 1940s that project the artist's vision of a world of interactive forces which connect floating personages and their surroundings.

Onslow Ford is credited with the invention in 1939 of the surrealist technique of *coulage,* a pouring of commercial enamel in which the paint, partially controlled by the artist, creates its own metamorphosing forms. A key painting of 1939, *Without Bounds,* uses a structure of geometric lines to impose order on the flux of paint. The content of his art is "the spaces of mind which are the spaces of the universe."[5] A few years later, Ernst, Hofmann, and, on the West Coast, Knud Merrild, employed pouring techniques but, as William Rubin has pointed out, it waited upon Jackson Pollock for *coulage* to achieve a "genuine style."[6]

Onslow Ford left Paris for the United States in 1940, but spent the years 1941 through 1947 in Mexico, living on the edge of a small village inhabited by Tarascan Indians. Here, he began to desire the visual innocence of the Indians which he felt to be unbiased by "the written word, by modern art fashions, and by hangovers from the renaissance."[7] His first one-person show was held at the Karl Nierendorf Gallery, New York, in 1940. In early 1941 Onslow Ford brought surrealism to the attention of New York audiences in four lectures, titled "Surrealist Painting: An Adventure into Human Consciousness," given at the New School of Social Research. In 1942 he was included in the First Papers of Surrealism exhibition. However, never a conventional surrealist, Onslow Ford resigned from the movement the following year. In 1948 he settled in San Francisco where a major presentation of his work was shown at the San Francisco Museum of Art that same year; in conjunction with this exhibition he published *Towards a New Subject in Painting.* In 1951 he collaborated with Wolfgang Paalen in the Dynaton exhibition at the San Francisco Museum of Art. Today Gordon Onslow Ford lives in Inverness, California.—AA ∎

Notes

[1] Gordon Onslow Ford, taped interview with E. Theodore Lindberg, August 1970, Archives of American Art, Smithsonian Institution.

[2] Onslow Ford, *Towards A New Subject in Painting* (San Francisco: The San Francisco Museum of Art, 1948), p. 11.

[3] Ibid., p. 13.

[4] Ibid., p. 23.

[5] Onslow Ford, Lindberg interview.

[6] Williams S. Rubin, *Dada and Surrealist Art* (New York: Abrams, 1968), p. 316, in which *Without Bounds* appears in color as plate 38, p. 325.

[7] Onslow Ford, *Towards A New Subject in Painting,* pp. 20–21.

96
Gordon Onslow Ford
Mountain Auras, 1939
gouache on paper
19½ x 25¼ (49.5 x 64.1)
Collection of the artist

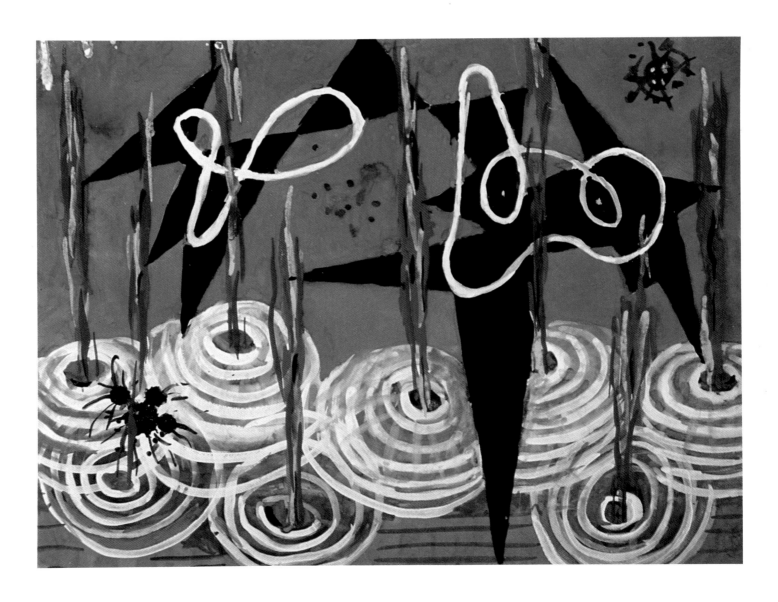

95
Gordon Onslow Ford
Mountain White, 1938
gouache on paper
14 x 24 (35.6 x 61)
Collection of the artist

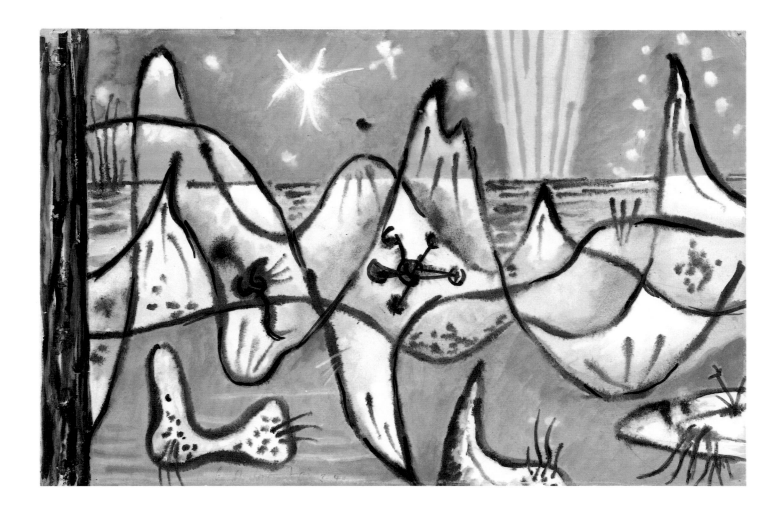

97
Gordon Onslow Ford
Amorous Landscape,
1940
gouache and watercolor
on paper
19½ x 13⅝ (49.5 x 34.3)
Collection of the artist,
Courtesy Arnold
Herstand & Company,
New York

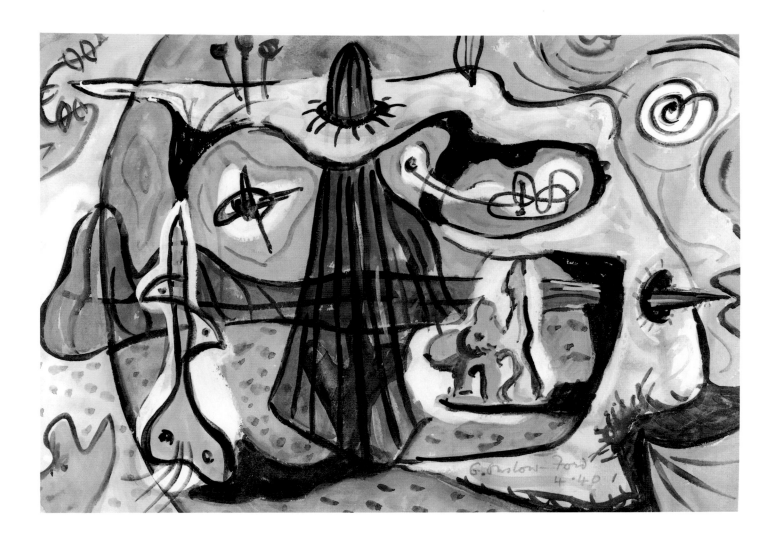

Wolfgang Paalen
1907–1959

The French-Austrian artist Wolfgang Paalen was born in Vienna in 1907. He settled in Paris in 1929 after travel and study in France, Germany, and Italy. Initially a nonfigurative painter, Paalen was drawn to the abstraction-creation group (1932–35) but soon found an active voice in the exuberant surrealist milieu. André Breton recognized Paalen's "great blaze of passion" and wrote that he sought "to realize a synthesis of myths in progress and myths past, and to live this myth in his own flesh."[1] Paalen participated in the 1936 *Exposition Surréaliste des objets* and in the 1938 *Exposition Internationale du Surréalisme*. In the lexicon of surrealist inventions, Paalen is credited with *fumage*—a technique for generating evocative patterns with the smoke and soot of a lit candle.

Paalen moved to Mexico in 1939, where he organized the *Exposicion Internacional del Surrealismo* in Mexico City in 1940, with the help of Breton. That same year, at the Julien Levy Gallery, Paalen's influence reached New York avant-garde circles. A visit from Robert Motherwell followed, and it is perhaps from this moment in Mexico City that Motherwell's emphasis changed from "psychic automatism" to "plastic automatism."[2] Paalen participated in the First Papers of Surrealism exhibition in 1942, but his quarrels with the official European credo were presented in the pages of his magazine *Dyn*, published in Mexico City (1942–44). Although his "Farewell to Surrealism" issue attacked the European movement for its dogmatic dialectical materialism, his impact on American art came from his defense of abstract automatism in the face of Breton's "reasoning stage" and Salvador Dali's veristic dream representations. Like the Americans, Paalen considered automatism simply a liberating technique that generated the raw material of art: "The everflow multicolored sauce or the verbal inflation finally becomes as boring...as the petty algebra of rectangular plastic purism."[3] Paalen remained uneasy, however, about contemporary use of primitive art and the self-conscious creation of present-day mythologies. He studied totemic art and reproduced tribal objects in *Dyn* but tended to identify the primitive with mankind's cultural and psychological childhood—views he somewhat modified after contact with Gottlieb, Newman, and Rothko.[4]

Paalen's surrealist paintings of the late 1930s placed fantastic personages, called "Saturnine Princes," in a dreamscape recalling Max Ernst's primordial forests and suggesting, as William Rubin has written, "a fractured, crystalline version of Tanguy's biomorphic illusionism."[5] Paalen's 1941 *Mexico* (cat. 99) is a visual cacophony of spontaneous drawing; its interpenetration of energetic force lines fractures the landscape and creates a macrocosmic vision. In 1951, at the San Francisco Museum of Art, Paalen joined with Gordon Onslow Ford and Lee Mullican to organize A New Vision—a "metaplastic" presentation of the Dynaton group which claimed "the emotional knowledge of forms beyond dimensions, of infra and ultra shapes."[6] Following this exhibition Paalen lived in Paris for two years. He returned to Mexico in 1953 where his late work abandoned figuration entirely. Paalen died in Mexico in 1959.—AA ∎

Notes

[1] André Breton, "Genesis and Perspective of Surrealism in the Plastic Arts." English translation in Peggy Guggenheim's *Art of This Century* (New York, 1942): reprinted in André Breton, *What Is Surrealism, Selected Writings,* ed. and intro. Franklin Rosemont, (New York: Monad Press, 1978), p. 228.

[2] See Irving Sandler, the discussion in *The Triumph of American Painting, A History of Abstract Expressionism* (New York: Harper and Row, Icon Editions, 1978), p. 41.

[3] Wolfgang Paalen, "The New Image," in *Form and Sense* (New York: Wittenborn, Schultz, 1945; originally published 1941), p. 34; quoted in ibid., p. 40.

[4] Ibid., p. 70, n. 5.

[5] William Rubin, *Dada, Surrealism, and Their Heritage* (New York: The Museum of Modern Art, 1968), p. 139.

[6] Wolfgang Paalen, "Theory of the Dynaton," *Dynaton* 1951 (San Francisco: San Francisco Museum of Art, 1951).

99
Wolfgang Paalen
Mexico, 1941
pencil on paper
32 x 24 (81.3 x 61)
Collection Gordon
Onslow Ford, Inverness,
California

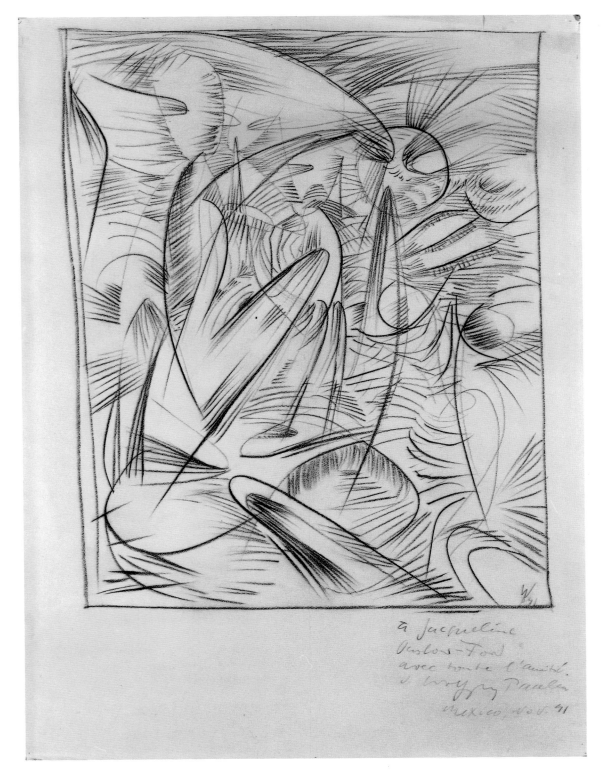

Jackson Pollock
1912–1956

Paul Jackson Pollock was born in Cody, Wyoming. By 1928, his family was established in Los Angeles, where Pollock was enrolled in the Manual Arts High School; in 1930 he began studies at the Art Students League, New York, with regionalist painter Thomas Hart Benton, whose expressive realism, sinuous contours, and heavy chiaroscuro influenced Pollock during the 1930s.[1] Unconvinced by regionalist subject matter, Pollock preferred the melancholy vision of Albert Pinkham Ryder—"the only American master who interests me."[2] By the end of the 1930s, he was introduced by the Mexican muralists Orozco and Siquieros to an epic wall space and the expressive potential of drips and spatters of paint.[3] Accidental effects gained potency for Pollock when fused with the European surrealists' antirational automatic techniques. Further, Pollock's early fascination with Jungian concepts and with American Indian cultures prepared the ground for his later sympathy with the surrealists' interest in myth and ritual.[4] His admiration for Picasso, evident in works of the late 1930s, brought formal control to his grapplings with the wellsprings of the unconscious psyche. Miró's paintings integrating pictographs and biomorphic forms (exhibited at the Museum of Modern Art in 1941) gave added impetus to investigate mythological sources.

In 1939 Pollock's alcoholism led him to Jungian psychiatrist, Dr. Joseph Henderson, who encouraged him to reveal conflicts through the medium of drawings. Pollock later gave approval to the surrealists' "concept of the source of art being the unconscious,"[5] but his interest probably was informed not by the surrealists' penchant for Freud but by the Jungian "collective unconscious" and its archetypes. The drawings dated c. 1939–42 in this exhibition are striking in light of the psychoanalytic sessions. *Untitled* (cat. 102) reveals bold chiaroscuro, a fusion of Picassoid with pre-Columbian form, and a Jungian lexicon of mask, fire, and animal symbols. *Untitled* (cat. 100) also is comparable to the psychoanalytic drawings in its apparent automatism; it abandons the conventional modelling and space construction of cat. 102 for a pictographic vocabulary of images that float to a decentered surface. The human personages dancing and swimming across the page have their genesis in Picasso, but Pollock introduces authentic childlike regressions and an aura of sexual confrontation. The fluidity of line and skillful interlocking of shapes speak, however, to conscious esthetic control. A comparison of cat. 102 with *Untitled* (cat. 108) is revealing of Pollock's assimilation of automatic calligraphy, expressive distortions, and an enriched surface texture that flattens space.

Pollock's ritualistic concerns remain in evidence in the works from 1943 in the exhibition. But *Untitled* (cat. 103) is incomparably more complex, its imagery varied, and the space tension-ridden. As Pollock gained confidence in automatism's force for generating meaningful form as well as significant subject matter, he conjoined surrealist tech-

niques with a masterly control of draftsmanship and space building. *Untitled* (cat. 104) is a richly textured explosion of pictographs and glyphs; linear patterns are contrasted with chiaroscuro renderings of repeating motifs. The ship and sea images suggest an underlying Jungian journey theme, and Pollock broadens his iconography to include sources from Indian, Egyptian, and Greek art, as well as alchemical references. Across this teeming imaginative universe is splashed a wash of black ink that seems accidentally spilled; drips and spatters of ink near the edges prefigure the monumental drip paintings of 1947–1952. The collage and ink work *Untitled* (cat. 106) explores symbolic imagery that juxtaposes recognizable figures with a hermetic vocabulary of signs. In *Untitled* (cat. 109), however, thick webs of red paint replace delicate calligraphy; the potentially recognizable imagery in the dark areas is overwhelmed as abstract line and shape become fused. In Pollock's drawing *Untitled* (cat. 111), populated with the biomorphic creatures and pictograms of earlier work, his line assumes a life of its own and evolves into an allover tangle obscuring the fantastic imagery. There now emerges in Pollock's work a sense of the creative act itself as the ultimate mythology. In the years 1947–54, his exploration of automatist techniques in the service of heroic content resulted in the monumental drip paintings; after 1952, Pollock reopened an investigation of his symbolic imagery of the 1940s paintings and drawings.

Pollock's first one-person show was at the Art of This Century in 1943. He was included in the 1950 Venice Biennale and 1952 "Fifteen Americans" at the Museum of Modern Art, New York (MOMA). Pollock, who lived with his wife Lee Krasner in the Springs, Long Island, from 1943 onward, died in a car accident in 1956. Retrospectives were held at MOMA in 1956 and 1967.—DM and AA ∎

Notes

[1] Francis V. O'Connor, "The Genesis of Jackson Pollock," *Artforum,* vol. 5, May 1967, p. 17.

[2] Jackson Pollock, in *Arts and Architecture,* February 1944, as quoted in Barbara Rose, *Readings in American Art Since 1900* (New York: Praeger, 1968), p. 152.

[3] Bernice Rose, *Jackson Pollock: Works on Paper* (New York: The Museum of Modern Art, in association with The Drawing Society, Inc., 1969), pp. 14–15. See also William S. Rubin, "Jackson Pollock and the Modern Tradition, Part IV, An Aspect of Automatism," *Artforum,* vol. 5, May 1967, pp. 30–31; and John Russell, *The Meaning of Modern Art* (New York: Harper & Row, 1974), p. 313.

[4] Judith Wolfe, "Jungian Aspects of Jackson Pollock's Imagery," *Artforum,* vol. 11, November 1972, pp. 65–73.

[5] Pollock, in *Arts and Architecture,* quoted in Barbara Rose, *Readings,* p. 152. See also C. L. Wysuph, *Jackson Pollock: Psychoanalytic Drawings* (New York: Horizon Press, 1970), p. 26.

102
Jackson Pollock
Untitled, c. 1939–42
C.R. #557
crayon and pencil on
paper
14 x 11 (35.6 x 27.9)
Collection Whitney
Museum of American
Art, New York; Purchase,
with funds from the Julia
B. Engel Purchase Fund
and the Drawing
Committee, 85.18

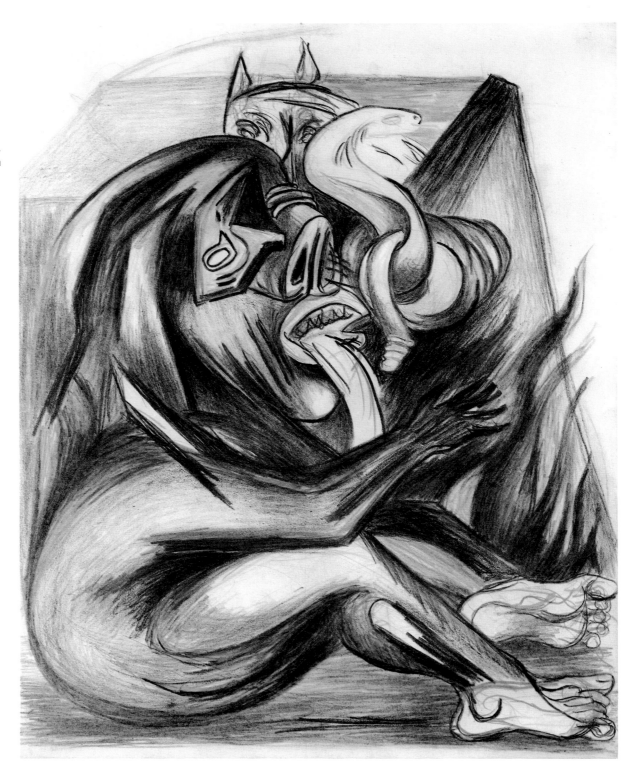

101
Jackson Pollock
Animal Figures,
c. 1939–42
C.R. #601
ink on paper
13 x 10⅜ (33 x 26.4)
Collection The Fort
Worth Art Museum, Fort
Worth, Texas; Purchase
made possible by a grant
from the Anne Burnett
and Charles Tandy
Foundation

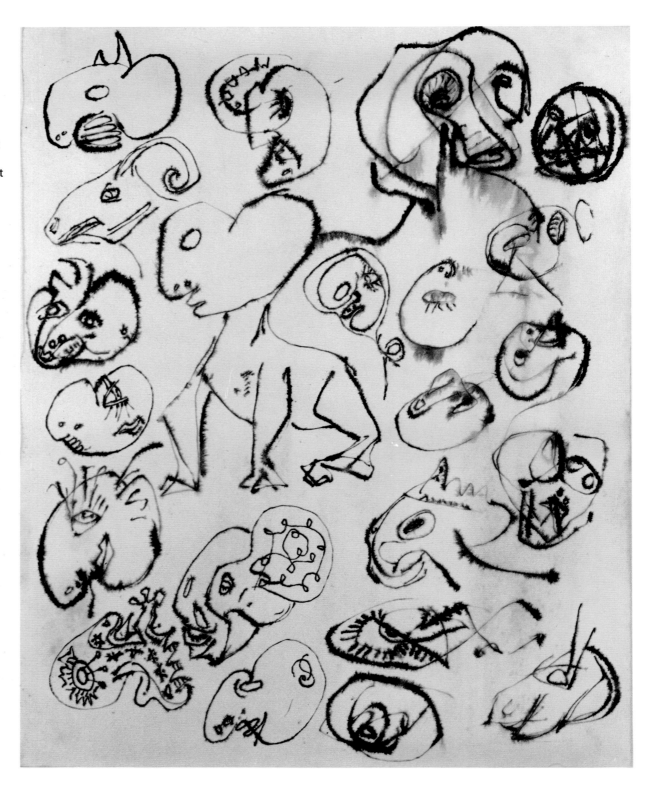

103
Jackson Pollock
Untitled, 1943
C.R. #698
ink and watercolor on
paper
26 x 20½ (66 x 52.1)
Montana Historical
Society, Helena,
Montana; Poindexter
Collection

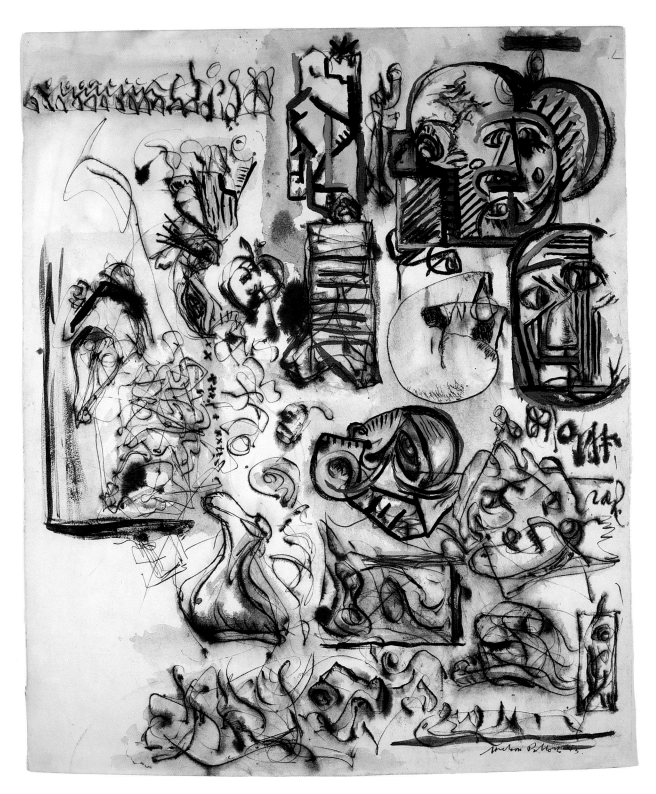

100
Jackson Pollock
Untitled, c. 1939–42
C.R. #603ʳ
india ink on paper
18 x 13⅞ (45.7 x 35.2)
Collection Whitney
Museum of American
Art, New York; Purchase,
with funds from the Julia
B. Engel Purchase Fund
and the Drawing
Committee, 85.19b

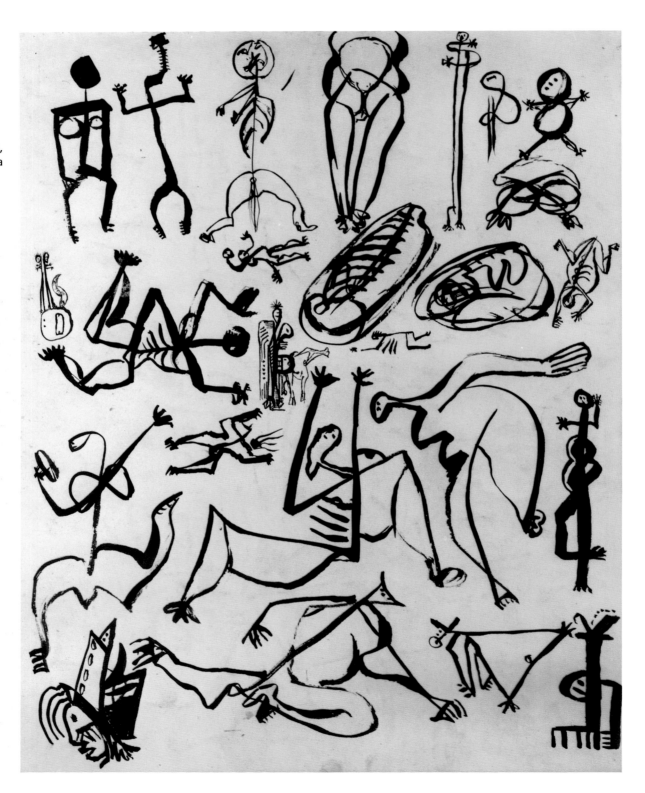

104
Jackson Pollock
Untitled, 1943
C.R. #972
ink and gouache on paper
18¾ x 24¾ (47.6 x 62.9)
Mr. and Mrs. Eugene
Victor Thaw, New York

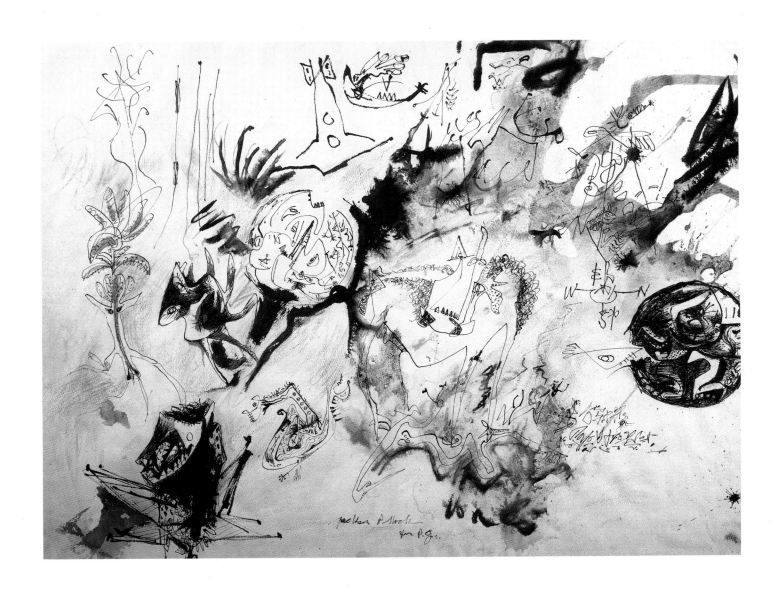

105
Jackson Pollock
Untitled, c. 1943
C.R. #704
ink and gouache on paper
12½ x 13 (31.7 x 33)
Collection Abby and B. H.
Friedman, New York

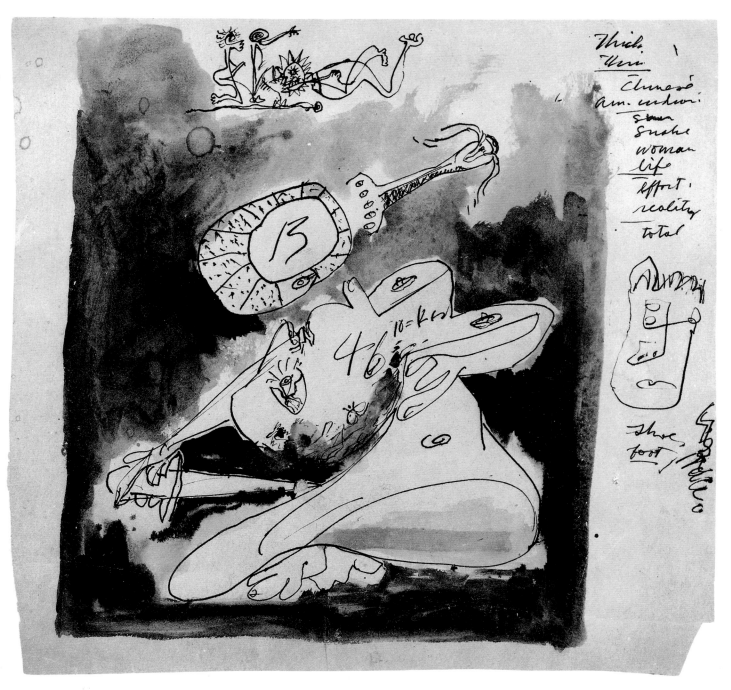

106
Jackson Pollock
Untitled, c. 1943
C.R. #1023
collage, ink, crayon, and
colored pencil on paper
15½ x 13⅝ (39.4 x 34.6)
Collection Marcia S.
Weisman, Beverly Hills,
California

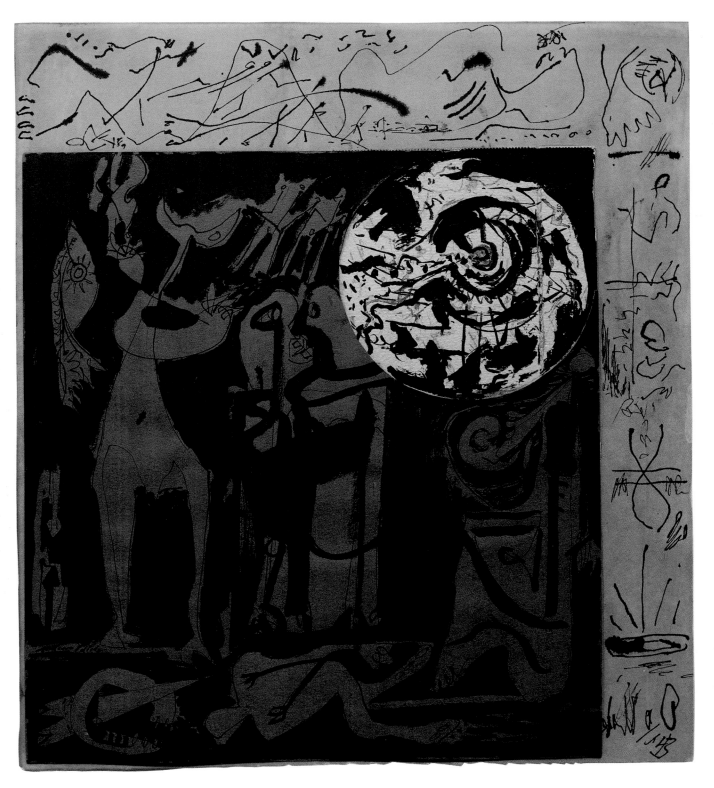

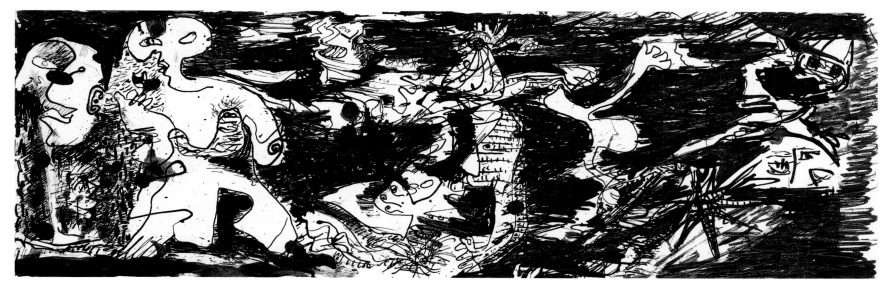

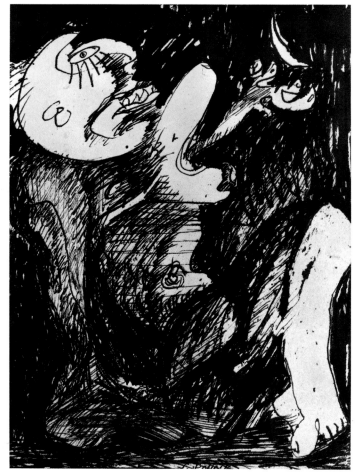

107
Jackson Pollock
Untitled, c. 1943
C.R. #702
ink and pencil on paper
5⅝ x 17⅞ (14.3 x 45.4)
Anonymous Extended
Loan to The Museum of
Modern Art, New York

108
Jackson Pollock
Untitled, c. 1943 (recto)
C.R. #701
ink on paper, drawings
on both sides of paper
7¼ x 5¼ (18.4 x 13.3)
Courtesy Allan Stone
Gallery, New York

109
Jackson Pollock
Untitled, c.1945
C.R. #997
oil and tempera on paper
15x12(38x30.5)
Collection Dorothea
Elkon, Courtesy Arnold
Herstand & Company,
New York

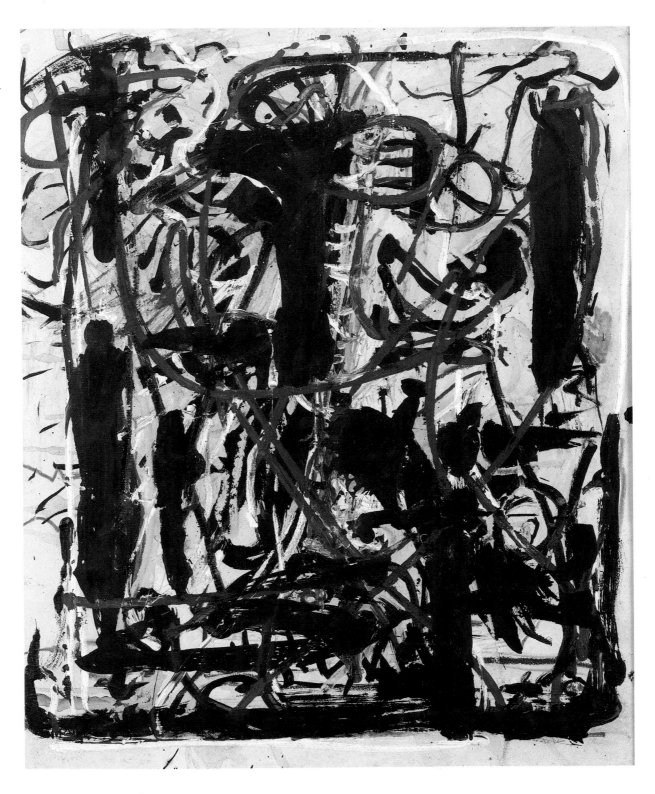

110
Jackson Pollock
Untitled, c. 1946
C.R. #761
ink on paper
5 x 11½ (12.7 x 29.2)
Betty Parsons Foundation,
New York

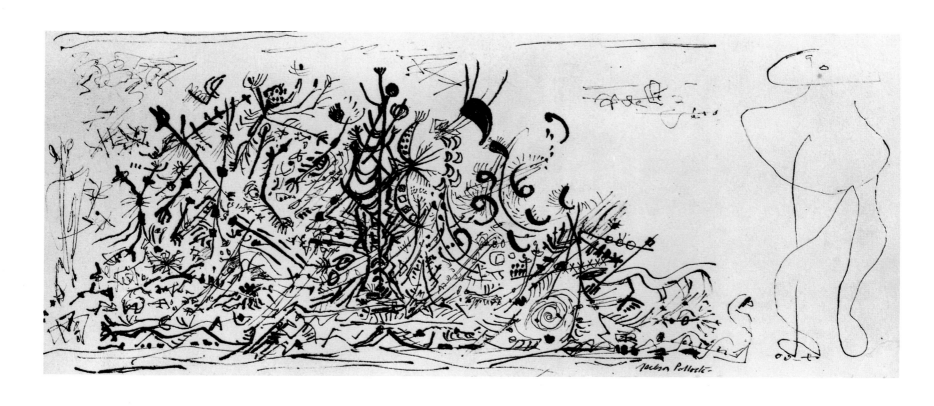

111
Jackson Pollock
Untitled, 1947
C.R. #762
ink and crayon on paper
17¾ x 23¼ (45 x 59)
Collection Duncan
MacGuigan, New York

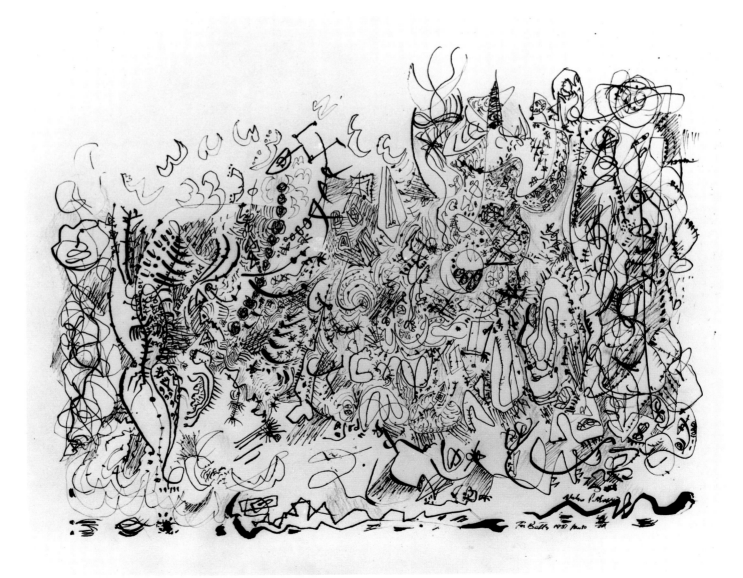

163

Richard Pousette-Dart
b. 1916

"Painting is a feeling thinking, a material awareness of spirit, a sense of direct experience which transcends any intellectual method."[1] In this way Richard Pousette-Dart elucidates the intuitive, spiritual quality that characterizes his art. The son of Nathaniel Pousette, an accomplished painter, and Flora Louise Dart, a poet, Pousette-Dart was born on June 8, 1916, in St. Paul, Minnesota. In 1918 his family moved to Westchester County, New York, where he and his two sisters enjoyed a comfortable childhood filled with art, music and poetry. After graduating from the Scarborough School at Scarborough-on-Hudson in 1935, Pousette-Dart entered Bard College. He abandoned his studies before the completion of his first year, however, because he "preferred to think for himself."[2]

Concerned with the inward, spiritual realities of the universe, Pousette-Dart works to convey his own inner vision through the application of rich pigments to his shimmering, all-over designs. The artist has explained, "I strive to express the spiritual nature of the Universe. Painting is for me a dynamic balance and wholeness of life; it is mysterious and transcending, yet solid and real."[3] Although he does not associate with organized religion, Pousette-Dart has always been a deeply religious man, admiring artists such as El Greco and Van Gogh, whose art is concerned with spiritual values. From the very beginning of his career his paintings have been intuitive and abstract, usually created without preliminary sketches[4]. *Hesperides* (cat. 113), for example, is a rhythmic design of swirling, crosshatched and scribbled lines that delineate ciliated cell, eye, egg and kidney shapes reminiscent of Miró's imagery. The composition overlays a pale yellow background suggesting sunlight and the radiance of spiritual revelation. Color has always served as a primary vehicle for the expression of his inner vision. As Lowery Sims has observed, "...it is the color, the flashes of chromatic bits, applied in a whipping calligraphic line, a staid ideograph, or merely one of an accumulation of daubs, squeezes, squiggles that has been utmost in his pictorial statement."[5] The result, as illustrated by *Untitled* (cat. 114), is a lyrical composition of biorganic forms—cells, flowers, cross-sections of fruit, seed pods, muscle striations—all unified by an underlying structure that reveals the artist's personal conception of the cosmic order of the universe.

In 1941 Pousette-Dart had his first individual exhibition at The Artist Gallery in New York, followed by shows at Marian Willard's Gallery, inclusion in an exhibition of American abstract painting and sculpture at the Museum of Modern Art, and a one-person show at Peggy Guggenheim's Art of This Century in 1947.—DM ∎

Notes

[1] John Gordon, *Richard Pousette-Dart* (New York: Praeger, published for the Whitney Museum of American Art, 1963), p. 11.

[2] Ibid., p. 8.

[3] Ibid., p. 9.

[4] *Flying Tigers* (Providence, Rhode Island: Bell Gallery, Brown University, 1985).

Pousette-Dart is quoted "I never make preliminary sketches but approach my canvas directly with whatever I happen to feel at the moment."

[5] Lowery S. Sims, in *Richard Pousette-Dart* (New York: Marisa del Re Gallery, 1983), p. ii.

113
Richard Pousette-Dart
Hesperides, 1944–45
mixed media on gesso
board
20 x 24 (50.8 x 61)
Courtesy Marisa del Re
Gallery, Inc., New York

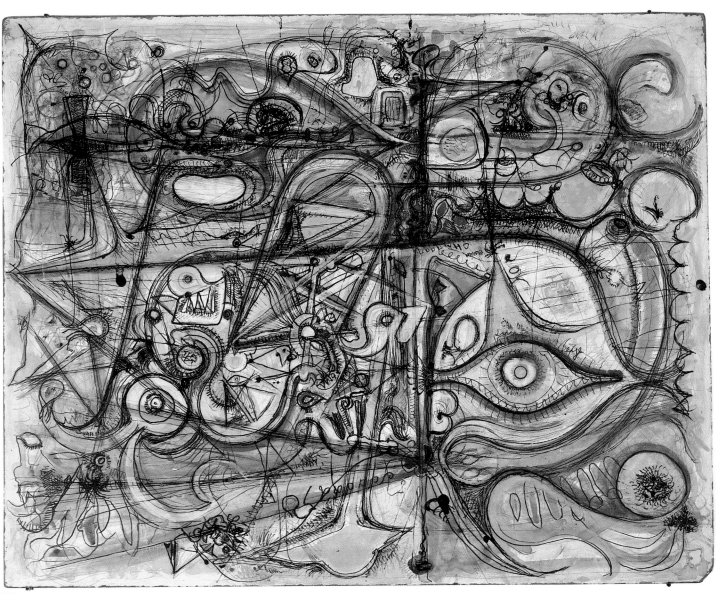

112
Richard Pousette-Dart
Untitled, c. 1943–46
watercolor and gouache
on paper
8 x 6½ (20.3 x 16.5)
Herbert F. Johnson
Museum of Art, Cornell
University, Ithaca, New
York; Gift of Mr. and Mrs.
John M. Goodwillie

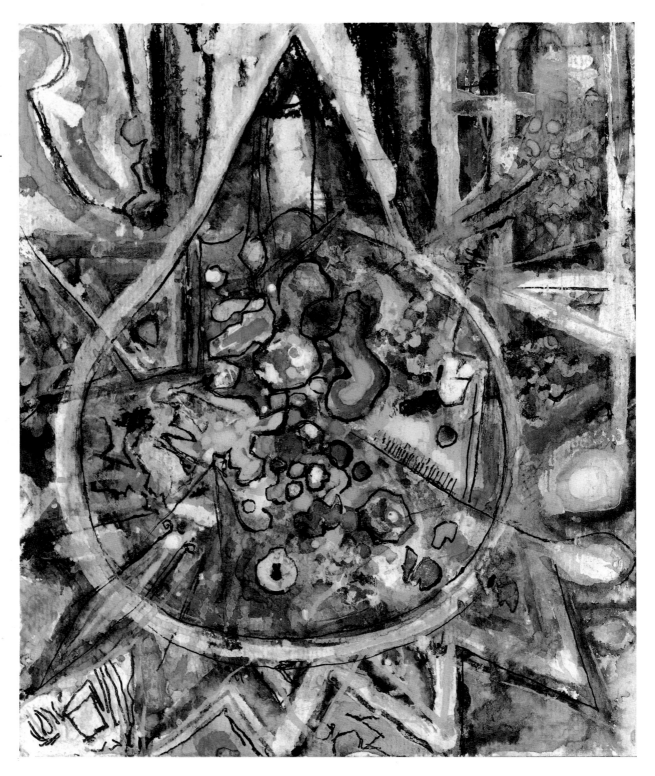

114
Richard Pousette-Dart
Untitled, 1945
mixed media and
gouache on parchment
22 x 18 (55.9 x 45.7)
Private Collection

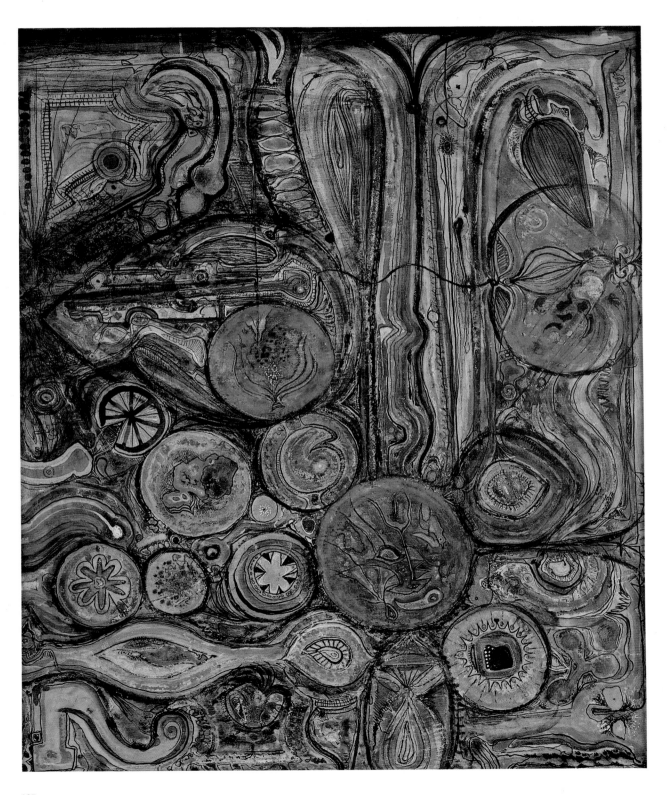

Mark Rothko
1903–1970

While the mature works of Mark Rothko eliminate all specific reference to the natural material world—a predominant subject in his drawings of 1938–48—his concerns and motivation remained the same throughout his painting career: "I became a painter because I wanted to raise painting to the level of poignancy of music and poetry."[1] For Rothko, art, like poetry and music, was to be an act of revelation. Born in Dvinsk, Russia, Rothko arrived in New York at the age of ten and settled with his family in Portland, Oregon. After two years of study at Yale University, he moved to New York City. During the middle to late 1920s, Rothko studied painting in Max Weber's class at the Art Students League. He was employed by the WPA Easel Division in 1936–37 and became a citizen in 1938.

Active during the formative years of the New York School, Rothko belonged to the Artists Congress and the Federation of Modern Painters and Sculptors, and with Adolph Gottlieb signed the now famous letter to *New York Times* art critic, Edward Alden Jewell in 1943. He was also active teaching children at the Center Academy in Brooklyn from 1929 to 1952, and, invited by Clyfford Still, he taught during two summers at the California School of Fine Arts, San Francisco.

Rothko dealt with social realist themes in the 1930s, creating works influenced by Milton Avery. He studied the art of Miró, Dali, de Chirico, Max Ernst, and Masson, and later in the decade, like many of his fellow artists, became interested in Jungian ideas, Freudian symbolism, and the writings of John Graham and Nietzsche. This led to a search for a more profound subject matter and an exploration of myth, primitivism, religious traditions, and surrealism. By the early 1940s, the titles of works such as *Antigone* and *The Omen of the Eagle* reveal Rothko's interest in Greco-Roman myth. Classical heads resembling Greek and Roman sculpture are juxtaposed irrationally with decorative, architectural and animal elements into stratified compositions. This stratification is a fairly consistent element and variously implies horizon lines, architectural structures or geological layers. It is easy to see the beginnings of Rothko's mature works with their characteristic hierarchy of color-forms in these compositions of the 1940s.

Other works from the early '40s (e.g., cat. 117 and 118) reveal a seemingly spontaneous mixture of biomorphic forms emerging from and merging into primordial land or water and surrounded by automatic, calligraphic lines. The strong horizontal register in some still blatantly suggests a landscape, while the vertical orientation of others such as *Baptismal Scene* (cat. 123) or *Untitled* (cat. 122) seem figurative.

Noting that Rothko studied biology and anatomy as a student, it is not surprising to discover in these works the presence of cellular or egg-like shapes swirling and floating freely as though suspended in water. Combined with the expansive quality of his projecting lines, and the use of brilliant primary reds, yellows and blues, this imagery suggests the universal concerns of birth, growth and evolution, and in a more figurative sense, symbolizes the artist's own creative processes. These stratified compositions have also been analyzed as symbolic of Jungian ideas of spiritual transformation and the collective unconscious.[3]

By mid-decade, Rothko's early preference for water-color and gouache became more pronounced, sparked by an increasing interest in luminosity. He began to move out of his mythic stage toward increasing abstraction and semitransparent forms. His grounds became creamy in color, all over, and his images grew flat, as in *Tentacles of Memory* (cat. 125) or *Entombment II* (cat. 127). As Waldman states, "The luminosity, flatness, frontality and close-value colors ascribed to the period of Rothko's great breakthrough in 1949–50 are already characteristic of the watercolors and pastels of the mid-1940s."[4] By 1947–48 the transition to the mature works is clearly apparent: the works become increasingly abstract, figures and ground merge, and pure color-forms replace literary, symbolic and biomorphic references.—EB ∎

Notes

[1] Brian O'Doherty, *American Masters: The Voice and the Myth* (New York, 1973), p. 153, as cited in Stephen Polcari, "The Intellectual Roots of Abstract Expressionism; Mark Rothko," *Arts,* vol. 54, September 1979, pp. 131–132.

[2] *Mark Rothko: Paintings* (New York: Art of This Century, 1945), as cited in Diane Waldman, *Mark Rothko, 1903–1970: A Retrospective* (New York: Harry N. Abrams, Inc., in collaboration with The Solomon R. Guggenheim Foundation, 1975), p. 44.

[3] Polcari, pp. 125–128.

[4] Waldman, p. 45.

116
Mark Rothko
Untitled, early 1940s
watercolor and ink on
paper
21 x 14⅞ (53.3 x 37.8)
Lent by Christopher
Rothko and Kate Rothko
Prizel, Washington, D.C.
© Estate of Mark Rothko,
1986

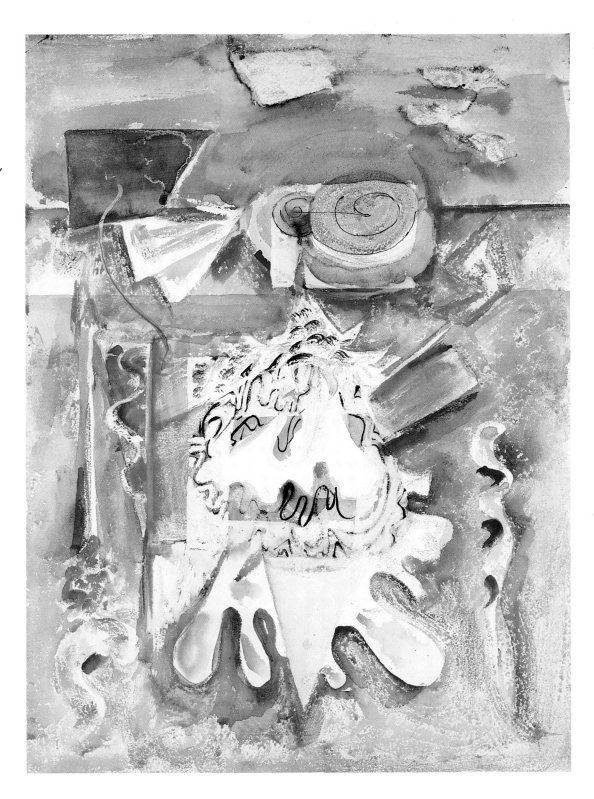

121
Mark Rothko
Untitled, 1944
watercolor and ink on
paper
21 x 30 (53.3 x 76.2)
Lent by Christopher
Rothko and Kate Rothko
Prizel, Washington, D.C.
© Estate of Mark Rothko,
1986

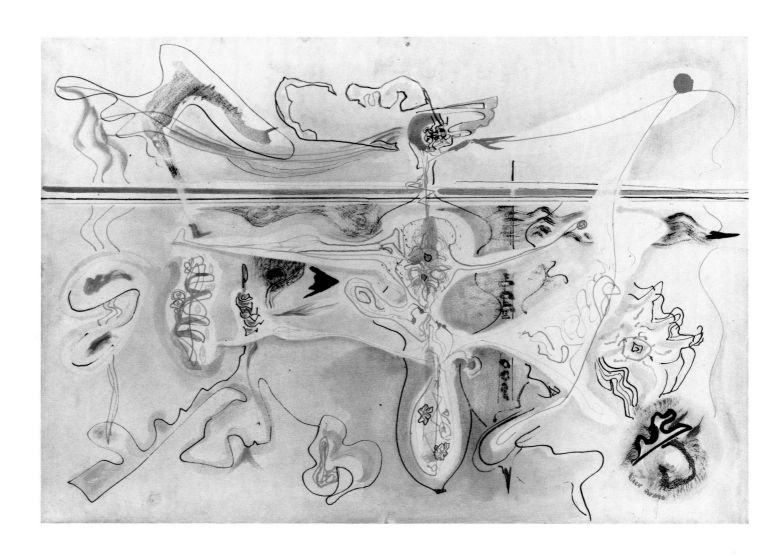

117
Mark Rothko
Untitled, early 1940s
watercolor and ink on
paper
15 x 21⅛ (38.1 x 53.7)
Lent by Christopher
Rothko and Kate Rothko
Prizel, Washington, D.C.
© Estate of Mark Rothko,
1986

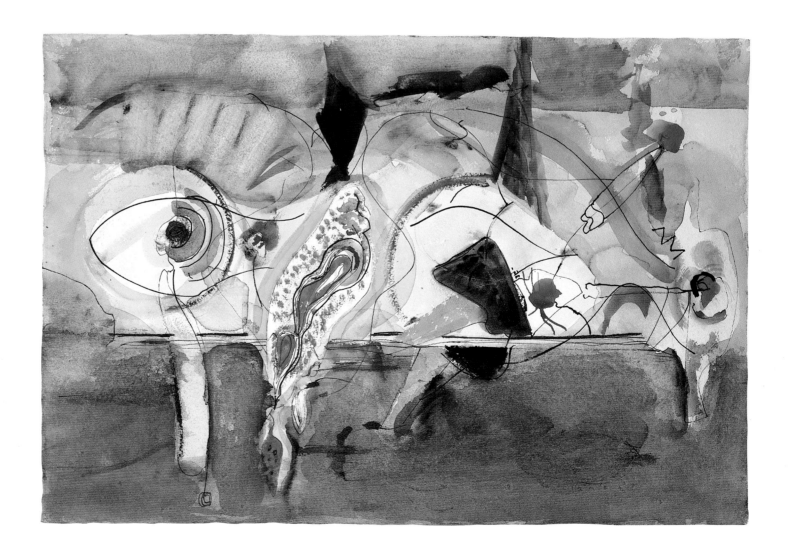

118
Mark Rothko
Untitled, early 1940s
watercolor and ink on
paper
21 x 30 (53.3 x 76.2)
Lent by Christopher
Rothko and Kate Rothko
Prizel, Washington, D.C.
© Estate of Mark Rothko,
1986

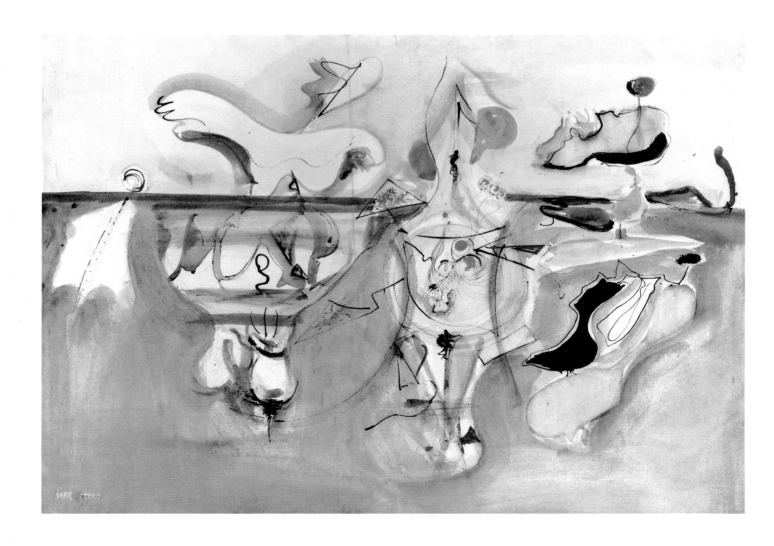

119
Mark Rothko
Untitled, early 1940s
watercolor and ink on
paper
21 x 28¼ (53.3 x 71.4)
Lent by Christopher
Rothko and Kate Rothko
Prizel, Washington, D.C.
© Estate of Mark Rothko,
1986

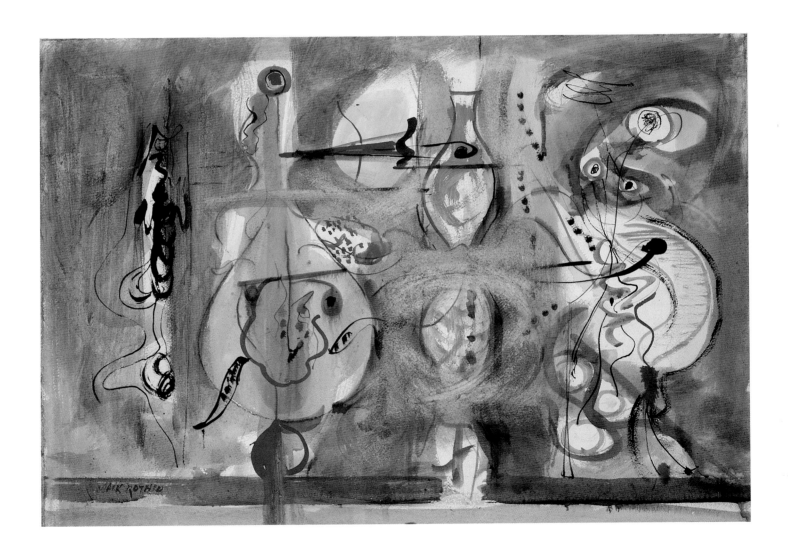

122
Mark Rothko
Untitled, 1944
watercolor on paper
26 x 19¾ (66 x 50.2)
Dougas and Carol Cohen,
Chicago, Illinois

120
Mark Rothko
Untitled, early 1940s
watercolor on paper
30 x 22 (81.3 x 55.8)
Lent by Christopher
Rothko and Kate Rothko
Prizel, Washington, D.C.
© Estate of Mark Rothko,
1986

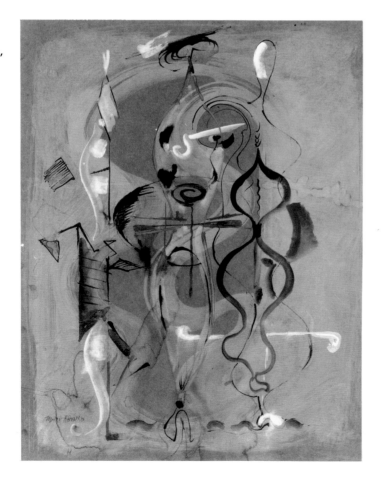

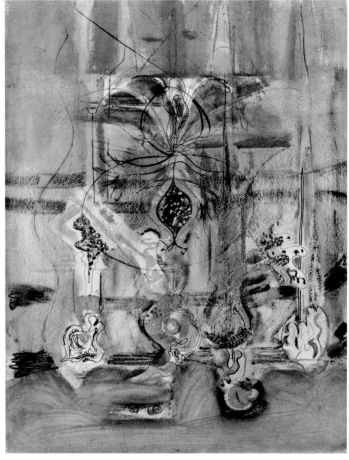

123
Mark Rothko
Baptismal Scene, 1945
watercolor on paper
19⅞ x 14 (50.5 x 35.6)
Collection Whitney
Museum of American
Art, New York; Purchase.
46.12

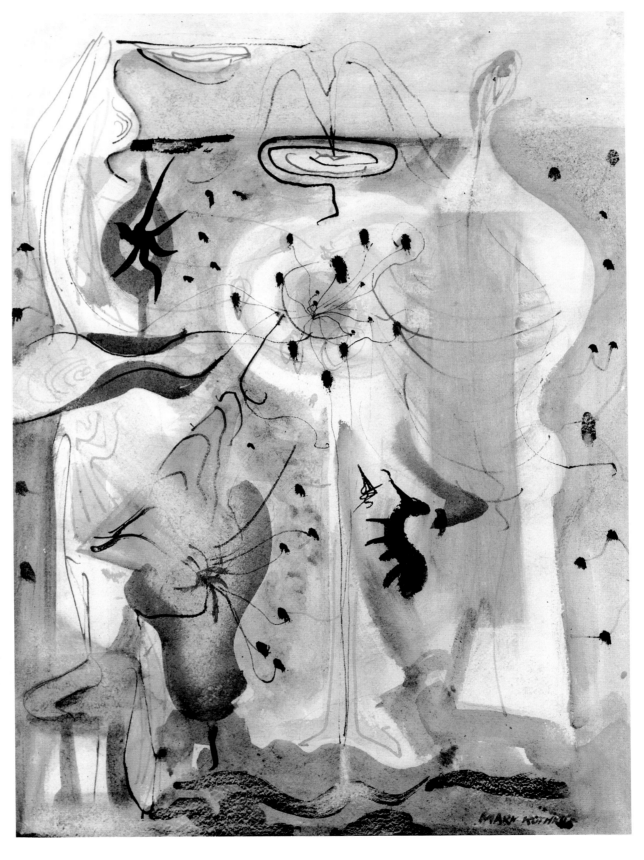

124
Mark Rothko
Untitled, mid-1940s
watercolor on paper
40½ x 27 (102.9 × 68.6)
Lent by Christopher
Rothko and Kate Rothko
Prizel, Washington, D.C.
© Estate of Mark Rothko,
1986

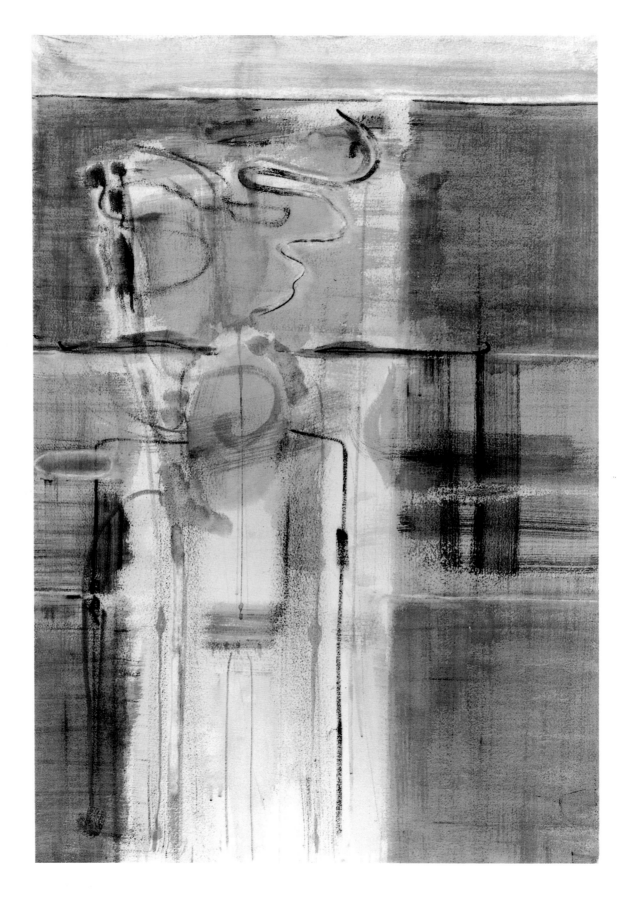

125
Mark Rothko
Tentacles of Memory,
c. 1945–46
watercolor and ink on
paper
21¾ x 30 (55.2 x 76.2)
San Francisco Museum
of Modern Art, San
Francisco, California;
Albert M. Bender,
Collection, Albert M.
Bender Bequest Fund
purchase 46.2794

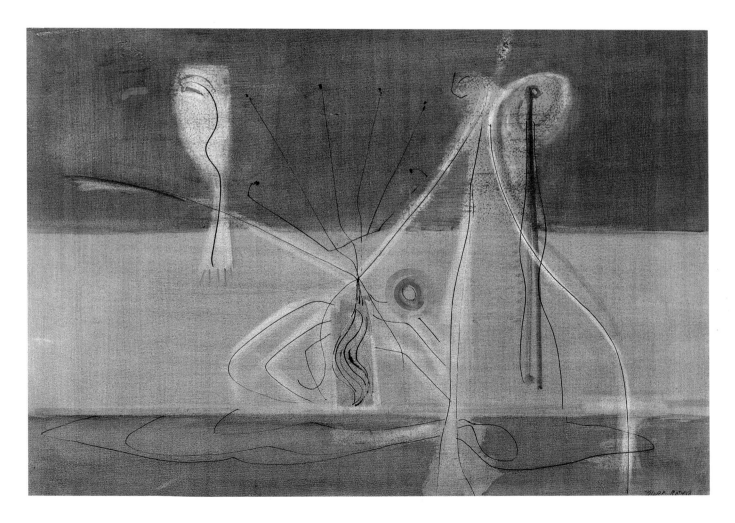

127
Mark Rothko
Entombment II, 1946
watercolor on paper
30 x 38 (76.2 x 96.5)
Private Collection

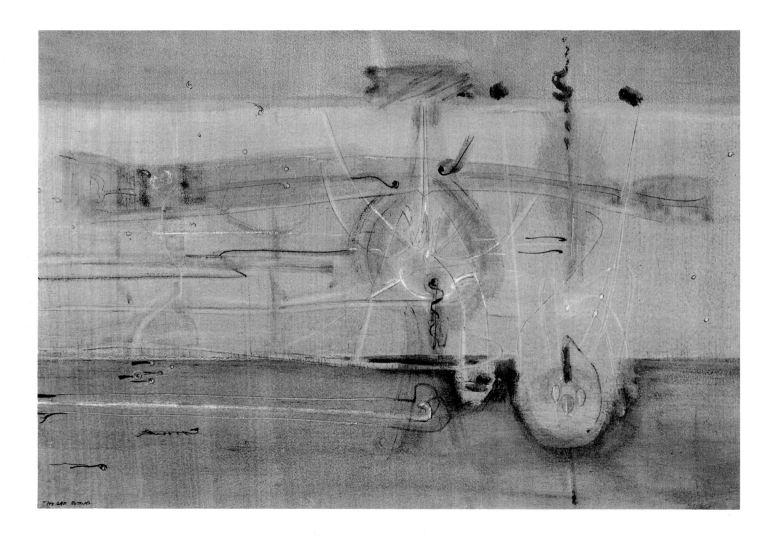

126
Mark Rothko
Entombment I, 1946
gouache on paper
20⅜ x 25¾ (51.8 x 65.4)
Collection of the Whitney
Museum of American
Art, New York; Purchase,
47.10

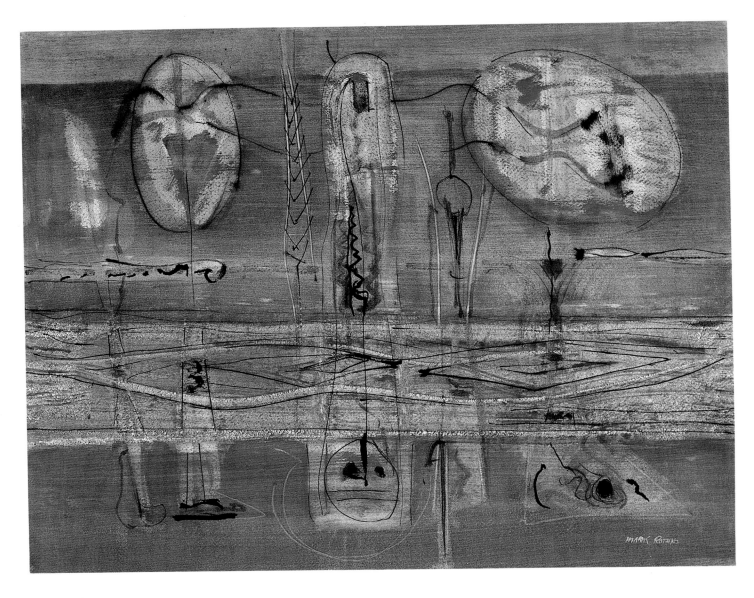

David Smith
1906–1965

In March 1906, David Roland Smith was born into a strict Methodist family in Decatur, Indiana. His formal education consisted of short enrollments at several of the large midwestern universities and an active involvement in the Art Students League in New York. His employment in the 1920s with several industrial metal-working plants had a profound effect on his development of the direct welding technique that led to his mature sculptural style. Recognition for his drawings and sculpture first came in 1938 at a solo exhibition at Marian Willard's East River Gallery. Exhibitions at I Bienal in Sao Paulo, Brazil; the XXVII Venice Biennale; and the Museum of Modern Art, New York, highlight his long and well-recognized career.[1]

Although David Smith is best known for his cubist-inspired, minimalist sculpture of the 1960s, he was also accomplished in the mediums of paint and ink. In his work of the 1940s, one detects the strong influences of the surrealists: a sense of fantasy, of pure imagination, and a release of the conventional and predictable. Smith moved the familiar into a world controlled and synthesized by the unconscious. Mythical creatures and totems to man and nature frequent his sketches and sculptures, animated by his interpretation of gesture and energy. Concurrently, in bronze or steel, he created sculptural parallels to the "mindscapes" of Tanguy and Matta. Whether working in two dimensions or three, the task was the same, to create a sense of movement, fantasy, and space.

Between the years 1938 and 1948, David Smith continued to work in both two-dimensional and three-dimensional formats. Pen and ink were used in *Pillar of Sunday* (cat. 128), a sketch for a sculpture of the same name, in which the drawing becomes Smith's first tool as he weighs the best possible choices for the elements of the sculpture.[2] "...Smith painted in an abstract-Surrealist style which incorporated fragments of a romantic imagery in emblematic abstract designs," describes Sam Hunter at the time of the Museum of Modern Art retrospective in 1957.[3] Because of his working knowledge of sculpted space, Smith was able to create collage-like shapes on a two-dimensional plane with the illusion that they could be removed from their setting and exist independent of any physical attachments. In *Untitled* (cat. 129) the totemic, spiritual beings appear to be merely passing through a room designed by the artist. This intended confusion of space, time, and animation reflects elements of cubism and surrealism. According to Smith, "the painting developed into raised levels from the canvas. Gradually, the canvas became the base and the painting was a sculpture."[4] —BS ∎

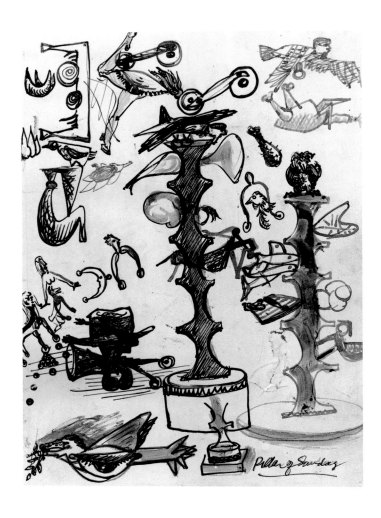

Notes

[1] Miranda McClintic, *David Smith* (Washington, D.C.: Smithsonian Institution Press, 1979), pp. 6–7.

[2] Sam Hunter, "David Smith," *The Museum of Modern Art Bulletin.* vol. 25, no. 1, p. 8 (New York).

[3] Hunter, p. 6.

[4] Quoted in Karen Wilkin, *David Smith: The Formative Years—Sculptures and Drawings from the 1930s and 1940s* (Alberta, Canada: The Edmonton Art Gallery, 1981), p. 5 and note 4.

128 (opposite)
David Smith
Pillar of Sunday, 1945
ink on paper
10 x 7¼ (25.4 × 18.4)
Collection Candida and
Rebecca Smith, Courtesy
M. Knoedler & Co., Inc.,
New York

129
David Smith
Untitled, 1946–47
oil on paper on panel
30⅜ x 22⅜ (77.2 x 56.8)
Collection Candida and
Rebecca Smith, Courtesy
M. Knoedler & Co., Inc.,
New York

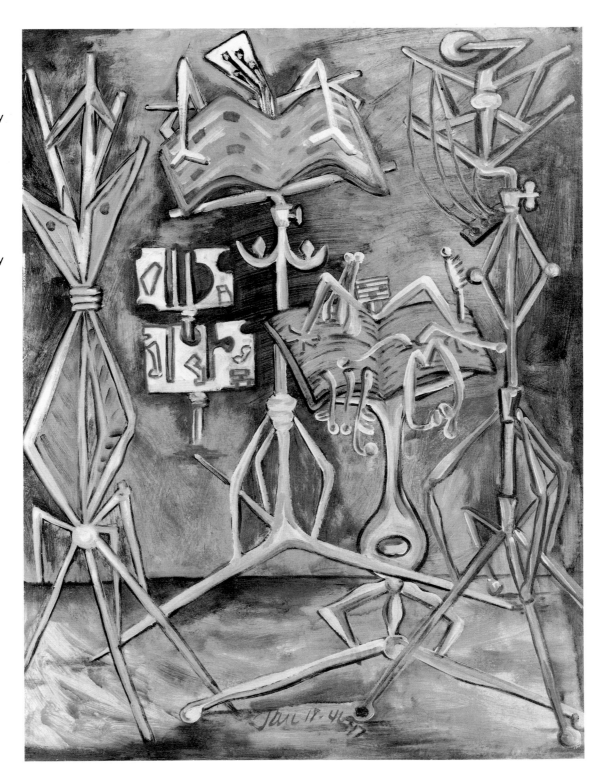

Theodoros Stamos
b. 1922

The son of a poor Greek immigrant family, Theodoros Stamos was born in New York in 1922. When he was fourteen he received a scholarship to the American Artists School in New York, where he studied sculpture under the instruction of Joseph Solman. Solman, a member of a politically active group of artists known as "The Ten," which included Adolph Gottlieb and Mark Rothko, encouraged Stamos to begin painting in 1937. Through frequent visits to galleries in New York as a student, Stamos became familiar with the paintings of Milton Avery, Arthur Dove and Paul Klee, and in 1943 the Wakefield Gallery in New York gave Stamos his first one-person exhibition. That same year he met Rothko (with whom he was to establish a lasting friendship), Gottlieb, and Barnett Newman.

During his early years as a painter, Stamos established his concern for the revelation of universal values and underlying truths common to all forms of nature. In 1957 he described his work of the 1940s:

> I entered the world of the echinoids, sea anemones, fossils and the inside of a stone. Many of them were arranged in a flat space, as if one were looking down at a strip of beach. Textures and brittle, feathery surfaces became an obsession. To free the mystery of the stone's inner life was my object.[1]

In *The Wind is III* (cat. 132), for example, Stamos penetrates the primitive marine life forms with a microscopic vision, revealing the most basic structural components of life common to all of nature. Dore Ashton has observed that Stamos "interprets the landcape through a temperament that seeks to go beyond the purely personal response."[2] He looks for correspondences among all facets of nature, from the most primitive organisms to complex human beings, in order to reveal what he considers to be universal values.

Stamos' artistic principles were shaped by a variety of influences in the early years of his career. His personal interest in primitive art and ancient rituals was enhanced by a childhood filled with stories derived from Greek mythology and legend. The primitive marine-life forms and ocean debris that compose much of his imagery reflect his youth near the New York and New Jersey coast. After reading about Oriental philosophies he became interested in Chinese and Japanese art and the deeply religious, mystic landscapes of Caspar David Friedrich. As a self-taught painter who was not bound to existing traditions, Stamos synthesized these diverse influences into an expressive, highly personal idiom emphasizing subtle gradations of tone and color and simplification of form. His *Untitled* (cat. 131), for example, portrays a cluster of abstracted forms suggesting sea debris, floating in gently modulated patches of grey wash with a grey-blue sand dollar providing the only spot of color.

Throughout his career, Stamos has remained faithful to the principles of subtlety of technique and a search for underlying universal truths which he formulated early in his career.

Stamos was included in one-person exhibitions at Betty Parsons Gallery (1947, 1948), at the Whitney Museum of American Art (1945 and subsequent annuals), and most recently at Camillos Kouros Gallery, New York (1985). —DM ∎

Notes

[1] Quoted in Barbara Cavaliere, "Theodoros Stamos: On the Horizon of Mind and Coast," *Theodoros Stamos: Works from 1945 to 1984* (Zurich: Knoedler Zurich, 1984), p. 20.

[2] Dore Ashton, "Stamos," *Stamos* (New York: Camillos Kouros Gallery, 1985), p. 3.

131
Theodoros Stamos
Untitled, 1947
ink and tempera on paper
12¼ x 18½ (31 x 47)
Turske & Turske, Zurich

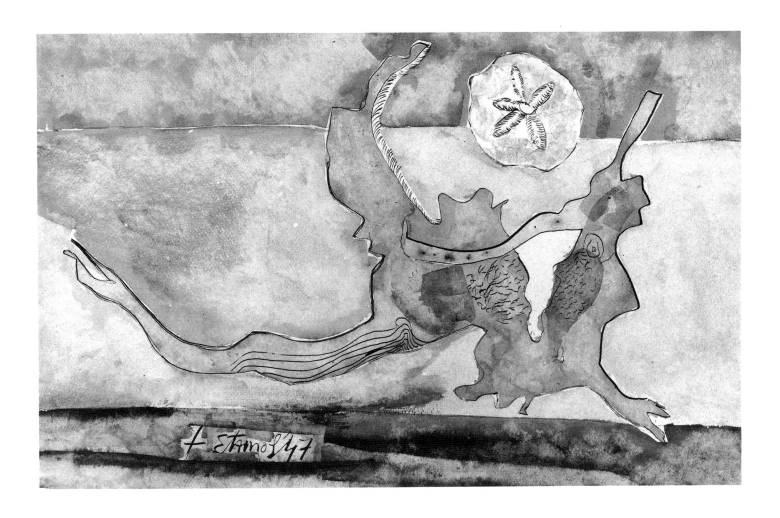

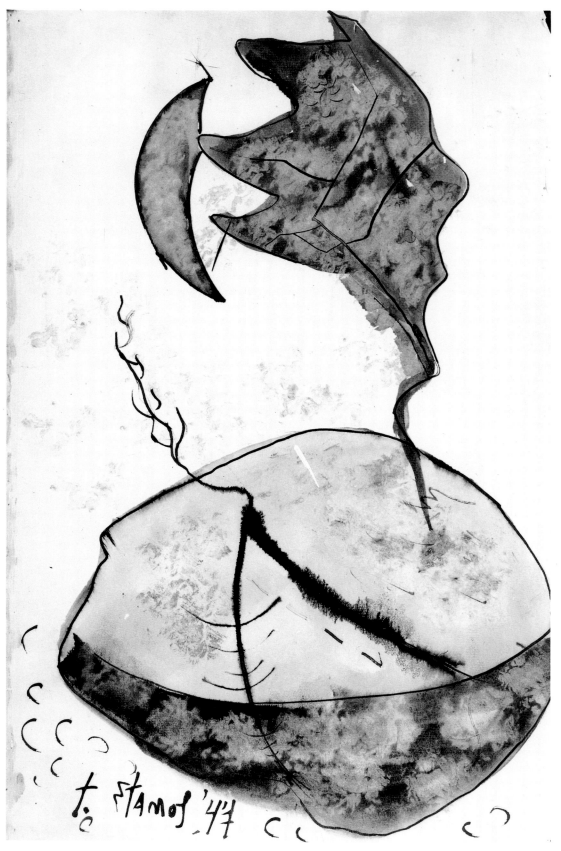

132
Theodoros Stamos
The Wind is Ill, 1947
ink on paper
19⅛ x 12¼ (48.6 x 31.4)
Turske & Turske, Zurich

130
Theodoros Stamos
Ancestral Worship, 1947
gouache, ink and pastel
on paper
17½ x 23⅜ (44.5 x 59.4)
Collection Whitney
Museum of American
Art, New York; Purchase,
48.9

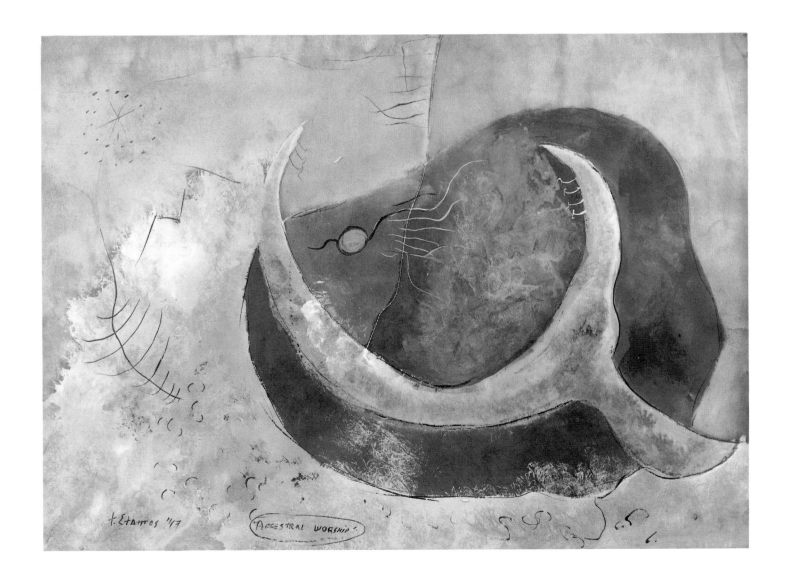

Yves Tanguy
1900–1955

In Yves Tanguy's landscapes of the 1940's dreams merge with reality to form "mindscapes" inhabited by organic and mechanical forms bathed in internal and external light. Unlike the "scribbled" automatic visions of the other surrealists, Tanguy worked very slowly and only when he felt impelled, his seriousness the opposite of the mirth of most surrealist art. He reinvented several methods of blind painting, including painting works hung upside down which, when turned rightside up, yielded new artistic possibilities. He was also one of the inventors of the surrealist game "exquisite corpse," in which each player, in turn, drew an image that was concealed from subsequent players, who would then add to the drawing; the result of the game was the aleatory combination of these images. Tanguy rarely drew preliminary sketches for his paintings because, "I found if I planned a picture beforehand, it never surprised me and surprises are my pleasure in painting."[1] Stylistically, he is best known for his dual manipulation of perspective, from far to near and high to low, as well as his ambiguous horizon lines and his strongly rendered shadows of objects, some of which float mysteriously in the sky. Emigrating to the United States, in 1939 he married American artist Kay Sage and settled in the "post card pretty" town of Woodbury, Connecticut, its quiet security a welcome respite from war-ravaged Europe. Of his relative isolation he observed, "I believe there is little to gain by exchanging opinions with other artists concerning either the ideology of art or the technical methods." However, his works, with their floating biomorphic shapes, were undoubtedly seen by artists in New York in the late '30s and throughout the '40s, and had a discernible impact on Matta and Gorky, to name but a few.

Crucial to an understanding of Tanguy's work from 1938 to 1948 is the effect of his 1939 emigration to the United States. Before arriving in America, his work was predicated on sensibilities he derived from his travels in Africa in 1930 and 1931. These works contained sharply defined shapes bathed in a strong, clear light. The shapes metamorphosed from vegetable to mineral, and the color became more complex, highlighted with extremes of light and dark. The fixed horizon was often replaced by a flowing treatment of space. In America, Tanguy's colors became more audacious, even though the space they inhabited became somewhat darker. The shapes hardened and became more machine-like, looming larger and higher in space, as in *Untitled* (cat. 133), and are rendered as if covered with cellophane, as in *Taille de guêpe* (cat. 135). It has been said that the "Americanization" of Tanguy's work resulted in canvases that were man-made and no longer the result of some chance encounter of organic objects on an imaginary seashore.[2]

Yves Tanguy was born in Paris and was self taught as an artist. His influence on Matta can be seen by comparing the resonating amorphic shapes that are strewn about Tanguy's landscapes with Matta's work from the same period. Discernible too are Tanguy quotes in Arshile Gorky's work, particularly the crowding of abstract forms into the foreground space in Tanguy's *Untitled* (cat. 134), as echoed in Gorky's *Untitled* (cat. 15). Included among his one-person exhibitions were shows at San Francisco Museum of Art (1939); the Pierre Matisse Gallery, New York (1939 through 1946); and the Wadsworth Atheneum, Hartford, Connecticut (1939). Group exhibitions included Artists in Exile at Pierre Matisse Gallery, New York (1942), European Artists in America at the Whitney Museum of American Art (1945), and Le surréalisme en 1947 at Galerie Maeght, Paris. —JS ■

Notes

[1] H. H. Arnason, *History of Modern Art: Paintings, Sculpture and Architecture* (New York: Abrams, 1968), p. 357.

[2] *Contemporary Art 1942–72*, Collection of the Albright-Knox Art Gallery (New York: Praeger Publishers, in association with Albright-Knox Art Gallery, Buffalo, New York, 1973), p. 211.

[3] Marcel Jean, "Tanguy in the Good Old Days," *Art News*, September 1955, p. 30.

[4] Jean Saucett, *Yves Tanguy* (Paris: Editions Filipacchi, 1973), p. 65.

[5] James Thrall Soby, *Yves Tanguy* (New York: The Museum of Modern Art, 1955), p. 17.

[6] Jose Pierre, "Le Peintre Surréaliste Par Excellent," *Yves Tanguy Retrospective 1925–1955*, Centre Georges Pompidou (Paris: Draeger Presses, 1982), p. 58.

[7] Roland Penrose, "Yves Tanguy," *Yves Tanguy Retrospective 1925–1955*, Centre Georges Pompidou (Paris: Draeger Presses, 1982), p. 28.

133
Yves Tanguy
Untitled, 1943
gouache on paper
14 x 11 (35.6 x 28)
Collection Mr. and Mrs.
Bruce Clark, New York

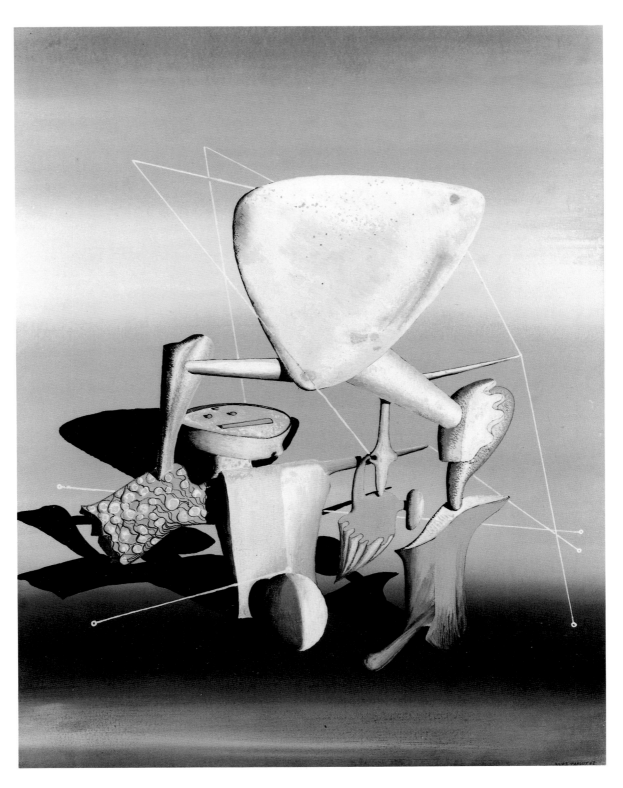

134
Yves Tanguy
Untitled, 1945
gouache on paper
17½ x 11⅞ (44.5 x 30.2)
Collection The Museum
of Modern Art, New
York, Kay Sage Tanguy
Bequest

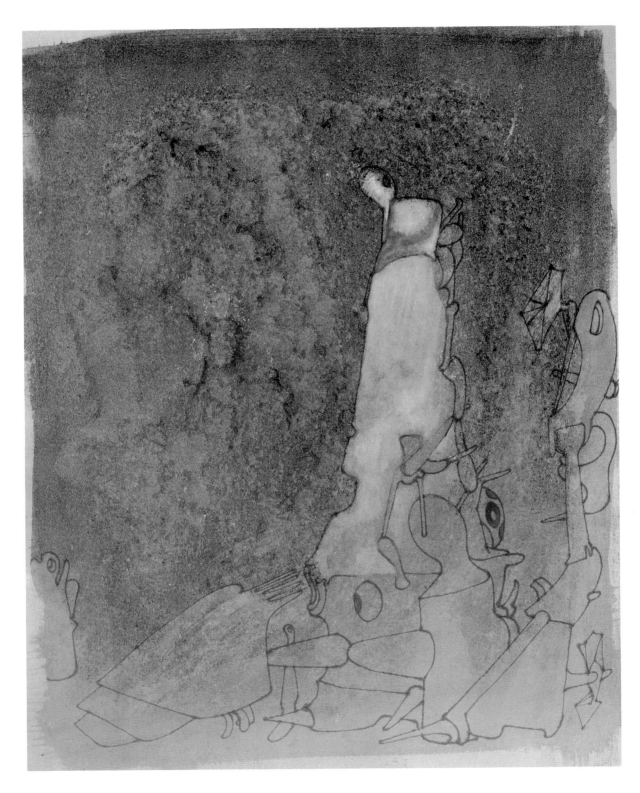

135
Yves Tanguy
Taille de guêpe, 1945
gouache on paper
22 x 11 (55.9 x 27.9)
Pierre Matisse Gallery,
New York

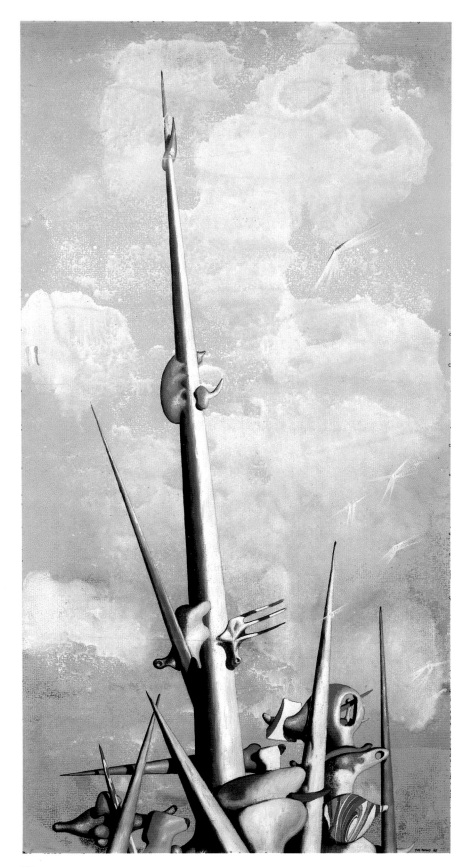

Mark Tobey
1890–1976

In December 1890, Mark Tobey was born in Centerville, Wisconsin. Stirred by an early interest in art but unable to afford to attend school full time, he commuted to Chicago from his home in Hammond, Indiana, in order to attend Saturday classes at The Art Institute. In his early twenties Tobey worked as a fashion artist and society portrait painter and traveled between New York and Chicago. In 1918 he joined the Bahai World Faith, which teaches the benefits of a universal religious harmony. His religious interests and spiritual nature played a large part in the development of his visual expression. In 1922 Tobey moved to Seattle and began teaching at the Cornish School of Allied Arts, a progressive school of art, music, dance, and theater. From 1925 until 1944 Tobey traveled extensively throughout Europe, Mexico, and the Orient. Since 1944, he has had many one-person exhibitions, and, when his work won first prize at the XXIX Venice Biennale in 1958, his contributions to painting became known internationally.[1]

By the early 1930s Tobey achieved the style for which he is best known. His animated, calligraphic lines on dark backgrounds, known as "white writings," traced out familiar images such as a Broadway street scene or a Gothic cathedral.[2] In the works of the 1930s and 1940s, patterns of lines, layered and intertwined, take on a more stylized view of the interaction between man, nature, and God. Personified by a gestural approach, his lines echo the energy and rhythm of man, who is the inspiration and subject of all his works; "The human energy spills itself in multiple forms, writhes, sweats and strains every muscle...."[3]

Revealing the energy, aura and animation in mankind and nature, Tobey moved his caricatures closer to an abstraction of resonating fields of energy. Tobey's "white writings" were concurrent with "action painting" and reflect a consistent concern of his contemporaries, such as Jackson Pollock, with control of automatic or seemingly unconscious techniques.[4] Tobey never made the full evolution from the gesture and automatism of his peers into abstract expressionism, but stopped at a plane of gestural, analytical abstraction.

Woven into the linear patterns of *Northwest Still Life* (cat. 136) are primitive bird images reminiscent of the masks and motifs of the native coastal tribes of North America. In *Red Man-White Man-Black Man* (cat. 137) his lines continually turn back on themselves, while the myriad colors and shapes form a tangled web of abstraction from which fish symbols emerge. Tobey speaks a pictorial language of spirituality and cultural interconnectedness in his mythic abstractions. —BS ∎

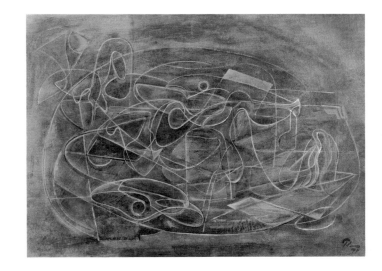

Notes

[1] *Tribute to Mark Tobey* (Washington, D.C.: Smithsonian Institution, 1974), pp. 13–14.

[2] Wieland Schmeid, *Tobey* (New York: Abrams, 1966), p. 7.

[3] William C. Seitz, *Mark Tobey* (New York: The Museum of Modern Art, 1962), p.36.

[4] Schmeid, *Tobey,* p. 8.

136 (opposite)
Mark Tobey
Northwest Still Life, 1941
tempera on board
20 x 26 (50.8 x 66)
Seattle Art Museum,
Seattle, Washington;
Eugene Fuller Memorial
Collection

137
Mark Tobey
*Red Man-White Man-
Black Man,* 1945
oil and gouache on
cardboard
25 x 28 (63.5 x 71.1)
Albright-Knox Art Gallery,
Buffalo, New York; Room
of Contemporary Art
Fund, 1943

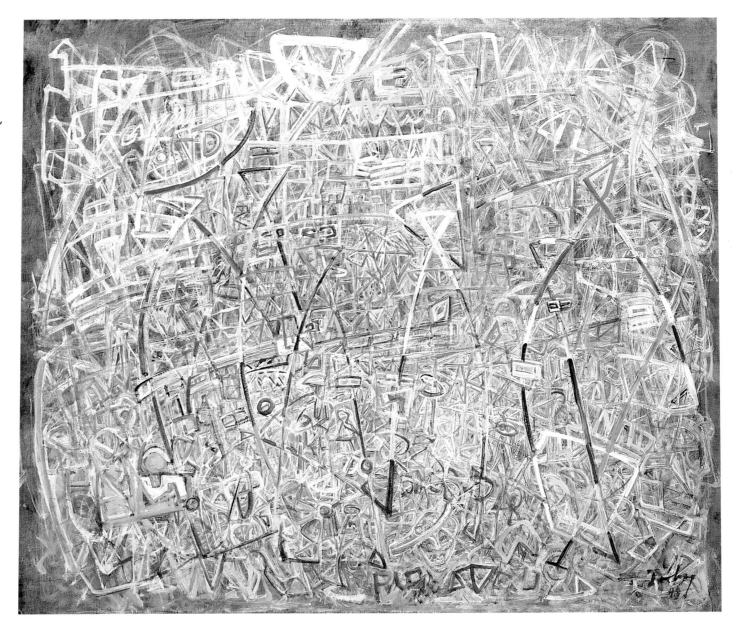

Catalog of the Exhibition

*Reproduced in color.
†Not reproduced in catalog.
Dimensions of the drawings are given in inches, followed by centimeters in parentheses. Height measurements precede width measurements. Titles, dates, mediums, measurements, and orientations of the works have been verified with the lenders wherever possible. In cases where dates and orientations were not indicated by the artist at the time of execution, we have relied on monographs, art historical sources and artist's estate for this information.

William Baziotes

†1 *Untitled,* c. 1939
watercolor and gouache on paper
12 x 9 (30.5 x 22.9)
Collection Ethel Baziotes, Courtesy Blum Helman Gallery, New York

2 *Untitled,* c. 1941–42
watercolor and ink on paper mounted on board
11⅞ x 7⅜ (30.5 x 19.1)
Collection Ethel Baziotes, Courtesy Blum Helman Gallery, New York

3 *Untitled,* c. 1942–43
gouache with frottage and ink on paper
9 x 11⅞ (30.5 x 22.9)
Collection Ethel Baziotes, Courtesy Blum Helman Gallery, New York

*4 *Untitled,* n.d.
watercolor on paper
7¾ x 9¾ (19.7 x 24.8)
Herbert F. Johnson Museum of Art, Cornell University, Ithaca, New York; Gift of Dr. & Mrs. Emanuel Klein

5 *Untitled,* c. 1943–44
charcoal on paper
12¼ x 15¼ (31.1 x 38.7)
Collection Ethel Baziotes, Courtesy Blum Helman Gallery, New York

6 *Untitled,* c. 1946–47
watercolor, gouache and ink on paper
13⅞ x 10⅞ (35.6 x 26.4)
Collection Ethel Baziotes, Courtesy Blum Helman Gallery, New York

*7 *Summer Landscape,* 1947
watercolor, ink and pencil on paper
14 x 16 (35.6 x 40.6)
Collection Mr. and Mrs. Bruce Clark, New York

*8 *Night Figure, No. 1,* n.d.
watercolor, gouache, ink and pencil on paper
18 x 15⅛ (45.7 x 38.4)
Collection Solomon R. Guggenheim Museum, New York

Byron Browne

9 *Head in Violet and Brown,* 1940
india ink and wash on paper
14 x 11 (35.6 x 27.9)
Meredith Long & Co., Houston, Texas

10 *Flying Shapes,* 1943
india ink and crayon on paper
12½ x 20¼ (31.8 x 51.4)
Meredith Long & Co., Houston, Texas

Arshile Gorky

*11 *Study for "The Liver is the Cock's Comb,"* 1943
ink, pencil and crayon on paper
19 x 25½ (48.3 x 64.1)
Collection Marcia S. Weisman, Beverly Hills, California

*12 *Anatomical Blackboard,* 1943
pencil and crayon on paper
20¼ x 27⅜ (51.4 x 69.5)
Mr. and Mrs. Walter Bareiss, New York

13 *Study for "The Plough and the Song,"* 1944
pencil and crayon on paper
18½ x 24¾ (47 x 62.9)
Allen Memorial Art Museum, Oberlin College, Oberlin, Ohio; Friends of Art Fund, 56.1

*14 *Virginia Landscape,* 1944
pencil and sargent crayon on paper
19 x 25 (48.3 x 63.5)
Stefan T. Edlis, Chicago, Illinois

15 *Untitled,* 1946
pencil, pen, ink and crayon on paper
19⅛ x 24¾ (48.6 x 62.9)
Courtesy Marisa del Re Gallery, Inc., New York

16 *Study for "Summation,"* 1946
pencil and crayon on paper
18½ x 24½ (47 x 62.2)
Collection Whitney Museum of American Art, New York; Gift of Mr. and Mrs. Wolfgang S. Schwabacher, 50.18

*17 *Virginia Landscape,* c. 1946
pencil and crayon on paper
18½ x 23⅝ (47 x 60)
Xavier Fourcade, Inc., New York

18 *Untitled,* c. 1946
ink, watercolor, pencil and wax crayon on paper
18¾ x 24⅛ (47.6 x 61.3)
Collection Solomon R. Guggenheim Museum, New York, Gift, Rook McCulloch, 1976

19 *Untitled,* c. 1946
pencil and crayon on paper
19¼ x 25 (50.2 x 63.5)
Xavier Fourcade, Inc., New York

20 *Untitled,* 1946
pencil and crayon on paper
19⅛ x 24 (48.6 x 61)
Varjabedian, H., California

21 *Study for "Agony,"* 1946
pencil, wax crayon, and watercolor on paper
18½ x 23¾ (47 x 60.3)
Collection Solomon R. Guggenheim Museum, New York, Gift, Rook McCulloch, 1978

*22 *Study for "Agony I,"* 1946–47
pencil, crayon and wash on paper
21¾ x 29½ (55.2 x 74.9)
Sarah Campbell Blaffer Foundation, Houston, Texas

23 *Drawing,* 1946–47
pencil and crayon on paper
18½ x 25¼ (47 x 64)
Xavier Fourcade, Inc., New York

*24 *Study for "Agony,"* 1947
wax crayon and pencil on paper
19 x 24 (48.3 x 70)
Collection Mr. and Mrs. S. I. Newhouse, Jr., New York

25 *Study for "Last Painting,"* 1948
pencil and sargent crayon on paper
11 x 14½ (28 x 37)
Herbert F. Johnson Museum of Art, Cornell University, Ithaca, New York; Herbert F. Johnson Acquisition Fund

Adolph Gottlieb

26 *The Centers of Lateral Resistance,* 1945
gouache on paper
32 x 24 (81.3 x 61)
Collection Solomon R. Guggenheim Museum, New York

27 *Composition,* n.d.
gouache and watercolor on paper
25¾ x 19⅝ (65.4 x 49.9)
Marlborough Gallery, New York

28 *Voyager's Return,* 1946
gouache and watercolor on paper
25½ x 19⅝ (64.8 x 49.9)
Collection Whitney Museum of American Art, New York; Gift of Mr. and Mrs. Samuel M. Kootz, 51.38

*29 *Untitled,* c. 1946
gouache and crayon on paper
19⅜ x 24⅞ (49.2 x 63.2)
Collection Phil and Norma Fine, Boston,
Massachusetts

*30 *Untitled,* 1946
gouache on paper
20 x 26 (50.8 x 66)
Everson Museum of Art, Syracuse,
New York; Gift of André Emmerich,
1969

31 *Incubus,* 1947
gouache on paper
23 x 17 (58.4 x 43.2)
The North Carolina Museum of Art,
Raleigh, North Carolina

*32 *Untitled,* c. 1947–48
gouache and sgraffito on paper
24 x 18 (61 x 45.7)
Private Collection

33 *Pictograph,* 1948
gouache on paper
18 x 24 (45.7 x 61)
The Arkansas Arts Center Foundation,
Little Rock, Arkansas

John D. Graham

†34 *Untitled,* 1942
gouache on paper
18 x 24 (45.7 x 61)
Courtesy André Emmerich Gallery,
New York

*35 *Untitled,* 1943
gouache on paper
24 x 19 (61 x 48.3)
Courtesy Allan Stone Gallery, New York

Hans Hofmann

36 *Monster of the Ocean,* 1944
gouache on paper
16¾ x 13¾ (43 x 35)
Courtesy André Emmerich Gallery,
New York

37 *Untitled,* 1945
gouache on paper
23½ x 17¾ (59.7 x 45.1)
Courtesy André Emmerich Gallery,
New York

*38 *Midnight Glow,* 1945
gouache on paper
28¾ x 22¾ (73 x 57.8)

Courtesy André Emmerich Gallery,
New York

39 *Flower Garden,* 1945
gouache on paper
23 x 28⅞ (58.4 x 73.3)
Courtesy André Emmerich Gallery,
New York

*40 *Phantasie in Red,* 1945
watercolor on paper
29 x 23 (73.7 x 58.4)
The Ball Stalker Collection, Atlanta,
Georgia

41 *Untitled,* 1945
gouache and ink on paper
17½ x 22½ (44.5 x 57.2)
Courtesy André Emmerich Gallery,
New York

*42 *Untitled,* c. 1946
gouache on paper
28¾ x 23⅛ (73 x 58.7)
Cynthia and Micha Ziprkowski,
New York

43 *Untitled,* 1948
india ink on paper
22¾ x 30 (57.8 x 76.2)
Courtesy André Emmerich Gallery,
New York

Gerome Kamrowski

44 *Rouge,* 1940
oil and enamel on paper
20 x 32 (50.8 x 81.3)
Collection Mary Jane Kamrowski, Ann
Arbor, Michigan

†45 *Forest Forms,* 1943
gouache on paper
22 x 30 (55.9 x 76.2)
Collection Mary Jane Kamrowski, Ann
Arbor, Michigan

46 *Small Scene on a Pagan Bluff,* 1943
gouache on paper
22 x 30 (55.9 x 76.2)
Jane Voorhees Zimmerli Art Museum,
Rutgers—The State University, New
Brunswick, New Jersey; Gift of the
artist

*47 *Emotional Seasons,* 1943
gouache and collage on paper on wood;
drawings on both sides of board
21½ x 21⅛ (54.6 x 53.7)
Collection Whitney Museum of Ameri-

can Art, New York; Purchase, with
funds from Charles Simon, 78.69

Wifredo Lam

48 *Maternidad—Yoruba,* 1942
charcoal, crayon, and gouache on paper
48 x 37½ (122.5 x 95.5)
Private Collection

†49 *L'homme à la vague,* 1942
gouache on paper
41½ x 34 (105.4 x 86.4)
Pierre Matisse Gallery, New York

*50 *Les yeux de la grille,* 1942
gouache on paper
41½ x 33 (105.4 x 86.4)
Pierre Matisse Gallery, New York

André Masson

51 *Vois l'antre des metamorphoses,*
1938
ink on paper
19½ x 25¼ (49.5 x 64.1)
Herbert F. Johnson Museum of Art,
Cornell University, Ithaca, New York;
Membership Purchase Fund

52 *Le rapt,* 1942
pastel on cardboard
19 x 25½ (48 x 65)
Courtesy Marisa del Re Gallery, Inc.,
New York

53 *Sexus,* 1942
charcoal, tempera, and Chinese ink on
paper
17⁹⁄₁₀ x 24 (46 x 61)
Courtesy Marisa del Re Gallery, Inc.,
New York

*54 *Amants entrelacés,* 1943
gouache on paper
10½ x 8 (27 x 20)
Courtesy Marisa del Re Gallery, Inc.,
New York

55 *Combat légendaire,* 1943
pastel on paper
30 x 22 (76 x 56)
Courtesy Marisa del Re Gallery, Inc.,
New York

†56 *Isabella d'este,* 1943
crayon and pastel on paper
25 x 19 (64 x 48)
Courtesy Marisa del Re Gallery, Inc.,
New York

57 *Le nu bleu,* 1944
pastel on paper
15¾ x 19 (40 x 48)
Courtesy Marisa del Re Gallery, Inc.,
New York

*58 *Regardant l'aquarium,* 1944
watercolor, ink, and pastel on paper
19¾ x 23½ (50 x 59.3)
Collection Anne and Jean-Claude
Lahumière, Paris

*59 *Vieux souliers sous la pluie,* 1945
tempera and Chinese ink on paper
21¾ x 18½ (55 x 47)
Courtesy Marisa del Re Gallery, Inc.,
New York

Matta

*60 *Untitled,* c. 1938
crayon and pencil on paper
12¼ x 19 (31.1 x 48.3)
Maxwell Davidson Gallery, Courtesy
Arnold Herstand & Company, New York

61 *Endless Nude,* 1938
crayon and pencil on paper
12¾ x 19½ (32.4 x 49.5)
The Museum of Modern Art, New York,
Katherine S. Dreier Bequest

*62 *Preliminary Study for "Prescience,"*
1939
pencil and colored pencil on paper
11 x 14⅝ (28 x 37.3)
Collection Luisa Laureati, Galleria
dell'Oca, Rome

*63 *Psychological Architecture,*
1940–41
crayon, pencil and colored pencil
on paper
16¾ x 21 (43 x 53.3)
Collection Mr. and Mrs. Bruce Clark,
New York

64 *Untitled,* 1941
crayon and graphite on paper
11 x 15 (27.9 x 53.3)
Courtesy Allan Stone Gallery, New York

65 *Untitled,* 1942
crayon and pencil on paper
23 x 29 (58.4 x 73.7)
Private Collection, New York

66 *Les lits des vulqivaques,* 1943
pencil and crayon on paper
22½ x 28½ (57.2 x 72.4)
Allan Frumkin Gallery, New York

67 *On ne possède sur les immeubles,*
1943
pencil and crayon on paper
22½ x 28½ (57.2 x 72.4)
Private Collection, New York

*68 *Woman Impaled and Five Other
Scenes,* 1943
pencil and crayon on paper
23 x 29 (58.4 x 73.7)
Private Collection, New York

†69 *Project for "The Onyx of Electra,"*
1944
collage and drawing on paper
15⅓ x 20 (39 x 51)
Collection Luisa Laureati, Galleria
dell'Oca, Rome

*70 *Crucifixion,* c. 1946
pencil and crayon on paper
17 x 21¾ (43.2 x 55.2)
Private Collection

71 *Untitled,* c. 1948–49
pastel on paper mounted on canvas
39 x 59 (100 x 150)
Private Collection

Joan Miró

*72 *Acrobatic Dancers,* 1940
gouache and oil wash on paper
18½ x 15 (47 x 38.1)
Wadsworth Atheneum, Hartford,
Connecticut; The Philip L. Goodwin
Collection

*73 *Untitled,* 1941
watercolor and ink on paper
19½ x 25½ (49.5 x 64.8)
Courtesy Marisa del Re Gallery, Inc.,
New York

74 *Personnages, oiseau, étoile,* 1942
gouache on paper
43 x 30½ (109.2 x 77.5)
Pierre Matisse Gallery, New York

75 *Personnage et oiseau dans la nuit,*
1942
pencil on paper
18 x 24½ (45.7 x 62.2)
Courtesy Galerie Maeght Lelong,
New York

Robert Motherwell

76 *The Mexican Sketchbook,* 1941
ink on paper, eleven pages

9 x 11½ (29.2 x 28.7)
Collection of the artist

77 *For Pajarito,* 1941
oil wash and ink on paperboard
8 x 10 (20 x 25)
Portland Museum of Art, Portland,
Maine; Purchase with matching grants
from the National Endowment for the
Arts and Casco Bank And Trust Co., 1981

*78 *Figure With Blots,* 1943
oil and collage on paper
45½ x 38 (115.6 x 96.5)
Mr. and Mrs. David Mirvish, Toronto,
Ontario, Canada

79 *Three Figures Shot,* 1944
colored ink on paper
11⅜ x 14½ (28.9 x 36.8)
Collection Whitney Museum of Ameri-
can Art, New York; Purchase, with
funds from the Burroughs Wellcome
Purchase Fund and the National En-
dowment for the Arts, 81.31

80 *Three Important Personages,* 1944
ink on paper
11 x 14 (27.9 x 35.6)
Richard E. and Jane M. Lang Collection,
Medina, Washington

*81 *Collage #2,* 1945
oil and collage on board
21⅞ x 14⅞ (55.6 x 37.8)
Collection of the artist

82 *Untitled,* 1945
watercolor and ink on paper
10½ x 8¾ (26.7 x 22.2)
The North Carolina Museum of Art,
Raleigh, North Carolina

83 *Untitled (Figure with Green Wash),*
1947
india ink and wash on paper
8 x 4 (20.3 x 10.2)
Collection of the artist

Barnett Newman

84 *Untitled,* 1944
tempera and wax crayon on paper
15 x 20 (38.1 x 50.8)
Collection Annalee Newman, New York

85 *Untitled,* 1944
wax crayon and oil crayon on paper
15 x 20 (38.1 x 50.8)
Collection Annalee Newman, New York

194

86 *Untitled*, 1944
wax crayon and oil crayon on paper
20 x 15 (50.8 x 38.1)
Collection Annalee Newman, New York

87 *The Slaying of Osiris*, 1944
oil and oil crayon on paper
19⅞ x 14¾ (50.5 x 37.5)
Collection Annalee Newman, New York

*88 *Untitled*, 1945
oil, oil crayon and pastel on paper
19⅜ x 25½ (49.5 x 64.5)
Collection Annalee Newman, New York

*89 *The Song of Orpheus*, 1944–45
oil, oil crayon and wax crayon on paper
19 x 14 (48.3 x 35.6)
Collection Annalee Newman, New York

90 *Untitled Drawing*, 1945
ink on paper
19⅞ x 14¾ (50.5 x 37.5)
Collection Annalee Newman, New York

91 *Untitled*, 1945
ink on paper
14⅞ x 16⅜ (37.8 x 41.8)
Collection Annalee Newman, New York

*92 *Gea*, 1945
oil and oil crayon on cardboard
27¾ x 21⅞ (70.5 x 55.6)
Collection Annalee Newman, New York

93 *Untitled*, 1945
watercolor and tempera on paper
11½ x 16¼ (29.2 x 41.3)
Collection Annalee Newman, New York

*94 *Untitled*, 1945
watercolor on paper
11½ x 16¼ (29.2 x 41.3)
Courtesy Margo Leavin Gallery, Los
Angeles, California

Gordon Onslow Ford

95 *Mountain White*, 1938
gouache on paper
14 x 24 (35.6 x 61)
Collection of the artist

*96 *Mountain Auras*, 1939
gouache on paper
19½ x 25¼ (49.5 x 64.1)
Collection of the artist

97 *Amorous Landscape*, 1940
gouache and watercolor on paper
19½ x 13⅝ (49.5 x 34.3)

Collection of the artist, Courtesy Arnold
Herstand & Company, New York

Wolfgang Paalen

†98 *Untitled (To Madame Meredith
Hare)*, 1940
ink on parchment
13 x 6 (33 x 15.2)
Herbert Palmer Gallery, Los Angeles,
California

99 *Mexico*, 1941
pencil on paper
32 x 24 (81.3 x 61)
Collection Gordon Onslow Ford,
Inverness, California

Jackson Pollock

100 *Untitled*, c. 1939–42
C.R. #603ʳ
india ink on paper
18 x 13⅞ (45.7 x 35.2)
Collection Whitney Museum of Ameri-
can Art, New York; Purchase, with
funds from the Julia B. Engel Purchase
Fund and the Drawing Committee,
85.19b

101 *Animal Figures*, c. 1939–42
C.R. #601
ink on paper
13 x 10⅜ (33 x 26.4)
Collection of The Fort Worth Art
Museum, Fort Worth, Texas; Purchase
made possible by a grant from the
Anne Burnett and Charles Tandy
Foundation

102 *Untitled*, c. 1939–42
C.R. #557
crayon and pencil on paper
14 x 11 (35.6 x 27.9)
Collection Whitney Museum of Ameri-
can Art, New York; Purchase, with
funds from the Julia B. Engel Purchase
Fund and the Drawing Committee,
85.18

*103 *Untitled*, 1943
C.R. #698
ink and watercolor on paper
26 x 20½ (66 x 52.1)
Montana Historical Society, Helena,
Montana; Poindexter Collection

*104 *Untitled*, 1943
C.R. #972

ink and gouache on paper
18¾ x 24¾ (47.6 x 62.9)
Mr. and Mrs. Eugene Victor Thaw,
New York

105 *Untitled*, c. 1943
C.R. #704
ink and gouache on paper
12½ x 13 (31.7 x 33)
Collection of Abby and B. H. Friedman,
New York

*106 *Untitled*, c. 1943
C.R. #1023
collage, ink, crayon, and colored pencil
on paper
15½ x 13⅝ (39.4 x 34.6)
Collection Marcia S. Weisman, Beverly
Hills, California

107 *Untitled*, c. 1943
C.R. #702
ink and pencil on paper
5⅝ x 17⅞ (14.2 x 45.3)
Anonymous Extended Loan to The
Museum of Modern Art, New York

108 *Untitled*, c. 1943 (recto)
C.R. #701
ink on paper; drawings on both sides
of paper
7¼ x 5¼ (18.4 x 13.3)
Courtesy Allan Stone Gallery, New York

*109 *Untitled*, 1945
C.R. #997
oil and tempera on paper
15½ x 12¼ (39.4 x 31.1)
Collection Dorothea Elkon, Courtesy
Arnold Herstand & Company, New York

110 *Untitled*, c. 1946
C.R. #761
ink on paper
5 x 11½ (12.7 x 29.2)
Betty Parsons Foundation, New York

111 *Untitled*, 1947
C.R. #762
ink and crayon on paper
17¾ x 23¼ (45 x 59)
Collection Duncan MacGuigan,
New York

Richard Pousette-Dart

112 *Untitled*, c. 1943–46
watercolor and gouache on paper
8 x 6½ (20.3 x 16.5)

Herbert F. Johnson Museum of Art, Cornell University, Ithaca, New York; Gift of Mr. and Mrs. John M. Goodwillie

*113 *Hesperides,* 1944–45
mixed media on gesso board
20 x 24 (50.8 x 61)
Courtesy Marisa del Re Gallery, Inc., New York

*114 *Untitled,* 1945
mixed media and gouache on parchment
22 x 18 (55.9 x 45.7)
Private Collection

Mark Rothko

†115 *Untitled,* early 1940s
watercolor and ink on paper
20¼ x 14¼ (51.4 x 36.2)
Lent by Christopher Rothko and Kate Rothko Prizel, Washington, D.C.

*116 *Untitled,* early 1940s
watercolor and ink on paper
21 x 14⅞ (53.3 x 37.8)
Lent by Christopher Rothko and Kate Rothko Prizel, Washington, D.C.

*117 *Untitled,* early 1940s
watercolor and ink on paper
15 x 21⅛ (38.1 x 53.7)
Lent by Christopher Rothko and Kate Rothko Prizel, Washington, D.C.

118 *Untitled,* early 1940s
watercolor and ink on paper
21 x 30 (53.3 x 76.2)
Lent by Christopher Rothko and Kate Rothko Prizel, Washington, D.C.

*119 *Untitled,* early 1940s
watercolor and ink on paper
21 x 28¼ (53.3 x 71.4)
Lent by Christopher Rothko and Kate Rothko Prizel, Washington, D.C.

120 *Untitled,* early 1940s
watercolor on paper
32 x 22 (81.3 x 55.8)
Lent by Christopher Rothko and Kate Rothko Prizel, Washington, D.C.

121 *Untitled,* 1944
watercolor and ink on paper
21 x 30 (53.3 x 76.2)

Lent by Christopher Rothko and Kate Rothko Prizel, Washington, D.C.

122 *Untitled,* 1944
watercolor on paper
26 x 19¾ (66 x 50.2)
Douglas and Carol Cohen, Chicago, Illinois

123 *Baptismal Scene,* 1945
watercolor on paper
19⅞ x 14 (50.5 x 35.6)
Collection Whitney Museum of American Art, New York; Purchase, 46.12

124 *Untitled,* mid-1940s
watercolor on paper
40½ x 27 (102.9 x 68.6)
Lent by Christopher Rothko and Kate Rothko Prizel, Washington, D.C.

*125 *Tentacles of Memory,* c. 1945–46
watercolor and ink on paper
21¾ x 30 (55.2 x 76.2)
San Francisco Museum of Modern Art, San Francisco, California; Albert M. Bender Collection, Albert M. Bender Bequest Fund purchase 46.2794

*126 *Entombment I,* 1946
gouache on paper
20⅜ x 25¾ (51.8 x 65.4)
Collection Whitney Museum of American Art, New York; Purchase, 47.10

127 *Entombment II,* 1946
watercolor on paper
30 x 38 (76.2 x 96.5)
Private Collection

David Smith

128 *Pillar of Sunday,* 1945
ink on paper
10 x 7¼ (25.4 x 18.4)
Collection Candida and Rebecca Smith, Courtesy M. Knoedler & Co., Inc., New York

129 *Untitled,* 1946–47
oil on paper on panel
30⅜ x 22⅜ (77.2 x 56.8)
Collection Candida and Rebecca Smith, Courtesy M. Knoedler & Co., Inc., New York

Theodoros Stamos

130 *Ancestral Worship,* 1947
gouache, ink and pastel on paper
17½ x 23⅜ (44.5 x 59.4)
Collection Whitney Museum of American Art, New York; Purchase, 48.9

131 *Untitled,* 1947
ink and tempera on paper
12¼ x 18½ (31 x 47)
Turske & Turske, Zurich

132 *The Wind is Ill,* 1947
ink on paper
19⅛ x 12¼ (48.6 x 31.4)
Turske & Turske, Zurich

Yves Tanguy

133 *Untitled,* 1943
gouache on paper
14 x 11 (35.6 x 28)
Collection Mr. and Mrs. Bruce Clark, New York

134 *Untitled,* 1945
gouache on paper
17½ x 11⅞ (44.5 x 30.2)
Collection The Museum of Modern Art, New York, Kay Sage Tanguy Bequest

*135 *Taille de guêpe,* 1945
gouache on paper
22 x 11 (55.9 x 27.9)
Pierre Matisse Gallery, New York

Mark Tobey

136 *Northwest Still Life,* 1941
tempera on board
20 x 26 (50.8 x 66)
Seattle Art Museum, Seattle, Washington; Eugene Fuller Memorial Collection

*137 *Red Man-White Man-Black Man,* 1945
oil and gouache on cardboard
25 x 28 (63.5 x 71.1)
Albright-Knox Art Gallery, Buffalo, New York; Room of Contemporary Art Fund, 1943

■

Selected Bibliography

Listed are the primary publications pertaining to the subject and time period addressed by this exhibition. The reader is referred to books and catalogs indicated by * in this listing for more comprehensive bibliographies.

General

*Arnason, H. H. *History of Modern Art: Paintings, Sculpture, Architecture.* New York: Harry N. Abrams, 1968.

Ashton, Dore. *The New York School: A Cultural Reckoning.* New York: Viking Press, 1972.

*Barr, Alfred H., Jr. *Fantastic Art, Dada, Surrealism.* New York: The Museum of Modern Art, 1936.

Carmean, E. A., Jr., and Rathbone, Eliza E. *American Art at Mid-Century: The Subjects of the Artist.* Washington: National Gallery of Art, 1978.

Chipp, Herschel B., with Peter Selz and Joshua C. Taylor. *Theories of Modern Art: A Source Book By Artists and Critics.* Berkeley and Los Angeles: University of California Press, 1968.

Contemporary Art 1942–72. New York: Albright-Knox Art Gallery and Praeger Publishers, 1973.

Flying Tigers: Painting and Sculpture in New York, 1939–1946. Providence, Rhode Island: Bell Gallery, Brown University, 1985.

Flying Tigers: Exhibition Histories of Painters 1939 to 1947. Compiled by Patricia McDonnell. Providence, Rhode Island: Bell Gallery, Brown University, 1985.

Geldzahler, Henry. *New York Painting and Sculpture: 1940–1970.* New York: E. P. Dutton, 1969.

Graham, John D. *System and Dialectics of Art.* New York, 1937; reprinted as *John Graham's System and Dialectics of Art.* Maria Epstein Allentuck, ed. Baltimore: Johns Hopkins Press, 1971.

Guggenheim, Peggy. *Out of This Century: Confessions of an Art Addict.* New York: The Dial Press, 1946.

*Guilbaut, Serge. *How New York Stole the Idea of Modern Art.* Translated by Arthur Goldhammer. Chicago and London: The University of Chicago Press, 1983.

*Henning, Edward B. *The Spirit of Surrealism.* Cleveland: Cleveland Museum of Art, 1979.

Hobbs, Robert Carleton and Levin, Gail. *Abstract Expressionism: The Formative Years.* Ithaca, New York: Herbert F. Johnson Museum of Art, Cornell, and New York: Whitney Museum of American Art, 1978.

Hughes, Robert. *Shock of the New.* New York: Alfred A. Knopf, 1982.

*Janis, Sidney. *Abstract and Surrealist Art in America.* New York: Arno Press, 1944.

Levy, Julien. *Memoir of an Art Gallery.* New York: Putnam, 1977.

Order and Enigma: American Art Between the Two Wars. Utica, New York: Museum of Art, Munson Williams Proctor Institute, 1984.

*Rubin, William. *Dada and Surrealist Art.* New York: Harry N. Abrams, 1968.

———. *"Primitivism" in 20th Century Art: Affinity of the Tribal and the Modern.* 2 volumes. New York: The Museum of Modern Art, 1984.

*Sandler, Irving. *The Triumph of American Painting: A History of Abstract Expressionism.* New York: Praeger Publishers, 1970.

Stangos, Nikos, ed. *Concepts of Modern Art.* New York: Harper and Row, 1974.

*Tuchman, Maurice, organizer. *New York School: The First Generation, Paintings of the 1940s and 1950s.* Los Angeles: Los Angeles County Museum of Art, 1965.

*Wechsler, Jeffrey. *Surrealism and American Art: 1931–1947.* New Brunswick, New Jersey: Rutgers University Art Gallery, 1976.

William Baziotes

Alloway, Lawrence. *William Baziotes: A Memorial Exhibition.* New York: The Solomon R. Guggenheim Museum, 1965.

Preble, Michael, organizer. *William Baziotes: A Retrospective Exhibition.* Newport Beach, California: Newport Harbor Art Museum, 1978.

Byron Browne

Berman, Greta. "Byron Browne: Builder of American Art." *Arts* 53 (December 1978).

Paul, April J. *Byron Browne—A Retrospective.* Naples, Florida: The Harmon Gallery, 1982.

Schlesinger, Stephen. *Byron Browne; Shapes in Perspective, 1929–1959.* New York: Gallery Schlesinger-Boisanté, 1984.

Arshile Gorky

Jordan, Jim M. *Gorky: Drawings.* New York: M. Knoedler and Co., 1969.

Levy, Julien. *Arshile Gorky.* New York: Harry N. Abrams, 1966.

Mooradian, Karlen. *Arshile Gorky Adoian.* Chicago: Gilgamesh Press, 1978.

Rand, Harry. *Arshile Gorky: The Implications of Symbols.* Montclair, New Jersey: Allanheld, Osmun and Co. Publishers, 1980.

Rosenzweig, Phyllis. *Arshile Gorky.* Washington: Smithsonian Institution Press, 1979.

Seitz, William C. *Arshile Gorky: Paintings, Drawings, Studies.* New York: The Museum of Modern Art, distributed by Doubleday, 1962.

Waldman, Diane. *Arshile Gorky: 1904–1948—A Retrospective.* New York: Harry N. Abrams and The Solomon R. Guggenheim Museum, 1981.

Adolph Gottlieb

Alloway, Lawrence. "Melpomene and Graffite." *Art International* 12 (April 1968).

Berger, Maurice. "Pictograph into Burst: Adolph Gottlieb and the Structure of Myth." *Arts* 55 (March 1981).

Davis, Mary R. "The Pictographs of Adolph Gottlieb: A Synthesis of the Subjective and the Rational." *Arts* 52 (November 1977).

Doty, Robert and Waldman, Diane. *Adolph Gottlieb.* New York: Frederick A. Praeger Publishers, for the Whitney Museum of American Art and The Solomon R. Guggenheim Museum, 1968.

Friedman, Martin. *Adolph Gottlieb.* Minneapolis: Walker Art Center, 1963.

Hirsch, Sanford and MacNaughton, Mary Davis, organizers. *Adolph Gottlieb: A Retrospective.* Text by Lawrence Alloway and Mary Davis MacNaughton. New York: The Arts Publisher, Inc., in association with the Adolph and Esther Gottlieb Foundation, Inc., 1981.

MacNaughton, Mary Davis. *Adolph Gottlieb: Pictographs, 1941–1953.* New York: André Emmerich Gallery in association with the Adolph and Esther Gottlieb Foundation, Inc., 1979.

John D. Graham

Butler, Joseph T. "The Work of John D. Graham." *Connoisseur* 169 (December 1968).

Gordon, Donald E. "Pollock's 'Bird' or How Jung Did Not Offer Much Help in Myth Making." *Art in America* 68 (October 1980).

John Graham 1881–1961: Drawings. Introductory essay by Eleanor Green. New York: André Emmerich Gallery, 1985.

Porter, Fairfield. "John Graham: Painter as Aristocrat." *Art News* 59 (October 1960).

Hans Hofmann

Bannard, Walter Darby. *Hans Hofmann: A Retrospective Exhibition.* Houston: The Museum of Fine Arts, 1976.

Greenberg, Clement. *Hofmann.* Paris: G. Fall, 1961.

Seitz, Willam C. *Hans Hofmann: With Selected Writings by the Artist.* New

York: The Museum of Modern Art and Doubleday, 1963.

Wight, Frederick S. *Hans Hofmann.* Berkeley and Los Angeles: University of California Press, 1957.

Gerome Kamrowski

Breton, André. *Gerome Kamrowski.* Paris: Galerie Creuze, 1950.

Maurer, Evan M. and Bayles, Jennifer L. *Gerome Kamrowski: A Retrospective Exhibition.* Ann Arbor: The University of Michigan Museum of Art, 1983.

Rosemont, Franklin. *Gerome Kamrowski: Then and Now.* Chicago: Gallery 2269, 1976.

Wifredo Lam

Calas, Nicolas. "Magic Icons." *Horizon* 14:83, 1946.

Fernandez-Santos, Francisco. "Wifredo Lam: 1902–1982." *Unesco Courier* (November 1982).

Gibson, Michael. "Picasso had Lam for Dinner." *Art News* 82 (September 1983).

Leiris, Michel. *Wifredo Lam.* New York: Harry N. Abrams, 1970.

Loeb, Pierre. "Wifredo Lam." *Horizon* 13:76, 1946.

Trotta, Geri. "Wifredo Lam Paints a Picture." *Art News* 49 (September 1950).

André Masson

André Masson. Florence, Italy: Salani Orsanmichele, 1981.

André Masson. Paris: Musée national d'art moderne, 1965.

Leiris, Michel. *Drawings, The Unbridled Line.* London: Thames and Hudson, 1972.

Rubin, William. *André Masson and Twentieth-Century Painting.* New York: The Museum of Modern Art, 1976.

Rubin, William and Lanchner, Carolyn. *André Masson.* New York: The Museum of Modern Art, 1976.

Matta

Calas, Nicolas. *Matta: A Totemic World.* New York: Andrew Crispo Gallery, 1975.

Kozloff, Max. "An Interview with Matta." *Artforum* 4 (September 1965).

Miller, Nancy. *Matta, The First Decade.* Waltham, Massachusetts: Rose Art Museum, Brandeis University, 1982.

Matta. Paris: Centre Georges Pompidou, Musée national d'art moderne, 1985.

Matta. Rome: Edizione Galleria dell'Oca. (not dated)

Joan Miro

Penrose, Roland. *Miro.* London: Thames and Hudson, 1985.

Rose, Barbara. *Miro in America.* Houston: The Museum of Fine Arts, 1982.

Rowell, Margit. *Miro.* New York: Harry N. Abrams, 1970.

Robert Motherwell

Arnason, H. H. *Robert Motherwell.* New York: Harry N. Abrams, 2nd Edition, 1982.

Ashton, Dore and Flam, Jack D., essayists. *Robert Motherwell.* New York: Abbeville Press for Albright-Knox Art Gallery, 1983.

Carmean, E. A., Jr. *The Collages of Robert Motherwell.* Houston: The Museum of Fine Arts, 1973.

Kozloff, Max. "An Interview with Robert Motherwell." *Artforum* 4 (September 1965).

O'Hara, Frank. *Robert Motherwell.* New York: The Museum of Modern Art, 1965.

Robert Motherwell in California Collections. Los Angeles: Otis Art Institute Gallery, 1975.

Barnett Newman

Cavaliere, Barbara. "Barnett Newman's *Vir Heroicus Sublimis:* Building the 'Idea Complex.'" *Arts* 55 (January 1981).

Hess, Thomas B. *Barnett Newman.* New York: Walker and Co., 1969.

_____. *Barnett Newman.* New York: The Museum of Modern Art, 1971.

Louw, Roelof. "Newman and the Issue of Subject Matter." *Studio International* 187 (January 1974).

Richardson, Brenda. *Barnett Newman: The Complete Drawings, 1944–1969.* Baltimore: The Baltimore Museum of Art, 1979.

Rosenberg, Harold. *Barnett Newman.* New York: Harry N. Abrams, 1978.

Gordon Onslow Ford

Onslow Ford, Gordon. *Towards a New Subject in Painting.* San Francisco: The San Francisco Museum of Art, 1948.

Wolfgang Paalen

Breton, André. "Genesis and Perspective of Surrealism in the Plastic Arts." English translation in Peggy Guggenheim's *Art of This Century.* New York: Art of This Century Gallery, 1942.

Paalen, Wolfgang. "The New Image." *Form and Sense.* New York: Wittenborn, Schultz, 1945.

Paalen, Wolfgang. "Theory of the Dynaton." *Dynaton.* San Francisco: San Francisco Museum of Art, 1951.

Jackson Pollock

Frank, Elizabeth. *Jackson Pollock.* New York: Abbeville Press, 1983.

Friedman, B. H. *Jackson Pollock.* New York: McGraw-Hill, 1972.

Kraus, Rosalind. "Jackson Pollock's Drawings." *Artforum* 9 (January 1971).

O'Connor, Francis V., and Thaw, Eugene V., eds. *Jackson Pollock: A Catalogue Raisonné of Paintings, Drawings, and Other Works.* 4 Volumes. New Haven: Yale University Press, 1978.

O'Connor, Francis V. "The Genesis of Jackson Pollock: 1912–1943." *Artforum* 5 (May 1967).

Rose, Bernice. *Jackson Pollock: Works on Paper.* New York: The Museum of Modern Art, in association with The Drawing Society, Inc., 1969.

Rubin, William S. "Jackson Pollock and the Modern Tradition, part V, The All-Over Compositions and the Drip Technique." *Artforum* V (February 1967).

Wysuph, C. L. *Jackson Pollock: Psychoanalytic Drawings.* New York: Horizon Press, 1970.

Richard Pousette-Dart

Gordon, John. *Richard Pousette-Dart.* New York: Frederick A. Praeger, 1963.

Sims, Lowery S. *Richard Pousette-Dart.* New York: Marisa del Re Gallery, 1983.

Mark Rothko

Ashton, Dore. *About Rothko.* New York: Oxford University Press, 1983.

Clearwater, Bonnie. *Mark Rothko: Works on Paper.* New York: Hudson Hills Press, in association with the Mark Rothko Foundation, 1984.

Gibson, Ann. "Regression and Color in Abstract Expressionism: Barnett Newman, Mark Rothko, and Clyfford Still." *Arts* 55 (March 1981).

Polcari, Stephen. "The Intellectual Roots of Abstract Expressionism." *Arts* 54 (September 1979).

Rosenblum, Robert. *Mark Rothko: The Surrealist Years.* New York: Pace Gallery Publications, 1981.

Selz, Peter. *Mark Rothko.* New York: The Museum of Modern Art, 1961; reprinted New York: Arno Press, 1972.

Waldman, Diane. *Mark Rothko, 1903–1970: A Retrospective.* New York: The Solomon R. Guggenheim Museum and Harry N. Abrams, 1978.

David Smith

Hunter, Sam. "David Smith." *The Museum of Modern Art Bulletin* 25, 1957. New York: The Museum of Modern Art.

Kramer, Hilton. *David Smith: A Memorial Exhibition.* Los Angeles: Los Angeles County Museum of Art, 1966.

McClintic, Miranda. *David Smith.* Washington: Smithsonian Institution Press, 1979.

Wilkin, Karen. *David Smith, The Formative Years: Sculptures and Drawings from the 1930s and 1940s.* Alberta: The Edmonton Art Gallery, 1981.

Theodoros Stamos

Ashton, Dore. *Stamos.* New York: Camillos Kouros Gallery, 1985.

Cavaliere, Barbara. *Theodoros Stamos: On the Horizon of Mind and Coast.* Zurich: Knoedler, 1984.

Yves Tanguy

Jean, Marcel. "Tanguy in the Good Old Days." *Art News* 54 (September 1955).

Pierre, Jose. *Yves Tanguy Retrospective 1925–1955.* Paris: Centre Georges Pompidou Musée national d'art moderne, 1982.

Saucet, Jean. *Yves Tanguy.* Paris: Editions Filipacchi, 1973.

Soby, James Thrall. *Yves Tanguy.* New York: The Museum of Modern Art, 1955.

Mark Tobey

Dahl, Joyce and Arthur. Essay by Lorenz Eitner. *Mark Tobey: Paintings from the Collection of Joyce and Arthur Dahl.* Stanford, California: Stanford Art Gallery, 1967.

Schmied, Wieland, *Tobey.* New York: Harry N. Abrams, 1966.

Seitz, William C. *Mark Tobey.* New York: The Museum of Modern Art, 1962.

Tribute to Mark Tobey. Washington: Smithsonian Institution Press, 1974.

■

Newport Harbor Art Museum

Board of Trustees

Ray H. Johnson
President

Harry G. Bubb
Vice President

John E. Dwan II
Vice President

Mrs. Samuel Goldstein
Vice President

Michael Meyer
Treasurer

James E. Henwood
Secretary

Trustees Emeritus
Mrs. John P. Hurndall
Mrs. Harvey Somers
Mrs. Richard Steele
Mrs. Richard H. Winckler

Mrs. M. Patricia Nelson
Docent Council

Alison Baker
Fine Arts Patrons

Mrs. Chris Marshall
Museum Council

Mrs. Marilyn Hansen
Sales and Rental Council

Mr. Bill Hitchcock
Business Council

Randy Morrison
Douglas Russell
Contemporary Club

Mr. Bruce Andrews
Mr. Hancock Banning III
Mr. Frederick Barnes
Mr. David W. Carroll
Mrs. E. G. Chamberlin
Mr. Warren D. Fix
Mrs. Ronald R. Foell
Rogue Hemley
Mrs. Richard S. Jonas
Mrs. Lucille Kuehn
Mrs. Roger W. Luby
Mr. Leon Lyon
Mr. Carl Neisser
Mrs. Robert Perkins
Dr. James B. Pick
Mr. Harold C. Price
Mr. George R. Richter, Jr.
Francis P. Shanahan
Mr. John Martin Shea

Mr. Joel Slutzky
Mr. David R. Stein
Mr. David H. Steinmetz
Mr. David S. Tappan, Jr.
Mr. Thomas Testman
Mrs. Charles Ullman
Mr. H. S. "Pete" Voegelin
Mr. Eugene C. White
Dr. Jay M. Young
Mrs. Nancy Zinsmeyer

Staff

Adminisration

Karen Ables, *Accountant*
Kevin E. Consey, *Director*
Ursula R. Cyga, *Admissions & Membership Officer*
Carol Lincoln, *Chief Accountant*
Helen McClanahan, *Admissions Clerk/Receptionist*
Jane Piasecki, *Associate Director*
Pen Robinson, *Administrative Assistant*
Carolyn Sellers, *Receptionist*

Bookstore

Martha Partin, *Bookstore Manager*

Curatorial

Anne B. Ayres, *Associate Curator of Exhibitions and Collections*
Lorraine Dukes, *Assistant to the Chief Curator*
Christie Frields, *Registration Intern*
Sue Henger, *Archivist/Curatorial Editor*
Paul Schimmel, *Chief Curator*
Betsy Severance, *Curatorial Fellow*
Natasha E. K. Sigmund, *Registrar*

Development

Claudia Bravo, *Development Secretary*
Kathleen Costello, *Public Relations Officer*
Vanessa Craig, *Research Intern*
Patricia Engel, *Public Relations Intern*
Karen Kramlich, *Membership Intern*
Kim Litsey, *Associate Director of Development*
Marijo Racciatti, *Membership Registrar*
Gloria Ruston, *Special Events Coordinator*
Margie Shackelford, *Director of Development*

Education

Ellen Breitman, *Curator*
Dinah McClintock, *Education Intern*

Operations

Terry Atkinson, *Technical Services Coordinator*
Douglas Carranza, *Janitor/Maintainer*
Brian Gray, *Chief Preparator*
Gary Keith, *Preparator*
Ginny Lee, *Preparator*
Gregory Miller, *Graphic Designer*
Sandy O'Mara, *Graphic Artist*
Steve Osborne, *Preparator*
Ross Rudel, *Preparator*
Kurt Schmidt, *Preparator*
Linda Stark, *Chief of Security*
Bill Thompson, *Preparator*
Richard Tellinghuisen, *Director of Operations*

Sculpture Garden Cafe

Marilyn Kaun, *Cafe Manager*
Bonnie Jo Smith, *Kitchen Supervisor*

KING ALFRED'S COLLEGE
LIBRARY

Photo Credits

Courtesy Albright-Knox Art Gallery *137*
Courtesy Allen Memorial Art Museum *13*
Oliver Baker *28, 74*
Ben Blackwell *127*
Courtesy Sarah Campbell Blaffer
 Foundation *22*
Chisholm, Rich & Associates *9, 10*
Geoffrey Clements *2, 7, 16, 47, 79, 100, 102,
 123, 126, 129, 130*
Ken Cohen *81, 128*
eeva-inkeri *66, 67, 68*
Courtesy Xavier Fourcade, Inc. *17, 19*
Courtney Frisse *30*
Courtesy Galerie Éditions Lahumière *58*
Emil Ghinger *4, 112*
David Heald *8*
Courtesy Arnold Herstand and Company
 109
Nick Hlobeczy *70*
Bill Jacobson Studio *6, 24, 35, 63, 64, 97,
 105, 108, 116, 117, 118, 119, 121, 124, 133*
Courtesy Herbert F. Johnson Museum of Art
 25, 51
Bruce C. Jones *23*
Courtesy Camillos Kouros Gallery *131, 132*
Mike McKelvey *40*
Robert E. Mates *18, 21, 26*
Aida and Bob Mates *93*
Robert E. Mates and Mary Donlon *120*
Robert E. Mates and Paul Katz *27, 33*
Courtesy Pierre Matisse Gallery *50, 135*
Andrew Moore *5*
Thomas Moore *78*
Courtesy Museum of Modern Art *61, 107, 134*
O. E. Nelson *3*
Courtesy North Carolina Museum of Art *31, 82*
Gene Ogami *11, 20, 48, 71, 106*
Douglas M. Parker *94*
Courtesy Betty Parsons Foundation *110*
Eric Pollitzer *65, 90*
Renate Ponsolo *83*
Courtesy Portland Museum of Art *77*
Courtesy Marisa del Re Gallery, Inc. *15, 52,
 53, 54, 55, 57, 59, 73,113, 114*
Kevin Ryan for André Emmerich Gallery *34,
 36, 37, 38, 39, 41, 43*
Courtesy San Francisco Museum of Modern
 Art *125*
Giuseppe Schiavinotto *62*
Courtesy Seattle Museum of Art *136*
Steven Sloman Fine Arts Photography *76*
John Smart *103*
Courtesy E. V. Thaw & Co., Inc. *12*
Steven Tucker *60*
Tom Van Eynde *122*
Malcolm Varon *84, 85, 86, 91, 97*
Victor's Photography *46*
Courtesy Wadsworth Atheneum *72*
David Webber *29*
David Wharton *101*